PAINTING PROFESSIO

D1033823

GENDER & AMERICAN CULTURE

Coeditors

Thadious M. Davis

Linda K. Kerber

Editorial Advisory Board

Nancy Cott

Cathy N. Davidson

Jane Sherron De Hart

Sara Evans

Mary Kelley

Annette Kolodny

Wendy Martin

Nell Irvin Painter

Janice Radway

Barbara Sicherman

Painting Professionals

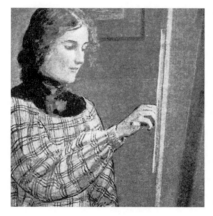

WOMEN ARTISTS & THE

DEVELOPMENT OF MODERN

AMERICAN ART, 1870–1930

KIRSTEN SWINTH

The University of North Carolina Press

Chapel Hill and London

© 2001

The University of North Carolina Press

All rights reserved

Designed by Richard Hendel

Set in Monotype Centaur

by Tseng Information Systems, Inc.

Manufactured in the United States of America

The paper in this book meets the guidelines for permanence

and durability of the Committee on Production Guidelines

for Book Longevity of the Council on Library Resources.

Publication of this book has been aided by a generous

contribution from the Greensboro Women's Fund.

Library of Congress Cataloging-in-Publication Data

Swinth, Kirsten.

Painting professionals: women artists and the development

of modern American art, 1870–1930 / Kirsten Swinth.

 p. cm.—(Gender & American culture)

ISBN 0-8078-2642-1 (cloth: alk. paper) —

ISBN 0-8078-4971-5 (pbk.: alk. paper)

 1. Painting, American—19th century. 2. Painting,

American—20th century. 3. Women painters—

United States. I. Title. II. Series.

ND210 .S93 2001

759.13'082—dc21 2001027413

05 04 03 02 01 5 4 3 2 1

FOR J. T. M.

Hardly more than a decade has passed since women artists of real ability and with serious purposes ceased to be a rarity. The flower- and still-life painting lady of amateurish tendencies has always been with us, but the energetic, hopeful female art student, abreast with the most advanced theories, and differing from her male fellow workers neither by her choice of subjects nor her manner of execution, is, as a class, essentially a product of to-day.
—Frank Linstow White, "Younger American Women in Art,"
 Frank Leslie's Popular Monthly (November 1893)

Some people think the women are the cause of modernism, whatever that is.
—*New York Sun* (February 13, 1917)

CONTENTS

ILLUSTRATIONS

ACKNOWLEDGMENTS

Writing acknowledgments must be one of the things authors endlessly fantasize about. There is, of course, relief involved. The end is in sight. But the fantasizing is as much about repaying the debts incurred in writing a book. I begin repaying those debts by thanking first the people who taught me to think about art, women, and culture together—Wanda Corn, Nancy Cott, Bryan Wolf, Alan Trachtenberg, and Jean-Christophe Agnew. Wanda Corn instigated this project by introducing me to Georgia O'Keeffe and American modernism fifteen years ago. Nancy Cott nurtured my interest in O'Keeffe by letting me consider her in the unconventional setting of women's history. And, more important, by intellectual and personal example, she has helped me understand the life of a professional. Her combination of rigorous criticism and encouraging comment made me a better scholar.

For help with locating and gaining permission to reproduce artworks, I thank Joan Whalen of Joan Whalen Fine Art, Gerard Jackson, Gabriel Weisberg and the Dahesh Museum, Erica Hirshler at the Museum of Fine Arts in Boston, Randi Greenberg at the National Museum of Women in the Arts, Barbara Buhler Lynes at the Georgia O'Keeffe Museum, Susan Shehan, Sophia Hewryk at Moore College of Art and Design, Wendy Hurlock and the Archives of American Art, and Ben Alexander at the New York Public Library. It was a great honor to interview Theresa Bernstein. (Thanks again to Joan Whalen for arranging the meeting.) Dahlov Ipcar, daughter of Marguerite Zorach, kindly spoke with me, as did Zorach's friend Arnold Potter. Both of them have my gratitude for their gracious patience with my questions. I had the good fortune as well to begin a correspondence with Jonathan Zorach, Marguerite Zorach's grandson, as I neared the end of the book. Three organizations have granted me permission to quote from material in their collections. I thank the Sophia Smith Collection at Smith College, Northampton, Massachusetts, for permission to quote from the Hale Family Papers; the Plastic Club of Philadelphia, Pennsylvania, for permission to quote from

their records; and Moore College of Art and Design Library Archives, also in Philadelphia, for permission to quote from Emily Sartain's correspondence.

To complete this study, I relied heavily on the resources of two institutions in Washington, D.C., the Archives of American Art and the National Museum of American Art. The staff at both has been knowledgeable and friendly. I especially thank Judy Throm, Beth Joffrion, and Cindy Ott. One hot Washington summer, Tara Tappert shared her wealth of knowledge on Cecilia Beaux and the Emmet sisters, kindly opening her files to me. The funding of several organizations secured the precious time I needed to write. I am grateful to the Mellon Foundation for a Doctoral Fellowship in the Humanities, to Yale University for an Alumni Fund Special Dissertation Fellowship, and to the Getty Grant Program for a Postdoctoral Fellowship in Art and the Humanities. In addition, a John F. Enders Research Grant from the Yale Graduate School supported work in the early stages of the project, and the Ames Fund for Junior Faculty at Fordham University underwrote the illustrations in the book. I owe a special debt to Bob Himmelberg, who never flinched when I asked for more help from the Ames Fund.

The illustrations in this book should be considered a collaborative endeavor. Without the exemplary assistance of Laura Schiavo on the illustrations, the book would be much duller. I am also pleased to thank Jennifer Beirne and Caroline Dunn, my research assistants at Fordham. My colleagues at George Washington University and Fordham University have encouraged without the pressure that can terrify a young colleague. For that tricky balancing act, and much more, I thank them. I am particularly grateful to Terry Murphy, Howard Gillette, Phyllis Palmer, Elaine Crane, Nancy Curtin, and Tip Ragan.

Other colleagues and friends provided the intellectual community that sustained my work. I thank Ann Fabian, Christine Stansell, and Beryl Satter for reading the manuscript in its entirety at different times. Kate Torrey has been consistently helpful, as have Linda Kerber and both readers for the University of North Carolina Press. Others have patiently read and discussed: Melani McAlister, Jennifer Price, Lisa Rabin, Karie Youngdahl, Eliza Harrison, Nina de Angeli Walls, April Masten, and Diana Korzenik. My special gratitude goes to Amy Green, who has remained "on call" for the decade I've worked on this book. Lastly, among my friends, I thank Ellen Hickey Grayson. Ellen died last spring, and I have finished this book thinking about how it began with her. That it got off the ground at all is a tribute to her intellect and support.

Families do not always occupy their deserved place in the rituals of fanta-

sizing about acknowledgments. But, with great pleasure, I thank my extended family—Mark Swinth and Kitty Powell, Max Deibert, Mary Mason, Sofie Mason and Paul Cooper, Polly and Charles Chatfield, and Roger and Marina Post. My mother, Heather Jackson, has inspired me by remaking her own life as a professional. My father, Robert Swinth, has taught me about the vagaries of academia and the power of a good laugh. For all the rest that it takes to complete a book—intellectual companionship, a partner's encouragement, and a marathoner's endurance—I dedicate this to Jocelyn Mason.

PAINTING PROFESSIONALS

INTRODUCTION

In 1864 Mary Cassatt wrote to Eliza Haldeman, her friend and fellow student at the Pennsylvania Academy of the Fine Arts. Cassatt encouraged Haldeman to submit a picture to the academy's annual exhibition. "Now please don't let your ambition sleep," she wrote, "but finish your portrait of Alice so that I may bring it to town with me & have it framed with mine sent to the Exhibition with mine hung side by side with mine be praised, criticised with mine & finally that some enthusiastic admirer of art and beauty may offer us a thousand dollars a piece for them. 'Picture it—think of it!'"[1] Awakened ambition carried Cassatt and Haldeman well beyond the decorous art training given to proper, but amateur, ladies in the late nineteenth century into public exhibition, critical recognition, and unabashed earnings. Without hesitation, without even a nod to Victorian womanly reserve, Cassatt proclaimed her ambition to be a professional artist. The hunger and drive compressed in that short command, "Now please don't let your ambition sleep," ring with a larger impact. The ambition of Cassatt and her peers shook up the art world. It disrupted entrenched beliefs about art, refinement, and high culture. A modern, twentieth-century and avant-garde art world would be profoundly shaped by late-nineteenth-century women's urgent desire to become artists. This book traces the relationship between the careers of women painters and the realignment of the American art world at the turn of the century.

Women entered art in unprecedented numbers after the Civil War, flooding art schools, hanging their pictures alongside men's, pressing for critical recognition, and competing for sales in an unpredictable market. By the end of the century, these ambitious women had created an extensive network of female artists seeking, as Cassatt had dreamed, to exhibit their works "side by side." Like Cassatt, such women developed sustained careers that easily transcended the stereotypes of flower painter and dilettantish amateur that still color descriptions of late-nineteenth-century women artists. Ultimately, women's growing presence triggered a reaction that decisively reshaped not only the art world but also the concept of culture in highly gendered terms.

The American art world expanded rapidly after the Civil War. The relatively small, intimate world of antebellum artists and patrons dissolved as the cultural nationalism that had fostered close patronage and dedicated purchase of American landscape paintings lost favor to a cosmopolitan taste for contemporary European figure and Old Master paintings. New industrial wealth funded vast collections and underwrote major art institutions such as the large urban museums founded in New York, Boston, and Chicago.[2] Vigorous collecting, tantalizingly high prices, and new public prominence made art a growth industry. Older art academies attracted rising enrollments as schools sprang up around them; both, responding to a new professional orientation among their students, standardized and regularized their teaching. Art students, in part sharing collectors' cosmopolitanism of taste and in part sensing the direction of the market, rejected the landscapes and genre paintings of the previous generation and demanded fully elaborated academic figure training. The figure rapidly became the centerpiece of cutting-edge American art. As early as 1883 the *New York Times* was declaring the field of art crowded, with the numbers of artists equaling the numbers of lawyers in cities such as New York, Boston, and Chicago. According to the *Times*, the rising status of art had reduced parental opposition to this volatile profession and brought burgeoning numbers of aspirants to the field.[3]

The *Times* discussion of artists' professional opportunities reflected the rising coverage art received in the Gilded Age. Several magazines devoted exclusively to art were launched, while major monthly magazines such as *Scribner's* and *Century* filled their pages with illustrations and expanded their circulations. Newspapers also hired their first full-time art critics. These men and women covered small and large exhibitions, artists' societies, and studio openings. They introduced a broad middle-class readership to the history of art and to its latest developments in order to inspire what one contemporary critic called "aesthetic evangelists." The adventurous, somewhat bohemian artist became a popular image in journalistic and fictional tales, with the exploits of the studio, the adventures of Parisian art study, and the oddities of the girl art student becoming stock figures.[4]

This extensive popularization was not accidental or incidental. Because art virtually obsessed Gilded Age Americans, it became a potent vehicle for defining social authority. Beginning with the 1876 Centennial Exhibition, critics and commentators subjected the late nineteenth century's world's fairs to intense scrutiny, assessing America's place on the artistic world stage but also disseminating and popularizing aesthetic norms and genteel standards of taste. The Centennial Exhibition was particularly important because it

sparked the wildly popular aesthetic movement. Most indicative of the Gilded Age devotion to art was the extension of art education to the public schools. Educators argued that art training promoted manual skills, tasteful consumption, and an "art spirit" that fostered individual development and social harmony. Gilded Age Americans, particularly the middle class, placed extraordinary faith in the power of art (and high culture generally) to instill values and unify society. This meant that much more than the latest aesthetic fashion was at stake. The dynamics of the art world influenced conceptions of high culture, its social purposes, and, more broadly, the form and content of middle-class assertions of cultural authority.[5]

Middle-class white women were essential to the expansion of art. Schools of design, founded as early as 1848, offered women instruction and employment in the decorative and industrial arts. By the early 1860s, women also began to enter traditional art academies for academic training in painting and drawing. Thirty years later nearly 11,000 women artists, sculptors, and teachers of art practiced their profession according to the 1890 census, rising stunningly from the 414 women counted in the same category just twenty years before. Proportionally, the increase was just as striking: women had been merely 10 percent of artists in 1870; in 1890 they reached nearly one-half of all those counted (48.1 percent). While the category encompassed a range of practices and art teaching diverted many from painting careers, these numbers reflected major inroads into the profession by women. In painting, the highest end of the profession, directories of artists and exhibitions indicated that women represented fully one-third of those active in the country at the turn of the century. These kinds of gains in a profession that was not on its way to becoming fully feminized are unmatched. In "traditional" professions such as medicine and law, women remained well under 10 percent; in academia, they reached almost a third of all professors and instructors, but not until 1930. The census numbers for women artists declined after 1890. They dropped more than 10 percent by 1930, a reversal induced undoubtedly by the backlash the twenty-year surge engendered. But in 1890 the census numbers meant a sense of optimism, flowering, and possibility for women.[6] "The energetic, hopeful female art student abreast with the most advanced theories," described by Frank White in 1893, could not be missed. Women and men alike perceived a major advance.[7]

With these numbers as a starting point, the landscape of Gilded Age and Progressive Era women's history looks significantly different than it has often been portrayed.[8] The women pursuing art as a career joined thousands of others who followed well-established routes for middle-class women into

charitable activity and civic reform. Gilded Age women entered the public sphere through this work, where their endeavors included what we might call "cultural housekeeping." As with the "social housekeeping" so often linked to women in this period, Victorian ideologies of womanhood justified this cultural housekeeping, but through the association of women with cultural guardianship, beauty, and refinement, rather than with a female maternal and nurturing nature. Beginning in the 1850s, then gathering momentum from the Fine Arts Palace at the 1876 Centennial Exhibition, women pursued a broad range of cultural activities: early charitable efforts to provide women with means of self-support in places such as design schools and decorative art societies; the massive club movement of the turn of the century; and finally civic campaigns such as the movement for art education in public schools and the municipal arts commissions formed in the Progressive Era.[9] One goal of this book, then, is to begin to redraw turn-of-the-century women's history in such a way that the artist and the cultural guardian become figures with dimension rather than the caricatured dilettantes and amateurs they remain in popular and scholarly imagination.

Although the numbers of women pursuing art careers and the wide array of women's artistic activity register advance and progress, with immense gains for women, the numbers alone mask a more complex history. This book does not uncover patriarchy overturned but rather gain, backlash, and recouping as gender ideologies shifted and as women's ability to access and leverage the dominant discourse and institutions changed. For example, female cultural guardianship created positive associations between art, refinement, and women's activity that helped validate women's careers (especially in the 1870s and 1880s), but serious women artists continuously struggled not to be drawn into the aura of velvet painting and bric-a-brac production that clung to female artwork. Numbers show neither the specific social and cultural battles women fought nor how the growing numbers of women artists changed the structure and dynamics of the profession.[10]

So, this book seeks to do more than count numbers. It tells two stories. The first is of women painters — of the careers they were able (and not able) to fashion and of the kinds of pressures they exerted on the art world for recognition and status. The second charts the emergence of modern, twentieth-century understandings of culture out of the contentious gender politics of the art world. In the book's first narrative, I follow two generations of women painters through three periods of change: the Gilded Age years of the 1870s and 1880s, the period of backlash and reorientation that followed in the 1890s, and the era of modernism between 1910 and 1930. After the Civil War, women

entered art schools in rising numbers and began to pursue careers. They succeeded in art schools, where they joined male students in advancing a new professionalism that stressed trained, educated skill and meritocratic advancement through the well-defined stages of academic art training. Outnumbering men in art schools by the 1880s, women sought to translate their training into exhibitions, sales, and reputations. They gained critical notice, passed juries for major exhibitions, and garnered some sales, even though the market for American art remained weak. To compensate for the weak market, women (as well as men) also worked in the "lesser" media associated with female amateurism, such as watercolor, which critics and consumers valorized as exemplifying genteel taste and cultural refinement.

By 1890, commentators and critics claimed that women were winning the "race" for art and outpacing men in their achievement. A backlash set in that fundamentally reoriented the art world. Institutionally, market structures grew smaller and more exclusive, especially as the gallery-dealer system developed. Rhetorically, rebellion against cultural refinement bred a new masculinity in criticism based on biological and Darwinian notions of creativity. Repudiation of highly finished academic work (and the trained skill behind it) translated into celebration of a more personal, brushy style. Read as male, these new, actively painted canvases became a prelude to an avant-garde aesthetic.

Women responded to these changes with professionalism, choosing skill, training, and hard work over biology. But as biology came to define artistic expression, women had increasing difficulty circumventing the small space allotted to them as the producers of the "essentially feminine" (such as charming and sympathetic portraits of women and children). In the second decade of the twentieth century, modernism, as the product of a bohemian avant-garde, seemed as if it might liberate women from the requirement to express the feminine. Instead, modernism carried forward the same gender-based closures of market and discourse that had developed in the 1890s. Figuring academic art as not only conservative but also the province of women, male avant-garde artists reinvigorated the selective galleries and the biological discourse of artistic virility from the 1890s.[11] Only in the 1920s did modernist women artists escape the imperative to paint womanhood by reformulating ideas about individuality and femininity.

To track the changes in women's position within the art world is to track a fundamental reorganization of culture. Changes in art world institutions and ideology helped rewrite understandings of high culture, from a realm of (feminized) genteel refinement to a space of heroic (masculine) self-expres-

sion. Women artists, I argue, by undercutting male control over art and culture, set off a chain reaction that shifted the ground beneath long-standing conceptions of culture. We could, in the traditions of melodrama, see this reformulation as a rescue mission, extracting culture from the clutches of the "evil empire" of the feminine.

So this book's second narrative parallels its first, unearthing the uneven, and sometimes unexpected, gender dynamics of the art world and unraveling larger transformations in the definition of culture. In the 1870s and 1880s, artists aspired to the ideal of the refined professional. The development of professionalism in art was part of the growing prominence of the professions in the late 1800s. By the end of the nineteenth century, a broadly diffused culture of professionalism was well ensconced. It extended the authority claimed by professionals to the middle-class generally and became a key component of middle-class identity.[12] In their drive to propel themselves solidly into the middle class, Gilded Age artists adapted the institutions, strategies, and autonomous outlook of traditional professions to the art world. Art thus professionalized in the sense that it both deepened the culture of professionalism and claimed the authority and prestige of the professions for itself.[13] But the normative image of the professional was masculine—rational, independent, expert—and professionalization, as women's historians have convincingly shown, was always a deeply gendered process.[14] This made women artists' involvement in art's professionalization complex. Still, seeing potential in professional norms and sharing male artists' class aspirations, they joined men in establishing professionalism in art schools and participated in setting its standards.

In addition to professionalism, Gilded Age artists aligned themselves with —and shaped—ideals of taste, including cosmopolitanism, gentility, and refinement. Art, literature, and intellectual life came to represent what we now think of as the realm of high culture.[15] The world of high culture shared much with the Victorian world of white, middle-class womanhood: a domain supposedly above and outside the market, a terrain of refinement and beauty, and a realm of morality and uplifting influence. More than overlaps in definition, these common meanings reflected the dependence of high culture on a gendered ideology that linked refinement and femininity and placed them outside the market. This understanding of culture became a cornerstone of middle-class identity and aspirations. It was a way for the middle class to define itself and a means to extend its authority, as middle-class leaders envisioned high culture as the means through which all classes would be brought under its own refining—and ordering—influences. There was a congruence,

then, between refinement and professionalism in this period. Even though their gender overtones were quite distinct, they were intertwined in a shared process of shaping middle-class identity and asserting middle-class cultural authority. The complex interaction between refinement and professionalism generated a degree of fluidity in the gendered ideologies of art and moments when male and female artists had similar aims because their goals were bound up in a shared class and race project about civilized, refined culture. Male and female artists agreed that culture aided not only the ordering of society but also the "civilizing" mission that marked and guaranteed Anglo Saxon supremacy.[16]

Then in the 1890s, professionalization and refinement stopped working to advance the status of art and support middle-class uses of high culture. Why? Artists responded to forces both within and outside the art world. Most important outside the art world was the deepening impact of industrialization. A growing immigrant and industrial working class evaded middle-class efforts at control. Amusement parks, dance halls, and eventually movies attracted far more working-class interest than middle-class programs for civilized refinement.[17] The corporate structure also profoundly altered middle-class male work as nineteenth-century ideals of manly hard work and self-discipline seemed of little use to men now employed in large, anonymous businesses. Industrialization eroded not only opportunities for male independence but also the centrality of men's roles as producers as consumption's significance to the economy grew. The rising importance of consumption, long understood as a female activity, signaled changed gender roles as well.

As the new economic order weakened nineteenth-century ideals of manhood, intellectuals, journalists, and scientists restructured middle-class white manhood. The hypermasculinity of Theodore Roosevelt's popular "strenuous life" reflected the celebration of virility, competitiveness, and self-expression dominating these new ideas.[18] Male artists certainly participated in this restructuring.[19] Their pursuit of refinement had changed male practice so much that their work, however much they wanted it to be professional (with its male connotations), left them far removed from Roosevelt's vigorous masculine existence.

Male artists' involvement in this society-wide restructuring of manhood helped realign the art world. But the changes in the art world stemmed from more than the sweeping, yet indirect, effects of industrialization. A far more immediate pressure lay in women's contest with men over the profession and culture.[20] This part of the story has not yet been told. By the end of the 1880s women's advances in art were substantial and widely perceived by their

contemporaries. Male artists encountered female colleagues face to face on a daily basis: women students populated classes with men; female petitions for membership filled artists' clubs' agendas; women's canvases inundated exhibition juries; female artists, such as the Frenchwoman Rosa Bonheur, grabbed headlines with notable sales, such as second highest ever price paid for a painting at auction in America; and women painters received reviews that declared them triumphing over men.[21] This female presence and the gender dynamics it provoked reverberated through the art world, stimulating institutional and discursive change and rupturing established ideas of culture.

By 1890, women could no longer be contained as rapt receivers of men's creations. Rather than dignifying the ideals of high culture, women started to appear threatening and disruptive. Art critics and magazine editors lamented "the vast horde of disorderly females who daub[ed] over plush and paint[ed] lilies of the valley on guitars." As part of a "horde," women signified the dangers of mass culture and popular consumption; as "disorderly females," their cultural productions signified a violation of gender roles. Daubing away, middle-class women endangered the gendered ideology backing up ideals of culture.[22] Women's entry into art thus stimulated intense conflict *within* the middle class over the control of culture. Acting as producers of culture, and not just as exemplars of refinement or aesthetic consumers, middle-class women artists effectively challenged middle-class men's control over "professional" art.

As the precarious balance between refinement, professionalization, and the elevated realm of culture outside the market fell apart, male artists and critics regrouped under the banner of a newly redrawn notion of culture. Based in Darwinian notions about the evolutionary basis of artistic genius, the highest achievement in culture altered. Art and cultural critics replaced the ideal of cultural refinement with the lauding of culture as the expression of an authentic self that was by evolution restricted to white men. True art displayed a virile selfhood. The purpose of high culture now lay not in elevating, refining, and ordering all members of society; it lay in individual self-realization. This is a modern, and ultimately modernist, understanding of culture. The move from genteel and academic art to avant-garde art was a highly gendered process that allowed men to reclaim culture for themselves. That modernists rejected an overbearing, feminized Victorian tradition is a mainstay of recent accounts of the formation of the early-twentieth-century avant-garde.[23] But, I argue, to understand modernism fully we need to read that repudiation in a more complex light. The modernist break with the Victorian past actually precluded female creativity on a par with men's. The modernist woman's

self-expression was her femininity; truly individualized self-expression became male. The *New York Evening Sun* was more accurate than it intended when it declared women the cause of modernism.[24] Avant-garde artists and critics responded to women's pressure on the art world when they followed turn-of-the-century commentators in rewriting culture as a heroic, but masculine, enterprise of liberation.

This modern reconstruction of culture is at once a more therapeutic understanding and one that preserves high culture as a realm apart from and untainted by the market because it comes from the "inner" self.[25] Part of the cultural work of the turn-of-the-century realignment of art and culture was transferring high culture to a masculine domain without losing its privileged position outside the market. This new conception of culture shed the social aims of the genteel tradition. I do not want to oversimplify the complexity of this cultural formation, but I do want to stress here how a gendered reading of the transformation in culture reveals an entirely new set of social purposes for high culture — one with conservative implications. These conservative results lay not just in the gender politics but also in the relatively undemocratic thrust of the ideals. Artists, in the modern formulation, model a process of self-expression and realization that only a few may achieve. Given all the top-down social control attributed to the genteel tradition, and given the often relieved accounts of its demise, the triumph of the heroic, yet singular, male artist has a certain irony. Even fewer people can truly gain access to culture.

The redefinition of culture and the reorganization of its social purposes across the late nineteenth and early twentieth centuries have not been fully mapped. This book elucidates how critics, artists, and other commentators extended and reformulated the category of "high culture" for the twentieth century and in particular underwrote the new cultural formation of modernism. Typically, early-twentieth-century high culture has been understood through a sharpening distinction between the "highbrow" and the "lowbrow" as a result of the expansion of mass culture.[26] Just as significant were changes within the category itself, notably the gendered construction of oppositions between refinement and virility and professionalism and self-expression. Modern high culture took its form not simply from the rise of mass, commercial culture but more immediately through women's challenge. Women, as producers of art, encroached on high culture until turn-of-the-century (and then modernist) artists and art avatars elevated style over subject and denied women the biological equipment to be true stylists.

Tracing the evolution of high culture from this gendered perspective deepens our understanding of the transition from a Victorian to a modern cultural

landscape. The blossoming of mass and consumer culture has been delineated as a gendered process, with the feminine connotations of these lowbrow arenas strengthening in the early twentieth century. This book helps explain the forceful gendering of mass culture as feminine. Male artists and their supporters enforced the divide between high and low to erase their own commercial labor (primarily as illustrators) and dismiss their female colleagues as daubers and painters of potboilers for an undiscriminating, mass, and female audience. By locating the rewriting of culture in the art world, I am also inviting us to understand the visual world as a major ground for cultural change. The gendered analysis of visual culture that this book undertakes unites matter often separated, such as subject matter, technique, high and low media, aesthetic ideologies, the marketplace, and artists' biographies. Proceeding from individual artists to institutions and discursive formations, this approach uses the problem of gender to tie together the different threads of visual culture. It makes evident the insights lent to cultural and social history by the study of the visual order.

Each chapter of *Painting Professionals* takes up a particular facet of the art world, making this a study of visual culture that proceeds not from the image but from the production and reception of images. My focus is on art's relation to broader social and cultural changes—the rise of the professions, the emergence of the New Woman, and the displacement of the genteel tradition by a masculinized culture—rather than on images, iconography, and their interpretation. The chapters advance from production to reception—from art schools, to the market, to criticism.

This study also focuses on the highest rungs of the profession and the dominant centers of art in the country, investigating women painters in three cities: New York, Boston, and Philadelphia. The standards set by the most prominent and the expectations at the center of the profession established the tone of the art world and set up the ideal artist. This approach bypasses art communities in less prominent centers, the careers of women painters who were not "successful," and the large numbers of women who pursued not painting but illustration, engraving, photography, and other "lesser" arts as their primary form of art work. Nevertheless, it is my contention that the dynamics at the center framed much of what happened in these areas.[27]

Chapter 1 spells out the new centrality of art academies in the late nineteenth century and argues that schools became a principal source of professionalization in art. Women students found much to be optimistic about in this transformation, and they carried this optimism with them to Paris, the subject of chapter 2. In Paris, men and women obtained their final credential

and launched themselves into careers. Returning to the United States, young artists faced a weak, fluid, and highly competitive art market. Chapter 3 examines how men and women managed this unsettled market in the 1870s and 1880s; chapter 4 looks at the gendered effects of its solidification around a modern gallery and dealer system in the 1890s. Chapter 5 traces the shifts in critical discourse paralleling the changes in the market, particularly investigating the rise of the ideal of the virile artist. Modernists extended both the market structure and the critical frameworks that developed in the late nineteenth century. In the final chapter, avant-garde women seek to find a place within this highly masculinized formation.

THOUSANDS UPON THOUSANDS

OF GIRL ART STUDENTS

"Although I was born in 1865 in San Francisco, it was not until sixteen years later that I started to live, for in 1881 I entered the National Academy of Design," remembered artist Louise Cox (fig. 1.1). She had "traveled from the Golden Gate to the Great Eastern Port seeking fulfillment in the field of art to which she was irresistibly drawn."[1] As she plotted her life story, Cox insisted that her true childhood and maturation took place in the New York classrooms and hallways of the National Academy of Design and, eventually, the Art Students League. She imagined that in her journey from Golden Gate to Eastern Port she began the true and only meaningful story of her life: her career as an artist. For her, art study vivified her life, giving it beginning, purpose, and direction. Like Cox, many women in late-nineteenth-century America found themselves "seeking fulfillment" in art and "irresistibly drawn" to art schools; they, too, remembered their lives beginning in the National Academy, the Art Students League, the Pennsylvania Academy of the Fine Arts, and other art schools. By 1897, artist Candace Wheeler could optimistically assert, "Girls are being educated for much arduous and responsible work in life, and for many varieties of it; but most of all, perhaps, they are studying art. There are to-day thousands upon thousands of girl art students and women artists, where only a few years ago there was scarcely one."[2] Wheeler's retrospective summation described the achievements of a generation of women who streamed through American art schools after the Civil War, seeking not only fulfillment but also the skills and credentials they needed to be professional artists.

This generation of women was also part of a generation of artists remaking the purposes of American art schools. Louise Cox insisted that in addition to marking the true beginning of her life story, instruction at the National Academy had "guided [her] initiation into serious drawing."[3] Her praise for detailed, rigorous study reflected new expectations for the art schools. As women and men like Cox flocked to art academies in search of this elaborate

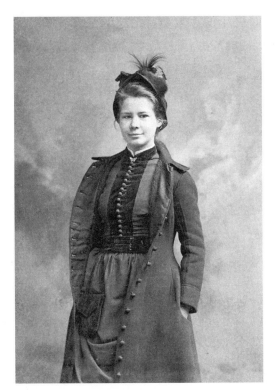

FIGURE I.I.

*Louise Cox at the Art Students
League. (Allyn Cox Papers,
Archives of American Art,
Smithsonian Institution)*

training, art schools became the central institution expressing — and struc-
turing — the career hopes and aesthetic ideals of a generation of American
artists. Between 1865 and 1900 art schools changed from rather informal and
casual institutions into programs with structured curricula, entry criteria, and
a full-blown discourse on "standards" versus "popularity." In essence, they
professionalized.[4]

A number of forces converged to create this reorientation toward art
schools and to focus the schools in the direction of professionalism. A new
dedication to figure painting made lengthy training seem necessary, and Euro-
pean art academies, which stressed a professionalizing process of program-
matic and detailed life study, offered an appealing model to their American
admirers. The success of European institutions seemed abundantly evident
as French art became the world's most admired and marketable during the
Gilded Age. Expanding interest in French art constricted sales of American
paintings in the 1870s and 1880s, just as many Americans began pursuing artis-
tic careers. Intensified competition increased the market value of both the
skill and the credential that schools promised to offer.

Women supposedly embodied the antithesis of the professional—dependent, imitative, and merely "accomplished" rather than autonomous, skilled, and expert.[5] Given this image, "thousands upon thousands of girl art students" threatened the emerging ideal of the artist as professional. The growing numbers of women art students and artists spurred and intensified the move to professionalism by men who sought to use professional standards to enhance their own status and delegitimize others in pursuit of "amateur accomplishments." Despite these intentions, new professional norms made art more available to women than it had been at midcentury. As figure painting and studio practice, rather than landscapes of the sublime, became the professional standard, women had easier access to the setting of art: as we shall see, even the nude was less of a barrier than the Catskill and Rocky Mountains had been. Women found many of the tenets of professionalism, particularly its stress on educated skill and objective achievement, more possible to leverage on their own behalf than antebellum ideals of innate artistic genius. Women, therefore, joined men in professionalizing American art schools, at times with common intent but at other times at cross-purposes. Sometimes men and women advanced professionalism to express a common class interest in improving the status of the artist. Women's numbers in art schools, moreover, put them in a good position to form alliances with men around some issues and advance their concerns from the center rather than the periphery. Professional ideology was also surprisingly supple enough to contain men's and women's competing interests: men's desire to exclude women using the selectivity, standards, and "masculine" overtones of the professional ideal and women's desire to claim a professional identity using its ostensible gender neutrality, objective criteria for advancement, and regularized training program. Ongoing tension between men and women over the meanings and thrust of professionalization pervaded the art world for the next thirty years. By the twentieth century, women modernists would enter the art world on very different terms than the ones shaped by women studying art in the years after the Civil War.

The Pennsylvania Academy of the Fine Arts in Philadelphia, the School of the Museum of Fine Arts in Boston, and the Art Students League in New York were part of a virtual boom in art schools in both major and regional art centers in the 1870s. New schools were established in Chicago in 1867 and 1879, in San Francisco in 1874, in New York in 1875, in Boston in 1877, in Providence in 1878, and in St. Louis in 1879, while other schools in New York and Philadelphia updated, expanded, and reinvigorated their programs.[6] At

the same time, schools attracted widespread popular interest, as newspapers and magazines featured articles describing, promoting, and popularizing their programs. William Brownell admonished the readers of *Scribner's* magazine, "*Take care of the art schools.* It is to these schools that one looks, both for accomplishment of good work and for the dissemination of aesthetic taste."[7] Increased popular attention, widening demands for improved taste to counterbalance the effects of industrialization, and promising career opportunities in art brought dramatically increased enrollments in art academies.

Throughout the antebellum period art training in America had remained highly informal and irregular. Students and artists worked alongside each other in the same classes with little instruction or criticism provided. The National Academy of Design in New York, for example, periodically hired instructors, but they served largely to maintain order—posing models or selecting lithographs for copying. The instruction that did occur came from rotating "official visits" by National Academicians who critiqued students' work. These visits tended to be infrequent, and most academy members did not take their visiting duties seriously.[8] There was even suspicion that nature should be the only source of an artist's technical skill and, therefore, some sense that schools were actually unnecessary.[9] Classes hovered somewhere between apprenticeships and a gentlemanly gathering of equals in a smoke-filled room.

Most antebellum art organizations functioned primarily not as educational but as exhibition and promotional associations. The major society organized by artists in the few decades before the Civil War, for example, was the American Art Union, which auctioned off works by American painters and distributed engravings to its subscribers. Unlike later in the century, training did not determine an artist's status and identity; rather, in midcentury, artistic success and prestige depended on successful exhibition, usually at the nation's preeminent art institution, the National Academy of Design, which dominated the art market.[10]

In the late 1860s a new generation of students and their advocates among younger artists began to urge greater emphasis on schools. At the National Academy of Design they demanded better facilities, more money, and "higher professional standards in training."[11] In the spring of 1875, when the National Academy not only failed to respond to their campaigns but actually decided to close its schools in the fall, students formed the Art Students League. The League became a base for a generation to break away from the control of an older generation, and its students directed the school to reflect their artistic and professional priorities. One early student at the League recalled that

they were "anxious to get in this country, what until then could only be obtained in Europe."[12] These young artists, many of whom aspired eventually to study in art academies in Munich and Paris, based their claims to professional status on a European model of academic training, and they particularly stressed the importance of figure study, which they identified as the core of the European tradition. They proudly announced that their teachers represented the most "progressive art movements of the day"—a kind of code for artists working in European-influenced styles—and their circulars explained that "animal and landscape painting [were] not taught"—virtually a direct repudiation of midcentury American painters who built their reputations on landscape painting.[13]

To meet these aims the Art Students League's founders defined "the establishment of schools for a severe course of Academic study" as a principal aim and, when they incorporated two years later, in 1877, repeated those demands, declaring the necessity of "Academic Schools" and "a complete system of education in art."[14] Similar changes at the Pennsylvania Academy also followed student initiatives as a series of petitions convinced the board to invite European-trained painter Christian Schussele to become the regular professor of painting and drawing in 1868. Schussele instituted a European academic system of regular courses that stressed careful training in drawing and extensive study from the nude model.[15] Boston's School of the Museum of Fine Arts was the slowest and most reluctant to commit itself to "Academic Schools" and did not really make the change until 1880. But even this school's founders acknowledged the desire for thorough instruction, regular faculty, and systematic methods of study by hiring another European-trained artist, Otto Grundmann, to be the school's permanent instructor when its doors opened in January 1877.[16]

Clearly, institutional priorities had shifted. A new generation focused its energies on educational institutions and began to define schooling as the foundation of the profession.[17] Although other institutions, most notably artists' societies, reinforced the move toward professionalism, none had the power of art academies to mold the identity of the artist and to establish the new attitudes of professionalism. More and more, artists and their supporters believed that it was lengthy, rigorous study, and not instinctive genius, that made someone an artist.[18]

At the same time that art schools became the cornerstone of the new professionalism, women's enrollment in art programs began to rise, and by the 1880s women students represented a majority. In the late 1870s women constituted just over one-third of the students at the Pennsylvania Academy; by

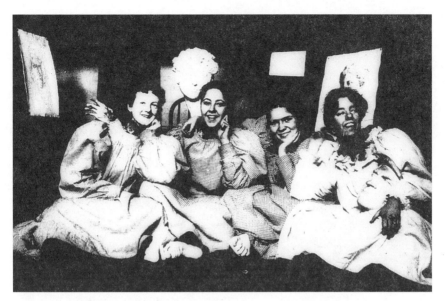

FIGURE 1.2. *Students at the School of the Museum of Fine Arts, Boston.*
(Courtesy of the Museum of Fine Arts, Boston. Reproduced with permission.
© *1999 Museum of Fine Arts, Boston. All Rights Reserved.)*

the mid-1880s they accounted for one-half.[19] In 1875, women had joined men in founding the Art Students League, obtaining equal representation on its board; by 1883, women made up well over half the League's students and membership. The *Art Amateur* reported that "in the principal art schools of New York the ladies [were] in the majority, and their work [was] equal in every respect to that of the male students."[20] At the Museum School, the Permanent Committee governing the school was dismayed to find in its opening days in 1877 that "a large part of the students were women and a large part amateurs." The committee recorded on January 3, as the school opened, that no more applicants would be accepted, "but no men had been refused." The student body remained consistently about three-fourths women, and even twenty years later the annual report bemoaned the "small proportion of men" (fig. 1.2).[21]

Why did "thousands upon thousands" of young women suddenly enter art schools after the Civil War? Upper and middle-class women had, of course, long been encouraged to draw, for drawing was considered an important accomplishment for a lady. As conceptions of culture shifted in the nineteenth century, however, art as a symbol of feminine refinement took on broader, public significance. Both women and culture appeared to represent values that

transcended the increasingly pervasive market, and women began to include the protection and cultivation of art and culture among their duties. John Ruskin's influential *Sesame and Lilies,* which was originally published in 1865 and reprinted in the United States throughout the nineteenth century, made this obligation explicit, insisting that it was woman's role to foster genteel taste and purify society through culture. Such responsibility made it possible for women to claim culture as an avenue for their own creative endeavors, transforming a lady's "elegant amusement" into public cultural initiatives and professional ambitions.[22]

In the process, a very different rationale legitimized public roles for women than has been typically described for this period. Most studies of women in the professions have stressed how women extended beliefs about their moral and maternal nature to justify their professional ambitions. By this rationale, Gilded Age and Progressive Era women could enter professions when they defended their actions "as fulfillments of the Victorian imperative for women to serve children and the poor."[23] Cultural work, on the other hand, required women's social and moral guardianship of culture. Construing womanhood in terms of instinctive refinement, cultivation, and aesthetic sensibility conferred the duty to advance and protect culture upon women. Both logics reinforced the prevailing ideology that opposed womanhood to the market and supposed women upheld key values, especially morality, that the market endangered. The latter paradigm, however, had advantages for women intent on a profession. Most notably, as calls for refinement in art intensified after the Civil War, a congruence between ideals of art and womanliness facilitated the transition from amateur pursuit to career. Only in fields such as social work, in which female traits and the aims of the profession could also be correlated, did women move as rapidly into the field.[24]

Writers in art magazines, women's magazines, and advice books began to encourage middle-class women to pursue art as a profession in the 1860s.[25] In 1861, the art magazine *Crayon* ran an editorial titled "Woman's Position in Art," in which the editors argued that art provided "a vast field for employment . . . open to women, consistent with their organic powers and social relationships." Concern about the employment of women left widowed and single by the Civil War increased support for art careers, so, in 1866, advice-book writer Dinah Craik identified painting and art among the four "female professions" women might pursue. In 1871, *Godey's Lady's Book* proposed "Painting as a Profession for Women" in its "Editors' Table."[26] More than ten years of experience with design schools for women had proven the merit of female art training. Founded as early as 1848, design schools provided some of the earli-

est art schooling for middle-class women seeking respectable employment. When art academies opened their doors to women in the 1860s, therefore, they found a body of students thoroughly primed to enter.[27]

Women's procession into art academies belonged as well to the expansion of educational and professional opportunities for women in the Gilded Age. In the 1870s, middle-class women entered higher education in rapidly growing numbers, turning to the new women's colleges and coeducational midwestern and western universities. Art education should be seen as part of this movement, with art academies providing women with another important opportunity for postsecondary education. As art schools took on professional norms, distinguished themselves from vocational art education, and even emulated liberal arts colleges in parts of their curriculum, they attracted students from the same respectable families sending their daughters to universities. Even feminist Charlotte Perkins Gilman, whose family belonged to well-established middle- and upper-class American stock, received her principal advanced education in an art school.[28]

A final set of rather more straightforward structural reasons also encouraged women to enter art schools after 1865: both the subject matter and the physical space of academic figure painting were more accessible to them than landscape painting had been. Women's exclusion from life study represented a fundamental form of discrimination against women; that women gained access to life classes as early as the late 1860s contributed significantly to the position women secured in art schools. Ironically, the figure may have been more available to women than the landscape, since the figure was couched in a rhetoric of refinement and uplift more approachable than "the strenuous, masculine associations of the romantic mountain sublime." Antebellum painters such as Thomas Cole and Frederic Church spent months traveling to remote interiors and the upper reaches of mountains.[29] As figure study moved the primary locus of art indoors, to the studio and classroom, the meanings of these spaces changed as well. When art academies formalized, they lost their gentlemen's club atmosphere. A growing insistence on the authority of the instructor diminished the potential for inappropriate relations: no longer was the art academy based on an easygoing familiarity impossible for respectable women to join. Once women could enter the classroom and pursue the well-defined and institutionalized stages leading to life study, art academies became much more hospitable to them.

To professionalize, art schools developed the curricula of European art academies. Long considered the highest standard in art training, the Euro-

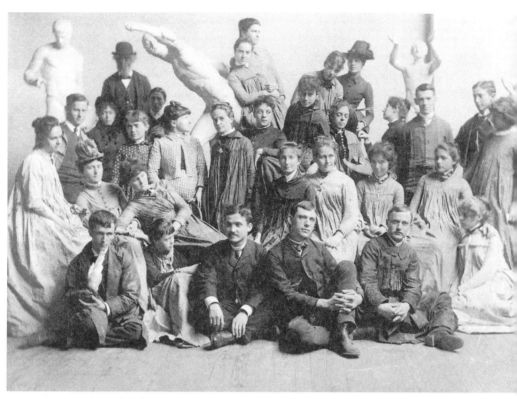

FIGURE 1.3. *Men and women in front of antique casts at the Pennsylvania Academy of the Fine Arts, ca. 1883–86. (Courtesy of the Charles Grafly Collection, Department of Special Collections, Ablah Library, Wichita State University)*

pean academic model made drawing of the nude figure the foundation of picture making and the central skill to be learned; students were expected to demonstrate precise control over line, proportion, and shading. Each student moved through an increasingly well defined progression separating beginners (and amateurs) from the advanced (and "serious"). Beginners drew from flat objects, then plaster casts of antique Greek and Roman sculpture; only after patient (and at times tedious) work could they attain the pinnacle, the life-drawing class, where they drew from the nude model (fig. 1.3). At each stage, students had to submit drawings for evaluation; demonstrated skill allowed the student to pass to the next level. Over a period of several years, students gradually acquired the skills of drawing and painting. Objective methods of review and advancement officially made merit the basis of judgment and guaranteed the standards and exclusivity of the highest levels of study.

In the academic model, American art academies found a curriculum that

linked new ideas about the highest form of artistic production to emerging ideals of professionalism. An academic program brought figure painting together with clearly demarcated steps of advance and standardized, rigorous training, all contained within a certified school. While Americans, who felt insecure about their own national culture, may have been looking abroad hoping to emulate French tradition (which they idealized), cultural insecurity does not fully explain their choice. In the end, art school boards, instructors, and students embraced the academic model because it was remarkably congruent with emerging faith in professional achievement and identity.

Orchestrated movement through levels of study gained permanence and institutional adherence in the ten years between 1877 and 1887 as enrollments grew, as women's attendance rose, and as directors and teachers sought to articulate a more evident hierarchy. In its first year, for example, the Art Students League offered only advanced life classes, adding more basic drawing instruction a few years later. By its tenth year, League students were told that they could enter any class "upon passing the examinations" but that "the regular course of advancement [was] from Antique [sculpture drawing] to Head to Life Classes, or Antique, Head and Painting Classes. The Life Classes [were] the standard in the school, especially in Drawing." [30]

This transition to a highly structured academic program did not always occur smoothly, or without conflict, as an older generation and established ideals were replaced. The Museum School repudiated a long "Boston tradition" extolling individual romantic genius when it adopted a strict academic program.[31] Influenced by that tradition, the school's managers initially feared that a structured academic program would stifle artistic creativity. The representative figure of the Boston tradition in the 1870s was William Morris Hunt, who had been Boston's leading local painter since the 1850s. Hunt brought to his popular, private classes an emphasis on creativity and spontaneity, eschewing detailed drawing training and introducing painting right away. He recognized that the Museum School would challenge his methods, telling his students: "I'm dreadfully afraid that they'll beat you at the Art-Museum School. . . . There they are made to be as careful as can be about all their drawing. Perhaps I should have done better to have begun so with you. I preferred to show you how to make pictures, and to *will* you to learn, and to give you as much of my own life as I could." [32] Hunt, who served on the Museum School's managing committee until his death in 1879, envisioned the school in the antebellum mode—as a large working atelier where different artists demonstrated their techniques.[33]

After Hunt's death in 1879, and not coincidentally just as the Museum

School began to reorganize its curriculum, local critics discredited both his methods and his students, claiming he offered to beginners what should be reserved for advanced students and citing a lack of discipline in his students' work. Francis D. Millet, another local artist who was also on the school's board, wrote that Hunt's students were "intentionists": "Their works show that they can see aright, and that their intentions are the best. But they can be called neither realists, idealists, nor impressionists, for their performances go little further than intentions."[34] By Millet's standards, Hunt's teaching produced unfinished and undeveloped stylists who could not fully execute their works, making the kind of individualist gesture Hunt had offered appear sloppy and careless rather than inspired and natural.

During its first few years, the Museum School adopted Hunt's more apprenticelike methods, offering the basic elements of an academic program but without grouping by level of skill or clearly demarcated steps of advancement. Individual students moved easily among cast drawing, painting, and life drawing, depending on their interests and instructor suggestions.[35] As the school repudiated Hunt's methods, the managing committee abandoned this more flexible and informal approach, dividing the school into three distinct classes: the elementary class drew from the cast; the middle class drew from life, portrait, drapery, and still life; the third class painted. The new curriculum established systematic progress through drawing classes and restricted work with oil paints to only a few advanced students.[36] Such a program represented the triumph of an idea of the professional artist: the idea that demanding study and cultivated skill produced the true artist had supplanted the romantic belief that artistic genius resided within a person.

Within a few years, all three schools began to modify, elaborate, and extend the basic academic programs they had established, adding composition, portrait, perspective, head, and still-life classes. At the Pennsylvania Academy, for example, classes listed for 1877 included antique (day and night), life drawing for men (day and night), life drawing for women (day), costume, clay modeling, perspective, portrait painting, and anatomy.[37] As new trends and interests emerged in the art world, schools added new types of instruction, refashioning and revising the academic model to fit their shifting needs without abandoning it and the authority it gave their programs. Augmenting their offerings, art schools secured their continued centrality as an institution in the Gilded Age art world as ever widening pieces of artistic training came within their purview.

As aspiring students flooded academy classrooms, managing committees increasingly sought to regulate student behavior in order to create an atmo-

sphere of restrained professionalism. The Committee on Instruction at the Pennsylvania Academy attempted to legislate a serious, regulated, and refined atmosphere in the classroom, directing the curator of the schools to require students to sketch the model (and not other students) and to remain in the classroom during class time.[38] Instructors at the Museum School also worried about discipline in the school, complaining that students did not attend regularly, talked and "promenad[ed]," and made lunch hour too long. They instituted monitors who regulated attendance, progress, and behavior and received permission to suspend unruly students between Permanent Committee meetings.[39] These types of regulations and rules established the authority of the school over students and created stronger hierarchies within the school. To the outside world, such rules certified the rigor and seriousness of the training, demonstrated the decorousness and even refinement of the school's atmosphere, and reinforced its professional image.

If students had to follow a certain decorum, so too did teachers. Thomas Eakins, who followed Christian Schussele as professor of drawing and painting at the Pennsylvania Academy in 1879, raised the reputation of the academy in the 1880s, making it one of the leading schools in the country.[40] An innovative, compelling, and unconventional teacher, Eakins attracted many students, including women, to the academy; nevertheless, in February 1886, the board fired Eakins for failing properly to uphold the dignity and authority of a teacher. Eakins had generated controversy throughout the early 1880s as he experimented with more and more radical teaching techniques, including in-depth anatomy dissections, field trips to slaughterhouses, and nude photographs for motion study. In the mid-1880s public dissent finally emerged with women's life classes the flash point for criticism. When Eakins removed the loincloth from a male model during a lecture to women (and possibly men) students, it was too much for the board, and it asked him to resign. Transgressions against female respectability secured Eakins's firing, but they were only part of the problem. Eakins refused to establish a formal, hierarchical teacher-student relationship. The loincloth incident culminated a whole series of improprieties. Students remembered Eakins speaking casually with them after class and, on occasion, demonstrating "a few simple gymnastic feats." Chatting and gymnastics—in conjunction with using himself and students as nude models—violated the board's vision of respectability and proper student-teacher relationships.[41]

Increasingly, schools relied on their faculty to certify and boost their reputation for seriousness and professionalism, not to threaten it as Eakins had done. The Art Students League announced that its instructors had studied

with "the masters of the best schools of Paris and Munich"; that they were "peculiarly qualified to encourage artistic study of the highest standard"; and that the faculty was "unequalled by any institution in the country." At the Museum School, the board hired two rising and ambitious stars to share primary teaching duties in 1890. Edmund Tarbell and Frank Benson would eventually become the leading practitioners of the turn-of-the-century "Boston School," and the two men built their reputations and the reputation of the school simultaneously, bringing in medals and prizes continuously for the next two decades. Developing a faculty with strong reputations helped generate a school's prestige, since prestige now came not from association with a well-known exhibiting association, such as the National Academy of Design, but from the faculty itself. In this sense, art academies were more like universities, which relied increasingly on faculty stature for their reputations. Although art academies never required the formal credential that the doctorate represented for universities, their concern with the background, training, and awards of their professors of painting and drawing reflected an equivalent concern with recognized merit and expertise.[42]

Although not embodied in a formal degree until after the turn of the century, work in a recognized school with substantial life study became a kind of credential, a certifier of artistic legitimacy that was reinforced in numerous ways in the late-nineteenth-century art world. Artists' self-conception honed in on academic training. At the Art Students League, members (who studied at the school but had the right to vote for board members and influence the school's direction) developed increasing distinctions between themselves and those who were merely students in the school. In 1884, for example, five League members proposed an amendment to the constitution requiring eight months' work in the life-drawing class (rather than the current three) to be eligible for membership.[43] Those invited to membership in the standard-setting professional associations that blossomed in the art world of the 1870s and 1880s were also those who had studied in art academies. Organizations such as the Society of American Artists, which was founded in 1877, turned to academically trained young artists for their exhibition pieces and membership lists. In an organization such as the American Watercolor Society, amateurs were increasingly pushed out in favor of the solidly trained and academically skilled.[44]

The exponential growth of art students threatened, however, to undermine the value of this newly minted credential. Anxieties about the "popularity" of schools soon surfaced as boards sought to balance the attendance of women, amateurs, and other "workers" against the need for standards. As the League

explained in 1886: "We have endeavored to keep in a true balance the two opposing tendencies of high standard and popularity, and we have lowered the standard we desired, just to that point of popularity that could pay all our expenses and keep out of debt."[45] No longer were art schools congenial congregating places for those dedicated to art, whether amateur, patron, or potential painter. Academies now constructed popularity and standards as "opposing tendencies," admitting the casual student only under the pressure of necessity. Such reluctance carried new gender connotations as well: "popularity," of course, consisted of the female students flooding the schools' classes. The quest for "standards" was ultimately exclusionary in intent. It legitimized entrance requirements and attendance restrictions designed to guarantee the seriousness, and presumably the professionalism, of its students. At the Museum School, the board repeatedly sought to institute an entrance requirement, so that instructors would not consume their time teaching students unprepared for a professional school. As the League unambiguously asserted, art academies were open "to all those whose artistic knowledge attain[ed] the standard set by the League, which, however, [was] placed sufficiently high to insure the exclusion of all those students whose aims [were] not serious."[46]

By the late 1880s, art academies had undergone their fundamental changes. They had instituted a structured system of training; they had convinced aspiring artists and the wider public of the value of their credential; and they had declared their commitment to standards on behalf of the most "serious." To academy leaders, the meaning of the transformation was quite clear. Unlike schools where the purpose was "general education" and the aim was "to assist in making [students] useful members of society," an art school, according to Pennsylvania Academy board president Fairman Rogers, was a specialized program for students with advanced knowledge and was designed to prepare them for a "successful career." Rogers claimed, "The students at the Academy come with a considerable amount of knowledge to commence with; they are somewhat in the position of those who take post-graduate courses in colleges; that is they are entering a professional school."[47] A professional school, moreover, was far removed from the vocational training provided in design schools or industrial art programs. The Pennsylvania Academy, the Museum School, and the Art Students League all insisted that the education they provided was on a par with liberal arts study. The League, for example, called for a "higher education in art" where training was as much "intellectual" as it was "technical" and comparable to the "literary education" at major universities such as Harvard, Yale, and Columbia.[48] "Intellectual" and "post-graduate," art schools aligned themselves with emerging patterns of professional education.

At the same time, the professionalization of art schools served another set of purposes. Since the ideal professional was male, the feminization of art school student bodies seemed to many male students, teachers, and nervous boards of directors to undermine their professional aspirations and threaten the status of their institutions.[49] Men often responded to the women in their schools with overt hostility and deliberate exclusion. Some teachers refused to take women students seriously, as did Art Students League instructor Carroll Beckwith, who, as Louise Cox remembered, "disapproved of women painting" and "never failed to give them a dig when the opportunity arose."[50] At the Museum School, administrators constantly fretted over the student body, which was three-fourths women. Presuming that women gave the school an amateurish cast, the managing committee angled "to fix the character of the school as a place for serious professional study, and not for the teaching of amateur accomplishments," by requiring full-time enrollment.[51]

Despite the belief that women undermined the status of the schools, no American art academy explicitly prohibited women students as did leading schools in Europe. Lacking the government patronage of their European counterparts, American schools depended on women students for their fees. At base, that meant they needed women for their financial survival.[52] Moreover, with women assigned the role of refiners and beautifiers, their training in artistic accomplishments also converged too closely with the calls for "aesthetic evangelism" to close schools to them. Finally, women were simply too active on their own behalf, consistently pressuring schools to give them equal opportunities. For the most part, directors and instructors focused, instead, on solidifying male prerogative by emphasizing aspects of professionalism. The hierarchy embedded in academic training methods became an avenue to preserve male superiority, just as the concept of professional itself became a means to distinguish male practitioners from the mass of female students.

In many ways, academic study registered as masculine: the rigorous preparation, rationalized training, and demanding instruction seemed both to embody and to require masculine rationality, strength, and autonomous drive. Many writers warned that women would not be able to tolerate the heat, poor ventilation, and crowded atmosphere of life-study classrooms. They claimed that the long hours of study, day after day, would sap the strength of all but the most hardy women.[53] In addition, women seemed to lack the independence of mind and autonomous will to be fully professional, as William Morris Hunt's critics implied when they repudiated his unacademic methods at the Museum School. The students in Hunt's class were all women, and many considered him responsible for a "feminine boom in art," a boom

that, reportedly, "gave to school girls what was meant for mankind." [54] Hunt encouraged his students to work from charcoal, aim for overall effect, and ascend rapidly to the higher levels of painting without lengthy life-drawing work. Hunt's critics argued that using charcoal, rather than the drawing tools of point or stump, required less "command of the hand" and "precision of line" and that his methods produced weak, tentative work. Hunt's methods also risked overwhelming rationality, bringing his students under the sway of his "personal magnetism" and instilling only imitation, a quality believed to be the central characteristic of female creativity. Boston's rejection of Hunt's looser, more informal techniques was thus explicitly gendered: it was an assertion of a masculine rationalism and control, suitable for men, over Hunt's feminized "intentionists" and "imitative individualism." [55]

Moreover, that "masculine" professional took its meaning by inflection with its opposite, the amateur, who stayed comfortably within the realm of "lady amateur" dabbling at art study. Just as the Museum School's Permanent Committee had done, Pennsylvania Academy directors openly discouraged amateur study, "since the system pursued [was] not that best adapted to the teaching of drawing as an accomplishment, or to cultivating artistic taste among amateurs." [56] In the Gilded Age, "amateur" lost all vestiges of its association with upper-class refinement and virtuous gentlemanly achievement: instead, as one writer explained, "amateur has collided with professional and the former term has gradually but steadily declined in favor." Writing in the *Atlantic Monthly*, this author claimed, "[Amateur] has become almost a term of opprobrium. . . . A mere amateur, amateurish, amateurishness—these are different current expressions which all mean the same thing, bad work." The "bad work" of amateurs was almost always understood to be the work of women, so that "amateur" appeared consistently as "amateur accomplishment," associating it with the tradition of female parlor training. Both feminine and the opposite of professional, "amateur," with its dual connotations, reserved the category "professional" for men and associated the training in art academies with masculine pursuits despite their largely female student bodies.[57]

Although the influx of women into art schools thus spurred and intensified their reorganization, professionalization was never unilaterally a male endeavor. Women who wanted to be painters and sculptors were among the strongest advocates of professionalized art schools. By emphasizing an "official" professionalism—meritocracy, standardized steps of advance, and gender-neutral "high" standards—women circumvented many of its masculine overtones. But women's actions went beyond simple endorsement of new

training norms. They pushed for changes alongside men—and sometimes in cooperation with men—because they deepened and solidified professionalism. It was in this sense that professionalization was a joint endeavor. At the same time, women proposed a competing counterpart for the professional: for many the appropriate distinction was not between professional and amateur but between serious and unserious, a distinction based not on gender but on attitude, and a distinction that could divide women from women as much as it did women from men. Whether they made their demands in concert with, or in opposition to, their male peers, female art students refused to concede the professional as masculine terrain.

Women's professional ambitions were embedded in the earliest changes in art academies. In March 1868, three months before Christian Schussele was hired at the Pennsylvania Academy, women students petitioned the board for a women's life class. In submitting this petition, women formally expressed their intention to gain equal training and their commitment to the academic model. The board of directors responded by resolving "that the use of the life school, including the model . . . be granted," and a month later, Committee on Instruction minutes noted that women's average attendance at life classes exceeded men's. By October 1869, after thirteen women had signed to join the class, the board made the women's life class permanent.[58] Achieving such an end was a major assertion of women's professionalism, seriousness, and determination, one they fought hard to maintain and extend and one they clearly used as a marker of equal opportunity with men.[59] Fifteen years later, as Edith Mitchill enrolled in the life class at the Art Students League despite her mother's reservations, she viewed it as an action equivalent to wedding vows. "I regard my work as sacred as marriage," she wrote in her diary. "Tomorrow I shall be . . . bound to my love." Once her work had begun, Mitchill exulted, "I am in the Life and enjoy life as never before."[60]

A photograph taken thirty years after Edith Mitchill's sacred marriage conveys the same import in life study (fig. 1.4). A class of women at the Art Students League encircle a nude, chairs upended to support easels and paper. At the center, four women smile for the camera. They've left their drawings, moved their chairs closer together, and even leaned in to look over a shoulder. They've posed themselves so purposefully, yet utterly unnecessarily for the shot. Deliberately, it seems, they've recorded their friendship, a sign of the camaraderie and professional solidarity generated by life study. The other women in the photograph, intent on their work, remind viewers of their seriousness of purpose. Dressed in skirts and shirtwaists buttoned to the neck,

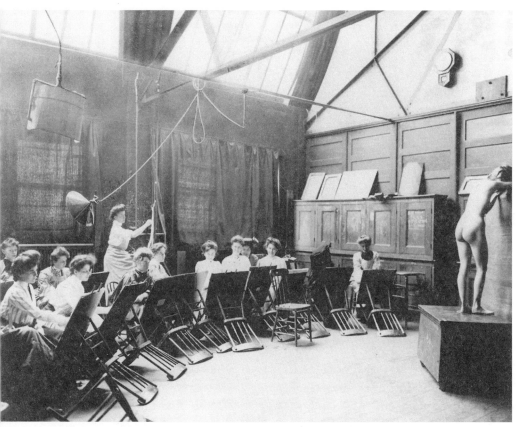

FIGURE 1.4. *Woman's life class at the Art Students League, 1905.*
(Photographs of Artists, Collection II, Archives of American Art, Smithsonian Institution)

they clearly master the work demanded of them, as the barricade of chairs demarcates the woman as artist from the woman as nude object of study.

As female students pressed for life training, they integrated their specific concerns into the broader changes in art schools and helped solidify their growing professionalism. Students had petitioned the Pennsylvania Academy board in February 1868 to hire a full-time professor. Although we do not know if women signed that petition, they most likely knew about it because they studied and socialized with the men in the Antique class. Their March 1868 life-class petition followed on the heels of the first one and may have helped push the board toward finally hiring a professor and elaborating the school's program. Nine years later women were still calling for more life classes at the Pennsylvania Academy. In November 1877, Susan Macdowell, as class represen-

FIGURE 1.5.
Susan Macdowell Eakins,
ca. 1885. (Courtesy of the
Pennsylvania Academy of the Fine
Arts, Philadelphia. Charles
Bregler's Thomas Eakins
Collection. Purchased with
the partial support of the Pew
Memorial Trust.)

tative, wrote to the board: "We desire to submit the enclosed petition for an additional life class. . . . Our desire in having this class is . . . the great advantage to all the students of having more opportunity to study from the nude. . . . We are earnest, and . . . ask only that whatever may be done by the Academy for the Students will be in the direction of the life classes, which means of study we understand to be the most important to those who wish to make painting a profession." [61] Macdowell made a series of significant assumptions and associations in her petition that reveal how serious women students understood their relationship to the academy (fig. 1.5). Women fought for better training for themselves within the framework of the academic model, arguing for the centrality of "study from the nude" to those who intended "to make painting a profession." But, Macdowell points out, "all the students," not just women, would benefit from more life classes. It is crucial to recognize that women pursued better opportunities for themselves within an overarching conception of professionalism that included male students as often as they sought them in the name of equal opportunities alone. Again and again, they resisted reduction of their aims to their sex.

As with life classes, women at art academies pressed for teachers who respected professionalism above all. By this insistence on serious instruction, they helped establish professional criteria as the standard. Susan Macdowell's November 1877 petition also asked the board to rehire Thomas Eakins, be-

cause he was "an able instructor and a good friend to all hard working students." [62] Here again, women called for Eakins because he was someone who would bring the best training to *all* students. Eakins took them seriously and opened every aspect of training to women, even the anatomy dissections, which were the grittiest part of the academy program. By asking for Eakins, women chose the consummate professional as their ideal teacher, since Eakins taught with an almost religious faith in the necessity of rigorous, precise, and thorough academic training. Alice Barber Stephens recalled that Eakins did not accept "imitation" as women's only avenue of artistic expression and included women in the "vigorous" (and male) production of art.[63] Women at the Art Students League found a much less obvious ideal teacher in Kenyon Cox. Cox had a reputation as a "confirmed misogynist," yet, because of his reputation for "unusually fine draughtsmanship" and his success with the men's class, the women's morning life class chose him for their instructor in 1885 and petitioned again for him at least once more, in 1887, making professional concerns—and ambitions—the determining factor in their decision.[64]

Women did not assert themselves in isolation. In much of their day-to-day experience of the school, they interacted with men and took active roles. The *Daily Graphic: An Illustrated Evening Newspaper* published a spread on the Art Students League shortly after the League's opening (fig. 1.6). Some of the scenes are unsurprising: a crowded, large men's life class, an all-male composition class. More unexpected are the illustrations in which women occupy the space with men. The vignette "Social Meeting and Exhibition" pairs a set of men and a set of women scrutinizing pictures while in the background men and women discuss a painting together. In "The Painting Class," women occupy choice positions closest to the model. A final illustration shows "The Sketch Class—Posing the Model." Here two women pose the model for the class as men look on. Neither wallflowers nor mere observers, women helped set the tone of the school. Contemporary observers of art schools recognized the privileged position women occupied. As early as 1880, one, writing an article titled "Young Artists' Life in New York," declared, "The association of the sexes on terms of perfect equality gives American art-student life one of its distinctive aspects." [65] That promise of equality and experience of "association" certainly encouraged aspiring American women to commit themselves to professional ambitions.

Just as men did, female students translated their commitment into professional elitism by participating in the calls for both high standards and admission requirements. At the Art Students League, the constitutional amendment proposed in 1884 to require eight instead of three months' study in the

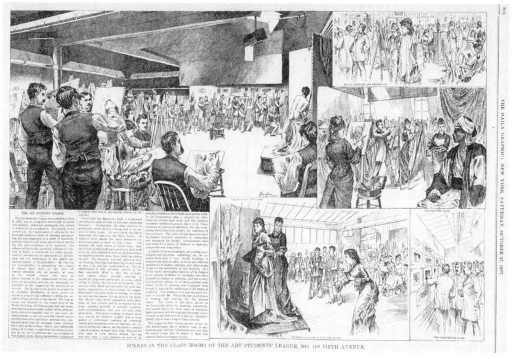

THE DAILY GRAPHIC, NEW YORK, SATURDAY, OCTOBER 27, 1877.

SCENES IN THE CLASS ROOMS OF THE ART STUDENTS' LEAGUE, NO. 108 FIFTH AVENUE.

FIGURE 1.6. *"Scenes in the Class Rooms of the Art Students League,"* Daily Graphic, 1877.

life class for League membership was sponsored by four women and only one man. In 1887, Grace Fitz-Randolph, long a member of the League's Board of Control and at times vice president, opposed the election of two women to the League. "I submit to the members of this society (in view of the absence of standard in the Afternoon Life Class during the present season) whether it is wise to abolish all artistic qualification admitting membership, as would seem to be the case should these ladies be [elected?] now," she wrote.[66] Fitz-Randolph's opposition was undoubtedly self-serving. She secured her position at the expense of other women, now defined somewhere between amateur and incompetent. Women seeking to establish themselves in the professions in the late nineteenth and early twentieth centuries frequently embraced such standard-setting practices. Women's medical colleges, new schools of social work, and design schools with all-female enrollments designed new entrance criteria and graduation standards.[67] Fitz-Randolph and her peers at art academies similarly demonstrated their belief in the principles of professionalism and their desire to elevate profession and practitioners alike. "Standards" met gender and class needs: women could position themselves in the mainstream

of the profession while allying themselves with the status-seeking purposes of professionalization. It aligned them with male colleagues while simultaneously challenging the presumptive association of masculine and professional.

Petitioners such as Grace Fitz-Randolph and Susan Macdowell often did not feel a sense of kinship with all women attending art schools. Those who were the most serious periodically conflicted with women who were less serious and less ambitious. A simple photograph of four women, students at the Pennsylvania Academy of the Fine Arts around 1880, initially seems like a straightforward grouping: serious students posed with the tools of their profession (fig. 1.7). The women in the picture, however, reveal subtle but important distinctions. In fact, only three women hold tools; the other, dressed in street clothes, grasps a small purse. Her glasses and features make her appear older than the three young women wearing their painting smocks. The compositional line that links the student sitting on the floor to the woman holding the clay model defines a divide between more academically oriented women and those dropping in for a class here and there.

Life classes often became the point of division. In November 1877 and again in 1879, conflict erupted among the members of the morning ladies' life class at the Pennsylvania Academy. The class split between those who named "leisure for improvement in art" as their reason for attending and those "who are always petitioning for more work to do." Clearly, women did not form a unified constituency, with the most career-oriented often wishing to distance themselves from women who seemed less serious. Professionalization in art, as in other fields, seems to have created a series of shifting alliances that often pitted generations and groups of women against one another as much as it divided women from men.[68] The divide between amateur and serious women represented an important conflict over the root meaning of female artistry — the expression of a lady's cultivated refinement or the work of a disciplined professional. Tension over when and how to invite connections between feminine traits and career aspirations surfaced regularly for female professionals in the late nineteenth century. In medicine, for example, many women remained ambivalent about the rise of scientific methods, especially if it meant downplaying the sympathetic bedside care that legitimized their presence as women in the field. All women seeking careers in this period would have felt the dual pull of their identity (and community) as women and their professionalism. The moment a woman came of age (before the Civil War, during the Gilded Age, at the turn of the century), her experience in separate-sex or coeducational schools and her status in relation to the dominant practice

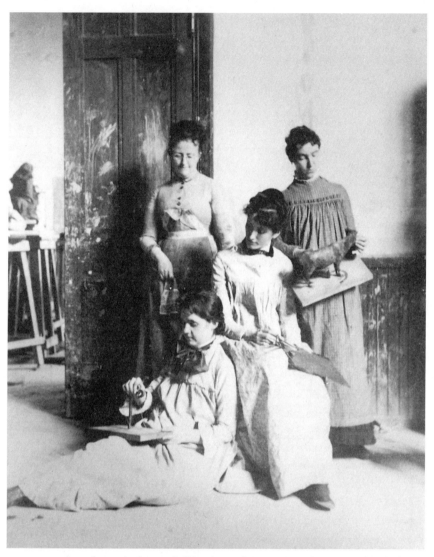

FIGURE 1.7. *Pennsylvania Academy of the Fine Arts students, ca. 1880. (Courtesy of the Charles Grafly Collection, Department of Special Collections, Ablah Library, Wichita State University)*

in the field (such as painter or commercial designer, regular physician or homeopathic doctor) shaped those allegiances. But by the 1870s and 1880s, a significant set reached for professionalism above all else.[69] American art schools offered women students a particularly effective place to move onto the same professional terrain as men. As we shall see, they would have difficulty holding on to that territory, but it left a formative imprint.

Why did so many painting women pursue the professional ideal as intently as men? What did it represent to them? How did they respond to its general thrust to solidify male control over the profession? At the most basic level, professionalism represented the best available expression of middle-class women's ambitions and the best available marker of the seriousness of women's intentions. It was the emerging model of artistic success and, at the same time, was much more available to women than the midcentury ideal of genius had been. Given the widespread trivialization of women's artistry, professionalism offered an apparent ungendering. Known for her focus on art, for her lack of interest in men, fashion, and parties, the "girl art student" seemed to be free of conventional feminine roles.[70] Obviously, this could create ambivalence and uncertainty as well, but for a generation of women just beginning to enter women's colleges after the Civil War and just beginning to search out professional opportunities, art provided an early promising outlet, and professionalism seemed the clearest path to fulfillment of their ambitions.

Life classes, which most obviously violated conventions of femininity, stimulated the most direct observations from women about the gendered meaning of their study. Columnists and reporters regularly visited schools to investigate this strange phenomenon of women students gazing upon a nude female body (and in some cases a partially nude male body). In February 1881, renowned columnist Jennie June attended the women's life class at the Art Students League. She reported that "there was no suggestion of sex about the matter. The girls were students, not women." As one student explained to June, "There is only subordination of an entirely arbitrary and conventional idea to the true interests and requirements of art study." Femininity, this student averred, had no relevance to women's pursuit of their goals.[71]

Avant-garde and modernist women would eventually shift strategies, but the leading women artists of the late-nineteenth-century generation adhered to this rather abstracted "masculine" professionalism. Fighting fewer ideological battles to get into art, women artists were not called upon to counter as many contradictions between "woman" and "professional" as they were in other professions. Both men and women, for example, had to reconcile contradictory gendered demands for elevated refinement and professionalism in the 1870s and 1880s. Moreover, within art schools, women were a relatively powerful constituency, with numbers as well as institutional dependence on their fees on their side. Given their early entry and relative power, women artists were in a good position to negotiate directly with men around "standard" norms of professionalism. Finally, this generation of women painters embraced professional ideals throughout their careers because, eventually, less

was at stake for men in reserving professional status for themselves. Unlike other fields in which professionalization intensified after the turn of the century, male artists retreated from professionalism as it failed to halt female inroads. A new generation secured the status and exclusivity promised by the professional ideal through a different framework.

In the short term, however, a generation of men and women entered art academies in droves, seeking the first credential of their career. The final stage of their preparation took them to Paris.

ILLUSTRIOUS MEN & TRUE COMPANIONSHIP

"Paris," exalted May Alcott Nieriker, "is apt to strike the new-comer as being but one vast studio."[1] Young American students reveled in the ateliers, galleries, museums, and great exhibitions that in their eyes dominated and defined Paris. Writers turned again and again to oceanic metaphors to describe the Parisian art scene, conjuring up a vast art world that surrounded the student and "into which he [was] plunged." Immersed in art, a student even breathed an "art-atmosphere." At the heart of this atmosphere was "the most active earnest effort of the present," what Americans took to be the most compelling, most modern, most sophisticated art of the day. To come to Paris was to experience the simultaneous pleasures of the best contemporary art and the most vibrant art center.[2]

With such glamour and allure, it is not surprising that Paris became "the Mecca of art students of both sexes."[3] Thousands of American students made the requisite pilgrimage—some twenty-two hundred Americans born before 1880 studied formally in Paris, about one-third of them women. The overwhelming majority came after the Civil War: in 1888 alone, a thousand American artists and art students filled Parisian academies. Speedier ocean crossings, a large expatriate community, and a well-publicized path made it increasingly easy to make the journey.[4] Widespread coverage in America of annual Salon de Paris exhibitions and of the comings, goings, and successes of American artists spread information about Paris. In addition, a whole genre of advice literature emerged to advise American students on their options for study, effectively promoting the romance of Paris for American artists. The Boston Art Students' Association at the Museum School even published a pamphlet, *The Art Student in Paris*, detailing places to study, eat, and live, with prices and addresses included.[5]

Many of these publications specifically directed women to the best ateliers and boardinghouses. Articles such as "The Girl Student in Paris" and "Lady Artists in Paris" supplemented books like the guide for women by Louisa May

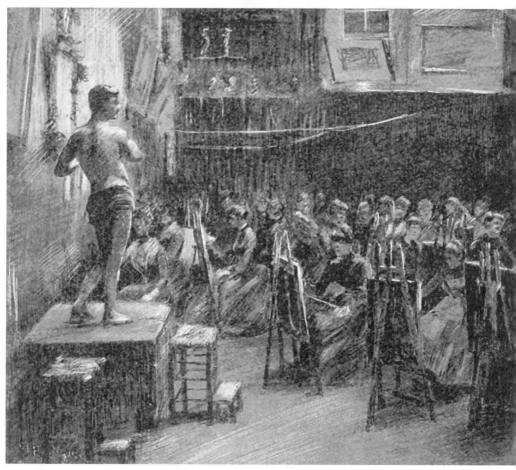

FIGURE 2.1. *"Atelier for Women (Bouguereau and Robert-Fleury),"* Cosmopolitan, *1890.*

Alcott's sister, May Alcott Nieriker, *Studying Art Abroad and How to Do It Cheaply.*[6] Other pieces featured illustrations and descriptions of women's ateliers. An article on the Académie Julian showed women bent over their easels before a male model (fig. 2.1). The text outlined demanding atelier procedures and named accomplished students, among them gold medal winners, prominent Salon exhibitors, and Marie Bashkirtseff, "a real genius." While not unambiguous in its evocation of the female art student—the women's atelier is a "fortress of the Amazons"—the visual evidence promised serious training. The depiction of women in Julian's classroom parallels illustrations of men's ateliers with students massed around easels, attention focused on their task. Prominently foregrounded and carefully delineated, the posed male model, nude except for a loincloth, invites the viewer to draw and paint him as the

students do.[7] The popular literature on Paris repeatedly reaffirmed this invitation, making it clear that women were a significant constituency for such advice.

By the late 1870s, American artists believed that Parisian instruction completed an artist's training, and the professional ideal adopted in art schools in the United States extended to study in Paris. There aspiring students fulfilled the academic ideals their generation embraced: a commitment to rigorous training and dedication to figure study.[8] Moreover, American collectors' rising interest in contemporary French Barbizon and academic paintings made mastery of French styles an economic necessity.[9] American dedication to academicism was a choice with ideological and political implications in the context of a fragmenting Parisian art world. The annual Salon de Paris was no longer the sole vehicle of contemporary art. *Cercles,* which sponsored their own *petits Salons,* and the more infamous Salon des Indépendants represented an art world in flux. The appearance of impressionism in the 1870s and postimpressionism a decade later further subverted the absolute authority of academic art. Yet, with the visible exception of Mary Cassatt, most American artists retained a vigorous commitment to the academic tradition until the late 1880s. The desire to establish the sophistication and maturity of American art was one impetus behind its professionalization. To practice forms that critics derided as the marks of the insane risked whatever progress American art seemed to have made.[10] When women staked their aspirations on the academic, they affirmed their class-based commitment to a national art of uplift, tradition, and refinement. In any case, joining the avant-garde remained problematic for women: it had strong associations with disreputable public spaces and vices and an upstart, fringe quality that American women, aspiring to the power and prestige at the center of the profession, most often eschewed.[11] Not until the early twentieth century would American women discover modernist art instruction in substantial numbers. Then a younger generation of "new women" sought out the liberatory possibilities of simultaneously smashing aesthetic and gender conventions. In nineteenth-century Paris "radical" remained defined by women's claims to academic professionalism. To study academic art in Paris was to claim a male prerogative as their own. Outward adherence to white middle-class ideals of respectable womanhood only partially masked the radicalness of women's ambitions.

Although nineteenth-century men and women left the United States in similar positions—especially after the mid-1870s—they returned to begin their careers positioned quite differently. In America, men and women had constructed art schools in interaction, reaction, and conflict; in Paris a dis-

aggregation occurred as women and men studied in separate locations. Paris generated a crucial transition as informal but separate-sex networks solidified into the informal alliances among colleagues that made up the backbone of the profession. Yet women students did not particularly perceive themselves establishing sex-segregated networks with consequences for their position within the profession. For most, individual development in a supportive, rewarding environment characterized their experience. They returned to the United States more confident, more sure of their artistic direction, animated by ambition, and ready to launch their careers. Many already had exhibition experience at the Paris Salon and looked forward to the recognition, prizes, and increased earnings that Salon exposure usually brought. It is around the critical disjunction between the exuberant expectations of individual women and the structural effects of Paris that this chapter revolves.

In Paris American women students honed their professional identities at two levels: first, by detaching from their families, including asserting their artistic intentions over other demands; and second, by focusing their training in Paris to position themselves well to compete in the art market when they returned to America.

"To go to a foreign country in search of teaching has one incontestable advantage. The student is set free from the trammels of daily life, can start early in the morning, and unwisely consume the midnight oil. New associates, new ideas, new methods, must do something to stimulate the imagination." [12] At the core of the Parisian experience, suggested this writer on female artists, was a feeling of freedom. In setting their own hours, meeting new colleagues, and immersing themselves without distraction in art, women had the opportunity to direct their own lives in ways unavailable to them at home, where they were often tangled in household and familial duties. Although Bostonian Ellen Day Hale studied art throughout the 1870s, worked in her own studio at home, and eventually opened a portrait studio in downtown Boston, constant interruptions shaped the flow of her work. For example, in the spring of 1877, while her father was away and her mother ill, Hale cared for household and siblings as she continued to paint. When she finally traveled to Paris in 1881, she went with Helen Knowlton, her teacher and colleague, and focused exclusively on art.[13]

To get to Paris women had to raise eight hundred to a thousand dollars for a year's study. Those sums required judicious negotiation of family and individual resources. Many women supported themselves entirely; in other cases, families provided women with a living allowance but refused to pay for their

art or for an expensive year of study abroad. The ability to raise such sums places most of these women solidly within the middle class. Yet the scrounging and saving testify to the falsity of the image that female art was a leisure activity, untethered from any consideration of money. Even Mary Cassatt, who came from an undeniably elite American family, had to support her own art, including studio, models, supplies, and travel. She spent an agonizing year in the United States trying to fund her second trip abroad, writing to her friend Emily Sartain that she was "ravenous for money." Simply raising the money to go abroad required women to extend their commitment to a professional life of earning.[14]

Emily Sartain, who joined Cassatt for her second trip abroad, funded her four years in Paris by working as an engraver, a trade she had learned from her father (fig. 2.2). Living off her savings, Sartain continued to earn money from her engravings and from finished paintings she sent home from Paris. She also borrowed money, most extensively, it seems, from her sister-in-law Harriet Judd Sartain, who probably assisted Sartain because she was a doctor and shared Emily's professional ambitions. By the end of her years abroad, Sartain was focused on the necessity of earning a sustainable living: "If I had an income of my own, I would stay abroad for years yet, — but as nothing of mine has sold yet, and I have no prospect of earning any money here next winter, I am going to Phila[delphia] where I hope to pay expenses at least, and I hope to pay off the large debt I already owe Hattie." [15] Sartain made the gamble that most women and men made when they went to Paris, trading her years abroad and their expense for the prospect of greater earnings and for the fulfillment of her artistic ambitions.

Those who gained family financial support also gained family recognition of their intentions. In garnering such support, women often made their first major bid for professional independence. Families typically made quite pragmatic calculations when they sent women abroad. Cecilia Beaux's uncle viewed his partial support of her Parisian study as an investment in her future, advising her to extend her stay in Paris as she wished.[16] She need not worry, he added, "about having none stored up" when she returned. "You will soon begin to accumulate again." Like Sartain, Beaux's uncle weighed expense against the expectation that Beaux would be able to earn her own living. Women's study abroad often became part of middle-class economic calculations about necessity and future earnings.[17]

Most arrived in Paris with bills of credit meant to last them through the first six months or year of their stay. Control over such sums invariably created a sense of exhilaration and freedom. Geraldine Rowland described her

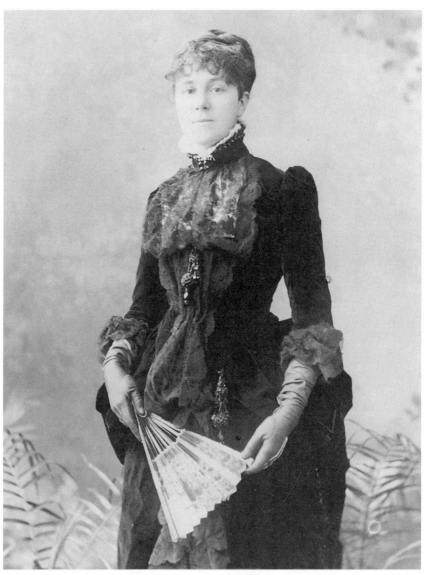

FIGURE 2.2. *Emily Sartain.* (*Courtesy of Moore College of Art and Design, Philadelphia*)

excitement at having seven hundred dollars all her own: "A little over [seven hundred dollars] in my letter of credit endowed me, who never before had had an allowance, with the complacency of a millionaire." [18] Women exercised "the complacency of a millionaire" with great aplomb, carefully choosing where they lived, what they ate, what entertainments they paid for, and what trips they took, often stretching their letters of credit to last longer. Mary Cassatt

and her companion on her first European trip, Eliza Haldeman, lived outside Paris in the small villages of Courances and Ecouen, partly because they were significantly cheaper. Eliza Haldeman managed her finances so efficiently that she told her parents not to send her more money; she figured she could make it for another year on the eight hundred dollars she already had. Haldeman's careful spending allowed her to extend her stay abroad much longer than she had originally intended. Money, therefore, was an avenue to freedom and to professional choices that would have been more difficult to achieve at home, and control over finances opened up opportunities for women's artistic and self-development.[19]

Growing confidence in their decisions appeared throughout the letters women wrote home from Paris. Dutifully women declared their homesickness, sought parental advice, and precisely justified changed plans (often to stay longer than they had originally intended); but a sense of independent decision making often undercut the more deferential and permission-seeking passages. In February 1867, for example, after having been abroad for just over six months, Eliza Haldeman asked her mother when she expected her home. "I hardly know enough of art yet to grow well at home, but it is six months yet till fall and I may know more then if you want me, that is, think I ought to come." Tempted to stay, Haldeman insisted she would "depend on you dear Mother to tell me what you think my *duty*."[20] Haldeman's desires jostled uneasily against her "duty" as she somewhat coyly played her artistic development against familial responsibilities. Six months later, such coyness was gone, and Haldeman confidently made up her own mind without deference to family. "I am glad you[r] and Fathers decision was so well in accord with mine altho I did not wait for it to make up my mind. I am thinking of nothing but of getting a picture in the exposition next Spring and am working hard for that purpose."[21] Like Haldeman, women regularly announced in their letters that they had changed their plans, found a new instructor, or even changed residences without soliciting the opinions or approval of their families. Their months and years abroad created a detachment and self-assurance that broke down deference to familial wishes and fostered an autonomy invaluable for professional development.

Such effects clearly surfaced in the confidence Paris often gave women to refuse marriage and make what they considered the final choice of career over marriage. Philadelphian Cecilia Beaux explained to her uncle, after her first spring and summer in France, that she would not be marrying because she had "expanded here and . . . could not get into the place [she] might have got into before." In Paris, Beaux felt confident enough of her prospects and

far enough from doubtful family eyes to refuse her suitor at last. Although choosing not to marry was a common decision for women artists, Paris often made such decisions both easier and more imperative as women settled into their professional identities.[22]

On their own, with control over their money and control over their time, women immersed themselves in art. Elizabeth Gardner wrote that she was up by seven, left the house at light, arrived at the Luxembourg Museum by eight-thirty, copied there for a while, and then went to her studio to work from the life model until dark. Similarly, Eliza Haldeman began life class at eight in the morning, worked until noon, and then went to the Louvre to copy throughout the afternoon.[23] A typical sojourn in Europe involved several months' study at a major studio, perhaps changing from one master to another periodically to get different instruction, followed by periods of work outside the city. During summer months women often traveled to the art colonies dotting the Parisian countryside or journeyed to Spain, Italy, or Holland for studying and copying.[24] Sometimes they simply spent a few months copying Old Master paintings in the Louvre or Luxembourg Museum. More advanced students obtained their own studios and worked independently, often on Salon pictures, occasionally taking their work to their teachers for criticism.[25]

Whether copying, attending classes, or working on their own, women sought the training that they believed would best develop their artistic abilities to compete fully on the American art market. Following prevailing American taste for the Barbizon school in the 1870s, many women went to study with Thomas Couture outside Paris, including Mary Cassatt and Eliza Haldeman from Philadelphia, Elizabeth Boott from Boston, and Maria Oakey from New York. They sought the rich, looser canvases that Couture's method of painting without extensive preliminary drawing allowed. Others pursued the stricter attention to drawing that most Parisian masters stressed, mastering the techniques of the most successful contemporary French artists. Often, women experimented to find the best instructor, shifting from one master to another as they developed skills or sought a different emphasis. Ellen Day Hale reported that she had studied at the studio of Emile-Auguste Carolus Duran, who offered "a very good method of painting to modify for one's self," adding, "You get ideas there which I have found of great value." Within a few months, however, Hale left Duran's class to join the Académie Julian, where she felt she acquired the discipline and drawing skills she desired. "We Julianites," she later wrote, "of course despise their [Duran's class] work in drawing, as drawing is the strong point in our class." Like Hale, women in Paris gauged their skills, their market, and the popularity of their teachers,

calculating who could best provide them with the artistic and professional growth they sought.[26]

By the late 1870s most American women found their way into several large, well-organized ateliers for women that began to supersede the private lessons and small classes Mary Cassatt and Eliza Haldeman had found in the late 1860s. The two best-known studios were the Académies Julian and Colarossi; women could also obtain instruction from several artists, including Carolus Duran, Charles Chaplin, Edouard Krug, and Alfred Stevens, who held special classes for women.[27] Julian's was typical of most of the Parisian ateliers. Founded in 1868 by Rodolphe Julian to prepare students for the entrance examination to the Ecole des Beaux-Arts, the academy had nine studios, five for men and four for women, by 1890 and added more through the turn of the century.[28] Elizabeth Gardner was among the first three women to enter Julian's atelier in the 1870s, and she remembered, "This number soon increased, for, the precedent established, women not only flocked thither from all parts of the world, but they divided honors with the men."[29] Between 1885 and 1889 alone, Ellen Day Hale, Gabrielle Clements, Dora Wheeler, Amanda Brewster, Rosina Emmet, Lydia Field Emmet, Mary Fairchild MacMonnies Low, Cecilia Beaux, and Elizabeth Nourse were among the American women to study at Julian's.[30]

A typical day at the Académie Julian began at eight, with students taking their positions around the model according to their place in the previous week's competition. Cecilia Beaux remembered that it was so crowded that each woman had "to mark each easel and chair with white chalk and to look out for encroachments."[31] The tangled tripods of easel legs in a photograph of the women's class at Julian's Rue de Berri atelier echo Beaux's description (fig. 2.3). Easel tops encroach on heads, shoulders line up like little tin soldiers, and bodies appear to mingle in a crowded circle in the center back. Until noon, all worked intensely, with only short breaks for the model to rest. Amid a packed, unventilated room women had to train themselves to focus: "None but those who try it," remembered one former student, "know the tension on the student of working in a crowded room. She must be deaf to voices, learn to reef her elbows, to wait without fretting for the model to sway back in to the chosen pose, and to keep in mind the first effect of light."[32]

Such intensity of space was matched by an intensity of experience. The women in the photograph of Julian's Rue de Berri atelier could easily observe one another's work. With a slight turn of the head or even a glance at a neighbor's canvas as they looked up at the model, women eyed classmates' work, testing composition, accuracy, or accomplishment against their own. Each

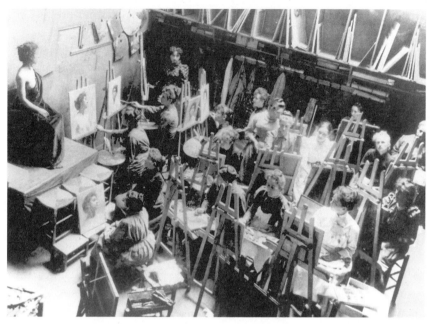

FIGURE 2.3. *Julian Academy, Atelier, 5, rue de Berri.*
(Courtesy of the André del Debbio Collection, Académie Julian Del Debbio, Paris, France)

student received her weekly criticism publicly, before the entire class, making the humiliation of a slashing criticism all the more intense. Moreover, much of the classroom experience was structured around competitions, with students winning weekly, monthly, and annual prizes that gave them the choice of best place before the model. The professionalizing character of the atelier is apparent as students from Julian's pose with the signs of their trade: on the back wall, prizewinning drawings; at the front, maulstick, palette, and a painted canvas (fig. 2.4). Scattered throughout, women peruse books, possibly their own sketchbooks, possibly works by the artists they aim to emulate. For many, the ateliers proved an intensely competitive experience as they sought not only individual recognition but also national superiority or studio pride in the competitions between the women's and men's ateliers.

Although winning the various *concours* brought recognition and pride, most women focused their attention on the weekly criticisms. Each week's classes built up to Saturday morning's visit of the master, with students hoping for at least a *pas mal* from one of the leading French artists who acted as critics.[33] Criticism — or praise — from some of the most famous painters of the day could dash hopes or affirm a student's development. The experience could be quite daunting, as, with a certain irony, Rosina Emmet explained to her

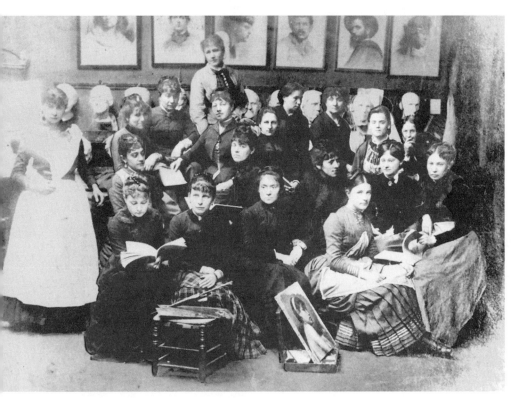

FIGURE 2.4. *Julian Academy, 5, rue de Berri.*
(Courtesy of the André del Debbio Collection, Académie Julian Del Debbio, Paris, France)

mother: "I am getting that meek and lowly that you would not know me. . . .
I have no doubt that I shall soon arrive at the condition of blind speechless
adoration for Tony [Robert-Fleury] that most of the class find themselves
in."[34] Emmet's image of "blind speechless adoration" reflected the conven-
tional stereotype of women's relationship to their teachers. Lacking criti-
cal and analytical faculties, women supposedly accepted the "overpraise" of
the master uncritically and, ultimately, merely imitated the master's style.
In "blind speechless adoration" women's own creative powers disappeared:
they had no eyes to see, no voice to defend their artistic choices. By poking
fun at herself, "getting that meek and lowly" so that "you would not know
me," Emmet substituted her will for the usual stereotype, making clear that
women's relationships to their teachers were far more complicated and subtle
than nineteenth-century critics acknowledged.

Men also negotiated relationships with their masters. They, too, faced the
risk of being labeled as imitative and the challenge of establishing their own

artistic identity. For men, however, the dynamic was somewhat different. The standard narrative of male students and their teachers included a triumph over those dangers, a break and separation from the master that established a male artist's legitimate autonomy. Women's susceptibility to a master's influence appeared permanent, so that the image of their relationship to their instructors was usually one of vulnerability, often with the underlying implication of sexual vulnerability. It was essentially an image of seduction, in which a woman, seduced by exaggerated praise and the magnetic authority of her master, gave up her creative independence.

Women, however, turned to other metaphors to define their relationships with their teachers.[35] Using images of father and family friend, women sought to exert control over the teacher-student relationship outside the dynamic of seduction; mentors and the informal alliances of the profession could be obtained, they hoped, through safer conventions of male-female relations. Ellen Day Hale warned women to pursue "friendship" with a professor carefully as "security against a fault very common among artists of our sex, that of imitating a master and doing nothing original."[36] Although Hale's advice reiterated the stereotype of the woman artist as imitative, it nevertheless suggested strategic decisions to avoid that characterization. In her own case, Hale attempted to turn the image from imitation to fatherhood, describing William Morris Hunt as her artistic father: "Now, ladies, I am going to speak to you of one who in many ways was a father to me. My own father was my father spiritually, but I can say Mr. William Hunt was my father in an artistic way. I can say that William Hunt formed me as an artist."[37] With this lineage, Hale could safely claim connection to her teacher as well as establish her artistic credentials. As artistic father, Hunt's professional prestige extended to her.

Emily Sartain pursued a different strategy, trying to establish herself as a friend of the family of her teacher, Evariste Luminais. In October 1872, returning from a summer in the countryside, she wrote her father, "I cannot tell you how cordially they greeted me, — just as if I were an old and highly valued friend."[38] She went on to describe Madame Luminais's attachment to her and over the course of the next year recounted various moments of intimacy and friendship with Luminais and his wife.[39] With a "friendship" between herself and Luminais's family, Sartain developed a closeness with her teacher that provided the support and encouragement she sought as an artist. "Friendship" made the teaching more personal, less fraught, and more affirming. Although both Sartain and Hale are somewhat exceptional in the intensity of their attachments to their teachers, both exemplify the range of options available to women for turning relationships with their teachers to

their advantage. In a world in which instructors often treated women's art cavalierly and with casual praise, securing genuine interest and sincere advice was an important source of encouragement and validation.

At the same time, women remained highly discriminating, selective, and aware of the limitations of particular ateliers or instructors. The Emmets and their friends generally agreed that Felix Giacomotti, who criticized at Julian's, was terrible and nicknamed him "Old Moocowmotti."[40] Even when they didn't dismiss the teacher out of hand, women often relied on their own judgments over the criticism of the instructor. Ellen Day Hale rated the quality of criticism by Parisian masters: Alfred Stevens was not "severe or sincere" enough; Jules-Joseph Lefebvre was a great painter but "too gentle, not hard enough" in his criticism; and Gustave Boulanger was "very severe" with men but less so with women. She recommended trying "to get a few rough words from him; for I should value his interest enormously."[41] Seeking "rough words," Hale and her peers resisted the patronizing, thoughtless, and careless criticism often given them simply because they were women. Although women like Hale and the Emmets may have been frustrated by the lack of respect in teachers' attitudes, the critical distance disrespect engendered unintentionally fostered the development of their own artistic authority. In shifting ateliers and evaluating the criticism they received, women formulated an independent critical perspective the very opposite of the susceptibility conventionally ascribed to them.

Compounding the difficulties of negotiating indifferent criticism were the broader inequities of Parisian training. Attending Julian's or Colarossi's academy was already something of a default choice, shaped by restrictions on women's study and a sex-segregated system of art training in Europe. Women could not study at the Ecole des Beaux-Arts, the famed French academy that enrolled the best male students from all over the world, until 1897, when they finally gained entry into the school and access to its free education.[42] The independent ateliers represented a second-best alternative that drew both unlucky men refused for the Ecole (and those still in preparation for it) and women. These atelier classes were, however, sex-segregated and unequal: men received criticism twice a week, compared with women's weekly instruction, and paid half the price. Perhaps more frustrating to the serious women students was the lower "standard" in the women's classes. Lydia Field Emmet and Rosina Emmet were disappointed in their class. "The standard is so low that it is not very inspiring," noted Rosina. "If they criticized conscientiously they would punch holes through some of the vile paintings and make them begin drawing from casts." Cecilia Beaux simply commented that most of the other

students produced "nothing but ridiculous weak scraggles," and she longed to study in the men's studio, with its "splendid work hanging around by the men students and the whole spirit of the place." By contrast, Thomas Eakins wrote home to his father of the "incalculable advantage [it was] to have all around you better workmen than yourself." Higher costs, less instruction, and weaker classes all meant an "incalculable" disadvantage for women at a crucial moment in their training.[43]

Awareness of this discrimination was certainly hard to avoid. Most American advice books and articles about Paris made a point of describing the distinctive obstacles women encountered, often contrasting the advantages women had in America with their restricted opportunities in Paris. "Nowhere," Phebe Natt noted, were there "the same liberal and generous arrangements for women's work as on our side of the Atlantic." Women studying in Paris recognized the unfairness of this system. May Alcott Nieriker used her own experience to remark in her advice manual on the "injustice" of the prices charged women and encouraged women to band together in order "to secure the same advantages now enjoyed only by men, at the same exceedingly low rates." Others joined one of the few mixed-sex classes available, but given the risks of "this condemned mode of study" — "less law, and order, and cleanliness, and decorum" — few pursued this option.[44] Attempts to form independent classes or to join men's studios occurred infrequently. Most women chose the well-marked and easily available route of the established ateliers. Paris schools thus separated American women from their male peers, undermining the benefits of coeducation and contributing to distinctions between men and women that would be reinforced in other parts of Paris life. These distinctions would also shape men's experiences. Men would return with an "incalculable advantage" and their membership in a male fraternity reaffirmed. Still, for women, the awareness of these distinctions, and of their unfairness, was not enough to rule out Parisian study. They needed it for a credential; they wanted it for the "art-atmosphere" they could breathe in Europe and the independent lives they could lead there; and they chose it because it was the next step in the fulfillment of their ambitions: in short, women went to Paris focused on the promise that it did seem to hold.

Whether they encountered disinterest or warmth from their teachers, injustice or opportunity in their classes, American women approached Paris deliberately and strategically. Such decision making is particularly evident in their focus on having a picture accepted for the Paris Salon. When they chose to dedicate themselves to the Salon exhibition, rather than, for example, try-

ing to change discriminatory teaching practices, women revealed their understanding of the purposes of Paris. Successful Salon exhibition proved the seriousness of a woman's intentions and represented an invaluable launching point for her career. Women still encountered bias at the Salon, but at least they competed directly with men in one of the most important events of their profession. Here, where they could be judged by merit rather than by sex, was where women chose to advance their cause, demonstrating their identification with professionalism and its ideal of gender-neutral objectivity.

A vast government-sponsored annual exhibition, the Paris Salon showcased living artists and contemporary art. Acceptance at the Salon marked a transition from aspiring student to artist and, moreover, usually led to notice in the press, more patronage, and acceptance at American exhibitions. Elizabeth Gardner wrote of her two pictures in the 1868 Salon: "It gives me at once a position among foreign artists and raises the value of what I paint. I have just received $400 in gold for one of the pictures." And for Eliza Haldeman and Mary Cassatt acceptance at the same Salon led to an introduction to a Mr. Ryan, correspondent for the *New York Times* and *Herald,* who promised to notice them in the paper. Given these rewards, women pursued the Salon assiduously, averaging around one-fourth of the American exhibitors.[45]

Most women planned very carefully for the Salon. To begin with, since atelier professors often served on the Salon jury and could help influence it in favor of a student, women strategically cultivated their masters. Cecilia Beaux wrote her uncle that she wanted her two instructors at the Académie Julian "to know [her], and recognize that [she could] do something": "It will count in the long run."[46] Within her first two months in Paris, Beaux had determined the importance of getting the attention of her teachers; she knew they could help advance her career if they viewed her work favorably, and she made decisions to get the attention of useful patrons. She continued to worry about which atelier to associate herself with, fearing that if she did not stay on at Julian's her "chance of the Salon [would] be small."[47]

Beaux tackled her Salon picture with some trepidation. She spent her winter working on her own in her studio, struggling with the picture, and writing home of her "blues and anxieties," worried because so much was "at stake." Showing her picture to Julian, she felt "alone and a good deal scared"; but, once she had finally had it framed in early March, she felt more confident, writing her family, "It looks quite well—not fresh nor free but it is noble and dignified."[48] Even though Beaux had exhibited in Philadelphia and even had a painting, submitted by a friend, accepted by the Salon the year before, it

was her first deliberate attempt at the exhibition, and it was her first major picture since she began her studies in Paris. A Salon painting required moving beyond the sketches and studies that were the routine work of the classroom to a fully conceived, and fully painted, composition. By completing such a painting, a student demonstrated her mastery of life drawing, her ability to manipulate and handle paint, and her talent for composition and artistic conception. Successfully completing a Salon picture was for Beaux, as it was for most women, an assertion of her mastery of the profession.

However much women sought to position their Salon successes and overall growth in Paris within the profession as a whole, they found themselves within increasingly sex-segregated settings. In Paris, women operated in a world of women, creating a female professional network based on shared living and shared study. Friendship, conversation, and information formed the currency of this network, seamlessly integrating everyday life and professional aspirations. In Parisian ateliers and *pensions*, women found themselves among other women who validated and nurtured their artistic development. Much of what allowed them to sustain their sense of accomplishment in the face of blatant discrimination lay in the power of these supportive ties. But with their sights set on individual professional achievement, women studying abroad often failed to notice the significance of the bonds they created. Like women in other fields focused on meeting the highest professional standards, artists intuitively identified with the individualism at the heart of professionalism. The sustenance of a female community could easily remain invisible when meritocratically based individual accomplishment defined professional status. The Parisian experience was riven with paradoxes: formation of a female network and, at the same time, a divide between male and female artists that would deepen upon return to the United States; creation of a supportive community of women artists and, at the same time, determined adherence to individual progress.[49]

Women's networks began at home. Upon arriving in Paris, most women settled into a *pension*, inexpensive hotel, or small apartment with the relatives or friends with whom they were traveling. Often they located affordable but respectable establishments by following the recommendations of friends, relying on the female network for their very first decision in Paris. Elizabeth Gardner set up home on the Rue Dauphine with Imogene Robinson, who had been her friend and colleague in Massachusetts.[50] The Emmet sisters rented a small two-room apartment that they shared with the maiden aunt who was their chaperone and caretaker (fig. 2.5). In these two rooms the Emmets held

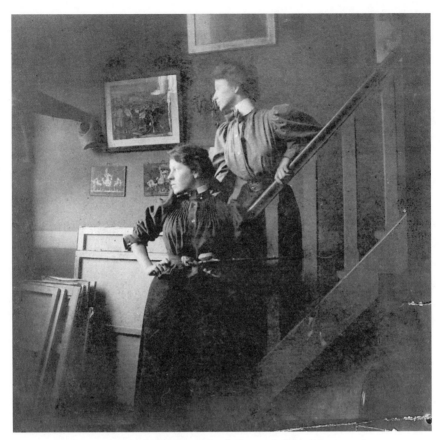

FIGURE 2.5. *Emmet sisters in Paris. (Emmet Family Papers, Archives of American Art, Smithsonian Institution)*

teas, suppers, and evenings of work with their closest friends, Dora Wheeler and Amanda Brewster. "Dora came over with her paints yesterday afternoon," Rosina reported, "and painted with us and took tea with us and stayed all evening. She is the best of company." The Emmets spiced this daily routine with special dinner parties and holiday meals that solidified their friendships with other young women training in Paris.[51]

By the early 1890s, Paris had become such a popular destination for young women that wealthy expatriate women had organized an American Girls' Art Club, "a home of delightful and economic safety for the legion of young women who, in the pursuit of art, annually go unprotected abroad." Situated in the heart of the Latin Quarter, the club offered "refined comfort" and "matronly supervision," at a "minimum of expense." Each woman had a room and access to the dining room, reading rooms, and garden.[52] Teas and evening get-

togethers formalized the kind of at-home evenings the Emmets had held, sustaining the important intersection of friendship, collegiality, and individual development. Surrounded by other lively and committed women, residents of the American Girls' Art Club found their ambitions supported—and even spurred on. As resident Geraldine Rowland described, "Thus, living in a beehive of ambition and work, I feel myself alive with activity; able, in fact, to ride to the finish both my hobby and my desire to become a great painter." [53] Whether women art students lived in hotels, apartments, or the American Girls' Art Club, their living arrangements created a supportive setting that validated their achievements and ambitions.

Living arrangements provided the foundation of most women's social life. Rooms at the American Girls' Art Club bustled with informal sketch classes, and residents held impromptu dances, "just among the girls themselves," with banjos, guitars, and refreshments served "picnic fashion." Club members also arranged more formal entertainments in which they reached out to the art world at large. "All artistic Paris, male and female," was invited to the annual "Exhibition Day," with an evening reception, supper, and dance. "Exhibition Day" successfully tied club residents to the Parisian art world, allowing women to bring famous French artists, American expatriate painters, and even potential buyers into an informal, social setting. Club residents also presented tableaux, sponsoring on one Thanksgiving "Paintings from the Louvre" for "numerous members of the art-world." Spoofs, like Velasquez's *Infanta*, with red-worsted hair, a cranberry-rimmed collar, and parsley bouquet, appeared alongside serious reproductions of Titian, Botticelli, and others. At such festive gatherings women participated in the inside jokes, allusions, and gossip of the art world and took advantage of an opportunity to bridge the usual gap between male sociability and female artists. [54]

Paris fostered the integration of the American art world, bringing Philadelphians, Bostonians, and New Yorkers together with ambitious students from the West and Midwest. [55] Interconnections of Boston and New York art worlds occurred, for example, when Rosina Emmet visited the studio of a Boston artist and met other young artists as well as four Boston women from her classes. [56] Three years later, in 1888, Cecilia Beaux found herself within the same home-based expatriate networks. She, too, met Bostonian Elizabeth Boott Duveneck (married and living in Paris), bringing a letter of introduction with her from Duveneck's old Hunt classmate, Ellen Day Hale. Beaux wrote home that she was "in the exact locality where [she] wanted to be . . . in the midst of [her] friends." She found herself among expatriate American artists, working near old friends from the Pennsylvania Academy, including Margaret Lesley

Bush-Brown, Gabrielle Clements, and Florence Este; receiving calls from artists Philip Hale (Ellen Hale's brother) and Ned Stewardson; and meeting other artists, both men and women.[57]

Formal calls and introductions often translated into evening entertainments as well, particularly in the more relaxed art colonies outside Paris. Cecilia Beaux, for example, participated in an active expatriate world of evening entertainments, attending various supper parties and soirees. One evening featured hypnotism and palmistry, with Beaux herself the palm reader; at a costume party at the summer artists' colony in Concarneau, cousin May Whitlock was a palette and Beaux appeared as a tube of rose-colored paint, her "favorite and indispensible [sic] color."[58] Like Beaux, Emily Sartain enjoyed a vigorous social life, recounting her many "dissipations" in her letters home. Amid a network of American friends—her old friend Sophie Tolles; the wealthy and generous Elder sisters, who were cousins of Sophie's from New York; the Hubers; and American artist Walter Palmer—Sartain created a community for herself that helped her mature emotionally and artistically on her own terms far away from the encompassing family life of artist father and four artist brothers.[59] Moreover, the social connections she made, like the connections other women made, created a network of women artists, solidifying and extending friendships made in classes and establishing colleagues in cities across America.

Integral to women's professional lives, this network of friends and colleagues provided the informal support, feedback, and information that complemented formal training. Women found their purposes and aims reaffirmed in friendships with other women artists. "I long to see you & have a talk about art," Mary Cassatt wrote Emily Sartain in June 1871.[60] Sartain reiterated those desires two years later: "Oh how good it is to be with some one who talks understandingly and enthusiastically about Art," she wrote home after meeting up with Cassatt, adding, "I find I soon get tired of even friends who are not interested cordially in painting."[61] To talk about art with another woman was to have their artistic ambitions mirrored. At tea and over supper, women discussed "Art" together and debated their own artistic direction as well as the merits of contemporary styles and trends. Sartain and Cassatt each used the other to argue for their diverging commitments to academic and impressionist art. Even though pleased to see Cassatt, Sartain told her father, "I by no means agree with all of Miss C's judgments,—she is entirely too slashing,—snubs all modern Art,—disdains the salon pictures of Cabanel Bonnat and all the names we are used to revere,—but her intolerance comes from the earnestness with which she loves nature and her profession,—so I can sym-

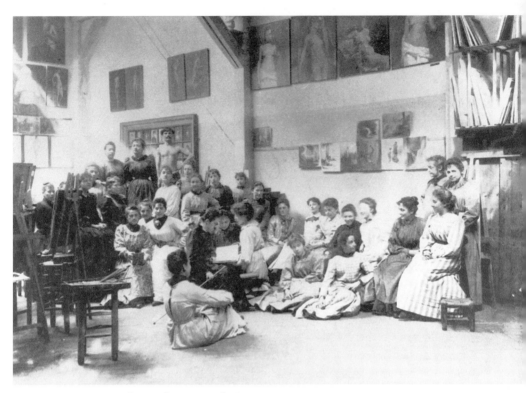

FIGURE 2.6. *Julian Academy, passage des Panoramas.*
(Courtesy of the André del Debbio Collection, Académie Julian Del Debbio, Paris, France)

pathize with her. . . . I agree with her in a measure in many of her criticisms, but am not so severe and sweeping in my deductions." [62] Vigorously disagreeing, embracing different aesthetics, Cassatt and Sartain nonetheless relied on their friendship.

Conversations about "Art" moved fluidly from classroom to home and back again. A class at the Julian academy studio on the Passage des Panoramas displays another side of the atelier experience (fig. 2.6). No longer crowded before the model or posed as professionals, these women sit informally, casually grouped along the length of the classroom. Some chat, while others pore over an art book. Presiding over the class from the back is the male model. His bare chest coolly satirizes endless photographs of men's life classes where the nude female model gazes out among the male students. Evoking that sign of male camaraderie and fraternity, the photograph substitutes a female sociability. Such irony and humor were a daily part of the atelier routine. Quick-witted caricatures of teachers, other students, and models documented student opin-

ions. They showed both the solidarity that a good laugh could supply and, at times, the rivalries and jostling among fellow students. Caricatures even made their way into the public pages of Parisian advice literature. In one 1878 article, words and images spoof the students in the class, including the naive female "*nouveau*." Other sections make the professors their target. In one illustration, two young women watch in amusement as another draws a chinless, thinning-haired head of the master on the wall. Captioned "He's gone, girls!," the drawing provokes a laugh that unites the female students at the instructor's expense.[63]

The conversations begun in class could easily be continued in the evening. When Rosina and Lydia Field Emmet had Amanda Brewster and Dora Wheeler over for tea or supper, for example, they worked on composition assignments, comparing one another's work and commenting on their successes and failures.[64] Such an exchange provided needed feedback given the often cavalier critiques of masters.

In her final year in Paris, Emily Sartain shared a studio with another student from her class, Jeanne Rongier. They covered their walls with their own studies, anatomical drawings, and reproductions of Michelangelo, creating a hospitable environment for art production. Sartain's friend Florence Este worked for a while in the studio, copying "an excellent flower piece of Jeanne's" that had been a gift to Sartain. Copying each other's work and surrounded by each other's studies, they learned and criticized together. Sartain explained how pleased she was to have Rongier around: "I shall be very glad to have my regular *comrade d'atelier.* She is so steady in her work, so exact in her attendance that she encourages me to keep at it." In the notion of "*comrade d'atelier*" Sartain evoked the seamless integration of friend and colleague women found in one another. Art formed the core of their relationship; comradeship defined its terms.[65]

In conversation and in criticism, women shared information about the best avenues to achieve their aims. May Alcott Nieriker wrote *Studying Art Abroad and How to Do It Cheaply* to provide "facts and figures" that would help other American women "overcome certain difficulties attending a first trip" and achieve "the most direct attainment of the desired end."[66] Advice, filtered through letters, contacts, and friendships, pointed women to the best ateliers, reliable teachers, and most likely means to attain a Salon entry. Ellen Day Hale was particularly prolific in her assistance. In one 1887 letter she advised a young woman planning to go to Paris on the merits of different teachers and on getting a picture in the Salon. She also provided Cecilia Beaux with a letter of introduction to Julian's atelier, and in 1885 Julian offered to reduce

Hale's fees, in part because of the number of women she had sent to study in his studios.[67]

The most extraordinary example of this kind of shared information is the letters Elizabeth Boott Duveneck sent back to Boston from her studies with Thomas Couture in 1876. Boott had just spent several months studying in William Morris Hunt's class and decided to send a series of letters to her classmates, "to keep you informed of my life hereabouts & give you a few statistics of the teaching which I hope will be so profitable to me." Boott provided more than "a few statistics"; she included detailed and lengthy descriptions of Couture's methods, such as his outlining and shading techniques, the brushes he used, and his explanation of how to build up color in a painting. At the top of each letter is a list of a dozen or so initials; as she read it, each woman in the Boston class checked off her initials. Preparing other women for their journeys abroad—some would even stay with her when they came—Boott guided them to the best France had to offer.[68]

Men developed a parallel but similar network in Paris. They, too, shared friendships, residences, study trips, masters, and information. William Merritt Chase, Walter Shirlaw, and Frank Duveneck were so inseparable that they were called "the Father, Son, and Holy Ghost"; George de Forest Brush, Stephen Arnold Douglas Volk, and Abbott Thayer all studied with Jean Léon Gérôme and remained friends once they returned to New York; Kenyon Cox and Theodore Robinson also studied at Gérôme's together, traveled to Italy, and eventually shared an atelier. As it had for women, this network integrated work and everyday life, creating an encompassing absorption in "Art." [69]

Separate-sex bonding had different and unequal implications for men and women, however. Typically, the newest student at an atelier in the Ecole des Beaux-Arts had to undergo a kind of hazing: the *nouveau* had to supply food and drink for the entire atelier, run errands for older students, and perform stunts or songs for the amusement of the class. The hazing and raunchy "Rabelaisian conversation" of the men's ateliers inverted respectability in ways emphatically not available to women.[70] The irony and wit in women's caricatures could never be as bawdy as men's because they already risked so much to study in life classes. In fact, commentators went to great lengths to assure outsiders of the respectability and propriety of French ateliers for women. Reassured one, "[The] atmosphere of th[e] rooms was irreproachably cool and pure" and Monsieur Julian was "in all respects a finished French gentleman." [71] The necessity to make statements like these constantly reminded readers that for women their gender took precedence over their profession. Bonds of transgression among men, on the other hand, initiated them into the fraternity of

the profession as they passed from *nouveau* to full-fledged member of the class. Combined with the rigorous entry examination passed to gain admission to the Ecole, this cemented a strong sense of shared membership and shared accomplishment from which women were excluded as a matter of course. Informal gatherings, suppers, and annual honorary dinners also brought men and their masters into a shared world of sociability.[72] The joking and drinking spilled over into the streets as men joined one another in cheap cafés and restaurants, where they discussed art long into the night. Men occupied the new "modernity" of Paris in an entirely different way than women, who could not enter its cafés and bars and theaters without threatening their respectability. A young *nouveau*, according to Clive Holland, could hope that after the pose his model, with "blood coursing ecstatically through her veins," would "tie the artist's cravat, smooth his coat collar, and away with him gladly enough." Needless to say, this made a walk in the Luxembourg gardens with a fellow student somewhat risky for middle-class women students.[73]

Avant-garde artists such as the impressionists had an even greater devotion to Parisian modernity: street, café, and backstage all became the subject of their paintings. While Mary Cassatt and French painter Berthe Morisot charted a path into impressionism through the modern woman ensconced in domestic scenes, the disreputable overtones of much avant-garde subject matter made it complicated for women to embrace and lent appeal to the academic model. Only when a younger generation, more openly subverting gentility in both art and womanhood, traveled to Paris to study in the early 1900s did the avant-garde gain significant appeal. It is no accident that the impressionism the older generation of American women did produce came from Claude Monet's country retreat at Giverny. There Lilla Cabot Perry translated to Americans the new ideas about light and paint in the 1890s, filtering impressionist radicalism through the landscape and garden scene.[74]

Certainly, men and women did socialize and did discuss art: separate-sex worlds were never complete or impermeable. Among the circle of Elizabeth Boott and her women artist friends were the "Duveneck boys," pupils of their teacher Frank Duveneck, who came over for evenings, bringing their copper etching plates and their press to make monotypes. Annie Wadsworth remembered that they "made many poor monotypes but had much enjoyment." Evenings of etching, sketching, or conversation brought men and women together, creating connections across male and female networks.[75]

Yet such socializing had its risks. Cecilia Beaux had to overcome her relatives' feelings that Paris was a "wicked city." Her aunt warned her: "Only remember that you are first of all a *Christian*—then a *woman* and last of all an

Artist."[76] Despite Beaux's own desire to reverse this sequence of identities, she found herself defending her actions after cousins reported some potentially risqué behavior: "You really need not be worried about any indiscretions of ours. We have almost no temptations nor any chance for any, & we are not going to do anything imprudent anyway. . . . Aunt S[arah] allowed Constance to go with us to Ned Stewardson's studio, so she ought'nt [sic] to say a word. When we were leaving Mr. Stewardson's studio I made a laughing sort of apology about its being Bohemian."[77] She continued, enumerating her various visits with men and defending her propriety. Socializing with men could not occur within the easy nexus of home and classroom that women had with one another; rather, it had to be justified, explained, and properly conducted.

Even the commonplace visiting of artists' studios required formal invitations and formal behavior. Visits to studios were an important opportunity for students to meet more established artists, to view their most current work, and to solicit their advice. They were especially important for women who did not attend classes with male colleagues and could not join them in their informal evening gatherings. A woman could not enter a man's studio without careful precautions, however, lest she be mistaken for a model. As Kenyon Cox reassured his mother, the only unescorted women who came to his rooms were models. Beaux's "laughing sort of apology" and her allusions to bohemianism convey the uneasy and awkward terrain women entered when they socialized with men. Such unease structured women's professional relationships: it limited their access to the casual sociability that cemented professional networks and reinforced the segregation of women artists into single-sex alliances. Interactions with men — and the professional possibilities they represented — were always constrained by social codes governing relationships between men and women.[78]

In contrast, in America, the effects of gender codes had been somewhat contained as women and men operated in a world that was remarkably heterosocial. In American art schools, all classes except life classes were mixed-sex classes. Men and women crossed paths in school hallways, in informal sketch classes, in school organizations such as the Boston Art Students' Association at the Museum School, and in school meetings such as monthly and annual meetings at the Art Students League. They planned and attended social events, from tableaux to balls, together. In a common institutional setting, men and women interacted informally, in ways that were not possible in Paris. Louise Cox remembered sketch classes as a place where peer criticism, from both women and men, helped her crystallize theories from class.[79] The ab-

sence of a shared institutional setting fundamentally distinguished Paris from New York or Philadelphia or Boston. The informal bonds formed in Paris did not allow for the same competing negotiations over the profession that American schools had. Without common institutional interactions and in a foreign country, men and women settled into the separate-sex worlds that codes of respectability prescribed and patterns of male professional preeminence reinforced.

Despite the separation of their networks, the similarity in the letters men and women sent home from Paris is remarkable. A kind of common rhythm shaped these letters as both women and men reported on activities, trips, classes, and progress. Both sexes expressed enthusiasm at their opportunities and commitment to their artistic development. Throughout the 1870s and 1880s women's consciousness of the difference between their experiences and men's remained muted, and the solidifying network of friends and colleagues in Paris remained a matter-of-fact part of everyday life. Women knew and discussed the injustices they encountered in educational opportunities, but this awareness did not translate into organization on their own behalf or into an identity as a "woman artist." The paradox of Paris was that the networks women formed were critical to their development. They were sustaining, validating, and, most practically, a safe haven in a foreign city. In many ways, women's individual professional development was made possible by this community of women artists who provided examples, inspiration, encouragement, and spurs to higher achievement. Nevertheless, for most of the late nineteenth century, women's dedication to professionalism and their desire to compete with men on the same ground kept their attention away from this collective experience.

As Parisian study distinguished women from men in ways they had not been distinguished in their American training, it also had an impact on men's perceptions of themselves. Men returned to America with their membership in a male fraternity reinforced by the French system of all-male instruction. Once home, they used their networks successfully, establishing a plethora of artists' associations in the 1870s and 1880s that brought male peers together while excluding women, repeating the experience of Parisian ateliers rather than of American art academies. Friendships in Paris translated into assistance and collegiality back home. William Merritt Chase and Carroll Beckwith, for example, became colleagues at the Art Students League; Theodore Robinson used a connection at *Scribner's* to supply the illustrating work that made it possible for his friend Kenyon Cox to come to New York.[80] Women's

networks did not initially translate into the same formal associations and professional connections. Poised to start careers, women brought the hopes of their individual Salon successes and their renewed ambitions back to America. But the distinctions between men and women that Paris created would have a significant effect in the art market, where they hoped to make their careers.

SELLING ART IN THE
AGE OF REFINEMENT

ike many other women, as Ellen Day Hale spent her final months of art study in Paris in 1885, she submitted a painting to the Paris Salon. For her second successful foray into this proving ground, Hale showed a suitably declarative work. *Lady with a Fan* coolly depicts a woman with calm exterior, chin lifted in self-possession, and direct, focused gaze (fig. 3.1). With hallmark touches of the aesthetic movement—a blue tapestry background, streaks of green, decorative lettering in her signature—Hale announces her artistic sophistication. She knows and can manipulate the most up-to-date aesthetic fashions. Careful modeling of the face and hands and mastery of light and shadow in flashes of white across the brim of the hat and swell of lace at the sleeve underline her control of academic technique and her professionalism.

A self-portrait, *Lady with a Fan* announced Hale's artistic maturity. Against her dark dress, Hale's hand, with white elongated wrist and loosely curled fingers, signifies her trade—her skilled touch and mastery of the brush. Her steady, clear eyes, set lips, and assertively tilted head convey self-assurance and intensity of purpose. One of a cycle of portraits and self-portraits made across a lifetime of friendships, Hale's painting is evidence of the network of friends and fellow artists she created for herself. With bangs across her forehead, hair tucked up in her hat, and boyish features, Hale represents herself androgynously. Selfhood, not gender, is the message of the painting.

Returning to the United States in late 1885, Hale moved definitively from student to artist. Immediately, she submitted a painting for exhibition to the North, Central, and South America Exposition in New Orleans. Accepted there, Hale maintained a vigorous exhibition record throughout her career, showing locally as well as at the large international fairs.[1] Her record of exhibiting is not unlike that of many of her peers, as exhibitions became a prominent element of a new kind of speculative, international art market in the Gilded Age. Circulating canvases around the country, Hale joined a gen-

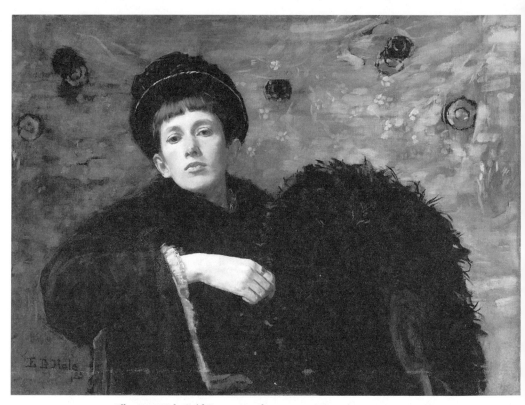

FIGURE 3.1. *Ellen Day Hale,* Self-Portrait, *oil on canvas, 1885.*
(Courtesy of the Museum of Fine Arts, Boston. Gift of Nancy Hale Bowers.)

eration of women and men making careers within an unsettled and rapidly
changing art market. The comfortable sale of artworks among a small circle
of loyal patrons had receded by the 1870s as collectors abandoned their self-
conscious cultural nationalism and joined the race for European treasures.
J. Pierpont Morgan, with his infamous appetite for art, was only among the
most visible of the new collectors. In twenty years of uninterrupted buying,
Morgan amassed a huge collection, snapping up in minutes collections that
had taken their owners years to create. The press gleefully reported Morgan's
acquisitions, noting the new might of American capital and cultural power.
The sheer magnitude of Morgan's collecting made him a symbol of a broader
movement: the growth of industrialist and merchant collectors, the infusion
of capital into the international art market, and the rise of speculative art buy-
ing and investment. Originally interested in Old Master paintings, American
collectors began to acquire the work of contemporary French Salon artists in
the 1880s, providing established French painters with a booming sellers' mar-

ket. A popular French artist such as Jules Breton could command more than twenty thousand dollars for his works. Part spectacle, part genteel mission for culture, art collecting and the coverage it received ensured that high art remained part of the period's popular culture and mythology.[2]

Watching the speculation in French academic painting with some bitterness, American artists experimented widely—and somewhat desperately—to create outlets and markets for their work. Figurative work offered the most promising route to compete with the Europeans, and young artists returning from Paris soon challenged established American artists whose success lay in landscape and genre painting. A highly uneven, mixed market of older styles, figure subjects, and diverse "lesser" media emerged.

American artists sought to gain control of this splintering market, and of the profession, through a flurry of association building. These associations sponsored exhibitions—annual or semiannual affairs that attracted press attention and collectors' eyes and served as crucial market venues in the 1870s and 1880s. By promoting the "fine art" status of a medium and by setting standards through exhibition juries and membership restrictions, artists' societies also performed functions similar to those of the associations founded by other professionals throughout the Gilded Age: they helped close ranks, narrow competition from outsiders, and ensure the success of status-building efforts. Women were often a casualty of these professionalizing maneuvers, and significant disparities opened between women's vigorous exhibiting record and their membership in the inner circles of these organizations.

Professional associations proliferated as artists also experimented with many "lesser" media that had the advantage of lower prices and wide appeal. They removed watercolor, for example, from the domain of lady amateurs, vigorously elevating the medium's reputation and creating a whole new market through watercolor societies and widely attended annual exhibitions. Other media—many of them also associated with female amateurship—had similar revivals, including pastels, etching, and some forms of illustration.[3] Many artists capitalized on the popularity of the aesthetic movement, which promoted artistic interiors and the decorative arts. Louis Comfort Tiffany chided his fellow artists for clinging to their narrow views of painting and sculpture. "No profession is more overcrowded," he claimed. "Clients do not keep increasing; it is rather the other way." Tiffany's remarks—and his own success once he left painting for decorating—reminded his colleagues that decoration and design could provide promising financial rewards even when their paintings were not selling.[4]

Ellen Day Hale and her friends and companions such as Gabrielle Clem-

ents, Margaret Lesley Bush-Brown, and Lilian Westcott Hale followed the path of many women through these uncertain decades. Like Hale, they exhibited with tremendous dedication, sending their canvases to a nationwide circuit of fairs and shows. And, like so many of their male colleagues, they experimented with a variety of media on larger and smaller scales. Most important for Hale was etching, but she also caught the final wave of the decorating impulse, producing a series of collaborative church decorations. Amid all this, Hale generated her own "clubbiness"—not the associations of her male colleagues but still a vibrant community of practicing artists.

Through the 1870s and 1880s, as women like Hale competed within this unpredictable and fluid art market, they found market niches and experienced gains in exhibiting, reputation, and sales. But in the 1890s, just as the market for American art finally improved, these openings contracted. Smaller, male-dominated artists' societies and a dealer and gallery system replaced vast exhibition halls. And the experimentation with watercolor and pastels acquired new meanings. Male artists had helped advance aesthetic ideals in the 1870s and 1880s that made such work seem worthwhile and a legitimate artistic practice rather than an amateur pursuit. The defense of this "feminized" male artwork subtly shifted critics' and audiences' understanding of refinement in art, blurring genres, disrupting hierarchies of media, and encouraging the market to value art in different terms. In the 1890s spontaneity, directness, the artist's touch all gained new discursive and commercial ramifications. The new meanings adhering to cultural refinement produced ways of thinking about art critical to refinement's eventual antithesis, modernism.

Defenses of male watercolorists, pastelists, and decorators additionally protected male prerogatives against women's ongoing pressure on the market. And it was ongoing pressure. The market's reshaping in the 1890s followed two decades of heavy contention. Too often the art world has appeared conveniently divided: bifurcated between "minor" and "major" arts with female and male lining up neatly on either side of the divide. But we cannot draw such a simple map in this period. At every level and in every arena from oil painting to wall papering, men and women tried to make their way, acquire sales, garner some prestige, and generally manage an uncertain market. Although women artists encountered resistance—and real limits—there was a sense that the market had openings on which women could capitalize.

By the 1870s, the annual exhibitions at the National Academy of Design and the Pennsylvania Academy of the Fine Arts contained hundreds of works. Opening night was one of the season's social events. Illustrated reports in

magazines and newspapers documented the orchestras, evening wear, and large crowds making these society affairs. At the National Academy of Design's annual exhibition in 1882, sales reached thirty-five thousand dollars.[5] Artists, perceiving the opportunity in free publicity and an attentive buying audience, founded a wide range of societies to sponsor similar exhibitions.[6] Women assiduously submitted work to these shows, making little headway at the National Academy of Design (where they remained about 15 percent of exhibitors through the end of the century) but gaining ground elsewhere. The Pennsylvania Academy had increasing numbers of women exhibitors, with women constituting a third of the artists on display by the mid-1880s. At the Society of American Artists, women produced 30 percent of the works shown in the 1900 annual. A fifth to a third of the artists exhibiting in a broad array of associations, from the Boston Art Club to the New York Etching Club, were women (see appendix, table 1).[7]

The new associations mingled professionalizing aims with market purposes, seeking to establish artist control, and thus professional autonomy, over an important market institution. The Society of American Artists, founded in 1877, brought together younger artists trained in Paris who chafed at the power older artists exerted at the National Academy of Design. Promoting their brand of Salon academicism, the new society attracted extensive publicity. The Society of American Artists introduced the aesthetic viewpoint of a younger generation to the public, making these "rebels" appear coherent, progressive, and promising for American art.[8] The New York Water Color Club perhaps best captured the conjoined professional and market impulses behind artists' societies. The New York Times reported that the new group intended "to encourage sociability among its members and to further their business interests in art matters generally."[9] Mingling sales and comradeship, credentialed members (who had, of course, to be elected) set standards and entry criteria for membership and exhibitions, and in a world where commerce seemed ever more intrusive, they created the image of disinterested self-regulation in the broader service of "Art."

Admitting women to artists' associations became a frequent source of contention. Self-conscious about their professionalizing functions, male artists saw these societies as a bulwark against "amateurs"—presumed to be female—and the new organizations gave men a means to assert their dominance in the profession. In the long run, just as critical as the exposure women gained in exhibitions were the limits they encountered in artists' organizations. The Society of American Artists reluctantly admitted women because one of its founders was a woman, but in 1889 only 4 of 108 members were

women and, even though membership nearly doubled in the next decade to 200, only 9 women were members in 1900.[10] Helena de Kay Gilder, the female founder of the society, recorded in her diary some of the difficulties she and her friend Maria Oakey Dewing had participating in the society, particularly in dealing with the powerful John La Farge. Even before the Society of American Artists had been officially founded, Gilder wrote in her diary that La Farge had dismissed her work, describing a visit in which he ignored the portrait she was painting, commenting only that her decorative panels were "pretty." "Why don't you women go into this sort of thing?" he asked her. "L. F. and I are forever estranged," noted Gilder. "I cannot think he has been noble in his action." Two years later, Gilder's experience had not improved, even though the two worked together that winter to found the Society of American Artists. Maria Oakey Dewing had not been elected a member because, as Gilder recorded, "L. F. did not second her."[11]

Sometimes the support La Farge withheld from Gilder and Dewing translated into formal rules of exclusion. With these kinds of rules, artists' associations echoed the strategies pursued by professional societies in other male-dominated fields such as medicine and science: they, too, restricted women's membership in the name of higher standards, a "professional" membership, and comfortable collegiality. A small group of Philadelphia men founded the Philadelphia Society of Etchers in April 1880 for the purpose of "promot[ing] a taste for Etching as a fine art." At only their third meeting, however, they were confronted with an unfortunate nomination for membership: Mary Franklin had been put forward. When the society returned to vote on Franklin's nomination a month later, tentative support for women members surfaced in a proposed amendment to the society's constitution that would have allowed women, "providing they [were] competent Etchers," to become full members. Tabling the vote one more month, the Etchers finally defeated it on December 7, 1880, officially barring women from membership. While the Society of Etchers minutes do not record the debate on this amendment, they do record the peer review and social exchange that the society provided and from which women were excluded.[12]

Much of the opposition to women seems to have been reluctance to allow women to pass judgment on the work of male artists, in both the informal settings of club meetings and the formal arenas of exhibition juries. Did women have the dispassion and authority to judge art properly? Would men be diminished by women's evaluation of them? In 1887, when Cecilia Beaux and Emily Sartain were the first women ever to serve on the Jury of Selection and Hanging Committee at the Pennsylvania Academy, their actions were heavily

scrutinized. Although some newspapers reported that their work proved that women could capably pass judgment on their male colleagues, that men would submit to such reviews, and that women should stand alongside men in the profession, other reviews suggested that women were "a little more lenient than a masculine committee would have been," since one-third of the works in the exhibition were by women and the show was generally not inspiring. The level of attention, as well as the range of comments drawn by Beaux's and Sartain's service, suggests male resistance to women's participation at any level that gave them real power or control.[13]

The informal socializing of many societies provided a further barrier to female participation. Founded in 1871, the Salmagundi Sketch Club invited only male members to their weekly meetings, where participants received "mutual criticism" on their sketches. Similarly, the club's annual reception was open only to men.[14] Another group, the Tile Club, achieved notoriety for its exploits through popular profiles in *Scribner's Monthly*. Tilers shamelessly "[stole] from the ladies" in experimenting with decorative tiles and other media but included only men among their members. Their canal-boat trips and evening gatherings, filled with smoking, drinking, and rowdy singing, transported the bonding of Parisian art schools to American soil and celebrated masculinity in the face of the club's feminized decorative work. Integrating these forms of male sociability into their societies, artists, like many other professionals, used them to lend a masculine tone to professional culture.[15]

While artists' societies set the tone for the profession and provided an important venue for sales, they did not directly foster the close relationship with patrons that created reliable patronage and prestige. To establish a sense of connection and loyalty with patrons, Gilded Age artists joined another set of clubs, the gentlemen's clubs that proliferated after the Civil War. With memberships in these clubs, artists crossed their professional networks with other professional and business circles. And art productively made its way into club activities. The prestigious Century Club, for example, exhibited works by its artist members that were then discussed at the monthly club meetings. There artists received feedback, developed a sense of the marketability of new and experimental works, and established relationships with potential patrons. Moreover, although the Century Club opened its exhibits only to its members and their guests, reviews in the New York papers produced substantial publicity. Most exhibitions displayed works loaned by artist members or paintings from the private art collections of other members, effectively favoring the most successful artists and virtually excluding women.[16]

Exhibitions at gentlemen's clubs were, nevertheless, not entirely closed to women: less prestigious clubs and some clubs outside New York showed women's works, although never frequently and never admitting women as members. The Lotos Club in New York showed work by far more nonmember artists than most other clubs, creating some opportunities for women. At the club's exhibit of American works in April 1878, women were six of the nonmembers who exhibited. In Boston, the St. Botolph Club opened its exhibition space to local women, particularly to more elite painters such as Sarah Wyman Whitman and Lilla Cabot Perry.[17]

Artists' association with these gentlemen's clubs took on heightened importance once major collectors turned their attention toward Europe. Among the few collectors who did build major American collections, however, women were not particularly successful and never established the intimate, sustained patronage that some men were able to obtain. Collector William T. Evans, for example, provided financial and personal encouragement to a number of artists including Frederick S. Church and Will Low; in the course of his collecting days Evans bought forty-one paintings from Church and twenty-eight from Low. Evans did not support a single woman artist to this extent: he never bought more than three paintings from any one woman.[18] Even when women established close ties to a major collector—most often a woman—they did not usually benefit to the extent their male colleagues did. Although Mary Cassatt advised Louisine Havemeyer from the latter's earliest collecting days, the Havemeyer bequest to the Metropolitan Museum of Art contained only two oils by Cassatt. Similarly, Cecilia Beaux was a friend of Boston patron Isabella Stewart Gardner, but Gardner did not particularly patronize Beaux or even aid her indirectly by lending her studio space or by seeking other patrons for Beaux's work as she did for John Singer Sargent.[19]

Although women artists did not find consistent patrons among either male or female major collectors, a network of women's patronage, often rooted in women's separate institutions, did exist. After Anna Klumpke painted Mary Hill Coolidge in France, Coolidge secured portrait commissions among elite women involved in charity and reform when Klumpke set up a studio in Boston in the early 1890s. Cecilia Beaux met not only Isabella Stewart Gardner but also Mrs. Teddy Roosevelt and Mrs. Andrew Carnegie at Helena de Kay Gilder's salon.[20] These connections translated into commissions, suggesting that salons held by wealthy women could connect women artists to elite patronage. These salons, however, were much more informal than gentlemen's clubs and much less direct an avenue to patronage. The clubs that women formed did, in some cases, follow similar avenues as gentlemen's clubs, hold-

ing special exhibitions of women's work, buying women's art (usually for local settlement houses, schools, or public libraries rather than for a private, permanent collection), and raising subscriptions for women's scholarships.[21] None of these activities matched men's in scale, amount, or scope, and women artists could not reliably turn to networks of women's patronage for sales and career development.[22]

Despite clubs and professional associations that lopsidedly favored men, commentators began describing the promising new careers in figure painting, portraiture, and landscape established by recently trained women as early as 1880. Just under ten years later, Charles Kurtz, art critic for the New York Star, found enough "serious women," standing on the same "plane" as the "leading men who paint[ed]," to warrant a four-part series on women artists, including a survey of past achievements and detailed biographies of many contemporary workers.[23] Throughout the period, women demonstrated their allegiance to the newest directions in art and their ambitions to achieve at the highest level available to them. In exhibitions, they showed figure paintings in rates that paralleled those of their male colleagues, and, whenever possible, they maintained careers in the more prestigious realms of figure painting, although to do so they often depended on a more local (and sometimes female) base than men did.

Continuing the tactic they had pursued when they had submitted to the Paris Salon, women focused on the venue most open to them for direct competition with men: exhibitions. Women's access to exhibitions regularly exceeded their memberships in artists' societies and often even roughly corresponded to their overall representation in the art world. The larger size of many exhibitions, the jury process, and the volume of women's submissions made it much more difficult to bar women from this wider arena than it had been to close club doors to them. The distinction between membership and exhibition created market institutions in which women were denied positions of authority but not excluded from the profession. In the 1870s and 1880s, when exhibitions were an essential market forum, this loophole permitted functioning careers for women.

Lydia Field Emmet exhibited almost annually at the National Academy of Design as well as at major international expositions. She won prizes at the World's Columbian Exposition (1893), the Atlanta Exposition (1895), the Pan-American Exhibition in Buffalo (1901), the St. Louis Exposition (1904), and the Carnegie International Exhibition in Pittsburgh (1912). She also won major prizes at the big annual national exhibitions, including the National Academy

of Design, the Society of American Artists, the Pennsylvania Academy, and the Corcoran Gallery in Washington, D.C.[24] Emily Sartain followed a similar pattern of exhibiting until she became principal of the Philadelphia School of Design for Women. She brought her successful Salon painting back to the United States and won a medal for it at the 1876 Centennial Exhibition. Then, throughout the late 1870s and early 1880s, she exhibited at the Pennsylvania Academy, the National Academy, and at the Interstate Industrial Exhibitions in Chicago.[25] In Boston, Alice Curtis and Adelaide Wadsworth showed steadily between 1875 and 1900 at the Boston Art Club, the St. Botolph Club, the Mechanic Fairs, and private galleries. Both also made the reach outside Boston and exhibited at a variety of locations, including the National Academy, the Society of American Artists, the Black and White Exhibitions of the early 1880s in New York, and several Philadelphia art societies.[26] Generally women placed their work most regularly at the important annual exhibitions within their own town but also sought out the major large exhibitions in other cities; by the turn of the century, this itinerary included such midwestern and western cities as Chicago, Denver, and Cincinnati. The growing numbers of exhibitions, art societies, and museums across the country provided an important additional outlet outside the highly competitive art centers of the eastern seaboard.[27]

Women went to significant effort to get their pictures exhibited. From overseas, both Anna Lea Merritt and Mary MacMonnies Low conducted detailed correspondence with dealer William Macbeth about the exhibition of their paintings. Merritt asked Macbeth to make arrangements to exhibit her painting, *A Piping Shepherd*, at the Society of American Artists or at the Carnegie Exhibition in Pittsburgh. She also asked him to try to find a New York outlet for her work, since she wanted to "work up a reputation in New York." Two months later she wrote, "I have heard that Pittsburgh was a very good place to sell but I know nothing about the galleries of America. . . . Send it where most likely to sell."[28] Mary MacMonnies Low similarly wrote Macbeth to arrange the submission and transfer of several works, shuttling them from Philadelphia to New York, St. Louis, and Pittsburgh.[29] Since they lived abroad, both Low and Merritt made arrangements through a dealer that most women conducted directly in order to avoid the fees Macbeth and other agents charged. Their correspondence, however, reveals some of the ways women approached the market as well as their expectations for major exhibitions. Both Low and Merritt hoped to sell their work at exhibitions and used serial display of the same painting to find a buyer. Merritt also made it clear that she hoped exhibiting would bring her exposure and help her establish a reputation in the

New York market. Attendance at major exhibitions was quite considerable, and even though it was hard to get attention for individual paintings in large exhibitions, they still introduced many people to the work. Even more important than attendance was the critical notice that women received. By the early 1880s reviewers made a special point of commenting on the works of women artists and the prizes they had been awarded. Special prizes for women at the Pennsylvania Academy, the National Academy, and the Society of American Artists brought women exhibitors steady publicity and recognition, an important achievement even if the same prizes set women apart and made it easier to deny them the more prestigious prizes usually given to men.[30]

Merritt and Low were not alone in submitting genre and figure subjects to exhibitions. Catalogs for the annual exhibitions of the National Academy of Design, the Pennsylvania Academy of the Fine Arts, and the Boston Art Club reveal that, despite the stereotype of the woman flower painter, women shared the commitment of their male peers to the new figure aesthetic (see appendix, table 2). Women's entry of still-life and flower paintings dropped substantially between 1880 and 1900, from around one-fourth to fewer than 10 percent of all paintings exhibited by women. At the same time, they entered figure paintings in increasing numbers, with percentages rising from under a fifth to nearly a third of the paintings women displayed. By 1900, women exhibited figure paintings in close to the same proportions as men.[31]

Men still exhibited more landscapes than women, while women showed more portraits than men, so distinctions remained between women's and men's displayed work. Although some women certainly established reputations as landscapists, a landscape career continued to be relatively less typical for women artists, especially given the accessibility and salability of portraiture. The difference in men's and women's exhibition of portraits may also lie in the structure of submission and commission: men may have more frequently submitted portraits under evocative titles such as "Rose" or "Reverie" that positioned the paintings as figure compositions rather than portraits, or men may have had more time for nonportrait work given their greater opportunity for patronage and commissions; at the same time, women may have found friends and family members particularly available subjects for drawings and paintings.[32]

Submitting canvases again and again, circulating their works widely and dedicatedly, women pressed onto the national scene and into one of the era's most important market institutions. Even when excluded from "membership," women entered the orbit of the new artists' societies as exhibitors, testifying to their presence in the art world and to their identities as serious, pro-

fessional artists. For the short term, exhibiting (as a strategy) worked well: it did not generate anything approaching parity, but it created the most opportunity and the most recognition at the point where these market institutions were potentially the most flexible and most open to women.

When exhibition sales fell disappointingly short, as they often did, American artists, both male and female, experimented with secondary and "lesser" media such as pastel and interior design. Affordable and in demand, these forms accorded with middle-class standards of taste and genteel aesthetic values. As the market for them heated up, male artists joined middle-class tastemakers in resuscitating forms often tainted by their association with female amateurism. Under the guise of creating a refined civilization, male artists could enter this female territory with high professional purposes, using a "feminized" ideal of culture to serve the joint needs of class and profession. When the newly formed Society of Painters in Pastel held its first exhibition in 1884, reviewers went to great lengths to assert the significance of men's new work: "Just as etching needed certain men of genius to raise it from the bog of amateurishness in which it floundered, so pastels required such chosen talents."[33] The "bog of amateurishness" was dangerous indeed for men proving their professional mettle. And they worked hard as they etched, crayoned, and decorated to get up on dry land.

First they asserted the difficulty, the seriousness of their work. John La Farge countered the fairly standard declaration that watercolor was "a pretty material for lady amateurs to use in flower-painting or vase-decorating" by rejecting the supposed superiority of oil painting.[34] "The painter of watercolor," La Farge insisted, "exercises far more skill, must be far more resourceful, and, in the end, with his simple means, often suggests more than the oil painter is able to represent."[35] Similarly, many artists went to great pains to distinguish "original" etchings and the work of "artist-etchers" from earlier practitioners who had mainly used the medium to copy paintings.

In addition to articulating these sorts of defenses, men created institutional structures to give a professional cast to—and simultaneously sell—their new work. Every new media had a society; every society carefully restricted its membership; and each group cultivated a market for its works through exhibitions and publicity. Whenever they could, women joined, but men exercised fairly tight control over membership, even in societies devoted to media traditionally practiced by women. No women were among the original seven members of the American Society of Painters in Pastel when it was founded in 1884; the American Watercolor Society had only four women

among its eighty-three members in 1882, and that number had actually declined to three in 1914, even though the overall membership grew. Here, perhaps, male artists wanted to declare even more forcefully their separation from a historically female form of work in order to create a distinct image—and market—for their work.[36]

The American Watercolor Society was emblematic of the changes wrought in these media in the 1870s and 1880s. In the fifteen years after its founding in 1866, it attracted a large and varied constituency, with illustrators, painters, decorators, and amateurs all finding a home for their work in the society's exhibitions. Sold "at prices everyday folks [could pay]," watercolor's popularity expanded, and the society's sales grew vigorously across the 1870s.[37] The popularity of watercolor attracted many painters. Winslow Homer, for example, followed his mother into watercolor: after she taught him watercolor technique and exhibited herself at the Brooklyn Art Association in 1873, Homer submitted his first work to the Watercolor Society in 1874. A year later, after submitting twenty-seven watercolors, Homer quit his work as an illustrator and turned to watercolor to support himself. It was through watercolor that he would attain fame and establish his reputation. He went on to be a stalwart of the watercolor association.[38]

Homer's mother was among the women artists who energized the watercolor movement and undergirded its popularity.[39] Like many of these women, Henrietta Homer was an amateur relying on her training at a young ladies school. But among the amateur ranks were a number of professional women. With her friend, sculptor Anne Whitney, Fidelia Bridges cultivated ambitions for a career in art and debated women's place in society; Bridges eventually spent a year in Rome, living with Whitney and Boston painter Adeline Manning. Her American teacher, William Trost Richards, introduced her to patrons when she opened her Philadelphia studio in 1862, and Bridges exhibited at the Pennsylvania Academy in the mid-1860s. By the end of the decade, she had turned almost exclusively to watercolor, slowly shifting toward a decorative style with less detail, asymmetrical compositions, simplified backgrounds, and deliberate Orientalism. Her paintings of flowers, birds, and grasses brought her popularity and recognition: election to the National Academy in 1873, membership in the Watercolor Society in 1874, and regular commissions form Prang and Company chromolithographers.[40] Professional women like Bridges successfully carved out careers as watercolorists amid amateurs and male colleagues.

Bridges benefited from beginning her career in the 1870s. By 1882, the Watercolor Society became "one of the art powers of America" according to a con-

temporary commentator.[41] It was a central player in the art market, and it began to act to protect that position. The club self-consciously became more restrictive in its exhibitions, limiting itself increasingly to professional watercolor specialists. Women found the doors closing as the society raised standards. The percentage of women exhibitors actually fell, and when Agnes D. Abbatt became a member in 1882, she was the last woman elected for nearly forty years.[42] The drive to establish watercolor as the work of serious professionals extended competition between men and women across the divide between high and low, "masculine" and "feminine" arts. In what would become a characteristic phenomenon of the Gilded Age art market, men's practice feminized, while, to the extent that women wrangled opportunities, theirs masculinized.

The Watercolor Society, especially in its more free-flowing early years, stimulated a diverse array of artistic activity. The New York Etching Club and the Society of American Painters in Pastel had their origins as sections of American Watercolor Society exhibitions. Both the Etching Club and the Pastel Society followed the model of the watercolorists: both revived neglected and lesser media, transforming them into legitimate forms of "high" expression. Etchers, for example, helped transform this medium from a tool used to copy paintings and reproduce illustrations to an art form used to produce "original" etchings by "artist-etchers." Perhaps not surprisingly, this elevation coincided with a burgeoning female presence as women provided the labor for the wood-engravings needed to feed the late-nineteenth-century boom in illustrated books and magazines.[43] Similarly, pastelists took a form unappealing because of its association with the feminine and elevated its status by shifting attention from its supposed amateurishness to its spontaneity, brightness, and suggestive effects. In each case, the societies stressed their painter membership; and likewise, in each case, painters sought to exploit a burgeoning market. Like watercolor painters, the Etching Club and Pastel Society held exhibitions, attracted publicity and reviews, and cultivated the market for their work. And they exploited the market for affordable work. The Pastel Society's Second Exhibition in 1888, for example, included works ranging from thirty to two hundred dollars in price.[44]

J. Alden Weir provides a good example of men's involvement in this varied terrain. He circulated actively in the overlapping circles of artists in the late 1870s and 1880s. He joined not only the New York Etching Club and the pastelists but also the Society of American Artists, the Tile Club, and the American Watercolor Society. Weir worked actively in these secondary media through the early 1890s. They represented a central piece of his oeuvre: when

he and his friend John Twachtman held a joint exhibition at the Fifth Avenue Art Galleries in 1889, Weir's thirty-two works included eight pastels and two watercolors, nearly a third of his work. Weir's involvement in artists' societies was fairly average; he was not the central mover and shaker, but he took advantage of the community of artists they created and the sales opportunities they represented.[45]

Women participated in the etching revival from its tentative beginnings in the late 1860s and, despite their exclusion from etching societies, were among the exhibitors at the New York Etching Club's first exhibition in 1880. Within seven years, when the Museum of Fine Arts held an exhibition titled "Women Etchers in America," twenty-four artists contributed more than four hundred etchings. Seventy American women received etching training in the 1880s and 1890s and then made it a part of their professional work: all of these women were also painters.[46] Ellen Day Hale learned to etch in the summer of 1885 from Gabrielle Clements as they traveled through the French countryside. With her first etchings of Chartres, Hale found the medium satisfyingly expressive and fruitful. She had that summer's work accepted by the New York Etching Club the next year and showed again in the Women Etchers of America exhibition. The national recognition the women etchers show received "far surpassed [her] expectation," Hale wrote to the exhibit's organizer. That success—and undoubtedly some sales—kept etching a part of Hale's oeuvre for the rest of her career.[47]

Much of the work in watercolor, etching, and pastel satisfied a growing demand for domestic art. In the 1870s and 1880s, the aesthetic movement and a burgeoning consumer-oriented middle class made homes an artistic focal point. Artists returning from Paris, noted one 1880 article, would find that while they were away "household art ha[d] invaded every furniture shop and there [was] a curiosity shop in nearly every street."[48] Critics and commentators widely acknowledged, and promoted, this surge of household decoration. Under the title "Culture and Progress," *Scribner's Monthly* proclaimed America's new impulse in 1874: "For in America, there is a real love of comfort and beauty; we love our homes, and gladly welcome any news of how to make them more agreeable to our friends and to ourselves. We are all sick of tameness and copying, and only ask to be shown the better way, to walk in it with a will."[49] *Scribner's* went on to publish a series of articles by Clarence Cook on interior decorating that, when gathered together in 1878 as *House Beautiful: Essays on Beds and Tables, Stools and Candlesticks,* became one of the standard texts of the period, with two reprintings within the next three years. Cook spurred the aesthetic movement, actively promoting the artistic decoration of homes

throughout the period and publishing another series of articles in *Art Amateur* in 1884 with room-by-room advice about how to create beautiful, pleasing interiors.[50] Home decorating thus occupied equal space with exhibition reviews and articles on art and artists in both popular and art magazines such as *Scribner's* and *Art Amateur.*

The aestheticism promoted by Cook and the genteel magazines stressed elaborate, extensive decoration with all surfaces heavily decorated. Its feel was eclectic and sumptuous, with colors, textures, and design forming an evocative whole. Japanese fans or prints might lie alongside other pieces of Orientalism, such as Moorish pillows, and these might be placed alongside a Greek vase. Aesthetic interiors conveyed an overall harmony or rhythm and, ideally, a kind of gracious charm: a space removed from the messy external world. Such spaces corresponded nicely to Victorian visions of female cultural authority: refined interiors, refined elegance, and refined demeanor went hand in hand.

And the force driving the decorating craze was female. The aesthetic movement, with its seemingly insatiable demand, spread from the amateur and female ranks of decorative arts societies and aspiring artists to accomplished professionals, *both* male and female. Not only was advice like Cook's aimed at women, but women also filled the burgeoning ranks of amateur decorators. Societies of decorative art formed across the country in the late 1870s spurred by the display of skilled needlework from the English South Kensington Royal School of Art at the Centennial Exhibition.[51] These societies promoted tasteful decoration and the production and sale of decorative work. The Boston Society of Decorative Art's directors explained their goals, admitting that women might have "the instinctive desire to decorate their homes" but not yet "the culture to do so with grace and charm." "The clue that has guided them to the result for which they had been dimly hoping" came directly from the society.[52] Societies of decorative art thus educated members with lectures and exhibitions, commissioned desirable designs, opened workshops and training for other needy women to complete the designs, and innovated means to market the work produced. The elite and middle-class members of decorative arts societies combined charitable impulses toward impoverished women with female authority over culture and domestic space.

Male artists typically entered this territory quite enthusiastically: it represented promising commissions and innovative artistic problems. Aesthetic decoration seemed congruent with male artistic ambitions despite its entanglement with feminine spaces and values. Men occupied positions of control in the movement, determining interior schemes and producing designs

for decorative arts societies. And the work was lucrative, providing "comfortable prospect of employment and emolument for native painters who [would] master the principles of decorative art." It was, *Harper's Weekly* continued, "to their profit to paint walls rather than to paint canvasses [*sic*]."[53]

Decoration served the reputation and career of an already established artist like John La Farge well. After collaborating on Boston's Trinity Church, La Farge found commissions multiplying, easing the financial stresses he had faced as he tried to make his living from painting. Watercolor, overall interior design, murals, embroidered hangings, and stained glass all came together in his work, with stained glass stimulating his most important innovations. La Farge's forays into decoration took him into a number of entrepreneurial ventures and shaped the rest of his career.[54] But his dedication to decoration made him somewhat unusual among artists. More typical was Albert Pinkham Ryder. Ryder's reputation has been built on an image of the isolated, reclusive artist, intensively, even obsessively, working on his canvases, regardless of commercial considerations. Yet decoration and commercial requirements shaped the first decade of his career. He worked for the design firm of Cottier and Company through the early 1880s, painting panels on gilded leather for folding screens, decorating smaller pieces of leather for furniture insets, and painting designs for a number of mirror frames.[55]

While men like La Farge and Ryder converted decoration into the work of professional artists, women — both amateur and professional — gave it slightly different meanings. In both the spread of artistic dress that accompanied artistic interiors and the writing in the art magazine *Art Interchange*, which was heavily influenced by decorative art movement leaders, women turned their participation into social change, creating an undercurrent of challenge to Victorianism and male authority in the movement.[56]

In the aesthetic ideals of the period, part of creating pleasing interiors was creating pleasing dress and appearance to harmonize with those spaces. Women adopted loose, uncorseted dresses, in typical aesthetic colors of sage green, yellow, brick red, and peacock blue. These dresses had long been known as wrappers, worn only at home, in private settings. In the 1870s and 1880s, many women began wearing aesthetically decorated wrappers in public. This fashion signaled the aesthetic movement's challenge to established gender relations twice over: aesthetic dresses displayed female artistic skill, and they inverted conventions of pure, domesticated womanhood by taking intimate, uncorseted attire into public spaces.[57]

Costuming themselves in aesthetic dress, women artists self-consciously tested its radical meanings. Ellen Day Hale and her friends wore aesthetic

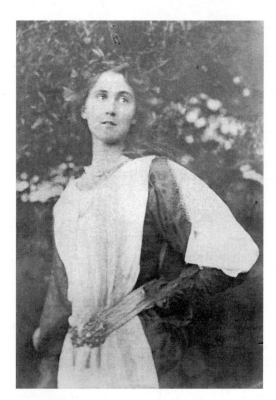

FIGURE 3.2.

Lydia Field Emmet in aesthetic dress. (Emmet Family Papers, Archives of American Art, Smithsonian Institution)

dress, while artist Maria Oakey Dewing advised women of "the mysteries of artistic costumes."[58] A young Lydia Field Emmet looks out from a photograph dressed in a loose, tunic-covered dress. With sleeves cut full and open at the top, but tightly fitted below the elbow, the dress is bound with an elaborately designed girdle of metalwork and glass strung loosely around the waist (fig. 3.2). It has the open fit of a wrapper and small details of artistic dress—cross-stitching on the sleeves, the decorative belt. With shoulder pushed forward and hand pressed to her hip, Emmet's pose is far from demure or languorous. The assertiveness of that pose, combined with Emmet's clear gaze and intent expression, shows a self-possessed young woman. Aesthetic dress, with its connotations of freedom from convention and artistic independence, reinforced Emmet's self-fashioning as autonomous artist.

The message of artistic dress spilled over into women artists' work, as in a small painting of 1892 by Louise King Cox. Painted on the eve of Cox's wedding, *A Rondel* depicts a complex allegory with figures pictured in aesthetic dress (fig. 3.3). The goddess Flora (sixth from left), attended by a line of nymphs in a friezelike composition, wears the marriage girdle of Venus,

FIGURE 3.3. *Louise King Cox, A Rondel, oil on canvas, 1892. (Courtesy of the Collection of the High Museum of Art, Atlanta, Georgia. Purchase with funds from the Phoenix Society, 1986.2.)*

a symbol of love and desire. Flora and her attendants are all dressed in aesthetic attire: long, loose dresses in sage greens, brick reds, and yellows, covered with highly decorative patterning. The fourth nymph from the left wears a classic aesthetic costume: an unbelted, open-neck tunic in carefully harmonized shades of Pompeian red, and a stitched pattern reminiscent of organic forms and William Morris. Flora herself wears an aesthetically inspired gown with floral designs, yellow background, and loose construction. Among Cox's emblems of flowering love and sexual desire are aesthetic wear.[59] But the aesthetic mode may have given Cox an even more complex way of representing herself. Flora is also, most likely, a self-portrait of Cox, who sent this painting to the World's Columbian Exposition as she ended ten years of art study. The painting represented Cox's statement of her own mastery: she had the technical prowess, experience, and confidence to compose works with multiple figures in different and varied poses and with ambitious allegorical themes. Marriage was merely a companion to this achievement. In a short piece, "Should Woman Artists Marry?," written a few years later, Cox explained, "Why should a woman, any more than a man, marry before completing her technical education, if she wishes seriously to pursue a profession? . . . This is to my mind the question: Not should woman artists marry, but why should women try to be artists with a less serious education than men?"[60]

That Cox redefined the problem as training rather than marriage is not, perhaps, entirely surprising from a professional artist. But her stress on

achievement over marriage ran through the aesthetic movement as a whole. The *Art Interchange*, the major organ of the decorative movement, had wide-based sponsorship in the art world, ranging from the National Academy of Design to societies of decorative art. Like aesthetic dress, the *Art Interchange* was another sign of the challenging politics of the movement. Running through its pages was an ideal woman who was assertive, independent, and dedicated to her own spiritual evolution through art.[61] For a magazine devoted to house-hold decoration, the attack on middle-class womanhood and marriage was remarkable but steadfast. In 1885, the magazine editorialized on its front page, "Of the woman of the future, self-reliant, capable, and financially indepen-dent, marriage will be an incident and not a career. A something to be carefully weighted and to be declined if it offers less of happiness or less congenial life work than her profession or her trade."[62] Many readers seem to have accepted this view, writing to inquire about places to study art and avenues to market their decorative work.[63]

The magazine went on to endorse work for women and criticize men's re-sistance. Editorializing again on its front page, the magazine insisted, "The question of work apparently disquiets the male mind to no inconsiderable extent." Evidence of this lay "in the frequent publication of articles in in-fluential journals devoted to the discussion of the kinds of work peculiarly suited to women."[64] Aptly catching the hypocrisy behind much journalism on women and work, the *Art Interchange* sought to legitimate paid work for women through aesthetic enterprise. Domestic art, like temperance and social reform, became a means to challenge Victorian domesticity.[65]

Women artists could play both sides of the movement: they could wear aes-thetic dress and proclaim their dissent with conventions of womanhood while at the same time exploiting the new links between professionalism, refine-ment, and decoration to advance their careers as professionals. So, like their male colleagues, many pursued lucrative decorating commissions. Lydia Field Emmet and, more extensively, her older sister Rosina Emmet Sherwood both had design commissions from Associated Artists. Candace Wheeler, who had been instrumental in founding decorative art societies, led Associated Artists. Under Wheeler's leadership it was one of the most famous decorating firms in the country.[66] Rosina Sherwood worked closely with Associated Artists and its crew of women artists for at least three years, submitting tapestry, cur-tain, and wallpaper designs.[67] Lydia Field Emmet also sold designs to Tiffany Glass Company in 1889. Other stained-glass designers included Louise Cox, Ella Condé Lamb, and muralist Violet Oakley.[68] Bostonian Margaret Red-mond made a career of stained-glass work. She obtained all the conventional

Gilded Age professional credentials, studying at the Pennsylvania Academy, at the Art Students League, and in Paris, adding additional training in "old glass" and design. She began her career working in oil and watercolor, exhibiting in Philadelphia, New York, Chicago, and Boston, but soon received a commission for a church window and "continued with this work—finding always great pleasure in working with light and color." [69] Redmond's commissions included windows for a library and a church in Englewood, New Jersey; a church in Wenonah, New Jersey; churches in Beverly and Peabody, Massachusetts; and a church in Old Town, Maine. By the late 1920s, Redmond was sufficiently well known to receive a commission for four windows in the famous Trinity Church in Boston's Copley Square, which paid her $12,800. Although the source of Redmond's commissions is not now known, Wenonah is a small town near Philadelphia, where she was born and raised, while Beverly and Peabody are both outside Boston, where Redmond based her career, suggesting that local connections—possibly family or friends—and local reputation helped channel her commissions. [70]

For all the ways that men, like John La Farge and Albert Pinkham Ryder, made secondary media men's territory, these media afforded opportunity for women. The popularity of lesser media, with their extensive connections to an ongoing tradition of female amateur artwork, invigorated certain kinds of female artistic activity. Middle-class and elite women, for example, took decorating as their domain. They translated it into a respectable means of self-support through societies of decorative arts. And they fostered the leap, for a smaller group, into designing and painting. Candace Wheeler, from her influential position in the decorative arts movement, promoted professional training and careers for women as a natural extension of their pursuit of household art. Women painters, as they "master[ed] the technique which ha[d] been hitherto the exclusive possession of men," would not only fulfill legitimate ambitions but also enrich the nation's art. [71] The art market's expansion around secondary media helped validate women's presence as sellers, on a market, in the public domain.

In many respects, women's overall participation in the art market paralleled the patterns of their exhibiting and decorative work. As they had entered canvases in all genres, women established careers in all fields of art. Some, like Louise Cox, painted academic figure subjects with ideal or allegorical themes, such as her *Rondel* and *Fates and Annunciation*. [72] Others had careers as watercolorists and flower painters. Philadelphian Margarette Lippincott, for example, quite successfully painted flowers throughout her career and ended up with

prizewinning paintings of the late 1890s in public and private collections in Philadelphia and Detroit.[73] Within this diversity, however, some concentrations of activity and patterns emerged.

Women found market openings where competition was less intense and patrons more numerous.[74] In some cases, markets for "new" art forms provided valuable opportunities for women. A number of women, for example, took advantage of popular interest in etching; others drew on the period's decorative movement to gain commissions for not only private but also larger public commissions, like stained glass and church decorations. Many women made important sales and income at the lower end of the market. In the first few years of her career, Lydia Field Emmet sold pastel sketches and portraits for $15–$125 and oil sketches and portraits for $25–$75. Similarly, Ellen Day Hale and her friend Gabrielle Clements made charcoal drawings and etchings from their summer travels, which they sold in the fall and winter for under $50.[75]

Men, of course, also used most of the same market avenues to make a living and to sustain careers outside the highest rungs of the profession. Male artists, however, had greater mobility and flexibility, giving them access to wider sources of prestige. Even though J. Alden Weir counted himself among the Tilers, painted watercolors, and exhibited with the pastelists, he also rose quickly through the artistic ranks, becoming president of the Society of American Artists, a National Academician, and a widely respected practitioner of American impressionism. Likewise, Irving Wiles discovered that doors kept opening, as membership in the Society of American Artists led to election as an associate of the National Academy of Design and then to the important Clarke Prize at the academy, all enabling a rapidly flourishing career.[76] Although a few women experienced such a sequence of opening doors, most did not. They were held at lower rungs, limited to wall space in the Society of American Artists, National Academy of Design, or other association exhibitions.

Portraiture provides the best example of women's distinctive success on the market. It offered many patrons, a local base for commissions, and prices ranging from under a hundred dollars to thousands of dollars. Moreover, portraiture was linked to the "feminine" at a number of levels — as a genre suited to women's abilities and as one that used feminine sensibilities for paintings of women and children.[77] From women's perspective, portraiture was appealing because of its renewed popularity and rising prestige in the Gilded Age: it was an opening on which to stake professional claims.

Portraiture offered such an opening because of the many wealthy and

middle-class Americans who sought painted images of themselves and their families. As photographs became a common form of portrait reproduction, interest in painted portraits surged among elites. With new flair, artists created portraits with lively and energetic brushwork and dramatic lighting that comfortably reaffirmed the uniqueness of the painted object and the power and status of their patrons. A number of historical portrait exhibitions, many prizewinning and celebrity-like portraits, and the fame of internationally known portraitists such as John Singer Sargent strengthened portraiture's new position within the art world and helped give it new stature.[78] Moreover, from the perspective of artists, portraits easily crossed genres into the idealized figure types that were so popular in exhibitions, as Cecilia Beaux well knew when she exhibited her paintings with titles such as *New England Woman* and *Mother and Daughter.* Blurring the boundaries between genres allowed artists to turn lucrative portrait commissions into reputations as figure painters while effectively expanding the prestige of portraiture.

Some of the best-known American male artists of the period built their reputations on portraiture, including John Singer Sargent, Thomas Eakins, William Merritt Chase, and Irving Wiles. Portraiture, however, still had a lower status as mere likeness making, lacking the greater compositional challenges of "higher" figurative works, and male portraitists did a fine dance to avoid complete association with portrait painting. William Merritt Chase enjoyed painting portraits, found portrait work demanding, and valued the variety in it, but he was reluctant to be known only as a portraitist, as was George de Forest Brush, who, when asked if he did portraits, responded, "I do some portraits but I'm a figure painter—I do figure pictures. When I do portraits, they're always pictures, suitable for hanging anywhere." Brush's insistence that he was a "figure painter," that he painted "pictures" not "portraits," underlined a still meaningful distinction in status that male portraitists sought to transcend.[79]

While the new popularity of portraiture provided a tempting but worrisome avenue for male artists, women were some of its most enthusiastic and significant beneficiaries. Clara Waters's *Women in the Fine Arts, From the 7th Century B.C. to the Present,* published in 1904, confirms the centrality of portraiture to women painters' practice. Waters based her entries on published information and surveys of contemporary women artists, and they form a useful sample of active women artists at the turn of the century.[80] As in exhibitions—and contrary to stereotypes—women very rarely defined themselves as flower or still-life painters, and only a few named it as their secondary interest (in both cases just around 5 percent). Women pursued all genres, but only landscape,

portraiture, and figure painting attracted more than a tenth of the artists. The highest percentages by far were in portraiture and figure subjects, with almost one-third painting portraits (full or in miniature) and another one-fourth painting figure subjects as their principal work. Another 16 percent listed portraits as their second field, making portraiture significant for almost half of all the women. Just under one-fifth listed portraiture as their only line of work. At the same time, there appears to be a significant link between portrait and figure painting: for both genres, about half of the women listed the other as their second field. Among the presumably successful women in Waters's book, therefore, portraiture provided a base, one that could also supplement other, perhaps less remunerative but more prestigious work (see appendix, table 3).

Portraiture supported both the best-known women artists living in the United States and a diverse array of less prominent workers. Rosina Sherwood described her potential earnings to her sister, asking, "How can I refuse to do thousand dollar portraits if people insist so upon having them! & yet my conscience pricks me always for doing such bad pictures."[81] Bostonian Marie Danforth Page's correspondence indicates that her prices in the early 1900s ranged from $350 to $1,600, which would have produced a reasonable income with even only a few commissions a year. As their reputations developed, some women found they could make quite a bit of money: Lydia Field Emmet's account book indicates that at the beginning of her career, in the mid-1890s, she charged $50–$350 for a sitting; by 1910 she earned almost $11,000 for the year, with portrait prices ranging between $1,400 and $3,000. Rosina Sherwood, Bay Rand, and Lilla Cabot Perry all supported their families by means of their portraiture.[82] Rose Lamb was fairly typical of the less prominent: a student of William Morris Hunt, she maintained a quiet—though successful—career in Boston, working privately, without exhibiting, but collecting orders, mostly of children from elite families, a year or two ahead.[83] With this level of commissions, Lamb most likely earned quite a decent living. Lucrative in a market that offered few such opportunities for women, portraiture was an appealing choice.

Despite the promise of reliable income and the rising status of the genre, women also found portraiture risky—risky because, like men, they built their reputations on a genre lower in the hierarchy and risky because, unlike men, they had less opportunity to develop reputations outside portraiture. Furthermore, a gendered division of artistic authority preserved male preeminence within portraiture by allocating to men the painting of male sitters, who supposedly required greater critical distance and analytical representa-

tion, and granting to women the painting of child and female sitters, who supposedly required greater empathy and identification. Bostonian Marie Danforth Page's "remarkable success with portraits of children" was only partly a product of "her sure draughtsmanship and knowledge of her craft," according to one profile. The rest of Page's success came from "her sympathetic understanding of her small sitters." With seeming ease, this article reduced Page's artistic training and skill to an adjunct of her womanly sensitivities.[84]

Women responded to this segmentation and the lower status of portraiture in a number of ways. Some resented their marginalization. Lydia Field Emmet regretted her success with child portraits because it gave her little time for the adult sitters she considered more challenging. Lilla Cabot Perry disliked the ways that portraiture provided a primary source of income for her and the consequent demands it made on her time, describing her relief at the end of her life at her escape from the "bondage" of portrait painting.[85] Others tried to counter the genre's lower status, defending their work as difficult and demanding. Anna Lea Merritt claimed that portraiture required extensive mental effort, since the artist had to engage the sitters to get them to reveal their character and entertain them to keep them from becoming bored and restless, all the while observing closely and painting. Marie Danforth Page also insisted on the difficulty of portraiture. According to Page, the portrait artist had to produce a subject not necessarily of her own choosing (or interest) on a schedule not of her own making.[86] Both of these defenses stressed the difficulty and strenuousness of the labor itself, emphasizing the discipline, skill, and mastery required to produce portraits.

Others defended the difficulty of likeness making as an aesthetic endeavor. Lydia Field Emmet explained, "Two problems confront the portrait-painter. . . . One is the problem of character, of getting a true likeness and expressing your sitter; the other is the decorative problem, the problem of painting a picture for its own sake. If you can't get a true likeness without spoiling your decoration or get a good decoration without spoiling your likeness you would better go into some other business."[87] Here Emmet makes painting good portraits into a challenging artistic problem: integrating likeness with good composition and overall effect. In lectures, articles, and interviews given over a twenty-year period, Cecilia Beaux developed the most elaborated defense of portraiture. She argued that true portraits had two essential qualities— "Imaginative Insight" and "Design," by which she meant that a portrait conveyed an "idea" or narrative while also embodying high academic principles of composition and representation.[88] Although neither Beaux nor Emmet ultimately transformed the status of portraiture, their defenses reflected the am-

bitions and desires of two of the most successful women painters in America. Both conceived of their own work as serious, difficult, and professional; both succeeded by mastering dominant styles and entering the market where it was most open and rewarding to women.

Ellen Day Hale was never a portraitist, but portraits made up part of her work, as did figure pieces, etchings, and murals for churches. Her self-portrait, painted as she became a full-fledged artist, shows the self-confidence, focus, and determination she would need to sustain a career for fifty years. Hale creatively made a life for herself, weaving art making and art selling together with a rich, multigenerational community of female colleagues. Hale, her friend Gabrielle Clements, and her sister-in-law Lilian Hale were the core of this network, and they exemplify steady pursuit of market and professional recognition while negotiating lives as daughters, comrades, wives, and mothers.

When Hale returned from Paris in 1885 with self-portrait in hand, she also returned to the work that financed her study: teaching. Hale had taught with Helen Knowlton in William Morris Hunt's class in the late 1870s. Once back in Boston, she assisted Knowlton again and taught in the Marlborough Street School in the late 1880s.[89] Teaching frequently became an important source of income for women artists, and even for those just starting out, it could bring in handsome sums. Like Hale, Lydia Field Emmet taught for her former teacher, William Merritt Chase. Emmet's account book shows that from 1891 to 1894 her winter and summer classes netted her between $350 and $600 each year.[90]

Women most often taught in private classes; special art programs like Chase's Shinnecock School on Long Island, where Emmet taught; and design schools. A number of women found important teaching posts at the Philadelphia School of Design for Women, where Emily Sartain used her position as principal to advance the cause of women in art: Alice Barber Stephens taught a portrait class and the life class that Sartain introduced into the school — one of the rare occasions on which a woman taught a life class; Margarette Lippincott taught still life, flower painting, and watercolor; and Charlotte Harding, an alumna and noted illustrator, returned to teach drawing.[91] Design schools provided women artists with teaching opportunities comparable to positions in art academies for male artists but, like other women's educational institutions, offered women less professional authority and recognition. The few women who did obtain positions in leading art academies had to overcome bias and their own insecurities. Cecilia Beaux believed that her job teaching the portrait class at the Pennsylvania Academy was "a great honor" but feared

that she would be outmatched by William Merritt Chase. "I am afraid," she wrote Rosina Sherwood, "my admonitions will seem very pale after his. And the boys and girls will all go to sleep on my shoulder." [92] For women to enter this highly visible terrain, to match the performance of their famous male colleagues, and to teach doubting male students required a major extension of their self-confidence.

Women in art academies typically had to settle for jobs in secondary fields or as assistants. At Boston's Museum School, women began serving as student assistants within the first four years of the school's founding; however, no woman was given her own class until 1885, and no woman taught life drawing or advanced painting until well after the turn of the century. The school often let dedicated women instructors go with little discussion. Men, on the other hand, retained long and secure tenure. Mary Hazleton, a star pupil from the school, began as a student assistant, taught introductory drawing for five years, but was never given more than a still-life painting class after that. Ellen Day Hale's brother Philip, who began teaching at the same time, had a very different experience: he taught for thirty years and eventually became the head of the school. [93] Even when women found positions through their mentors, as Lydia Field Emmet had done, they remained in secondary positions, most often responsible for introductory classes. Teaching thus provided some men with the opportunity for rewarding employment, accompanied by growing respect and prestige, and a number of men built their reputations around teaching at the leading art academies. The stratified assignment of women to design schools or introductory classes made it difficult for them to take advantage of this work to develop a professional reputation, so even though teaching may have provided income that kept the artistic careers of both men and women going, it did not usually provide the same boost for women that it did for men.

While Philip Hale advanced though the Museum School's teaching ranks, Ellen Day Hale's small, private classes formed part of a multipronged pursuit of earnings. One obvious source, after her 1885 return from France, was etching (figs. 3.4 and 3.5). When Hale came back to Boston, she brought not only her self-portrait but her summer's work etching. Hale and Gabrielle Clements (not only Hale's etching instructor but also her close friend and traveling companion) clearly understood the market possibilities in etching from their first forays. As Clements prepared to submit work to the Pennsylvania Academy that fall, she withheld the etchings, explaining to their mutual friend Margaret Lesley Bush-Brown that she had "some new ones but must reserve them for some great commercial coup." [94] Eight years later, when Hale was work-

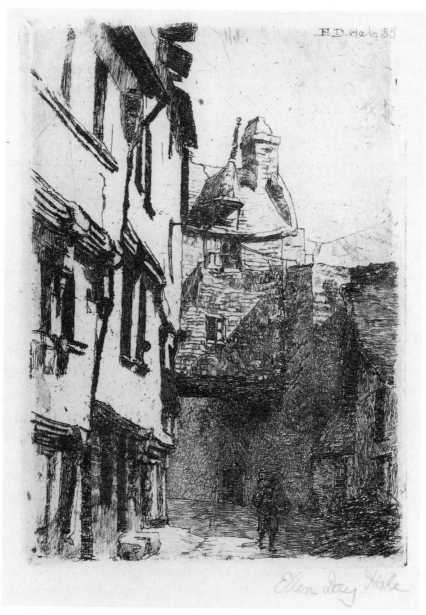

FIGURE 3.4. *Ellen Day Hale,* Street in Mont St. Michel, *etching on paper, 1885.*
(Courtesy of the National Museum of Women in the Arts, Washington, D.C.
Gift of Wallace and Wilhelmina Holladay.)

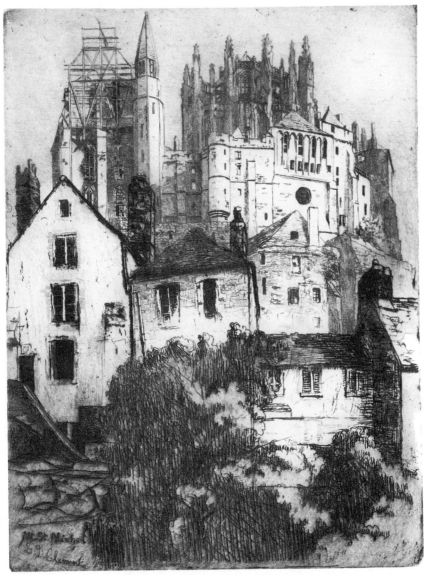

FIGURE 3.5. *Gabrielle de Veaux Clements,* Church and Castle, Mont St. Michel, *etching on paper, 1885. (Courtesy of the National Museum of Women in the Arts, Washington, D.C. Gift of Wallace and Wilhelmina Holladay.)*

ing and traveling in California, etchings were still serving the same purposes: "These etchings I have been engaged on will I hope be profitable," she wrote home. "Before I leave the State . . . I mean to do plates, if possible, of the missions between this place and San Francisco. . . . They are the sort of thing tourists like to buy."[95] Etchings provided Hale and her friends with work that was quite commercially popular, relatively easy to show, and an invaluable source of income. The French scenes and the California mission series were only two of a number of commercially viable series Hale and Clements produced.[96]

Gabrielle Clements attended Cornell from 1876 to 1880 and studied at the Pennsylvania Academy of the Fine Arts. After her winter and summer in France with Hale in 1885, she returned to Philadelphia, where she exhibited, taught, and had several mural commissions, including a panel for the Pennsylvania Building at the Chicago World's Columbian Exposition. Clements moved to Baltimore in 1895 to take charge of the Department of Drawing at the Bryn Mawr School after M. Carey Thomas, president of Bryn Mawr and an old Cornell friend, prevailed on her. While in Baltimore, Clements completed numerous etchings and decorated several churches with Ellen Day Hale.[97]

By 1893, Hale and Clements had established a summer home and studio in Gloucester, Massachusetts; after 1900, they lived together with their mothers, in Baltimore, Washington, D.C., and eventually Charleston, S.C., during the winters and Gloucester in the summers. Periodically, they traveled to gather material for their etchings, including a trip to Palestine and Egypt in their seventies. Hale's niece remembered that Clements, Hale, and other "old maids" alternated work on etchings and church decorations: "If a church decoration was under way, Miss Clements and the other old maids might all work on it—painting great oranges, like burning orbs, high on the Tree of Life, or many-colored flowers in the Palestinian grass—while Aunt Nelly worked on the circle of radiance around the Child. Another year it might be etchings they worked on."[98] Hale and Clements supported themselves for nearly fifty years: church decorations provided fewer but more lucrative commissions and opened opportunities for figure painting, while etching offered accessible and fairly reliable sales at the lower end of the market.[99]

Ellen Day Hale and Gabrielle Clements studied together, traveled together, worked together, owned property together, and lived together for nearly fifty years. They had the intimacy often described of late-nineteenth-century professional women who integrated private and working lives. Hale began let-

ters to Clements with "dearest girl" and "my own dearest girl," described her day's or week's work, and then often ended expressing her longing to see Clements.[100] Throughout Hale's papers are valentines, poems, and correspondence expressing loving friendship and shared lives not just between herself and Clements but also among their artist friends, Eliza Orne White, Margaret Lesley Bush-Brown, Rose Lamb, and others.[101] Hale wrote a lengthy "letter of instructions" to explain how she wanted her personal belongings disposed of after her death and specified gifts to Clements and to each of the women in her circle of friends.[102] As it had in Paris, this network provided emotional support and encouragement as well as vital professional information and assistance. Friendships created the informal professional alliances men found in the artists' associations that excluded women. Moreover, shared living, shared work, and shared finances helped women compensate for the flexibility and mobility men enjoyed by virtue of their sex alone.

Philip Hale, ten years younger than Ellen, married Lilian Westcott in 1902. She was a gifted and serious art student who was known for her lack of interest in parties, dancing, and flirtation. Lilian Hale's dedication to work shaped even her ambitions for her daughter, for when her daughter began going to dances and dating, Hale commented to a friend, "All she seems to want to do is get married and have children. It isn't *serious!*"[103] With Philip Hale, who was seventeen years her elder, Lilian Hale shared a life shaped by art: after their marriage both continued to paint. As Lilian Hale became a more successful artist than her husband, however, an awkward dynamic developed. Their daughter remembered Lilian Hale's careful negotiations, describing an evening ritual as Philip Hale returned home and arrived at his wife's studio: "'I need a crit!' she would cry, embracing him at the front door. The slang abbreviation, used by callow art students, carried certain nuances that, as a child growing up in that house, I was sensitive to. It suggested the relationship of master and pupil, and this in turn suggested an attitude of respect on my mother's part, which, while deeply sincere, was also a delicate and needed attention. My father . . . was not so successful a painter as my mother."[104] Although Philip Hale consistently supported his wife's career, it was not without costs to both of them: he was made anxious and uncertain by his relative failure and its disruption of traditional gender roles; she was required, despite her rising professional stature, to play the role of pupil and keep gender hierarchies in order.

For Hale, it is likely that one consequence of these divided roles was that she was often ill, "tired" with the malaise that frequently incapacitated late-

nineteenth-century women. "It was as if some fearful presence hovered around her," wrote Hale's daughter, "menacing, evil. . . . To me, as a child, that presence seemed almost real: harsh, male, cruelly demanding."[105] In Nancy Hale's description, that fearful, hovering presence seems to symbolize both the conflicting demands of Lilian Hale's marriage and a more generalized critical "male" voice that "menaced" women's creativity. Each summer when the Hale family went to stay with Ellen Day Hale and Gabrielle Clements at their home on the Massachusetts coast, Lilian Hale revived. She broke her usual solitary painting regimen and joined her sister-in-law, Clements, and their friends in etching or other work.

As it did for Lilian Hale, marriage required a complicated negotiation of costs and benefits for women. Professional lives already violated the Victorian belief that women's primary duty was to family and home; combining a career with marriage required even greater contravention of gender norms, and the vast majority of turn-of-the-century professional women did not marry. Of the women in Clara Waters's 1904 biographical dictionary, however, slightly more than half married. At least two-thirds of those who married did continue to paint, but the level and intensity of their work varied quite widely.[106] At times artist husbands proved sympathetic and helpful partners. Male artists often offered at least indirect assistance to their artist wives by introducing them to colleagues, collectors, and critics. Maria Oakey Dewing's work was purchased by Charles Lang Freer and John Gellatly, both major collectors who had bought works by Thomas Dewing. On at least one occasion, painter Will Low wrote to gallery owner William Macbeth, promoting Mary MacMonnies Low's work and asking Macbeth to include a recent painting of hers in one of his gallery exhibits. "If I know anything about painting," Low wrote, "[this painting] is worthy of a place in any exhibition of contemporary art anywhere in the world." Both Low and Dewing marshaled their access to the male networks of the art world to benefit their wives on the market.[107]

More often, though, once they married, promising women artists abandoned the market or shifted their work to less ambitious media or scope. Susan Macdowell Eakins had been active in promoting the women's life class at the Pennsylvania Academy, exhibited there regularly, and won several important prizes. After her marriage, she dedicated most of her energy to tending Thomas Eakins's career. She kept a studio in their home, selling occasional portraits for between $75 and $150, but she did not work wholeheartedly until after Thomas Eakins's death. Eakins had difficulty conceiving of herself as a professional, referring in several letters to her "little paintings" and express-

ing embarrassment at putting a price on her work.[108] While Susan Macdowell Eakins retreated from the professional identity she had cultivated when single, other women backtracked from their broadest ambitions. There was a certain irony to Thomas Dewing's endorsement of Maria Oakey Dewing's work. When Maria Oakey married Dewing, she stopped painting figure compositions and dedicated herself to stunning out-of-doors flower paintings. This shift made it possible for Dewing to fulfill her child-rearing responsibilities and took her out of the direct competition with her husband that was so disruptive for the Hales. Dewing's compromise allowed her to continue to paint and work throughout her marriage (including collaborating on her husband's canvases) but required her to stifle her own ambitions. A few months before her death, Dewing wrote to a friend of her feeling of loss: "I have hardly touched any achievement—it was a handsome talent the Lord gave me and though [critic Royal] Cortissoz calls my flowers & still lifes 'consummate' and [William Merritt] Chase calls it 'my impeccable flowers'—this seems only a mockery[.] I dreamed of groups & figures in big landscapes & still I *see* them." [109] Dewing's mocked dreams are a vivid image of the lives many women had to accept as the presumption that their first duty was to husband, household, and children shaped their daily lives.

From that perspective, Lilian Hale's uneasy alliance with Philip was, undoubtedly, a worthwhile compromise. She always had Ellen Hale and Gabrielle Clements's studio filled with lively women artists as a counterweight. Hale and Clements created an atmosphere that was stimulating and productive. "I sat with a book in my lap," remembered Nancy Hale, watching as "the old ladies gave themselves to 'process'—the preparing and painting of plates— with a peculiar, gay, intensity. . . . Afterward they all clustered around to examine critically the result achieved. The atmosphere—brisk, fresh, precise— was permeated by the smell of the nitric acid bath." [110] Nancy Hale's vivid memory suggests the appeal to women of an artist's life in a studio enlivened by enthusiastic colleagues and artistic experimentation.

Hale looks out at us, once more, from a painting later in her life. This time it is from a portrait by lifelong friend Margaret Lesley Bush-Brown (fig. 3.6). We know she has aged—the lines around her eyes and the skin along her cheekbones and jaw show age. Gone are the aesthetic touches of the 1885 self-portrait. This painting has a somber, simple background with Hale's torso and head occupying nearly the full canvas. But what is remarkable is how much is the same: high collar and fur around the neck; a hat pulled down across the forehead, squaring the face; clear, steady eyes; and a calm, unwavering

FIGURE 3.6. *Margaret Lesley Bush-Brown,* Ellen Day Hale, *oil, ca. 1910. (Courtesy of the National Museum of American Art, Smithsonian Institution, Washington, D.C. Gift of Arthur Hale.)*

expression. Starkly lit, with Hale's face illuminated against the plain background, Bush-Brown's portrait invites us to understand Hale in her gaze and features. Palette, brushes, studio—none of the marks of profession appears on the canvas. Still, the intelligence and self-possession of Hale's face more determinedly convey her seriousness and standing. The young, slightly auda-

cious woman in Hale's self-portrait has been transformed into a practiced, surviving professional.

Ellen Day Hale and her friends succeeded in the postbellum art market because they experimented widely, pursuing both the most ambitious and the most popular ends of the market. Whether in figurative canvases or in etchings and watercolors, women artists put steady pressure on the market, coming head to head with men's work. More practiced in the ways of the market and more entrenched in art institutions, men ultimately retained control over the societies and associations that helped them manage this evolving market for American art. And I could tell a declensional tale here about women's persistent marginalization. Yet something more complicated happened. Women's steady gains, their direct competition with men, and the wide public notoriety they attained stimulated a reaction that went beyond the eminently predictable exclusion of women from centers of power. Their challenge led the market to new centers and to value, and thus buy, art on new terms. It is as if, just as the picture came into focus, a new camera angle became dominant.

Skilled professionalism and academic technique had been the rallying cry of art schools, of big annual exhibitions, and of organizations such as the Society of American Artists. But as secondary media grew in popularity, buyers and artists prized them in a different way. The sketchiness that could have made watercolors and pastels examples of unrefined, uncultivated, and unprofessional work seemed evidence of expressiveness, spontaneity, and intimacy. Refinement remained a byword; yet its meaning shifted subtly. Slowly, refined sensibilities came to be those responsive to immediacy, intimacy, and subjectivity rather than an ideal beauty that elevated those surrounded by art to a higher plane and true civilization. The finish of academic work looked uncannily like the finish of the ever more present mechanically reproduced image. Those sketchy, feminine, amateur media conveyed a directness between image and artist that critics and collectors came to value. Although male artists and critics eventually rejected the genteel ideal of refinement as too problematically feminine, the subtle transformation of its meaning in the Gilded Age laid the groundwork for modernism by giving refinement a definition that stressed expression of the artist's subjective vision. But selling art in terms of style and expressiveness, rather than skill and uplift, required different structures and a different aesthetic ideology than the exhibitions, artists' societies, and combination of professionalism and refinement had provided in the 1870s and 1880s. Over the next decade, in an absolutely essential precursor to a modern-

ist art world in the twentieth century, the art market consolidated around the smaller-scale, more intimate setting of galleries, where the individual artist could be featured.

How women artists could make their way changed as well. As the market fostered new aesthetic ideologies, women struggled to retain the professionalism that had served them effectively in the 1870s and 1880s but faced a system in which they could best sell when promoted as the "woman artist."

CHAPTER FOUR

THE GENDERED MAKING OF A
MODERN MARKET SYSTEM

I n 1888, Sheridan Ford, a young journalist and critic, published a wholesale attack on the art market in a little tract that he titled unsubtly *Art: A Commodity*. "There is a striking similarity between the tricks of the picture market and the stock jobbing methods of Wall Street," wrote Ford. "Picture dealers work up an artificial demand for the productions of those artists they control and pocket the profits. They 'bear' prices on pictures a rival dealer is overstocked with and when they in turn control the supply at once proceed to 'bull' them." Speculation, manipulation, and the corrupt practices of business characterized art buying and selling. The market made no distinction between "*chef d'oeuvres* from the hand of a master" and "unsightly daubs by misguided slaves of the brush." [1] A polemic, *Art: A Commodity* excoriated artist, dealer, and buyer alike, but Ford caught the essential fact of the emerging modern art market. Speculative capital drove it. Public auctions, which had a certain fashionable cachet in the 1880s, had demonstrated the speculative investment value of American paintings while lubricating a commodity market for art by making prices more transparent. Successful auctions of two important collections at the end of the 1890s proved that American art could draw significant prices. A wave of interest in American works followed.[2] As the market for American art improved over the 1890s, the techniques of Wall Street infiltrated the studios, exhibition halls, and clubs where American art was for sale.

According to Ford, artists had been forced to adopt the techniques of the "showman" and crudely sell themselves to succeed in this system. Dedicating his book to a roll call of famous American artists, Ford argued that respectable dealers would lift artists and the market above crude commodification. "The place," he concluded, "for the exhibition and sale of current American art is in a specially designed room at some well-managed dealer's, . . . the time is all year round, and the manner is with a tone and independence that no dealer has as yet even dimly foreseen." [3] Ford's solution appealed to artists.

The gallery and dealer system mediated the capital flowing into the market, while papering over the negative associations of hucksterism with a properly dignified and professional tone.

The dealer system solidifying at the turn of the century replaced the mix of exhibitions and association formation that had shaped the market in the 1870s and 1880s. Dealers became essential middlemen as large infusions of capital, flowing out of postbellum industrialization, brought a surge of speculative buying to art.[4] As collectors turned to art dealers, and as finance capital underwrote not only the purchases but the galleries themselves, artists also pushed the market in that direction. Galleries provided artists with smaller venues, the opportunity for individual recognition, and, for some, the security of exclusive representation.

The gallery and dealer system also appealed to male artists because it served the gender politics of the art world. By the 1890s, men's practice in the realms of refinement and commercial art loomed as problematic as women pressed tenaciously, and with noticeable success, for a place in the field. In artworks of the 1880s, artists had already unintentionally exposed the logical consequences of pursuing refinement in art: ceding to women the production of art. At the same time, secondary media, so valiantly wrested from amateur hands, now seemed uncomfortably parallel to the mass-produced images that were rapidly gendered a degraded feminine.

William Merritt Chase returned to the United States in 1878 after studying in Munich for six years. He settled in New York, where he established a large, elaborate studio to showcase his talents and his aesthetic. Lined with aesthetic objects from around the world, including thirty-one musical instruments, thirty-seven Russian samovars, thirty-seven Moorish plaques, thirty-seven brass candlesticks, a Peruvian Indian head, and numerous Japanese wares, the studio paid homage to the aesthetic movement. Its eclectically arranged artifacts, harmonious colors, evocative objects and images, and sensuous surfaces expressed Chase's devotion to a world of refined sensibilities where art and interior spaces were congruent. In a series of paintings of this studio Chase conveyed male artists' allegiance to the world of refinement.[5]

A Corner of My Studio depicts a corner of Chase's studio filled with shining samovars, an elaborately carved chest, rich red tasseled tapestries, and a deep, inviting fur rug (fig. 4.1). The colors, glistening lights, and textured surfaces invite the viewer into a self-contained world of beauty and sensual experience, where the practical realities of industry and business have been banished. Chase marks this sensuous world as that of art: a red leather-covered portfolio

FIGURE 4.1. *William Merritt Chase,* A Corner of My Studio, *oil on canvas, ca. 1885.* *(Courtesy of the Fine Arts Museums of San Francisco. Gift of Mr. and Mrs. John D. Rockefeller 3rd, 1979.7.29.)*

and gilded, framed portrait guide us into the deeper space of the left third of the image, revealing a room filled with canvases and a woman at work at an easel. Portfolio and tilted portrait are more than casual objets: they form the axis of the painting and convey the equivalence between the foreground of aesthetic sense experience and interior art making. It is almost as if Chase pulls back the curtain dividing the rooms to reveal that it is art that produces the harmonious world of the foreground. Moreover, it is no accident that the painter in the image is a woman: art, interior space, and aesthetic experience were expressions of feminine values — and, importantly, productions of female hands. Chase could not have made clearer the deepest implications of defining the idea of culture in terms of refinement.

It is tempting, as some historians have done, to see this painting demonstrating male mastery of the aesthetic domain, with women made objects among the many beautiful things in the studio interior.[6] Yet that interpretation erases social reality. Among the last of Chase's series of paintings of his studio, *A Corner of My Studio* grapples with the implication that, as exemplars of refinement, women perhaps represented the ultimate producers of aesthetic refinement. Women were Chase's students. They painted and worked in his

FIGURE 4.2. *Rosalie Gill,* The New Model, *oil on canvas, ca. 1884. (Courtesy of the Baltimore Museum of Art. Fanny B. Thalheimer Memorial Fund. BMA 1974.45.)*

studio, and many of them became artists. Rosalie Gill's *The New Model* is evidence of their presence (fig. 4.2). A promising young student, Gill most likely studied with Chase both at the Art Students League and in his studio. In 1884, she had her first painting accepted at the National Academy, listing Chase's studio as her address. Her painting echoes Chase's *A Corner of My Studio* in composition, color, and brushwork. *The New Model* has the same division of space into left and right, foreground and background; the same tonal scheme of deep, rich colors; and the same evocation of aesthetic space.

Yet Gill made explicit what was only implicit in Chase. Chase's painting is deeply static. The sensuousness, the artfulness—the art making—in *A Corner of My Studio* exist out of time. Gill's image takes us into time. Despite the similarities in the composition of the two paintings, Gill's work is much more circular. Chase established a back-and-forth rhythm, a set of equivalences between foreground and background. Gill keeps her viewers near the surface of the picture plane with a sequence of verticals, including door frame, standing model, long curtain, and carved pillars on the chest. We chase those verticals across the canvas and back again: Gill invites viewers into a world of active

looking rather than depth and contemplation. Her model gazes out at us, so that a subjectivity (existing in time) is invoked. This gaze, of a painter's model, forces us to remember Gill herself as the painter. Aesthetic space is here clearly engendered by, indeed, given the composition, energized by a woman's art making. We have the same aesthetic space as Chase's *A Corner of My Studio;* this time, however, the female production of it merely revealed in Chase's canvas is vigorously asserted.

While the contradictions that Chase and Gill's paintings reveal in the logic of refinement only slowly became more apparent, the secondary media enthusiastically produced in the 1870s and 1880s seemed rather suddenly mired in a flood of mass-produced images. Mass visual culture took off in the late nineteenth century. Ubiquitous "picture factories" offered the "shanghai" — a mass-produced knockoff of work by prominent artists. At the peak of the market for French Barbizon painting, the *New York Evening Post* investigated a "Corot Factory" where such cheap paintings were churned out by the hundreds.[7] Cheap, color reproductions of paintings — chromolithographs — proliferated in the decades after the Civil War. Often for less than a dollar, or free as a premium for a magazine subscription, Americans could obtain visual images to line their walls.[8] Chromolithographs were the most visible sign of a new visual era that gained even greater momentum with the development of photomechanical image reproduction in the 1890s. Up to the 1890s, illustration had involved a complicated process of wood engraving that was time consuming and expensive. Artists who produced illustrations still did so for "quality" magazines; their work united with that of middle-class promulgators of taste.

In the 1890s, halftone technology revolutionized the production of images. Halftone was a form of photomechanical reproduction. An image could be transferred to steam-powered roller presses and reproduced in limitless numbers. In 1893, Frank Munsey produced the first magazine to be fully illustrated with halftones. He sold his *Munsey's Magazine* for ten cents an issue, significantly less than even a chromolithograph. Within a year, *Munsey's* circulation exceeded half a million copies; by the end of the century, it claimed to have the largest circulation in the world, more than double that of *Harper's*, *Scribner's*, and *Century* magazines, the trio of highbrow volumes that dominated the magazine field in the middle years of the century. At last the masses had access to pictures they could afford and in abundant quantity. In *Munsey's* images graced the cover, dominated interior spreads, and transformed pages of advertising into visual seductions. And Munsey did not relinquish the world of art to his middle-class competitors: he counterbalanced the girl on the cover

with spreads on famous art. Artists who had found illustration lucrative and legitimate artistic activity in the 1870s and 1880s now faced the reality that their images were purely a commodity form: Munsey and his cohorts mass-produced illustrations, made the artists' art part of mass-market magazines, and increasingly used artists' work in advertisements to sell goods directly.[9]

For many commentators, this visual revolution seemed a welcome democratizing force. Halftones would "cultivate in the public a better and finer taste in the matter of pictures and illustrations." Similarly, one speaker at the first conference of the Industrial Art League in 1902 argued, "The phrase 'prostituting art to commercial uses' is much used by those (mainly unsuccessful artists) who affect to uphold a standard sometimes called 'art for art's sake.' . . . The restriction of art to galleries and parlors, following a custom wholly medieval and founded on class distinction, constitutes in my mind the prostitution of art." [10] Artists, needless to say, often found they could not agree with this definition. For them, the clash between art for art's sake and the prostitution of art went to the heart of their status and enterprise. As the distinctions between fine art and mass art were drawn more vigorously, the apologies for "commercial" work grew more vociferous. Fewer artists crossed, as Winslow Homer and John La Farge had, from illustration to watercolor, oil painting, and then back again. Illustration seemed no longer aligned with high literary aspirations; now it was for advertising.[11]

The burgeoning commerce in cheap images put pressure on male artists by bubbling up from below and intruding on their efforts to elevate and professionalize "lesser" media. The success of the halftone revolution reminded artists that the "low" arts had only recently been segregated from the amateur and crassly commercial. The rise of mass culture at the turn of the century reinforced associations between lesser arts and the feminine. Critics linked mass culture to voracious, but irrational, female consumerism and a desire for sentimental kitsch like women's "daubs" on velvet or endless romantic fictions.[12] As mass culture acquired these feminine connotations, the divide between the professional artist painting watercolors and decorating parlors and the female amateur churning out charming *objets* blurred again. The cross-dressing 1870s and 1880s were beginning to unravel, and the art market, as it became increasingly polarized, hardened around new oppositions.

The gallery system countered the mounting gender pressures men faced. The small scale and exclusivity of galleries limited women's presence fairly easily, especially because dealers rarely evoked merit or objectivity, those key professional values for women, in their selection. Instead, dealers sold an image of the artist—one that validated masculinity and disenfranchised

women. The development of a masculine ideal was a critical maneuver. The commodification of the upper reaches of art sales that Sheridan Ford railed against threatened to destabilize art's sanctified position above and outside the market. Yet, as we have seen, continuing to locate art within the realm of the refined became a perilous strategy. High culture had to be withdrawn from this feminized realm and resurrected as a masculine enterprise independent of the market. As a market system, the gallery and dealer structure facilitated this endeavor. It mediated between artist and market. More important, the dealer spotlighted the individual artist whose gravitas in pursuing his art protected culture and transcended economic motivation. For women, the masculinization of high culture meant expansion of the smaller market venues that more effectively excluded them and the circulation of a rhetoric that expressed market hierarchies in a newly gendered form.

Encouraged by the larger context of a speculative market, mass reproduction of images, and rising angst about feminization, male artists also pushed the market in the direction of galleries because they perceived women's advances as a substantial threat. Dominating art classes, routinely forcing male juries to consider their work, and garnering critical praise as a fresh new force, women artists challenged men persistently and visibly. A generation of women had established careers, and another was in training, creating a network of female colleagues and friends that extended from Paris to New York, Philadelphia, and Boston. Starting in 1889, women artists founded professional associations that opposed discrimination against them and resisted their exclusion from the market. These organizations reflected both women artists' strength and their first expressions of unfulfilled expectations.

The large exhibition societies that had set the tone for the market in the 1870s and 1880s began to weaken in the 1890s. The innovator and leader in the decades after the Civil War, the American Watercolor Society, lost ground. It attracted few new painters to its membership lists, including none of the rising generation of artists; lost many of its exhibitions' best works to one-man shows; and once again allowed the number of women exhibitors to rise to one-third (signaling the decline of tight jury controls and reentry of amateurs excluded in the early 1880s).[13] By the turn of the century, the Watercolor Society's decline was typical. The *New York Evening Post* noted in 1897 that the Society of American Artists had given up "the pyrotechnics of young men" in favor of "sobriety, soundness of method and sincerity of purpose [in] painting."[14] No longer the spawning ground of artistic change and reputation making, the Society of American Artists officially rejoined the National

Academy of Design in 1906. Annual exhibition of the newly combined organizations threw tremendous weight and prestige behind the "official" art of the country, but was in fact increasingly irrelevant for the newest directions of the market. The National Academy had become a lumbering elephant in a world of smaller, more fleet-footed creatures.

Small, specialized artists' groups and the ever more numerous galleries thrived in this new atmosphere. The first major indication that artists understood—and would exploit—this change came as "the Ten," a popular group of impressionist landscapists, left the Society of American Artists in 1897 to hold small exhibitions where their works would have greater prominence than in the big society shows. Exhibiting together for twenty years, the Ten helped set the tenor of the new market structure.[15] The group bypassed the jury system altogether. Artists no longer had to prove their merit and the professional status it indicated; instead, style distinguished artists. The Ten shared impressionism, and their exhibitions harmonized in ways quite unlike the larger annual exhibitions of the academies and Gilded Age artists' associations. That stylistic unity helped attract an audience that then discovered ten individual artists. The Ten innovated an entirely new way of arranging exhibitions when they gave each member his own section of the wall (chosen by lot) where he set up his own pictures. Rather than inundate visitors by stacking pictures up to the ceiling, the group hung all the major pictures at eye level, and perusers could easily observe the distinctive style of each artist. "Individualism," the *Art Amateur* pronounced, "rules."[16]

A more mercurial but equally infamous group came together in 1908, when "the Eight" waged a savvy public-relations battle with the National Academy and held its own successful exhibition at the Macbeth Galleries.[17] When newspaper critics designated the exhibition the "outlaw salon," they encapsulated the essence of the new forms of art display marketing: eight distinct individuals banding together and selling their works.[18] By 1910, artists had clearly come to terms with this new form, founding the Macdowell Club for "direct presentation of the artists to the public." Groups of eight to twelve members could unite, rent the club's galleries, and exhibit without facing a jury.[19]

In many ways, though, the Macdowell Club was an anomaly. Like both the Ten and the Eight, most artists took advantage of the wall space opening up in commercial galleries. Commercial art galleries expanded rapidly at the turn of the century, and a number began representing American artists, even showing American art exclusively. In 1898, the *American Art Annual* listed only two art dealers in Boston, four in Philadelphia, and thirty-one in New York;

five years later that number virtually doubled, with six in Boston, seven in Philadelphia, and forty-nine in New York.[20] William Macbeth launched the one best-known for American art in 1892. Macbeth had spent a long apprenticeship at the print galleries of Frederick Kempel, running the New York office and eventually becoming a partner. He began, in the late 1880s, organizing a series of exhibitions of watercolors by American artists at Kempel's; eventually, he moved to his own galleries at 237 Fifth Avenue and became the first to devote his gallery entirely to American art.

Macbeth operated on two fronts. He held exhibitions, both group and single-artist shows; and he kept a substantial stock of artists' works at the gallery to show to inquiring patrons. Although the exhibitions attracted press notice, sales came significantly from stocked works.[21] Macbeth kept the gallery afloat by showing popular landscapists, with his greatest sales coming from Alexander Wyant. Yet he was eclectic in his tastes, displaying impressionists John Twachtman and J. Alden Weir and sponsoring the urban realists, particularly Robert Henri and Arthur B. Davies of the Eight. He walked a fine line between conservatism and innovation.

Macbeth was clever about the modern requirements of dealing art. He changed the paintings on his wall space regularly, earning notices in the papers every few weeks and keeping the gallery in the public's eye. By publishing his own house organ, *Art Notes*, he promoted the gallery. *Art Notes* detailed activities at the gallery and in the art world and went to patrons, clients, and interested figures throughout the country. Macbeth also conducted a massive correspondence with dealers and museums across the country in order to lend, exhibit, and sell works of art to which he had access. Cultivating connections paid off handsomely, with museums ranging from the Metropolitan Museum in New York to the Utah Art Institute in Salt Lake City buying works from the Macbeth Galleries. All of Macbeth's activities ensured the gallery's prominence in the circuit of capital and media sustaining the market and positioned Macbeth, the dealer, as the expert to act as mediator. In *Art Notes* Macbeth openly described the importance of his role: juries, where artists made decisions, were always partial (rather than meritorious, as they were supposed to be), but his judicious guidance would prevent poor selections and ensure that "quality" prevailed over "dollars," while discreetly handling the needs of sellers and buyers. Macbeth prospered, at least in part, because he knew how to occupy the middle ground of the modern art market.[22]

Macbeth's success inspired other dealers to join him in handling American art or, at a minimum, to increase their representation of Americans. By the turn of the century, for example, Boston dealer Robert C. Vose had been con-

vinced by Macbeth to add Americans to his gallery; just ten years later Vose told Macbeth he could not keep pace with the demand for work by American artists. In New York, seven galleries dealt in American art by 1900, and more arose in each subsequent decade, including Alfred Stieglitz's famous "291" in 1905, the Madison Art Gallery in 1909, the Charles Daniel Gallery in 1913, and the Downtown Gallery in 1926. American art had begun to end its dry spell.[23]

Like the Macbeth Galleries, most dealers stocked a range of artists, keeping works on hand by a fairly broad array of artists but typically concentrating their stock on a central core. Pictures moved in and out of the gallery as they went on exhibition, returned to the artist's studio for a viewing, or were traded for other canvases. This meant that an artist could garner occasional patronage and periodic sales without real commitment from the dealer to his or her work. In fact, the gallery-dealer system worked to concentrate a dealer's attention on a few artists whom the dealer could readily promote and to whom the dealer felt a particular commitment. The narrowing impact of galleries comes out clearly in exhibition patterns. Artists who had the dealer's devotion received one-man or one-woman shows regularly and appeared most frequently in group shows. Gallery dealers often contrived groups to showcase their most important artists. For example, the Macbeth Gallery's exhibition of American paintings in November 1906 displayed works by fifteen artists, eight of whom had already been featured in the gallery in either solo or two-person exhibitions.[24]

Arthur B. Davies was fairly representative of the artists who succeeded most under this system. Davies painted nudes in mysterious settings. When Macbeth held an exhibition titled "Figure Subjects by Seven American Artists" in March 1894, a young Arthur Davies was among the seven artists; that October, after three of Davies's paintings sold by mid-May, Macbeth opened the fall season with Davies's first one-man exhibition. By the end of 1894, Macbeth had sold fifteen Davies paintings (under a hundred dollars each). Davies was rewarded with four more solo exhibitions between 1895 and 1905 and steady sales, at increasing prices. In the process, Davies became close friends with Macbeth, cementing a profitable relationship for both artist and dealer.[25]

Sometimes a woman succeeded in developing a similarly close and productive relationship with a dealer. Impressionist Elizabeth Wentworth Roberts, for example, had a long and productive relationship with Doll and Richards in Boston. Roberts, who had studied in Paris and successfully sent her work around the exhibition circuit, showed virtually every year in the teens and commanded good prices for her work. Most of her exhibitions were titled "Figures on the Sand, Dunes and Salt Marshes" and featured oils and water-

colors of shore scenes with figures. Her prices ranged from under $100 to $600 for new oil paintings. At her March 1913 exhibition, Doll and Richards recorded selling seven paintings—four for $80–$100, but also three for about $350. Clearly, Roberts had a productive relationship paralleling the one Arthur Davies had with Macbeth.[26]

Despite Roberts's success, women more generally found the gallery system inhospitable. Few women made it into a gallery's "stable"; when they did, they were often exhibited less frequently than men; and few even got to the first level of occasional support, with most group shows containing only one or two women. At the Macbeth Galleries, only four women had solo exhibitions before 1915 (only 7 percent of the total fifty-five men and women who had one-man or one-woman exhibitions). None received the support that Arthur Davies and five other men, including Robert Henri and William Sartain, did, all of whom received at least three solo exhibitions. Even a woman who established a close relationship with Macbeth fared poorly in public advancement of her career. Clara McChesney, a successful painter of watercolors and oils known particularly for her Dutch scenes, corresponded with Macbeth about pictures, prices, and selling works from the 1890s to the 1920s. Yet McChesney often wrote Macbeth of gathering other artists' works in Europe for him to sell and of visiting other dealers to hawk her own works. Although Macbeth stocked some of her pictures, possibly showed her work to major collectors such as Thomas Clarke, and noticed her comings and goings periodically in *Art Notes*, he never featured her, never gave her a one-woman exhibition, and rarely included her in group shows.[27] The same was true across galleries in New York. When the venerable Avery Galleries began exhibiting and selling works by American artists in the late 1880s, only Anna Lea Merritt received a one-woman exhibition in the fifteen years between 1888 and 1903, a poor record at best and only 4 percent of the total twenty-six men and women. The Montross Gallery gave no women their own exhibitions in its first fifteen years exhibiting American artists (1900–1915). But for men, the Montross was quite rewarding—of its seventeen solo male exhibitors, almost a third had two or more shows and had their work repeatedly promoted in the annual exhibitions of the Ten, which Montross held beginning in 1905. The major exception was the famed French Durand-Ruel Galleries, which opened a branch in New York in 1895. Among its artists receiving one-man or one-woman shows were five men and three women, the latter the most successful turn-of-the-century female American artists—Cecilia Beaux, Ellen Emmet, and Mary Cassatt.[28]

The story in group shows was equally disheartening. The Milch Gallery, which opened in 1911, held many group shows in its first decade. In 1914, an

exhibition titled "Portraits in Oil, Miniatures, and Sculpture" included only Helen M. Turner among the eight oil painters. Turner established a strong reputation in New York around the turn of the century. Beginning in 1897, with the New York Watercolor Club, she exhibited widely and successfully. For the few years around 1900 she displayed mostly portrait miniatures but then moved on to show large oils. In 1913, she was elected an associate of the National Academy. Turner's inclusion in the Milch Gallery group show in 1914 reflected a decade of hard-won recognition; in 1917 that recognition translated into her first one-woman show (at age fifty-nine) at the gallery. After this, Turner was among the few women regularly shown in the Milch's group shows. She appeared in the "Annual Holiday Exhibition of Selected Paintings of Limited Size by American Artists" in 1918 but was only one of three women among the forty-five artists (less than 7 percent). Smaller shows at the gallery regularly included no women: in 1920 "Six American Artists" were only men; in January 1921 another "Exhibition of Paintings" displayed the work of six men. Few women made it in; when they did, it was typically in larger groups shows and women who already had established relationships with the gallery.[29]

Women's most fruitful avenue into galleries was portraiture. Many of the early one-woman shows were portrait exhibitions. Doll and Richards in Boston presented a number of women portraitists in the teens, for example, including Rosina Emmet Sherwood and several miniaturists. The gallery noted standard prices for the artists' work in its catalogs and may have also helped these artists use exhibitions to secure additional commissions. Still, commercial galleries did not generally display portraits. The Doll and Richards exhibitions were only a small segment of their overall exhibition schedule.[30] William Macbeth told readers of *Art Notes* that "as a rule [he] steadfastly refuse[d] to exhibit portraits." His only exceptions, he explained, were Ellen Emmet and Cecilia Beaux, and for this he felt sure that he would be "forgiven" because of the strength of their work.[31] Portraiture was, at the Macbeth Galleries, the work of women, and it required justification. Macbeth does not spell out his objections to portraits, but undoubtedly their aura of imitativeness rather than imagination was not entirely welcome in the gallery.

Women may have themselves avoided galleries, resenting the commission dealers charged. Lydia Field Emmet wrote to the Macbeth Gallery explaining that her orders came to her directly and that she did not want to forgo a portion of her price as a dealer's commission. If she did secure work through a dealer, she would have to raise her prices. But, she concluded proudly, it would not come to that because she had more than enough work.[32] Emmet

was particularly successful, but her response undoubtedly reflected a calculus many women used. Whether by women's choice or by limited dealer support, portraiture, which had been the area of women's greatest success, remained at the margins of the gallery system.

In contrast to women's rising participation in the exhibition circuit of the postbellum years, the gallery system narrowed opportunities for women. Even the stodgy National Academy of Design had a higher percentage of women exhibitors than galleries, and the Society of American Artists, Pennsylvania Academy, and Boston Art Club had consistently admitted a fifth to a third women (see appendix, table 1). Buried in the scrapbooks of the Milch Gallery shows is a small clipping that perhaps best exemplifies the place women artists found in galleries. A sort of short "around town" column of four paragraphs, the clipping announces that the Macbeth Galleries have opened an exhibition of watercolors by Paul Dougherty, that the E. & A. Milch Gallery is "holding a general exhibition of American pictures" (probably the Holiday Exhibition with only three women among the forty-five shown), and that the Montross Gallery has both antique Chinese art and contemporary painting and sculpture on display. Not until the fourth paragraph do women appear, and then it's at the "Women's University Club" (Misses Helen M. Turner, Jane Peterson, Theresa Bernstein, and Maria J. Strean). There they are, bypassed by the mainstream of the market, afforded space only by women's organizations.[33]

The system of galleries and dealers worked so effectively in sidelining women because it solidified the market around small institutions that were premised on marketability rather than merit (the terms in which women had their greatest opportunity). In fact, it hastened the divergence between the art world and the models of scientific professionalism gaining currency in the early twentieth century by moving market demands away from academic qualifications and high standards to the selling of the unique artist. The gallery and dealer system relied on an idea of artistic identity that asserted the creative artist's individual genius. Dealers sold distinctive artists with distinctive styles rather than skilled practitioners or particular media or genres, moving art hierarchies in new directions. Given the pressure women artists had placed on art and the extent of the feminization of art and culture, dealers and critics increasingly framed that distinctiveness in terms of gender, creating an avenue to reassert artistic masculinity. For women, cultivating such a distinctive artistic persona other than as the second-class "woman artist" remained difficult.

The dramatic transformation of gallery space was one indicator that the gallery and dealer system created markets through selling the individual artist

FIGURE 4.3. *Newman Gallery, Philadelphia, in the late nineteenth century. (Newman Galleries Photographs and Printed Material, Archives of American Art, Smithsonian Institution)*

and his unique style. As the Ten had done at their first exhibition, turn-of-the-century dealers reorganized gallery walls to showcase the work of a single artist, even in a group show. And more important, they rearranged the space around each canvas. Paintings were no longer bunched together, with some at eye level but many jammed into the upper reaches of the walls. Instead, they were sparingly and harmoniously arranged against simple, dark backdrops.

Exhibits at the Newman Galleries, founded in 1865 in Philadelphia, exemplify this transformation. Located at 806 Market Street until 1893, the gallery filled every inch of its available wall space, with small paintings tucked away in corners (fig. 4.3). The Newmans even took their crowded walls into the streets, traveling across town and countryside (most likely) with a wagon filled with pictures and frames for sale, on display like a traveling theater (fig. 4.4). Twenty years later, their gallery had lost all its edges of hucksterism and its aura of crowded busyness. At their location on 1732 Chestnut Street, opened

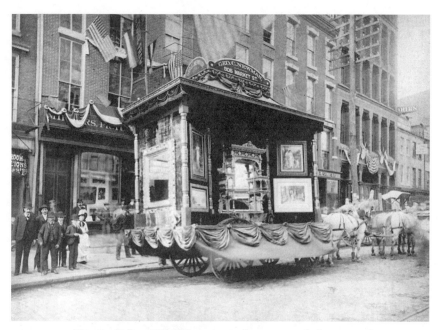

FIGURE 4.4. *Newman Gallery, Philadelphia, street vending wagon in the late nineteenth century.* (Newman Galleries Photographs and Printed Material, Archives of American Art, Smithsonian Institution)

in 1918, the atmosphere was serene and rarefied. Carefully positioned lighting illuminated a mere dozen or so paintings in a room, with each image at eye level, discrete and special (fig. 4.5).

The written counterpart to this spatial presentation similarly emphasized the distinctiveness of artworks and artists. *Art Notes,* put out quarterly by William Macbeth, did more than promote the gallery's regulars. With its tidbits by Macbeth and inserted quotations, the little pamphlet promulgated the dealer system's ideal of the artist. The best art, one excerpt explained, comes out of "intense sincerity," "total absorption," and "the vision [the artist's] own soul sees." The "perfect individuality" of such work created "pure style." [34] Artistic vision, perfect individuality, and pure style: those were the essential requirements. And dealers quite deliberately moved away from other visions of the artist, such as the well-trained technician or the commercial success. Pictures should, according to Macbeth, "carry us beyond the mere execution—the drawing and the paint." [35] Training and skillful rendering— the marks of professionalism—were being supplanted. Moreover, artists who wanted Macbeth's support because they produced "ready sellers" were forewarned: "[Far] from being indifferent to the pictures that are only painted

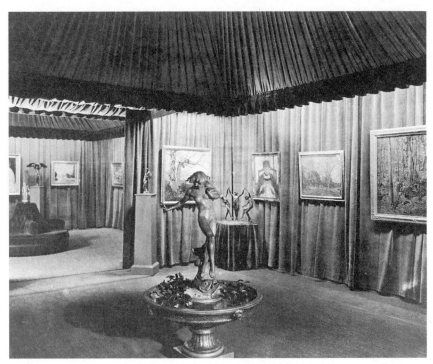

FIGURE 4.5. *Newman Gallery, Philadelphia, in the early twentieth century. (Newman Galleries Photographs and Printed Material, Archives of American Art, Smithsonian Institution)*

to sell, I find that I am growing strongly antagonistic to them and their authors." [36] The purity of the artist's interior vision and expression relieved Macbeth of too much overt commercialism while simultaneously giving the gallery owner a distinctive, sellable product. It was in these terms that Macbeth presented his artists.

He prefaced his catalog for Arthur B. Davies's March 1896 exhibition with a short, laudatory biography but wrote nothing of Davies's professional qualifications in the form of teachers, ateliers where he studied, or successes in exhibitions and prizes. Instead, we learn that he is "gifted and eccentric" like James Abbott McNeill Whistler, that he has "persistent courage in following where his convictions have led him," and that more important than "following art as a profession" he has always been "imbued with the art spirit." Arthur Davies, Macbeth carefully asserts, is singular, and his work reflects that dedicated uniqueness.[37] Macbeth constructed a similar biographical narrative for the California painter William Keith in *Art Notes.* Keith was someone

tutored by nature, rather than people. His products were "thoroughly individual," scenes "that only a master hand could so interpret." Reclusive and shy of publicity, Keith had still achieved: material success had come without overt commercialism.[38]

A little piece in the *New York Times* perhaps best captured the spirit of the gallery system. The paper published a short announcement of Macbeth's exhibition of work by impressionist Theodore Robinson in 1895, and its reporter concluded, "These pictures possess much interest, his view is a personal one." This cryptic remark is still highly telling. Artists, dealers, and (as we shall see in the next chapter) critics equated sellable work (pictures with "interest") with distinctive style (a "personal" view).[39]

Within this scheme, what made women's artwork distinctive was its expression of femininity. Dealers created space in their galleries for women *as* women. They held group shows of "women artists," and when they featured a female artist, they promoted her as a "woman artist." The gallery-dealer system limited the "personal" view of a woman artist to her sex. The Milch Gallery had two exhibitions up on its walls in November 1920: one of its few one-woman exhibitions, work by the young modernist Theresa Bernstein, and a show of "Six American Painters."[40] There is a critical irony here. Bernstein obtained the most important recognition the gallery system could bestow; at the same time, her work hung visibly, tangibly not that of the "American Painters" in the rooms next to her. Bernstein as "woman artist" occupied different territory than her male, "American" colleagues. Women often found display space in galleries as groups of women. In the late teens, "The Group" exhibited at Boston's Doll and Richards Gallery, showing the work of a small core of women artists.[41] As the Ten had done, the Woman's Art Club arranged with a series of New York galleries to show its annual exhibitions.[42] Still, the galleries provided only partial support, since they merely rented space to the women's groups without in any way committing to the artists and only rarely culling from their own stock where they had a vested interest in selling.

Even when it was not directly as women that they appeared in galleries, women artists still found their distinctiveness marked by gender stereotypes. Rosina Sherwood never received credit for her "personal" view in her one-woman exhibition at the Macbeth Gallery four years after Robinson's show. Instead, she successfully captured "child life" and "excelled in the portrayal of children." Many notices commented on her successful and skilled drawing; she gained respect as a serious professional. Still, this status paled as the reviewers all stressed Sherwood's insight into the charm and "artless grace"

of her little sitters. "Mrs. Sherwood is to be taken seriously, within the field she has chosen." Here, in the first one-woman show ever given at the Macbeth Galleries, was the space allotted to women.[43]

Helen M. Turner had a similarly restricted artistic vision granted her. In January 1917, her one-woman exhibition opened at the Milch Gallery to positive notices. "'Alden Weir's favorite pupil' is the occasional characterization of Miss Helen M. Turner by those who know of her studies. She may well have been Mr. Weir's favorite pupil, for her accomplishments are such as to make any teacher proud of her," noted the *New York Herald*. "Her style somewhat reflects his in the method of overpainting, yet she is an independent artistic individuality." Just as they granted Turner that crucial characteristic for the modern art market—"independent artistic individuality"—the reviews consistently withdrew it by identifying Turner's work with that of her "master," J. Alden Weir. Turner must have been horrified by these reviews, for a month later the *American Art News* printed a brief amendment after receiving a letter from Turner explaining that she had never studied with Weir (but was a student of Kenyon Cox, *Art News* let us know). "It must be said," *Art News* ended in self-defense, "that the erroneous report was a very natural one as Miss Turner's art has much of the same delicate refinement of tone and color, and is very similar in sentiment and treatment to that of Mr. Weir." So much for independent artistic individuality.[44]

Thus, galleries systematically and structurally bracketed women in the art market. Dealers sold the distinctive artist, with distinctive implicitly the masculine, "American" stylist rather than the "woman artist." The segregation of the "woman artist" was an essential part of reorienting the hierarchies of the market to reflect women artists' challenge to men's dominance and men artists' experimentation with feminine media. In the process, the figurative modes of history painting, portraiture, and genre painting became less distinct, disrupting the hierarchies of genre that had helped set prices, reputations, and prestige.[45] Landscapists similarly softened the detail and domesticized the setting of their works, laying the foundation for the lightened palette and loosened brushwork of impressionist-inspired landscapes. Even the boundary between figure painting and landscape blurred, further breaking down traditional demarcations of genre. The gallery-dealer system facilitated this reshuffling of market priorities by privileging subjectivity and individual artistic expression over genre hierarchies and standards of professionalism.

As the gallery system transformed the market in the 1890s, women responded by organizing female art associations. These clubs built on a tradition

of women's benevolent and professional activity, as well as on the art associations founded mostly by men in the 1870s and 1880s. But women's societies were not simply counterparts to the male-controlled world of the Etching Club or the Tile Club; they appeared a decade or more later and reflected a specific stage in women artists' professionalism and a specific consciousness of the position of the "woman artist." As separate-sex organizations they represented a concession: professionalism in its purest form was not going to be sufficient. The discrepancy between women's growing numbers in art and their steady exclusion (especially as the charge of amateurishness and dilettantism seemed increasingly unjustified) became apparent in a way that shifted the hopes of the post–Civil War years and induced action. By shaping themselves as exhibition societies, these organizations struggled to continue to place women artists in the market—even at the center of the market—balancing the merit-based promise of juried shows with the special-interest approach of small artists' groups and galleries.

Early associations for women artists had appeared just after the Civil War. The most successful of these was the Ladies' Art Association, founded in 1867 for "the promotion of the interests of Women Artists." [46] The means to achieve this goal, as the organization's constitution delineated them, were meetings for "the discussion of subjects of professional importance," lectures and readings on "Art and Art-Industry," collections of art properties for members' use, and studio space at low cost. Members could be fellows, juniors, or associates: fellows had to be "professional artists," juniors were students of art, and associates were amateurs and connoisseurs. Ladies' Art Association leaders professed to make professionals their primary constituency, but they defined the category broadly.[47] In the course of the next ten years, the association revealed its long-term allegiance to this more inclusive vision of art. At their 1877 exhibition, the association displayed decorated shells, wax flowers, gilded plaster casts, and other objects amid oil paintings, drawings, and watercolors in the multiple and indiscriminate fashion of antebellum art fairs. Much of the energy of the association went into providing classes in art instruction and in the decorative arts. As one program of courses explained, "These classes were founded with the aim of opening remunerative employment for women at home, and improving the Art Industrial standard of manufactures in this country." By this time "subjects of professional importance" and "professional artists" no longer appeared in Ladies' Art Association aims and activities.[48]

The Ladies' Art Association should be understood as a bridging organization. It appeared in the decades after women's design schools appeared,

as women entered art academies in increasing numbers, and before the blossoming of decorative arts societies. At its inception all these trends remained intertwined, and the organization's early constitution reflected the multiple possibilities for women's art activities, possibilities that could not be contained within the same organization only ten years later. By the late 1870s, the charitable and decorative intentions of the Ladies' Art Association had been channeled into the societies of decorative art founded in the wake of the 1876 Centennial Exhibition as part of the aesthetic movement. The societies for women artists that appeared in the late 1880s represented a significant shift in women artists' advocacy of their own cause in the art world. They rejected the genteel framework of aiding impoverished women set out by the Ladies' Art Association and many decorative art societies and replaced it with artistic professionalism.

Breaking with the benevolent model of the Ladies' Art Association provided one context for professional women's art clubs. The extraordinary proliferation of women's associations in the late nineteenth century represented the other important source for women artists' organizing.[49] The earliest women's clubs, the New England Woman's Club in Boston and Sorosis in New York, both founded in 1868, established a pattern of organizing for self-education, self-improvement, and the benefits of association. These two clubs became the foundation of what nineteenth-century women called "organized womanhood," bringing thousands of women into societies dedicated to education, charity, reform, and, eventually, professional affiliation. Sorosis in particular provided a framework for women artists' associations: largely career women, Sorosis members deliberately rejected a benevolent or reform mission in favor of a singular dedication to self-development. The club attracted a range of women professionals, including doctors, writers, editors, and artists, who gained the benefits of fellowship and the experience of self-organization. When the professional associations founded by men closed their doors to women, women had ample models and decades of experience to support their own organizing.[50]

The Woman's Art Club, founded in January 1889, was among the first of the new artists' associations. Five young women, many of them students at the Art Students League, met in the studio of Grace Fitz-Randolph and laid plans for a club. As Edith Mitchill Prellwitz later recorded in her journal, they hoped the club would "be productive of something good."[51] Designed explicitly as an exhibiting society, the goal of the Woman's Art Club was to create juried exhibition opportunities for women artists. Club founders chafed at the unfair judgments of the all-male selection and hanging committees that determined

not only whose work would be hung but also whose work would be displayed well. Even critics noted that one of the benefits of club exhibitions was that women could "show their own work by itself, unaffected by the opinion or the prejudice of masculine juries of acceptance and masculine hanging committees." [52] Although its first two exhibits were reviewed in the society pages, Woman's Art Club exhibitions generally received wide and favorable reviews throughout the 1890s. Unlike the Ladies' Art Association, the Woman's Art Club did not mix bric-a-brac and decorative objects with artworks, and a review described its third annual exhibition as composed of "very nearly 300 oils, water colors, pastels, etchings, and crayons." [53] According to a club history, club founders believed "that serious consideration of the work of women could be won only when it could be shown in sufficient quantity to demonstrate that creative achievement need carry no sex distinction." [54] By holding its own exhibitions, the Woman's Art Club simultaneously challenged ongoing discrimination against women artists and affirmed its commitment to a meritocratic professionalism: club members expected that objective and fair assessment of women's work would simply follow the exposure that exhibitions would provide. Even when its exhibitions used the wall space of commercial galleries, the Woman's Art Club never acceded to the terms of the new market system. Its membership remained open, and its selections of work to exhibit remained merit-based.

Successful exhibitions brought many women into association with the Woman's Art Club. The best-established artists, such as Mary Cassatt and Cecilia Beaux, exhibited periodically with the club but did not become members, reluctant to be identified with a separate-sex initiative that could be construed as an amateur woman's art club. Although Cassatt allowed her dealer to lend works for the 1894 and 1896 Woman's Art Club shows, she expressed reservations about the value of such exhibitions:

> I have just received a letter from a lady secretary of the Ladies Art League, telling me that you promised her a choice of my pictures belonging to you to show in the exhibitions that these ladies are going to have, subject to my consent. I refuse absolutely and I believe that you will not profit at all in showing my work in this exhibition. I know that my works have been sent even to the most amateur exhibitions of women artists in America. I doubt that this practice will do me any good, nor you. I would have thought that for selling, there would have been more opportunity last year in London.[55]

While club founders hoped that their exhibitions would bring due recognition and increased stature for women artists, Cassatt made clear that such

an outcome could easily be subverted and women's exhibitions relegated to amateurism.

Well-established women such as Cassatt and Beaux chose their association with women's art societies selectively; for many young women, usually ten to twenty years younger than Cassatt and Beaux, the Woman's Art Club seemed a more promising possibility. For those just beginning their careers in the 1890s, the club offered opportunities for exhibition and public notice. Many rising young women joined and exhibited with the Woman's Art Club in its first decade: they included Edith Mitchill Prellwitz, one of the club's founders, who went on to win numerous prizes in the 1890s; Louise Cox, who also gained her first recognition in these years; Amanda Brewster Sewell, who was the first woman to win a major prize at the National Academy; and Ella Condie Lamb, who was one of the two women elected to the National Society of Mural Painters before World War I.[56] Moreover, all these women had studied at the Art Students League and were part of the blossoming of women's art study in the 1880s. Nourished on a growing community of women artists, on rising expectations for women's success, and on a flurry of association formation by professional women, these young women may have also found joining a woman's art association a more logical extension of their professional identities than their older colleagues.[57]

In Philadelphia, women organized the Plastic Club in response to their exclusion from the men's clubs that they believed provided men opportunities to socialize, exchange ideas, and hold exhibitions that they continued to lack. Founded in March 1897, the Plastic Club had more than 125 members from its beginnings, and newspaper reports of the first meeting noted, "Nearly all of our most successful professional workers are represented in the initial clientele."[58] Club members recognized the importance of the "sustenance of women with prestige and talent," asking Emily Sartain to preside over their initial meeting and inviting other prominent women to join.[59] The membership of Philadelphia's leading women artists gave the club important credibility and ground on which to stake their claim in the art world; for established women, the informality and sociability of the Plastic Club's initial purposes may have made it easier to join than the Woman's Art Club.

The Plastic Club defined its purpose in its first constitution: "to promote a wider knowledge of Art, and to advance its interests by means of social intercourse among artists." The club focused on expanding communication among women artists, but, according to its president, the society also brought "the work of [its] members into the light" with the result of "incit[ing] interest and encourag[ing] emulation." As their male colleagues had discovered, ad-

vancing the interests of "Art" and "social intercourse" went hand in hand with advancing the cause of women artists. The Plastic Club organized a wide range of activities, including weekly teas, evening events, lectures, annual entertainments, and exhibitions. It mixed social interaction in club rooms and evening gatherings with educational and professional purposes in lectures and exhibits. Moreover, the club held two major exhibitions a year as well as several one-woman and small group shows, providing women with the small-scale, selective exhibitions that were becoming the cornerstone of the market and adapting their society to the shape of the new market system.[60]

In addition, the Plastic Club publicized its shows with high-quality exhibition announcements, posters, and catalogs (fig. 4.6). "These," the president wrote, "have been one of our means of reaching the public, or putting ourselves before the world; in fact, one of our opportunities." She went on: "Their artistic quality and . . . the example they have set has, as we hoped it would, made its impression, at the same time giving to us an air of prosperity and progressiveness not to be despised or ignored; it has won for us respect and put us on the footing of an authority, an enviable position to have reached."[61] Conscious of the presumptive amateurishness associated with women's art clubs, the Plastic Club quite carefully husbanded a public image of quality and selectivity. This, it believed, was the means to authority within the art world.

The club's Second Annual Report summarized the "authority" two years of hard work had brought it. "We had prejudices to meet and overcome, we had the belittling prejudice against women's art clubs, and we had, to justify that, the history of many mediocre organizations against us." But, the Plastic Club could proudly put forward its own success as a counterexample. "We have established ourselves as an art club, and as one quoted, recognized, and respected not only in our own city but in other great cities. We have shown that there was room for us, that we were needed, that from us might emanate a new art interest, an art atmosphere that adds to and aids the art in Philadelphia." The Plastic Club's interests harmonized with the needs of the art world as a whole. "We have not," declared the report, "attempted or wished to encroach upon or interfere with any other organization with art aims, but to work with them for the same interests, the fostering, the furtherance, the improvement of that which is of greatest account to us—Art."[62]

This report encapsulates the struggles of women's art associations in general.[63] When men's clubs and professional societies excluded them, women's groups made formal the informal ties that had developed in Paris. Like societies for women in medicine, law, and other professions, women's artists' as-

The Plastic Club
Exhibition

CORNELIA — GREENOUGH

From November the Twenty-
Seventh until December the
Sixteenth, *INCLUSIVE,* at 10
South Eighteenth Street,
PHILADELPHIA, MDCCCXCIX.

FIGURE 4.6.
"The Plastic Club Exhibition,"
Exhibition Announcement,
November–December 1899.
(Courtesy of the Plastic Club,
Philadelphia)

sociations provided fellowship, mutual support, and contact with peers. The Plastic Club noted that besides all its professional activity, one of its most important purposes was "to bring [its] artists close together." [64] But this was not a simple task. Female artists' clubs had to prove their professionalism against a background of "mediocre organizations." Ironically, the women's clubs like Sorosis and other self-improvement societies that had provided a model now

proved a burden as women artists sought to create distance between themselves and "amateurs." More interested in identifying themselves with their male colleagues, women artists closed off what could have been a valuable and rewarding alliance with women's amateur arts associations including societies of decorative art and women's clubs.

Given this allegiance to men and the profession, to challenge prejudice against women without calling into question the meritocratic terms of professionalism itself and without retreating to the space offered the "woman artist" by the new market system also required careful positioning. Both the Plastic Club and the Woman's Art Club stressed the natural recognition that simple exposure would bring, the importance of meritocratic evaluation and high "quality," and the harmony between their aims and the aims of "Art." Here, women artists' clubs had much in common with other professional women's associations, all caught in the difficult position of advancing their interests as women without undermining the apparent gender neutrality of professionalism.[65] Moreover, by creating separate women's art societies women artists risked strengthening the "feminine" persona that the new gallery system sought to sell. However much professionalism might be receding as a market force, to abandon that identity—the woman who "[has] taken up art as a career"—risked relinquishing the meaning of "woman artist" to that constructed by the new market system.[66] As men reworked refinement and beauty into directness and intimacy, they relegated the genteel aims they had once embraced into "feminine art." Professionalism, contrasting with both refined amateurism and refined high culture, was a way for women's organizations to fight that reductive categorization of female art. That women's art clubs grew as men's associations shrank and, chameleonlike, changed the terms of the art world made these organizations signs of increasingly contested terrain over the status of professionalism, the terms of artistic identity, and the meaning of the "woman artist" in the marketplace.

The Woman's Building at the 1893 World's Columbian Exposition was the most visible emblem of the dilemmas that these clubs encountered. Planned to display women's accomplishments, women organized, designed, and decorated the building. The Board of Lady Managers filled the building with exhibits of women's products and activities—galleries of art and handicrafts, displays of inventions and scientific achievements, representatives from women's organizations, a library of women's writings, rooms for individual states, and spaces for foreign exhibits. The building's central gallery of honor contained the art display, with works by leading women artists as well as six

specially commissioned murals.[67] A vast showcase, a central position in the hall of honor, and a large international audience would seem to embody the triumph of three decades of women artists' expanding numbers, skill, and recognition. Yet the board found many women reluctant to show their work in the Woman's Building—that is, reluctant to ally themselves with the separatist vision of women's progress that the building represented. The contradiction between seeming promise and actual reluctance reveals the struggles over the meaning of "woman artist" at the turn of the century.[68]

On the one hand, the Woman's Building represented an excellent opportunity for patronage for women: female patrons commissioned female artists to create the decorative sculptures and murals for the building. Amid the proliferation of decorating commissions that the exposition's White City generated, the Woman's Building provided the only significant commissions for women. It gave women the opportunity to formulate their vision of women's progress and prospects: Mary MacMonnies Low's *Primitive Woman* and Mary Cassatt's *Modern Woman* provided counterbalancing visions at the ends of the great gallery of honor, while Lydia Field Emmet, Rosina Sherwood, Amanda Brewster Sewell, and Lucia Fairchild Fuller represented different aspects of women's history and occupations along the side walls.[69]

The two Emmet sisters, for example, created symbolic representations of women's place within the Republic. Rosina Sherwood painted an allegorical figure of the Republic placing laurel wreaths on symbolic American women— a mother, musician, artist, and writer—in her *Republic's Welcome to Her Daughters.* Lydia Field Emmet depicted five women in contemporary dress demonstrating their livelihoods—a painter, a sculptor, an embroiderer, a musician, and a scientist dressed in academic robes—in her *Art, Science, and Literature* (fig. 4.7). Lydia Field Emmet in particular translated conventional allegorical painting, with its female muses of the arts, into literal representations of women's contemporary roles as art makers.

Moreover, the murals provided women artists with an opportunity to demonstrate their mastery of academic styles and techniques and to prove their professionalism. Amanda Brewster Sewell's *Arcadia* displayed her ability to paint the human figure, develop complex compositions, and manage the subject matter of history painting. Mary MacMonnies Low argued for the importance of this very display when Bertha Potter Palmer, chair of the Board of Managers, raised questions about the propriety of her use of the nude: "I think that one of the objects of the Woman's Building is surely to show what I may call our 'virility,' which has always been conspicuous by its absence. I don't know how much of the nude has been used by the men in their

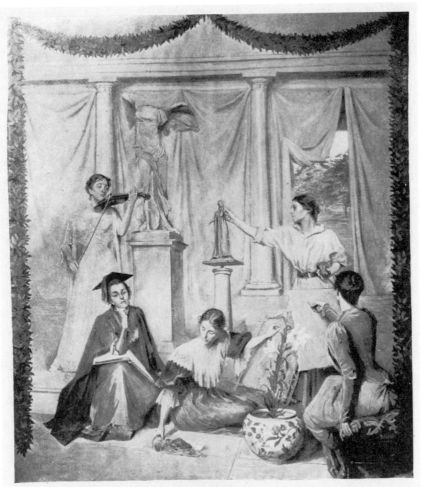

DECORATIVE PANEL—"ART, SCIENCE, AND LITERATURE."
LYDIA EMMET. UNITED STATES. (Copyrighted.)

FIGURE 4.7. *Lydia Field Emmet,* Art, Science, and Literature, *halftone, 1893 World's Columbian Exposition Mural. (Courtesy of the Chicago Historical Society, ICHi-02312)*

decorations—paintings—?—but I know that in their sculpture the whole exhibition is full of it. Well, are we going to recoil and once more bear the reproach of timidity and feebleness. Also, in matters of Art as in matters of Science should not the ones who *know* impose their will, which is the right one, on those who do *Not Know?"* [70] Painting the nude, MacMonnies Low argued, was an integral part of the work of male artists and as such should be embraced without hesitation by women: the Woman's Building should not ex-

emplify a tradition of women's "timidity and feebleness" but should embody the "virility" of their hard-won training, skill, and authority. Moreover, it was their authority as professional artists—not that of genteel lady patrons— that should be the guide to proper art. In the fault lines of the ideologies of womanhood and professionalism, MacMonnies Low made clear the allegiance of women artists. She and her peers chose the masculine, the project of "Art" and its "virility."

In MacMonnies Low's case the professional won out. But in many other instances, to participate in the Woman's Building, artists had to conform to models of femininity and watch their work reduced to domesticized womanhood. Although Bertha Potter Palmer accepted MacMonnies Low's logic, other women did not bypass her scrutiny. A Miss Robbins lost her possible mural commission because Palmer had heard "that her character was not above reproach" and decided that they "could not afford to have any woman about whom there could be the slightest doubt, as [they] would want to have social relations with her."[71] Much as women artists wished to avoid it, standards of womanhood intervened between them and their professional identity: the question of being a true "woman" was as much in the air as the question of being a good "artist."

Those standards were applied to women's art as well as to their persons. Critics praised Mary MacMonnies Low's mural for addressing the viewer "in a gentle and insinuating fashion" and creating an overall "pleasing" effect rather than for her "virility" as she had wished. MacMonnies Low was, however, rather lucky, as critics savaged Mary Cassatt's mural, describing its "impudent greens and brutal blues . . . [that] seem to indicate an aggressive personality with which compromise and cooperation would be impossible. Indeed, Miss Cassatt has a reputation for being strong and daring; she works with men in Paris on their own ground."[72] Cassatt's problematic colors additionally signified her impressionism, a movement known, as we have seen, not for its decorum and gentility but for its fascination with the modern male worlds of bar, café, and backstage. Held not to standards of artistic merit but rather to standards of Victorian womanhood, Cassatt failed miserably: she conveyed impudence, brutality, aggressiveness, and uncooperativeness—in short, she unsexed herself. Such external regulation imposed constraints on women, regardless of their own views about meritocratic professionalism. When women professionals overstepped boundaries of respectable womanhood, they regularly drew public scrutiny and ire. The viciousness of the criticism against Cassatt was matched in other cases, such as the very public scandal surrounding renowned gynecological surgeon Mary Dixon Jones, who had tread on

the very male terrain of surgery and whose case became a cause célèbre in the early 1890s.[73] Even a comfortable location in the Woman's Building, so much a symbol of separatist woman's culture, could not inoculate Cassatt against those requirements. In fact, her intense—and masculine—professionalism may have only been more sharply heightened.

Within the context of the Woman's Building it was even more difficult than usual for women's art to be judged independently of their sex. As one *New York Times* reviewer claimed in June 1893, "The strong point . . . is that the atmosphere of the entire building is not . . . equal suffrage and . . . woman's right to invade the domain of man, but the sublimely soft and soothing atmosphere of womanliness." He went on to explain that the Woman's Building revealed "the female successes in the more delicate and finer products of the loom, the needle, the brush, and more refined avenues of effort which culminate in the home, the hospital, the church, and in personal adornment."[74] In such an atmosphere, women artists found their proud twenty-five years of work trivialized and relegated to the margins.

Consequently, many women reluctantly committed themselves to the Woman's Building. Most preferred to exhibit in the juried Fine Arts exhibition, where they could emphasize their professional identity. Even if there was discrimination in the selection of women's works for the Fine Arts Palace and even if only one woman served on the jury, women believed they at least had the possibility to compete at the center of the profession. In their reluctance to exhibit at the Woman's Building, in their hesitation to join women's professional and art clubs, and in their doubts about being featured in articles on "women artists," women expressed their ambivalence about "encourag[ing] a separate point of view towards their professional work" as well as their fears of the marginalization that might accompany separatism.[75] As Anna Lea Merritt explained in 1900, "Recent attempts to make separate exhibitions of women's work were in opposition to the views of the artists concerned, who knew that it would lower their standard and risk the place they already occupied. What we so strenuously desire is a place in the large field: the kind ladies who wish to distinguish us as women would unthinkingly work us harm."[76] Aiming for the "large field," many women feared reversing their gains by association with women alone. Helen Turner, when invited to join a special exhibition titled "Six American Women," tellingly pushed to "sandwich in a man or two"—a wish to compete and be recognized at the center of the art world.[77] To embrace the Woman's Building fully, even with its promising patronage, demanded risks that many women artists were not willing to take.

Instead of accepting the space carved out by the Woman's Building, women

commonly returned to the themes of earned professional merit and individual achievement. The professional ideal led Cecilia Beaux to a radical denial of sex in art, despite the rising insistence on its centrality at the turn of the century. In a 1915 address at Barnard College, Beaux declared, "I very earnestly believe in the text which is that there should be no sex in art. . . . I am pointing, I know, to a millennium at least in the woman's view if I predict an hour when the term 'Women in Art' will be as strange sounding a topic as the title 'Men in Art' would be now."[78] At the same time, Beaux accepted the notion that "true" creativity in women was unusual, depicting herself as exceptional. And although this formulation served Beaux's own ends quite well, it effectively reinforced emerging rhetoric about women's artistic abilities. Beaux's conception of herself translated into Homer St. Gaudens's description of her as "the exception to the rule that though the feminine sex may imitate in art they lack power to create initial objects, for she works as the one woman in a thousand who has no man between herself and her productions."[79] To protect her position within the profession, Beaux, like other women artists, walked a fine line: with professionalism and exceptionalism, she found ideals that cast her into the center of the art world. Professionalism provided the route to eradicate "sex in art," while exceptionalism (for successful women at least) forestalled deeper critique of the systemic bias against women and allowed them to maintain a veneer of common cause with male artists on behalf of "Art." Not until another generation encountered feminism and modernism would women artists turn away from professionalism and claim for themselves the kind of creative individualism enshrined by the dealer system.

The "woman artist" had other counterparts, too. The "woman doctor," "woman scientist," and other female professionals also advanced through the difficult terrain of the professions in the late nineteenth century, struggling like women artists over the space they could occupy and the shape of the profession. In all fields, ideologies and practice defining "women's work" steadily mapped women's labor onto a second tier. Like female "lab assistants" who never advanced to permanent posts or positions of authority, women artists had difficulty scaling the hierarchy of art, so that, whatever their qualifications or experience, they had little opportunity to paint major figure compositions or receive large-scale commissions. Moreover, just as anthropology could be seen as suitable for women because they could presumably study women and children more easily than could men, so portraits of women and children could seem to require female sensitivities. The consequences of this segregated domain of women's work, which appeared not only in art and science

but also in medicine, academia, and other professions, were the same: men reserved the highest levels and greatest prestige for themselves.[80]

As the reality that men would seek to relegate women to the periphery of the professions sank in, and as many women grappled with the contradictions between white middle-class womanhood and professional career, leaders struggled to legitimize women's work. Pioneering physician Elizabeth Blackwell argued that women's sympathetic nature specially fitted them for medical diagnosis and treatment. Other, often younger women resisted Blackwell's "female professionalism." Trained in the rigors of the laboratory, germ theory, and scientific medicine, Blackwell's friend Mary Putnam Jacobi cast herself with the men transforming the field into modern medical practice at the turn of the century. Across the professions, women negotiated between the orientations laid out by Blackwell and Jacobi.[81]

In art, the overlapping impulses of refinement and professionalism had muted the divide between a "female" professionalism and a "pure" professionalism. The unusual feminization of male practice in the 1870s and 1880s, and the relative acceptability of art as a career for women, generated fewer contradictions for the "woman" artist: put simply, the field was not so overtly, explicitly, or solely male terrain. Moreover, the categories of "amateur" and "professional" conveniently suppressed those tensions, writing out of the field of "serious" practice voices potentially equivalent to Blackwell's. Professionalism, in its "male" form, was functional and progressive.

As the tenor of the art world changed, so did the meaning of women artists' continued adherence to professionalism. In medicine, a Jacobi, by joining men, was forward-looking. However much a minority, she was going in the direction the profession was going. In art, there was no science. The valorization of expressive individuality submerged the professional tenets of rational training and skilled execution, and art diverged in fundamental ways from other professions. Thus, women's continued adherence to professionalism in art, however allied with a seemingly masculine professionalism, was a rearguard action that women would not supersede until much later, well into the twentieth century, with, as we shall see in the final chapter, the modernists.

The system of galleries and dealers that emerged at the turn of the century represented success for the artists' societies begun in the 1870s and 1880s. As specialized professional associations, these organizations promoted the cause of a particular genre or aesthetic, defined its legitimacy and standards, and fostered markets for their members. Such purposes allowed men to gain control over a tight market and to preserve the status of those included even

when their practice encroached on traditionally feminine domains: membership established both professional and aesthetic authority, verifying the superiority of some over others for buyers and critics. Women were usually the implicit—but sometimes the explicit—casualty of the specialization, exclusivity, and informal connections these groups espoused. Men's protectionist impulses thus pushed the center of prestige building and recognition essential to the art market away from more democratic and open forms, such as large-scale exhibitions, where women had relative success and closure was less manageable, toward concentration of power in smaller organizations easily dominated by men. The twentieth-century system of galleries with dealers representing an exclusive group of artists enshrined the patterns of centralized power and narrow selling venues established during the Gilded Age.

New aesthetic ideologies, moreover, provided essential promotional material and legitimating rhetoric for these market structures. Given the fluidity of genres—the melding of portraits into figure subjects and of landscapes into domestic garden scenes—and the financial success of "feminine" watercolors, pastels, and portraiture, it became increasingly difficult to sustain the market poles that rewarded figure painters with high prices and prestige. As subject matter, genre, and even medium failed to distinguish the levels of the market, a critical rhetoric praising individual style, "virile" brushstrokes, and a distinctive hand stepped into the breach. Its counterpart was an "essentially feminine" touch that permanently distinguished women's work from men's. "Feminine art" became the handmaiden of the "woman artist."

WIELDING THE "BIG STICK" IN ART

THE RHETORIC OF ART CRITICISM

he idea that women's art was "essentially feminine" — that it expressed a distinctively female touch and viewpoint — emerged in the 1890s after two decades in which art critics praised those very same "feminine" attributes in painting by both men and women. In 1880, when the *Nation* reviewed the exhibition of the Society of American Artists, it praised a portrait by a Mr. Marshall, describing it, without a trace of irony or condescension, as a "masterpiece of sympathy and sweetness." Nearly thirty years later, a review of the Pennsylvania Academy's annual exhibition took a different approach, praising the painter Cecilia Beaux, not for her sentiment, but because she "wield[ed] the 'big stick' in art . . . imposing her point of view upon us." [1] The strenuous language of the 1908 review contrasts sharply with the feeling of the 1880 comments. How did the ideal of "sympathy and sweetness" develop into the "big stick in art"? Why describe a man's work with the seemingly feminine traits of sympathy and sweetness? And how did Beaux become the exceptional woman, wielding Teddy Roosevelt's big stick in all its masculine splendor?

In the forty years between 1870 and 1910, the language and tone of art criticism changed dramatically, essentially reversing course halfway through the period.[2] In the 1870s and 1880s, Gilded Age critics called on American artists to make art that was academically skilled and refined in sentiment. They expected men and women to demonstrate both qualities, looking for sympathy and sweetness in men's art as much as women's and seeking technical accomplishment in women's work as much as men's. Throughout these two decades, the rhetoric of an implicitly "masculine" technique and an implicitly "feminine" refinement seemed to work in unison, simultaneously elevating the profession and art without drawing much explicit attention to their gendered meanings.

In the 1890s, however, gendered language in criticism became more insistent, more absolute, and more explicitly aligned with sex — virtually a

drumbeat in its intensity. Successes by women artists and anxieties about masculinity that were sweeping the country called the alliance between technique and refinement into question and triggered a revision of art criticism's language and tone. Rejecting refinement as too "feminine" and technique as too mechanical, critics called for greater individuality and virility in American art. They praised art that seemed to display "masculine strength," which they defined in terms of a striking, individual vision and a "virile," virtuoso style. However, only men could achieve such art: from women, critics now demanded the "essentially feminine," something fundamentally different and almost always lesser. This new aesthetic ideology shored up male artists' confidence, reasserted their control over culture, reaffirmed the changes in market structure, and relegated what were now dangerous "feminine" aesthetic traits to women. More effectively than any other constraint, this change in critical rhetoric checked thirty years of gains by women artists.

A radically revised aesthetic terminology had significance well beyond the politics of the art world. Art criticism was a major discursive site for elaboration of the ideal of "high culture" and for definition of art's social purposes. The Gilded Age's virtual obsession with the visual and plastic arts meant that middle-class Americans turned to visual culture to embody their cultural authority and made art criticism a central vehicle for the articulation of it. The problems with American art that critics began to pinpoint in the 1890s — overcivilization, affectation, excessive refinement — all did more than resonate with larger cultural tensions of the fin de siècle. Art criticism figured and shaped this crisis of culture in crucial ways. From a Gilded Age ambition to employ art in the service of refining society, turn-of-the-century cultural and art critics retreated to the less ambitious, less universal aim of self-realization and individual liberation. The gender conflicts shaping critical rhetoric thus had a profound impact on twentieth-century understandings of high culture and the nature of middle-class claims to cultural authority.

In the decade and a half after the Civil War, art criticism earned new respect — even respectability — and obtained a wider audience. All the major magazines, including the popular weeklies, illustrated monthlies, and a host of new art periodicals, covered art world activities in detail; newspapers expanded their coverage, hiring their first full-time art critics and granting them bylines. Reviews were lengthy, often extending over several editions, and new books, new artists' societies, and new movements in art all received notice and analysis. Other articles covered the history of art, the lives of Old Masters, and famous contemporary artists.

At the same time, critics began to regulate their own practice, urging a more detached, objective, and analytical approach. Before the 1850s, American art criticism was occasional and haphazard, with sketchy reviews, a largely descriptive content, and a tone often more enthusiastic than critical. A number of critics began to define a more restrained and rational method in the early 1860s: according to Russell Sturgis, one of the first to articulate these new principles, "cool, considered, moderate judgements of the worth of works of art" should imbue criticism. He stressed the importance of knowledgeable critics. Over the next several decades, articles appeared regularly in art journals and in popular monthly magazines, reaffirming Sturgis's viewpoint and defining standards for professional criticism. Although there was much divergence among critics, they generally settled on four basic principles. The first was a focus on the intentions of the individual artist. The more analytical, considered approach of the new criticism helped direct attention to the evolution of a single artist's work and to the kind of artistic monograph that we now find familiar; this focus on the individual would reinforce the shift in criticism after 1890. The second concern of criticism was detached review of technical ability and accomplishments; its third theme required describing the "tendencies" of art, outlining the evolution of styles, schools, and the history of art. Finally, Gilded Age critics dedicated themselves to a public role of education, instruction, and elevation of taste.[3]

Clarence Cook was a well-known critic of these decades, and his career typifies the new criticism. In 1864 he became the art critic for the prestigious *New York Daily Tribune*. From that base, he wrote criticism for all the major magazines, including *Atlantic Monthly, Scribner's Monthly*, and *Art Amateur*; from 1884 to 1892, he also edited *Studio*, another art magazine of the period. In his criticism, Cook expressed his growing commitment to more "poetic interpretation" in art and less "honest reporting," praising art that was more aesthetic, more emotional, and more interpretive. By the mid-1870s, Cook had become a spokesman for the aesthetic movement. Then, in the late 1880s and 1890s, he endorsed the impressionists and began to praise painters in the gendered rhetoric of energy and vigor. Cook was not the most systematic or detached critic, but his sharp analysis, his refusal simply to praise, and his evolving aesthetic criteria make him representative of the professionalism and priorities of the period.[4]

Although many artists complained that Cook's pen was too critical, he still belonged to a mutually reinforcing circuit of camaraderie and interaction among artists and critics. Many critics began as artists; others became prominent artist-critics; and still others joined in the bonhomie and fun of the

artists' studios and cafés. For example, William Brownell, one of the first to detail the work of the "new men" in the 1870s, was part of the artistic life centered around New York's Tenth Street Studio Building. Critics and artists thus occupied parallel but integrated worlds, sharing assumptions and bridging the gap between aesthetic ideals and artistic practice. It was a world whose interchanges and sociability most often benefited the male artists who subsequently appeared in criticism and commentary.

A few women did become art critics in the late nineteenth century. Mariana Griswold Van Rensselaer, the most important of these, began her career in 1878. Van Rensselaer was distinguished by her "conscientious professionalism," often outdoing her male colleagues in her thoughtful, probing analysis. She insisted that American artists develop good technique and high standards. Van Rensselaer treated women and men similarly in her reviews. Given her professionalism, the apparent gender neutrality of Van Rensselaer's criticism is neither particularly surprising nor particularly different from the attitudes of women artists themselves. Van Rensselaer's judiciousness probably aided women to the extent that she treated them seriously, incorporated them regularly within her reviews, and did not address them as "women artists." Moreover, since Van Rensselaer wrote most of her art criticism before 1893, the absence of such special consideration may also have reflected criticism's more general lack of interest in a distinctively "feminine" art in the 1870s and 1880s.[5]

As art criticism professionalized in the 1870s and 1880s, it underwrote middle-class ideals of high culture. By 1898, *The People's Webster Pronouncing Dictionary and Spelling Guide* gave its one-word definition for culture as "refinement."[6] To the late-nineteenth-century users of *The People's Webster,* refinement highlighted the idea of a "sphere" of activity outside the market presided over by women who brought to it their humanizing, purifying, and edifying influences.[7] Culture elevated, carrying its viewers, listeners, and readers to a higher plane. Appreciating the aesthetic—being refined—signified civilization, that resonant catchphrase for late-nineteenth-century America of Anglo-Saxon achievements and superiority.[8]

It was obvious to nineteenth-century observers that not every home met the demands of "refinement," but, increasingly, cultural commentators like art critics hoped that their readers would aspire to attain it. Historian Lawrence Levine has argued that the proponents of culture believed that "maintaining and disseminating pure art, music, literature, and drama would create a force for moral order and help to halt the chaos threatening to envelop the nation."[9] With a "refined" populace, cultural leaders hoped social and class differences could be transcended; hoping was soon not enough, and cultural

elites quickly viewed culture in a more utilitarian light as a force for order. In 1878, just one year after the upheaval of the Great Railroad Strike, an *Atlantic Monthly* piece made these links explicit, calling on "those who believe[d] in culture, in property, and in order, that is in civilization" to promote "new," "better," and "higher" culture in order to avoid the "peril of democracy."[10] The belief that culture should create order and unify society turned culture into an expression of middle-class authority. Although apparently democratic (it could, after all, be attained by anyone through education and aspiration), culture actually embodied upper- and middle-class versions of a society under the sway of its values of refinement.[11]

Artists and art critics helped elaborate this idea of high culture. In the decades before the Civil War, critics considered art an avenue through which beliefs about political conflicts, public behavior, and national identity could be expressed and debated. Abandoning this cultural nationalism, Gilded Age artists and critics envisioned art less as an avenue and more as an end in itself, premising middle-class cultural authority on ideals contained in the aesthetic itself.[12] In 1877, in an article titled "Morals in Art and Literature," *Appleton's Journal* echoed the sentiments of cultural leaders when its editors declared, "[Art's] business is to select, to discover and portray the beautiful, the elevated, the ennobling, the pleasurable." As if advertisements for Matthew Arnold, pronouncements like these reiterated a belief in art's place in a realm beyond the material and in art's purposes as elevation, uplift, and inspiration.[13]

This true art, like other forms of culture, would refine society and provide a needed impetus for social harmony. Painter Will Low declared Gilded Age artists "pioneers in a movement for uplifting the general standards and educating the public." Much less subtly, Anna Lea Merritt insisted, "The place of art is not to be dependent on democratic opinion, but to rule and elevate that opinion, to record national interests in a universal language."[14] Merritt and Low shared the widely held belief that art should raise standards and instill ideal values in a public that increasingly appeared vulnerable to the manipulations of cheap commercial art and in need of education and direction.

Armed with their new professionalism and this vision of their role as saviors, artists and their critic spokespersons introduced new critical frameworks. Antebellum artists and critics had stressed the artist's selflessness, which translated into effacement of the artist's presence on the canvas. Critics looked for careful transcription of nature, praising highly detailed renderings and elaborate finish in which brushwork and handling disappeared, as if the artist were simply a tool of nature. The influences of the German school at

Düsseldorf, where several Americans studied in the 1840s and 1850s; the ideas of Ruskin, who was very popular in America and highly influential on leading American critics; and the transcendentalist ideas about nature that infused many landscape painters' work all reinforced this basic impulse. For this generation of painters the subject, not the artist, should dominate the canvas. Quite unlike Cecilia Beaux wielding a big stick and imposing her will upon us, the artist in midcentury America remained a medium through which other ideals were conveyed.

After the Civil War, critics elevated the artist over nature and sought the imprint of both professional skill and refined sentiment on the canvas. Criticism coalesced around two keywords: technique and sympathy.[15] "Technique" was usually the first concern, more and more considered a requirement for compelling art: "Technique," enthused one critic, "the God-given and labor-trained cunning of retina and wrist, how all-important! often how all-sufficing."[16] Critics typically complained that American artists lacked technique and that the past record of American art was undistinguished, a stage gladly left behind. Drawing on evolutionary metaphors, they praised the acquisition of technical skills by a new generation. A critic for the *Art Amateur* claimed in 1880, "A generation of artists has arisen in America not content to be simple untutored savages in art. . . . [They] are creating a new American art."[17] Americans finally began to master the means of painting, including academic drawing, chiaroscuro, control of values, and skilled brushwork. Together, these methods, which were of course the methods of academic art training, formed "the science of the profession."[18] Associating technique with the methods and rising prestige of science, critics made the technical skills of academic training (rather than a particular subject matter or the depiction of a transcendent nature) the marker of artistic status and achievement, reinforcing the professionalization of art.

As critics promoted academic technique in the 1870s, women often provided evidence of the very failures they were trying to eradicate. William Morris Hunt's "female foster-children," as one critic called them, attracted extensive commentary for their lack of technique.[19] William Brownell attacked the "essential whimsicality" of their work and a supposed tendency among them to "belittle severity of training." He thought they approached their work with a "cheery confidence" that was ultimately dilettantish and belied the "years of study and practice upon which every painter of any importance has based the work that has made his reputation."[20] Hunt pupil Elizabeth Boott received similar commentary on her 1884 exhibition: the *Boston Post* thought she "seem[ed] to have the idea that broad brush work, sketchy

methods, and bold pasty painting constitute a picture."[21] For a generation still proving the centrality of technique, the failures of Boott and her companions in drawing, modeling, and flesh painting provided a case study of the dangers of rejecting academic methods.

At the same time, women were also used to demonstrate a very different lesson. Alongside the descriptions of women's weak technique were descriptions of their ongoing acquisition of skill, proof in some critics' eyes of the overall progress in American art. Thus, while some critics were busily finding women painters deficient, others announced women's remarkable new successes. In an 1881 review of the Pennsylvania Academy's annual exhibition, the reviewer noted the advance in women's skills. "There is very little tendency to overwork or detailed pettiness. The leaning is quite in the other direction."[22] In the other direction, this reviewer meant, women were acquiring good academic methods and strong painting skills. Their entry into art schools had produced results: for the 1880 Pennsylvania Academy of the Fine Arts annual exhibition the *Philadelphia Inquirer*'s reviewer detailed the achievements of women who had been studying at the academy. Their pictures in the annual exhibition were "well painted, handled with remarkable firmness and freedom," "good in drawing and well modeled," and "good, honest work . . . worthy of praise."[23] With its slightly more progressive atmosphere, Thomas Eakins's commitment to women students, and local pride in the academy's success, Philadelphia seemed especially to produce this kind of commentary, but by 1885 even some of Hunt's former students drew praise for their skillfulness. The *Art Amateur*'s "Greta," who had long been ambivalent about Hunt's legacy, praised Ellen Day Hale's 1885 *Self Portrait*. In it, according to Greta, Hale "display[ed] a man's strength in the treatment and handling of her subjects — a massiveness and breadth of effect attained through sound training and native wit and courage."[24] Women were thus not permanently barred from full professional status during these two decades because the idea that education, training, and acquired skill produced good technique made its acquisition possible for the female graduates of art academies.

Once critics had elevated technique into the foundation of good art, they increasingly argued that all other effects of art — from conveying meaning to provoking sentiment — stemmed from good technical execution: "The painter who knows not how to draw, model, color, and, in short, *paint* will never excite our emotions by dramatic effect or poetic feeling. . . . If our artist stammer over his alphabet, how shall he tell us of great truths and beauties, or reveal to us his power of imagination."[25] The root of good art was not nature, or even subject matter, but rather paint. Through technique, then, critics

began to define a new purpose for art, one based in painting and the emotional and imaginative effects it conveyed. Critic S. G. W. Benjamin praised artists whose "thoughtful and refined" work revealed "a thorough appreciation of the fact that art, for itself alone, is the only aim the true artist should pursue."[26] Art "for itself alone" did not mean abandoning a relationship to a wider world; rather, it meant believing that the aesthetic effects produced by skillful technique, instead of nature or literary content, conveyed meaning in art. Elevating technique helped elevate the aesthetic as an end in itself, without reference to representation, a transcendent nature, or morality.[27]

Fears that excessive technique would result in vacuous academicism and wipe out these more ideal meanings did emerge among some critics. Particularly in Boston, where a strong strain of romantic idealism lingered, critics hesitated to endorse fully the calls for good painting. When Bostonians found their own William Morris Hunt criticized by visiting New Yorkers for his "flesh-tints, ears and knuckle bones," a local critic attacked the "scholastic stupidity and technical narrowness" of the New Yorkers and rebelled against the "French system of preternaturally perfect technique."[28] Ironically, the same critics found themselves, often within the same review, endorsing better painting, routinely praising good drawing, effective composition, and mastery of color and values.[29] Ultimately, rather than an actual problem, excessive technique provided a useful focal point for debates about the source of meaning in art. Although Gilded Age critics thus differed in the importance they attributed to technique, they still fundamentally agreed that it was a central component of art and a necessary next stage in the development of American art.

The companion of skilled technique in 1870s and 1880s critical discourse was poetic conception and ideal intention. Critics used a series of related words to describe desired poetic effects: most important was sympathy; its corollaries were charm, sentiment, feeling, and suggestiveness. All pointed to an emotional effect, a relay of the artist's feeling for the subject to the viewer, who was in turn stimulated to an emotional response. William Brownell explained the change quite succinctly: "Whereas it used to be the main effort of American painters to imitate nature, it is the main effort of the new men to express feeling." Similarly, Mariana Van Rensselaer enthused over John La Farge's watercolors because they "exhibit[ed] all his indefinable charm of sentiment."[30] Critics praised painters and paintings for their evocations of sympathy, drawing attention to their "sweet natural sympathy," "sympathy with the soul," "sympathy with certain aspects of nature," or even "thorough sympathy with the simplicity and beauty of childhood."[31]

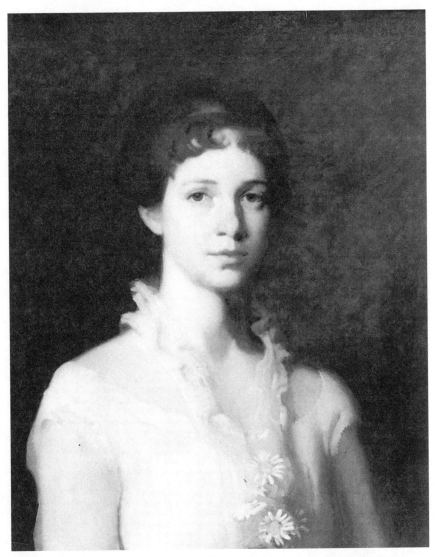

FIGURE 5.1. *Abbott Thayer,* Anne Mumford Palmer, *oil on canvas, 1879. (Courtesy of the Memorial Art Gallery of the University of Rochester, N.Y. Gift of the Estate of Emily and James Sibley Watson.)*

In April 1880 the *Nation* reviewed the National Academy of Design's annual exhibition, describing at length the "gem" of the exhibition, a portrait of a young girl by Abbott Thayer (fig. 5.1). Thayer painted "delicately," suggestively, and with "charm," so that his "rendering . . . not only betrays a singularly sympathetic feeling for the elusive charm of the subject, but exhibits a

pictorial refinement." Neither "oversweet" nor conventionally pure, Thayer's painting sustained the effect of sympathy without resorting to sentimentality or pat morality. In this sense, the *Nation* distinguished Thayer's art from a popular sentimental culture associated with the feminine. Nevertheless, the critic praised the picture unconditionally for its delicacy, suggestiveness, and charm, high-culture terms that brought together refinement and womanly attributes: what counted as poetic effect in 1880 were sensibilities the Victorians considered distinctly feminine.[32]

Other effects did not warrant the same praise. In 1881, the *Critic* praised Wyatt Eaton's work at an exhibition of the Society of American Artists because it avoided important dangers: "Mr. Eaton is a painter to whom people never apply the words strong, bold, dashing, and it is probable that he escapes these half-derogatory adjectives because he has the art of concealing his art." Like most critics in this period, this reviewer approved of Eaton's thorough technique. As William Brownell averred, "Fidelity must precede vigor." In just four words Brownell stated the basic Gilded Age critical principle. Strong, bold, and dashing meant that a painter had strayed too far from more subtle — and more desired — effects. Ten years later, strength and boldness would verify artistic authority, but in 1881 they remained "half-derogatory" critiques.[33]

Despite the high value placed on sympathy and its companion traits in the late 1870s and the 1880s, critical writings did not describe special access for women artists to these supposedly feminine qualities. Even when critics distinguished poetic effect from technical skill and linked the latter to a presumably masculine "scientific" side of art, they did not assume women had more insight than men into refined effects. Given the overlap in gendered language and gender norms, women might have been seen as specially suited to the task of expressing and conveying these ideals — as they were in France, for example — but American critics stopped short of fully developing the logic of refinement and did not grant women privileged ability to convey aesthetic meaning.[34] At times, women even revealed an absence of sympathy and charm. Mary Cassatt's "neglect of, or incapacity for, the poetic and sentimental, not to say spiritual, side of painting" tempered critic William Brownell's enthusiasm for her "force" and the "intelligent directness in her touch."[35] Although Brownell could have implied that Cassatt unsexed herself when she neglected these apparently more feminine traits, he did not; rather, throughout his three-part review of the younger painters of the 1870s, he held women to the same balance of refinement and skill that he expected of men.

Indeed, the language used to describe the poetic effects of men's and women's art is remarkably consistent. A painting in Elizabeth Boott's 1884 ex-

hibition was "admirable in its dignified and sympathetic treatment," according to one reviewer.[36] Another found that "the gorgeous and tender in flowers seem to appeal equally to this artist, though she obviously throws her strength into the pictorial rather than sentimental side of their values. The work as a whole . . . is directly simple in sentiment."[37] Elizabeth Bartol, another student of William Morris Hunt, received similar praises from William Brownell for her "tender and poetic, yet gravely treated" work (fig. 5.2). Brownell noted that Bartol brought both "force" and "sweetness" to her painting and imbued her canvases with "spiritual interest."[38] The rhetoric of sympathy, sweetness, and poetic effect drawn out in the reviews of men's work is directly paralleled in these comments, revealing an overarching—if temporary—satisfaction with the reigning paradigm of refinement. A gendered set of expectations applied to both men and women—without many distinctions drawn. Such expectations served the needs of both men and women artists: men did not fully relinquish cultural authority to women, even when the logic of critical ideology entailed they do so, while women evaded a doctrine that stressed their sexual difference rather than their shared professionalism with men.

This paradigm also allowed men to embrace a more feminine image of their work at a time when practical considerations and other cultural trends made it beneficial to do so. The idealization of refinement in art and society during the Gilded Age made art's feminine dimensions less threatening to male status. In fact, the reverse was often the case. Seemingly feminine traits could verify male artists' achievement of refinement. The fashionability of the aesthetic movement and its passion for decorative design and "artistic" interiors helped elevate more intimate, domestic qualities in art. In this context, charm, tenderness, and delicacy appeared to be far more appealing traits for men than their feminine connotations might suggest.

From the late 1870s to about 1890, therefore, art critics established aesthetic standards using a highly feminized rhetoric. An artist's purpose was to draw the viewer into a realm dominated by sensibilities associated with the feminine. This realm was one of abstract and idealized refinement, where sympathy, charm, grace, sweetness, and tenderness were all conveyed. With this aesthetic ideology, critics abandoned the more overtly political purposes of antebellum commentators, aligned art with the domain of the noncommercial, and elevated the aesthetic as an end in itself. In turn, the aesthetic had social meaning: it would provoke refined sentiment and, ultimately, refine society. Refinement's partner in this enterprise was technique, both the means to create these aesthetic effects and, more important, the evidence of the artist's expertise and professionalism. This professionalism proved the

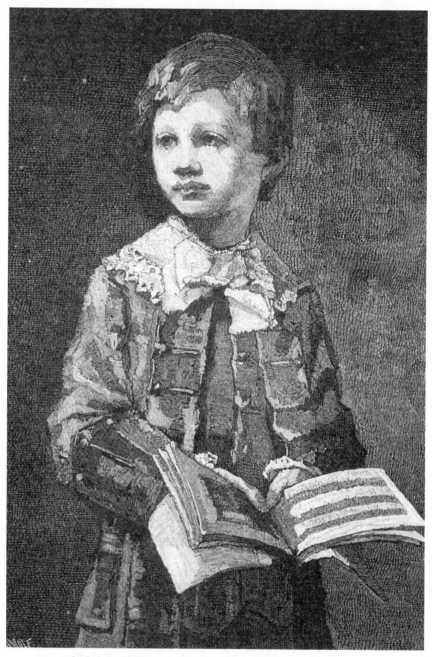

FIGURE 5.2. *Elizabeth Bartol,* Portrait of a Boy, *oil. Engraving from William Brownell, "The Younger Painters of America. III,"* Scribner's Monthly, *1881.*

artist's distance from the realms of cheap, commercial "low art," reinforcing the status and presumed purity of "high art." Refinement and technique were thus intertwined and interdependent threads in developing and sustaining new roles for art in the Gilded Age.

Between 1890 and World War I an entirely different critical rhetoric developed. The language of sympathy and technique that had not required overt gender assignments became a terrain of distinct masculine and feminine aesthetic traits. A "union of womanly delicacy and refinement of feeling with a manly vigor in the painting" characterized Cecilia Beaux's work according to Clarence Cook.[39] Charles Caffin measured achievement by a similarly gendered code in 1904, explaining the success of a portrait by Ashcan school artist Robert Henri: "It is a combination of robustness and subtlety, a wedding of the masculine with femininity."[40] The masculine inevitably claimed superiority in this landscape, particularly with the success of a new generation of "younger men" whom critics characterized as infusing American art with "an exhilarating spirit of manly vigor." In the new critical ideology, the "super-refined affectation" of a Gilded Age artist paled next to the "straightforward, virile work" of the twentieth century.[41] If the earlier language of criticism can be understood in terms of an unusual "feminization" of aesthetic rhetoric, this new language reflected a sharp reversal, a "masculinization" of rhetoric and ideologies that was insistent and intense.

It was so insistent and intense, in part, because by the 1890s it seemed possible to some critics that women might exceed men in their achievements. Clarence Cook, who had remarked as early as 1883 on the "considerable" participation of the "Amazonian contingent" in the new art movements, announced in 1896 that women had equaled men: "Even in the swiftest glance across the field of our art the eye is arrested by the women; for where little that is rightly to be called great has been done by the men, with their larger opportunities and more assured position, we find the work of not a few of our women as interesting every whit as that of the men, and showing an equal cleverness and mastery of means." Hinting that women's work was in fact the most interesting of the day, Cook nevertheless remained confident that eventually men would "scorch ahead." In the meantime, he concluded, "We watch the race with zest."[42] And, in the eyes of many critics and male artists, a race it was, and they were not so sanguine about men's triumph. In 1901, and again in 1902, the *Philadelphia Press* declared women the winners of this race, writing first in 1901, "Never before in the history of local art has the palm been so completely wrested from the hands of the male exemplars of the art," and then

in 1902, "Philadelphia women artists have been so long at the front in prize-winning that many believe men are losing their old time cunning."[43] Even William Merritt Chase conceded that women now "competed with men" in their subjects, and he concluded (despite much patronizing), "I see no reason why women should not attain as great success as men have attained or can attain. Genius has no sex."[44] The dynamic between men and women was now openly competitive. To call it a race and make the finish line almost near was only to formulate a more immediate and visceral metaphor for women's challenge to the art world.

This threat gained form and dimension as the "girl art student" and "woman artist" became stock figures in turn-of-the-century novels and popular journalism. Varying in meaning, the fictional woman artist sometimes symbolized ambition and women's new powers; at other times, she was the complete opposite, a sign of failed ambition and creative triviality. Made to fill a number of social purposes, this stock figure was pliable cultural material. Fluidly moving between fiction and true stories, the girl art student and the woman artist took on even greater visibility and tangibility. The righteous stance of articles examining the diaries of ambitious Russian art student Marie Bashkirtseff easily reappeared in fictionalized tales of the downfall of struggling women artists; and the blithe tone of popular journalism when describing the girl art student in the atelier easily translated into the trivializing attitude of magazine stories on women's artistic aspirations. What is important, in this context, is not the success of the "girl art student" and "woman artist" in standard accounts (a success that, in fact, rarely occurred) but rather the popularity she achieved and rhetorical role she played. In the art world, her ubiquity only made real women artists seem more prominent and male artists potentially more eclipsed.[45]

In conjunction with the pressure of practicing women artists on art schools, exhibitions, and markets, the vision of a race that women might win and the pervasive popular figure of the woman artist spurred and intensified the change in critical rhetoric. In addition, the broad-based masculinizing movement of the turn of the century gave force and urgency to the new language. This movement valorized an aggressive male activity quite unlike the genteel refinement of the previous two decades. Taking its cue from Teddy Roosevelt's call for the "strenuous life," this masculine impulse appeared in a wide range of forms, including sports enthusiasm, militarism, and a "muscular Christianity."[46] As one of the most "feminized" realms of society and one in which broader cultural authority seemed to be at stake, the art world was an important site for the contest over the form and meaning of male authority.

An invigorated rhetoric provided an opportunity for men to reclaim cultural authority on new terms without concession to female avenues of authority such as refinement.

By the turn of the century the new rhetoric had taken hold, and signs of masculine vigor seemed to be quite evident. With high praises for the 1907 winter exhibition at the National Academy, the *New York Herald* reviewer summed up its accomplishments: "Although it contains pictures which are beautiful and many that are dainty and pretty, the exhibition does not lack in the strong and virile."[47] Virility became the first new keyword for criticism; individuality was the second. Represented by vigorous brushwork, a supposed "manly" strength of painting, and at times, an urban theme or male subject, virility meant skilled handling, an aggressive display of technique, and an active presence of the artist on the canvas. Increasingly, virility took its highest form in the distinctive, individual style that was the hallmark of the new gallery and dealer system. Individuality thus had a series of related meanings. It required a distinctive style for its evidence, but it was based on the developing belief that style was the expression of the artist's self and that the artist was the ultimate source of meaning, playing a crucial mediating and interpretive role between nature and the viewer. Both of these keywords gained credence and dimension through two parallel semiscientific, semipopular discourses that also filled magazines during these decades. For individuality, art critics drew on new psychological and biological explanations of artistic genius; for virility, they turned to polemics about the "effeminization" of American culture.

"The history of art," insisted a writer for *Arena* in October 1900, "is closely associated with the fact of sex." In full elaboration by 1900, a formula for the biological basis of differences between men's and women's creative abilities was worked out in the preceding decade. As the *Arena* article explained, masculine energy effectively transcended the "personal, conserving force of feminine energy," so that, in creativity, "the supremacy of man is unquestioned." Women lacked the "masculine emotions" needed for great art: "China painting and decorative art in general," intoned this *Arena* writer, "are the specialty of woman, who excels in the minor, personal artistic impulses, and in this way gives vent to her restricted life."[48] Conveniently, newly formed biological explanations could be used to restrict women to the forms of art they had traditionally produced and exclude them from the fields they had begun to enter.

This reasoning encountered a major obstacle. Creative impulses or instincts

often seemed uncomfortably close to feminine traits. Commentators agreed that women and artists were "akin" in their "eye for color" and "inborn good taste." How, then, could sexual difference determine genius? According to "Two Brothers," writing in *Macmillan's Magazine*, it was because woman's "constitutional determination to the showy and the superficial" deprived her of the imagination and abstraction essential for true genius.[49] By the social Darwinian logic the "Two Brothers" employed, women hit a kind of evolutionary plateau. Hampered by their biological "determination" to serve men, they did not develop the individuality essential for the highest creativity. Individuality was thus a gendered concept, one that was without a doubt gendered male.[50]

The problem for contemporary art was the denial of this difference, of women assuming "mannishness" in their writings and becoming "unwomanly in their attitude towards life and art." A woman was not supposed to aspire to match the achievements of her male colleagues; rather, her art "should beat the thanks that she was a woman." Those thanks should be visibly revealed on the canvas—a requirement that applied to men as well. The "Two Brothers" warned readers to be wary of the fate of English Pre-Raphaelite painter Edward Burne-Jones, who had become a "consumptive Eve in the male genius." At the sight of Burne-Jones, they suggested, "does not [the true man's] artistic sense suffer a certain shrinking at the absence of any token that it was a man, and not a woman, who wielded the brush?" The sympathy, sweetness, and simplicity Abbott Thayer had depicted in his 1880 portrait would have seemed a suspect emasculation in 1900. True genius appeared not in the form of refinement, which might superficially seem to embody artistic impulses, but rather in masculine "strength," in the transference of a distinctively masculine outlook onto the canvas.[51]

Ultimately, this was the point. Genius had now been defined independently of the ideal of refinement, which had been a major source of women's claim to aesthetic activity. Instead, biological and evolutionary explanations of men's and women's genius confirmed men's superiority. Walter Sparrow at least defined genius as "bisexual" in his 1905 book *Women Painters of the World*, but the feminine, which would forever dominate women's work, was always lesser. Sparrow praised the work of French painter Elisabeth Vigée Lebrun for its "complete womanliness," yet, given the maternal theme of her paintings, he still concluded, "Such pictures may not be the highest form of painting, but highest they are in their own realm of human emotion." Now clearly part of "their own realm," women's work remained permanently inferior.[52]

To sustain these claims, writers marshaled a mishmash of biological, psychological, and evolutionary evidence. The *Arena* writer compared the devel-

opment of creativity to sex differences in birds, to cave drawings done by pre-historic men (leaving the arts and crafts to women), and to recent studies on artistic taste of "over nine hundred individuals." Two *Forum* articles on woman and genius drew on evolutionary biology to anchor women's creativity in evolutionary progressions. In each article, the predominance of "intuition" — essentially part of the "maternal survival instinct" — kept women from the critical reason that made up genius. Drawing on the popularity and authority of science, these writers turned evolutionary ideas to cultural ends.[53]

The conclusions reached by these 1890s commentators are all the more striking in contrast to the conclusions drawn thirty years earlier. In 1865, critic F. T. Palgrave posed a similar question: Was "genius in art" a matter of "nature" or "education"? Although he acknowledged the importance of artistic "gift," Palgrave insisted that training was utterly essential. Women, he argued, could achieve artistic success if they were given the same education and public challenge offered to men. Palgrave, like many writers of the 1860s and 1870s, did not employ the biological reductionism of later writers and held out the possibility that through education women's achievements could equal men's. For women, one of the most serious consequences of the discourse of biological genius was the eradication of the potential for equality implicit in this commitment to educated genius and technical skill.[54]

The *Arena*, *Macmillan's*, and *Forum* promulgators of biological genius joined other writers in a formulation that appeared regularly from 1890 on, gaining only in intensity and overdetermination. Beginning with the *Forum* articles in 1890 titled "Woman's Intuition" and "Genius and Woman's Intuition," they fanned out into an 1891 debate in the *Critic* based on the article "On the Absence of the Creative Faculty in Women." That article drew letters of agreement and refutation from readers all over the country, and the debate spanned nearly six months of weekly issues. Later articles raised the problem of "manhood in art" and insisted on the failures of women artists.[55] Written mostly by cultural commentators rather than by active art critics, these articles nevertheless represented part of the continuum of critical rhetoric: embedded in art criticism was their language and much of their logic. Biological genius provided a convenient intellectual rationale as art critics strengthened and elaborated this framework in valorizing a masculine individuality in art.

For a second set of writers, masculinity in culture appeared more and more urgently needed. These writers warned of the dangerous "effeminization" of American culture and the stultifying "overcivilization" of American men. A writer for the *Atlantic Monthly* claimed that women had successfully "invaded" culture: they were "taking over the field of liberal culture" to such an ex-

tent that they "monopolized" education, literature, art, and intellectual life.[56] Turning to the metaphor of battle, this writer declared women the winners. They had "carried [culture] by storm" and "compelled capitulation" from men.[57] Like the image of a race for the leadership of art, the language of warfare revealed the sustained pressure of women on art and the intense contest for control over culture in these decades. The visible symptom of women's invasion of culture was "overcivilization" — an excessive refinement that had sapped the strength and vitality of both individual men and society as a whole. According to the polemics of overcivilization, women's dominance in rearing male children, their position as the majority of schoolteachers, and their campaigns for social morality had effectively emasculated much of social life and many men. The cries of overcivilization invoked debates about the superiority of Anglo-Saxon society. Defenders of American and European civilization used refined culture as tangible evidence of that superiority; yet, in order to rework the meanings of culture at the turn of the century and remove art from feminine domains, that correlation between the "civilization" of a refined Anglo-Saxonry and the genteel products of artists had to be broken and reimagined. The hysteria about overcivilization served that purpose well because it connected a reconstructed culture to a reinvigorated manhood.

Artists, not surprisingly, provided particularly notable evidence of effeminization as the now dangerously feminized domain of art seemed to characterize its producers as well. According to Charles Caffin, the seductive financial rewards of high-society portraits of fashionable women had damaged American artists, "until a considerable portion of our art is obsessed with femininity, and many a young artist . . . is seduced from such virility, as he may have had, into a lady-like condition of mind, young ladyish at that."[58] With the depiction of refined femininity and, more broadly, of refined sensibilities, the artist had become his subject: he had lost his masculinity, become a "lady-like" artist like the "lady-like" art he painted. Many male artists tried to counter this widespread presumption of effeminacy. Guy Pène du Bois noted that William Merritt Chase was a consummate defender of artists' masculinity: "[Chase] was filled with the importance of the artist and could defend him with clipped, witty, biting sentences, could even make him acceptable to men convinced that art was an effeminate pastime, the last resort of incompetents. Some may even have shivered a little, seeing him approach."[59] Chase, after abandoning his elaborately decorated aesthetic studio in 1896, clearly felt it necessary to reassert the masculinity of the artist's image.

Chase's reaction to this perceived feminization and overcivilization was repeated throughout the culture. The celebration of male vigor inverted Vic-

torian civilized morality and made virtues of the primitive and savage. In the culture at large, this translated into the gymnasiums, imperialist energies, and outdoor movements of Teddy Roosevelt's "cult of the strenuous life."[60] It was not always clear how such remasculinization could enter art, but art critics made the translation by rejecting the superrefined and oversophisticated. The strenuous life in art effectively meant endless calls for virility, vigor, and strength in subject and style. The rhetoric of overcivilization that had taken shape with the failings of American art as its primary evidence had in turn supplied art critics with a justification for the celebration of masculine virility.

Insightful critics had been noting the importance of the individual artist since the early 1880s. Sylvester Rosa Koehler claimed that "with the decline of interest in the subject," and with the rise in interest in the aesthetic, "the individuality of the artist gain[ed] in importance."[61] By 1891 the vice president of the National Academy of Design could assert without hesitation, "It is beyond dispute that individuality marks the highest point of development in art."[62] Two years later, Winslow Homer's painting *The Herring Net,* on display at the 1893 World's Columbian Exposition, received unqualified praise for its individuality. According to William Coffin, "The whole charm and power of the work lie in the artist's interpretation of what he has seen and imagined. Its force comes entirely from his unyielding individuality in saying what he feels in his own way."[63] The meaning of art—its "force"—now lay not in a set of aesthetic sensibilities but in the individual vision of the artist.

The first principle of an individual art was that it was not narrative. Critics, as they elevated technique, had privileged the act of painting over the subject of the painting and had been criticizing art based on "*l'anecdote*" since the late 1870s.[64] By 1890 critics accepted that the problem of technique had been overcome and that the goal of good drawing and painting had been achieved by American artists.[65] So, while critics of the 1870s and 1880s had seen technique as the cure for too much anecdote, critics of the 1890s sought the artist's distinctive expression of his theme. "It is this," claimed W. J. Stillman in 1892, "and not the choice of subject, or the more or less decided tendency of a painter or a school, which constitutes the distinction between 'high' or true art and 'low' or spurious art; the test is not in fidelity to nature but to one's own self."[66]

Some in the late-nineteenth-century art world expressed reservations about the triumph of nonnarrative painting, usually as part of their reservations about the influx of the principles of modern art. Many considered the focus on painting itself too narrow an aim for art and insisted on some larger moral

purpose. But just as those fearing technique had shared common assumptions with its exponents, so the attackers of art for art's sake shared with its proponents a faith in the distinctive vision of the artist. William Brownell challenged the "contemporary tyranny" of the "art-for-art's-sake gospel" in an article on painter Elihu Vedder. Yet Brownell began and concluded with the individual: he opened with praises for Vedder's "individual artistic attitude" and his "aesthetic point of view" and closed with an argument for the "personal force" of the artist as the basis of artistic expression.[67] He and other critics distancing themselves from art for art's sake did not wish to return to narrative storytelling but still wanted to invest paintings with symbolic and moral meaning. The fundamental source of this meaning, however, was the individual's response, and in this they shared common ground with other critics.

The artist's role was to mediate between nature and representation, filter what was seen through his or her consciousness, and offer a more personal image for his or her viewer. Postbellum landscape painters abjured description of nature for a more meditative stance, where the artist's subjective encounter with the landscape predominated.[68] Figure painting also appeared in more subjective and reflective versions. Figures of women in particular became symbolic components of an artist's conception in a way that effaced their individual presence and stressed their compositional and aesthetic function. Sadakichi Hartmann noted that painter John White Alexander's subjects "[were] not women, they [were] merely his means of expression."[69] In other words, for critics of Hartmann's era, the artist's act of expression was of primary importance.

Critics increasingly described the basis of that individual vision as the artist's self, and after the turn of the century, they began to draw on the very modern—even modernist—notion of art as self-expression to explain the meaning of individuality. In 1912, Guy Pène du Bois rather casually commented, "Generally we accept the explanation that a successful work of art is a sincere expression of the personality of its creator."[70] Paintings themselves had become projections of the artist's personality—the twentieth-century version of individuality—rather than an interpretation of, or even inspiration from, nature. The artistic self was authoritative. In the absence of subject matter, the artist's distinctive vision and difficult act of self-expression carried meaning. The artist's individuality provided a model for the viewer: art became less an experience of refinement—of emulating and diffusing aesthetic values to society at large—than a demonstration of individual self-realization.

This artistic individuality was not androgynous: more than anything else,

sex governed the artist's self, a seeming fact for which women painters provided convenient evidence. The "modern woman painter," according to Pène du Bois, must accept that, "whether she wills it or not, she is feminine at the bottom and successful in part particularly because of that base. *The moment woman forgets her sex she loses her art expression."* [71] Pène du Bois then pronounced his highest praise for portraitist Lydia Field Emmet, repeatedly drawing attention to her "essentially feminine" and "particularly feminine" expression. Both the 1890s valorization of "individuality" and the modernist cult of "self-expression" made sexual difference a centerpiece of the artist's vision. "Individuality" thus became a means to dismiss women's art for violating the principles of self-expression. Sadakichi Hartmann, who later became a major spokesman for modernism in America, described the problem of mannishness in women's art with undisguised misogyny in 1897: "Women push themselves to the foreground everywhere, but the result in art is rather dissatisfactory and tiresome. Why do they always paint such trifling subjects? Why do they always imitate men, instead of trying to solve problems which have never been touched before? . . . *The women artists have still to come . . . who can throw a new radiance over art by the psycho-physiological elements of their sex, and only then the large number of women will be justified in modern art."* [72] Hartmann reversed decades of battling by women to be considered professionals, regardless of their sex. The logic of a "psycho-physiological" expression closed the highest levels of the profession to women: they could not aspire to the center of art without betraying their sex. That center was now the domain of an "individuality" that women, by the tenets of biological genius, could never achieve. If women did aim for the center, they would find their work dismissed because it was too masculine, since in women's hands strong painting became brutal and unnatural. Not accidentally, just as women artists fully entered men's domain, this critical discourse threw out their achievements.

On the canvas, the measure of artistic individuality—of the masculine artistic self—came to be a distinctive and visible style. And it was through style that virility, criticism's other new keyword, appeared. Beginning with the Society of American Artists' show in 1890, critics enthused regularly over actively painted surfaces and evident manipulations of paint. At this exhibition John Singer Sargent was the unanimous "hero," singled out because his handling was "miraculously clever." [73] His *Carmencita* became the talk of the town (fig. 5.3). While other portraits in the show left a "pleasant general impression," Sargent's created a "vivid remembrance." Although the painting did not earn unstinting praise, that mattered little amid the mastery and "bold" color of the aggressively painted figure and vigorous yellow dress (which made

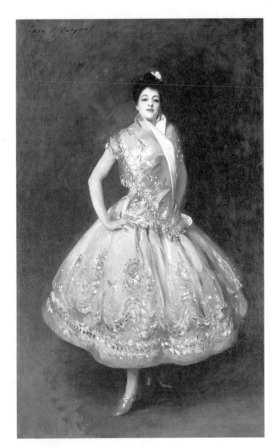

FIGURE 5.3.

John Singer Sargent,
Carmencita, *oil on canvas,*
1890. (Courtesy of Réunion
des Musées Nationaux / Art
Resource, New York.)

a nearby portrait of a young lady in yellow by Edmund Tarbell a "pale reflection").[74] Rosalie Gill's *The Orchid,* shown at the same exhibition, could hardly compete with such praise (fig. 5.4). The painting earned bons mots—"remarkably clever" and "one of the important ones of the exhibition"—but beyond that could garner only flat narrative description. A mother wore a black dress trimmed with violet. A child in white held a violet-colored orchid. The filmy sleeves of the mother's dress and floating lace covering the child did not draw the effusions about vitality and mastery that spilled over Sargent's lace-covered dress.[75]

Because of their skill as painters, Sargent and William Merritt Chase, the society's president, received the most notice: reviewers commented repeatedly on their "brilliant technique," "frankness and skilfulness of execution," "virtuoso" performances, "audacity and brilliancy of execution," and painting with a "dash."[76] Eclectic in their praise of a variety of stylistic schools—ranging from impressionism to realism—critics focused on the surface of the

FIGURE 5.4. *Rosalie Gill,* The Orchid, *oil on canvas, 1889. (Courtesy of the Maryland Commission on Artistic Property of the Maryland State Archives, MSA SC 4680-10-27)*

canvas and the structure of the painting rather than its sentiment or imaginative sensibilities. Poetic effect, which had been an equal partner to technique in the 1870s and 1880s, now took second place as reviewers read the emotion and meaning of the artist's vision through a painting's style.

The highest achievements of style were brilliance and vigorousness in execution, a kind of painting that drew attention to the act of painting itself.

Here, in the "sweep of line" and "scaffolding of the picture" were the "virile qualities" men needed to display.[77] This was the crucial equation: an actively painted surface conveyed virility, which was in turn the central code for masculine individuality. The technical skills needed for the achievements of a Sargent or Chase were now distinctly masculine qualities, and women's technical skills represented a kind of trespassing on the terrain of men, as, for example, when Pène du Bois described Lydia Field Emmet's control of her brush as "lessons" learned from the men. Somewhat unusually, critics did not condemn Cecilia Beaux for her "masculine breadth of technique" but nevertheless made it quite clear that this trait "come[s] to us from a man like Sargent." In other instances, Beaux served as a clear warning of the dangers women must avoid—her "capacity for strength" was exceptional because it lacked "that brutality so common to women in search of masculine qualities."[78]

In the course of the two decades between 1890 and 1910, art critics formulated a gendered division of aesthetic labor. Handling and technique lay on the masculine side, but sympathy, charm, and poetic effect belonged to the feminine domain. According to one profile, Alice Barber Stephens proved the point that "woman with her more delicate sensibilities and her natural love of the beautiful is apt to have a closer sympathy with nature and life, and a quicker perception of the poetic element."[79] Praise that had been extended to men's masterpieces of sympathy and sweetness in 1880 now surfaced only in explicit connection to women's paintings as part of a series of interlinked traits: "simplicity, directness, and feminine charm."[80] Qualities that had had no specific gender tag when they were desirable for men now received gender designation as they became suspect attributes in male artists. This lineup of masculine and feminine aesthetic traits was never, however, complete. Women, as we have seen, continued to demonstrate so-called masculine strength, and men continued to receive notice for the poetic side of their painting. Turn-of-the-century critics never entirely abandoned beauty, subtlety, and sentiment. They continued to praise those qualities in men's work, albeit only as long as they remained subordinate to "brilliant" execution. This ideological unevenness made the rhetorical division of aesthetic labor—and its preservation of male authority—quite fragile and ultimately intensified the efforts to push real women artists away from the center of the art world.[81]

The shifts in art criticism's tone and rhetoric after 1890 were the logical conclusion of professionalism in the arts. The triumph of academic technique had created both the standards and the standardization that underlay the professional ideal, and no one in 1900 challenged the expertise of the artist's brush

as the distinguishing mark of the true artist. The focus on virtuoso style and individuality only strengthened these ideals by further stressing the authority of the individual artist as the only legitimate interpreter between "client" (or viewer) and "knowledge" (or image). In more important ways, however, the shift in rhetoric was profoundly antiprofessional. Biological genius was fundamentally antimeritocratic. Critics returned to conceptions of "genius" that had been downplayed after the Civil War and gave them new vigor with the pseudoscientific discourse on the natural "instincts" of genius. The emphasis on technique, acquired skill, and educated artistry evolved into a focus on self-expression, originality, and style: that is, art critics rewrote the basis of prestige in art, turning away from skilled professionalism and toward the modernist cult of the self. When they sidestepped meritocracy, critics also subverted professionalism's ostensible gender neutrality. The "individuality" the artist was now supposed to attain was not fully available to women, who were relegated to a permanently different terrain, the realm of the "essentially feminine." As critics elevated biological genius, women were left to imitation at the worst, the "minor" or "lesser" arts as a middle ground, and displays of womanly genius at best.

The new rhetoric also resolved a different set of social and market problems for artists than professionalism had done. The demands of selling art within a dealer and gallery system reinforced criticism that valorized artistic individuality. James McNeill Whistler's shrewd presentation of his image shaped critical commentary and created a distinct niche for his work. Similarly, the rebel Ashcan painters of the early twentieth century learned from their leader, Robert Henri, the importance of cultivating a striking aesthetic and personal image. Art critics, overburdened by massive annual academy exhibitions and rising numbers of artists, found the distinctive persona and unique style cultivated by dealers a manageable way to write about artists.[82]

Individuality and virility thus represented solutions to new market imperatives and established a new set of purposes for art. Taking this form in large part as a response to women's continued pressure on the art world and to fears of further "feminization" of culture, these new purposes reinvigorated male cultural authority. Yet when critics withdrew culture from the feminine realm of refinement, they did so at the expense of the broadest, most democratic impulses in the tradition of genteel uplift. Individuality and virility initiated an understanding of high art whereby the artist's authentic, even heroic, self-expression triggered the viewer's own self-realization. Now essentially a therapeutic process, the purposes of culture were limited to the individual.

Rather than unifying all of society through a set of universal ideals, culture's role was simply to foster the individual liberation of a narrowed, relatively elite audience.

Throughout this period, the position they would occupy in the art world troubled women artists. Initially, in the 1870s, they formulated the problem as a question of why there were no great women artists. In the eyes of Emily Sartain it was "a singular and suggestive fact that we have very few women painters who are entitled to be called great." According to her, "The chief reason why women have been so reluctant to enter this inviting field, whose splendid prizes are enough to excite the ambition, if not to inspire the enthusiastic devotion of every artist-soul, probably is that the restrictions and depressing influences to which they have so long been subject have hindered their development, and checked their aspirations, and made them look upon such heights of achievement as beyond their reach. . . . They never dream that they too can excel if they will, and that the highest genius may be enshrined in a woman's soul."[83] Sartain pointedly attributed women's inability to imagine the "highest genius" within themselves to the effects of discrimination. Sartain's younger colleague Eleanor Greatorex argued in a similar vein that American women's poor showing at the Centennial Exhibition reflected their lack of opportunities and hindered aspirations: women were "too weak, too new in art" to compete with men, whose "advantages of study and of start in the race are multiplied a hundred fold."[84] Greatorex insisted, however, that American women showed promise if they pursued serious training, since "even now the woman who is inspired to begin at the grammar of painting, and instead of daubing unmeaning, imbecile pictures, submits what talent she has to an education, even with the limited opportunities afforded here, may show honest work."[85] Greatorex assumed that no permanent disability prevented women from attaining the essential skills of the artist. The basic processes of a professional art would prevail — education and merit would secure for women their deserved stature.

The reason there were no "great" women painters, Greatorex and Sartain both discovered, was unequal opportunity and a recent entry into art: history, not woman's capacity for genius, explained their position. In the first fifteen years after the Civil War, women believed they could overcome the image of the female artist as weak, dilettantish, and amateur. They distinguished themselves from popular images of the woman painter and even joined standard art criticism in dismissing the finishing-school work of previous generations and the amateur "daubing" of contemporaries. Dedicated study, high ambitions,

FIGURE 5.5. *Cecilia Beaux and Emma Leavitt in their studio in the mid-1880s. (Courtesy of the Pennsylvania Academy of the Fine Arts, Philadelphia. Gift of Cecilia Saltonstall through Tara Leigh Tappert.)*

and a new era promised respect, recognition, and greatness for the "woman artist." Sartain, Greatorex, and their contemporaries saw enormous promise. "If we have no great woman-artist," Sartain concluded, "it is because woman's hour has not yet struck. But the hand already nears the figure twelve on the dial."[86]

By the 1890s, however, the clock seemed far from striking twelve. After twenty years of training and exhibiting, historical disability no longer seemed to be a convincing explanation of women artists' position. Moreover, the question of women's creative achievements had been hijacked as that question became the underpinning of writings on biological genius. Cecilia Beaux articulated the most forceful response by directly repudiating the question of sex in art and reaffirming the ideal of professionalism (fig. 5.5). She insisted

she "[did] not much believe in the question of sex in art." There was no specifically "girl-art-student side of the question," she argued, even in an article titled "Why the Girl Art Student Fails." [87] Individual nature and discipline, not sex, determined the art student's success.

In other, less direct forms, many women repeated Beaux's response by insistently returning to the theme of professionalism well into the early twentieth century. When Marie Danforth Page found her reputation shaped by a single painting, she asked an interviewer not to mention it. "I am sick and tired of having that . . . picture, which is not better than many others that I have done, always referred to," she told him, adding, "No painter cares to be known by one picture, you know." [88] Many reviewers claimed that the woman in this picture, *Tenement Mother*, typified purity, an idea that Page vociferously repudiated. She was clearly reluctant to be known not only by a single painting but also by a painting whose maternal theme was often assumed to be a distinctively feminine expression. Attempting to exert control over her reputation, Page tried to establish a wide-ranging professional image that would transcend particular themes, images, or idealized values associated with women.

In a 1915 article on flower painting, Maria Oakey Dewing also refused the equation of a feminine art with a feminine expression, continuing, instead, the Gilded Age themes of intertwined professionalism and refinement. She insisted that this supposedly most feminine of genres actually required great technical skill and poetic feeling. Dewing called for the correct drawing of flowers, as was the standard expectation of the human figure. "Let not the student think that flower painting is the business of the amateur," Dewing insisted; rather, the "grammar of standards" applied fully to the flower painter, who should demonstrate the highest technical ability. She also argued that flowers offered a "removed beauty" that was both "abstract" and "exquisite": neither mundane nor trivial, flowers provided artists with an opportunity to explore some of the deepest levels of beauty and meaning. Implicit in this defense of the ideal beauty of flowers was enduring faith in art's need to embody refined sensibilities. For Dewing, as for many women, refinement continued to be a companion of professionalism in sustaining women's access to the highest art.[89]

As Dewing's dismissal of the amateur suggested, commitment to professionalism remained essential to marking the boundary between the serious and the daubing. Many established women disliked the easy availability of art study because, as Anna Lea Merritt claimed, "of all businesses *art* is the most popular and fashionable. Therefore an excessive number of young ladies with very moderate ability come to art for a living." [90] Decrying the "excessive"

number of young women in art schools allowed Merritt to defend professional standards and, hopefully, preserve the ground serious women had already gained for themselves. In a sense, professional women artists wished to relegate the qualities of "feminine art" for which they were dismissed to the set of women called "amateur." To try to contain "feminine art" to the amateur was never particularly effective; instead, it was a tactical maneuver that reproduced the problem of essentialist rhetoric rather than directly challenged it. Generally, the rhetorical framework that emerged in the 1890s frustrated this generation of women artists. They persisted in articulating the ideals of professionalism because those ideals contained a commitment to merit and objectivity that advanced their position, but they were not able to formulate a head-on response that would keep doors open and promise to align them with men the way professionalism had done.

Women's identity was also at stake in deeper, more profound ways within the new framework. Although a career and public life for a woman contravened gender expectations throughout this period, the official gender neutrality of professionalism at least gave women a point of entry that the association between art and refinement reinforced. The shift in language brought women careerists' violations of gender roles into sharper relief. Marie Bashkirtseff, the young Russian artist whose frank diary expressed her ambition and desire for fame, became a symbol of the conflicting demands on women when the diary was published in 1890. All the major magazines printed reviews of the diary, and many used it as an occasion to question the womanliness of women artists, to call them unnatural, and to challenge the legitimacy of their ambition. In Century Magazine, one writer made clear, with extraordinary virulence, Bashkirtseff's challenge to men: "The generality of men do [sic] not easily pardon an egotism which encroaches upon their own, an ambition which measures itself with theirs, and an absence of reserve which seems the very abdication of womanhood. To state the case against her: we must look upon her almost as a monstrosity—an abnormal and irrational being, entirely unworthy of our attention, sympathy, or respect."[91] Needless to say, Bashkirtseff provided a highly publicized object lesson to women of the dangers of fully embracing an artistic identity.

These sharpened conflicts between the "reserve" of womanhood and the "egotism" of art made it more difficult for women to formulate and argue for positions in their own defense. Writings by women in this period are filled with strange, unexpected contradictions. Nowhere is this more evident than in Anna Lea Merritt's "A Letter to Artists: Especially Women Artists," which changes direction from paragraph to paragraph and, occasion-

ally, from sentence to sentence. Merritt insisted that women had been "fairly treated" in exhibitions even though no women had been elected to the British Royal Academy (where Merritt, based in London, exhibited regularly). Still, she argued that when a deserving woman came along, that woman would be elected.[92] Although Merritt broke the unofficial silence of women on their arbitrary exclusion from meaningful honors and positions of power, she could not sustain her critique of the Royal Academy. In the end, she reaffirmed her faith in the fundamental meritocracy of the art world.

In fact, Merritt immediately shifted her attention away from the art world and its institutions, suggesting that "the inequality observed in women's work [was] more probably the result of untoward domestic accidents." "The chief obstacle to a woman's success," she remarked, "is that she can never have a wife." Again Merritt proposed a quite radical analysis of women's position, linking their failures to the social and historical arrangements of domesticity. Again, however, Merritt embedded within this analysis its own contradiction: "Women who work must harden their hearts, and not be at the beck and call of affections or duties or trivial cares. And if they can make themselves so far unfeminine, their work will lose that charm which belongs to their nature, and which ought to be its distinction."[93] There is no way out of this conundrum. To succeed, women had to abandon traditional domestic duties, but if they did so, their art became worthless because they had unsexed themselves. The result: Merritt, a staunch defender of professionalism, suddenly insisted on "feminine art." Never a very profound or consistent thinker, Merritt could not work her way out of these contradictions, and she was not alone. Most women artists in this period never fully resolved the tensions between belief in meritocratic professionalism and the experience of ongoing discrimination, that is, between artistic and female identities. Still too close to the change in rhetoric and still too effectively marginalized within the profession to mount an offensive response, this generation never circumvented the rhetoric of individuality and virility. Instead, that rhetoric boxed women into contradictions between professional and sex identities more firmly than ever before.

The most promising challenge to the rhetoric of "feminine art" finally appeared in 1908, in two articles by critic Mary Fanton Roberts. Roberts was a writer and editor who worked on newspapers and art magazines throughout her life; her columns and articles covered a wide range of subjects, from the arts of dance, drama, and painting to her childhood in Montana. Born in 1871, Roberts had a very different approach to her career than Mariana Van Rensselaer, who was twenty years her senior: Roberts began her career as an

independent, single woman; she believed girls should be trained for a "profession"; and she consciously sought to define careers for women in the fine arts.[94] Roberts also supported woman suffrage, which Van Rensselaer ultimately opposed. Not surprisingly, Roberts addressed the question of women in art in a way Van Rensselaer never did. Roberts supported the newest directions in early-twentieth-century art, but she was not fully comfortable either with the sex distinctions drawn by male critics or with the presumption of women's inferiority behind those distinctions. She used the occasion of an exhibition of women's art to explore these questions.

In the two articles that followed this exhibition, "Is There a Sex Distinction in Art?: The Attitude of the Critic toward Women's Exhibits" and "The Quality of Woman's Art Achievement," Roberts formulated a pathway through the thicket of writings on the "essentially feminine" that women artists would eventually adopt and develop.[95] In the first article, Roberts attacked separate women's exhibitions as "Eighteen-Thirty in expression," something that "belong[ed] to the helpless days of crinoline." She encouraged women not to succumb to "hurt vanity" or "pouting and fretting" over their rejections from exhibitions and "never for one moment [to] admit that the rejection [was] made because it [was] *women's* work." Strict professionalism and high standards were the best response. At the same time, Roberts also attacked the patronizing tone of the criticism received by the show and berated men for "let[ting] loose the floodgates of masculine sentimentality" when they wrote about women's art. Roberts granted a "compulsory sex difference in art" but called for equally serious attitudes by both women artists and male critics.[96]

Six months later, Roberts considered this "compulsory sex difference" more closely. She began by acknowledging that some "lurking suspicion" still remained that women's work was "on average distinctly inferior to man's." The question was still "not one of sex discrimination"; in fact, Roberts believed that art institutions had proved themselves largely meritocratic. Instead, the problem was one "of fundamental sex variation in expression." To explain the causes and consequences of this variation, Roberts laid out her theory of art. "True art," she insisted, "must forever reflect existing conditions of life; in other words, that painting must be saturated with the outlook of the painter, and his outlook in turn must be great or small as the life he lives affords him freedom." Roberts thus joined her contemporaries in defining art as an expression of the self, but when she applied this theory to women, she discovered historical obstacles. Women lacked the "perfect freedom of observation and expression" necessary for great art. This was not inevitable, observed Roberts, but to seek such goals required "self-immolation" of a woman—an abandon-

ment of her identity as a woman and of "her birthright as a mother and a sweetheart." Most women's art was thus "subjective, and subjected as well to her greater duties." Roberts insisted on the worth of this work, but she also reiterated the idea that women's "lovely portion" was not the realm of the "genius" that congregated on "high Olympus." To this extent, Roberts echoed her male colleagues. Still, somewhat inconsistently, she claimed that a few women had transcended "modern social conditions" and achieved "absolute freedom of soul and mind." [97] It was this critique of social conditions (the justice or injustice of which Roberts admitted she was not considering) and the language of freedom that modernist women later adopted to mount another challenge to male preeminence. In 1910, however, women artists and critics had only a tentative, somewhat ambiguous response to the rhetorical changes of the 1890s.

MODERNISM AND

SELF-EXPRESSION

"rt to me is natural expression. I painted," declared Theresa Bernstein, "before I was aware of a class called artists."[1] Although she had studied at the Philadelphia School of Design for Women and the Pennsylvania Academy of the Fine Arts, Bernstein understood her work in terms alien to the academic tradition these institutions represented. To define art as a "natural expression," independent of any skilled training, left the nineteenth-century culture of refinement and professionalism far behind. Bernstein had followed the well-defined path that Louise Cox had blazed into academic training, but modernist works she saw in Europe in 1912 and at the immense, shocking display at the Armory Show in New York in 1913 redirected her sensibilities. She began to work in an urban realist style. Bernstein, never among the most avant-garde of this generation, avoided abstraction throughout her career, yet she understood her own work in the idiom of the modern movement.[2]

Once she had adopted an urban realist style, this young artist pursued a vigorous career. She exhibited widely and gained critical recognition. Her work prompted John Sloan to note in his diary in 1914, "We should all keep our eyes on Theresa Bernstein." By the late teens, reviews regularly linked Bernstein to leading Ashcan painters such as Sloan.[3] After her marriage in 1919 to artist William Meyerowitz, Bernstein deferred somewhat to his career, yet her work in the 1920s demonstrates a continued expressiveness and interest in urban street life and popular culture. *Lil Hardin and Louis Armstrong* depicts the quintessential 1920s symbol of America—the jazz concert—in vibrant yellows and with energetic, pulsating paint handling. In subject matter and style, Bernstein displayed her avant-gardism—and her membership in a new generation of artists and women (fig. 6.1). Bernstein's aesthetic modernity seems a minor chord to strike compared with Georgia O'Keeffe's dominating presence in histories of modernism, and I return to O'Keeffe as a compelling symbol of the female modernist at the end of the chapter. But Bernstein's

FIGURE 6.1. *Theresa Bernstein,* Lil Hardin and Louis Armstrong, *oil on canvas, ca. 1927. (Courtesy of Private Collection, Texas. Photograph by Stanley Jesudowich.)*

more modest history resembles decisions made by many women to experiment aesthetically and to embark on a new identity for the "woman artist." Her career reminds us to suspect histories that replicate the early modernist construal of O'Keeffe as the true (and only) female modern.[4]

Bernstein promoted the summer art school she founded in Gloucester, Massachusetts, in modern terms. We give our students, she said, "a method so fundamental that it fits any art expression."[5] The idea that art was an "expression" and that there could be the pluralistic, individualistic approach implied by "any art expression" epitomized the modernist approach to art. Early-twentieth-century advanced artists celebrated self-expression above all else and understood that self-expression within the same biological frameworks established in the late nineteenth century (overlaid with a heavy dose

of Freudian psychology and modern sexology). Bernstein herself accepted this organic definition: art was "natural expression." For many in Bernstein's generation these premises held substantial appeal. They found in modern modes authorization for a new self-understanding and release from confining respectability.

Modernism promised escape: its aesthetics repudiated refinement and restraint; its context of a bohemian avant-garde questioned convention and social custom as a matter of course. Encountering feminism and a new language of critique, female modernists were able to articulate their discontents with a male-dominated art world more forcefully and directly than the previous generation. They would eventually rework metaphors of "essential femininity" into a looser, far more variable "flavor of sex" (which, in turn, gained legitimacy by an aesthetic politics of experimentation and antiorthodoxy). In the modernist art world of the teens and twenties, women artists steered a path through the vitriol of their male peers by relinquishing the gender-neutral individualism of professionalism for a new kind of individualism. This was a dangerous path given the masculinized meanings adhering to self-expression, but women artists attempted to shed those meanings and reconfigure the modernist project.

It is tempting to tell only this story, to celebrate these modernist women. They seem, at last, free as artists and people of the straitjacket of gentility. The true legacy is more complex. Just as professionalization created openings and closures for female artists, so did modernism. Its institutional shape depended heavily on a market dominated by gallery and dealers. And when male modernists privileged the notion of self-expression, they reaffirmed ideas about "essential femininity" that continued to construct the "woman artist" as she had been by the discourse of the 1890s. The possibility of female self-expression existed (a crucial opening that, as I have suggested, modernist women exploited), but it remained something limited to an essential womanliness, a womanliness increasingly reduced to female sexuality.

Explaining this continued adherence to nineteenth-century versions of the woman artist requires a fresh look at the history of modernism. Modernism's birth has been bequeathed to us as a critical rupture, a thankful escape from the dead weight of Gilded Age refinement. Modernists, we've been told, arose to respond to the machine, the arcade, and the polyglot street.[6] By the early teens, according to the standard account, bourgeois culture appeared smug and stultifying, pushing artists to find a way around oppressive social norms and the "weightless" banality of excessively feminized gentility. The experiences of industrialization, urban growth, immigration, and consumerism

standing behind this characterization of genteel culture stimulated a reaction, and modernists undoubtedly rebelled against Victorian evasiveness and corseted respectability. What has been more recently recognized is that women's new roles constituted a central component of the social and economic ruptures we now label "modernity." [7] The widely popularized New Woman of the turn of the century entered a stunning array of previously male realms—from politics and social reform, universities and professions to art and bohemia. For those living through the shocks of modernity, often its most immediate and intimate impact was in the claims women made to a new standing in society.[8] If one was a man among the avant-garde, or even circulating at the fringes of bohemia, it was de rigueur to proclaim the legitimacy, and indeed necessity, of women's equality. Avant-garde men, historian Christine Stansell has explained, envisioned themselves as women's "coconspirators" in shaping a modern world.[9] In the modernist milieu, proclamations of artistic liberation became entangled with women's liberation, even when artists and their critic supporters defined the latter incoherently.

But this narrative of rupture, release, and liberation obscures continuities and occludes the gender politics shaping American modernist art. Given their professed adherence to equality, we might expect avant-garde men to welcome female colleagues as equal partners. That simply did not happen. First, modernism was not simply an easy break with the past. Its contours and content were the culmination of a male-led drive, first articulated in late Gilded Age discourses and institutions, to reassert control over culture. Faced with female producers of art populating classrooms and exhibition spaces and with a well-ensconced correlation between art and an effeminate, overly refined culture, male struggles since the Civil War to secure the professional status of the artist seemed futile. Other social and cultural trends reinforced the male reaction to female challenge. A turn-of-the-century reconfiguration of white middle-class manhood that placed a new imperative on aggressive sexuality and male virility strengthened resistance to refined gentility.[10] The rising tide of imperialism and nationalism at the turn of the century only reinforced a cultural masculinism.[11] Finally, the mass scale of the woman suffrage movement and the high visibility in artistic circles of feminism strengthened the perception that women had mounted a substantial and effective challenge to male dominance. Male modernists thus professed disinterest in professionalism and turned instead to the language of individuality and the celebration of style first formulated in the 1890s as the most promising avenue to reclaim art and their authority.

Modernism appeared surprisingly congenial for recouping culture. Theo-

dore Roosevelt, advocate of the strenuous life, has been infamous for, Philistine-like, attacking the most advanced cubist art at the Armory Show, which first exposed the broad public to modernism. Most commentators have missed, however, Roosevelt's extensive praise of the moderns: "There was not," he declared, "a touch of simpering, self-satisfied conventionality. . . . There was no stunting or dwarfing." Those with something to say had expressed themselves.[12] Culture, so freighted as feminine and refined, served as a compelling ground even for the military-minded Roosevelt for reworking male authority in turn-of-the-century America. Modernists, elaborating Roosevelt's basic logic, rewrote the meaning of high culture. The true purpose of art — and of culture in general — modernists believed, was to stimulate liberation from arbitrary social constraints. That liberation was modeled by the artist's own process: a heroic act of self-expression. The artist's individual liberation from convention and expression of his deepest self demonstrated freedom, change, and renewed cultural vigor. Another reason male modernists never allowed much female access to the new art was to protect this idea of creativity, an idea at the very heart of their ideological purposes as modernists. Inheriting their definition of creativity and genius from the previous generation, modernists gave individuality ultimate priority.[13] But to rely on the 1890s formulation of creativity was to carry forward its deeply gendered and deeply biological character. Modern psychology, which spread widely in the early twentieth century, strengthened and affirmed the Darwinian logic of biological genius. Modernists' insistence on the expression of the self actually deepened the divide between men's and women's art as the root of selfhood seemed ever more conditioned by sex. Both Darwinian and psychological theories presumed that the self was irrevocably gendered, so when modernists defined art as the expression of the self, they expected the artist to transpose that gender to the canvas. To reconsider women's roles fully — to view women as equal talents — could have very well called into question the polarities (and hierarchies) of the modernist tenets of individual self-expression.

As male modernists gendered creativity, they simultaneously gendered the "freedom," the liberation, women embodied in a post-Victorian world. In these male formulations, to be a free woman was often simply to be sexually available and sexually expressive. There is, therefore, a final reason why modernist male artists and critics guarded their control over modernism so intensely. They wanted to protect their understanding of modernity, an understanding that was in many ways predicated on a highly male-constructed version of the "liberated" woman. The experimental dadaists, for example, idealized the American New Woman as Amazonian and insatiable. They often

incorporated this dynamo into their works depicting anthropomorphized machines, representing machine and woman as equivalent signs of modern reality.[14] As with creativity, to relinquish control over the image of the liberated woman was to risk a central aim of modernism to devise an art of modernity. After all, welcomed in fully, women artists might contest male accounts of modernity to which they were deeply wedded.

While the purposes of high culture — authentic, individual self-realization — became a masculine enterprise, modernists consigned other purposes of culture to the discarded Victorian feminine. They associated amusement, entertainment, and uplift with women and femininity by way of the lowbrow and middlebrow. Middlebrow culture, in particular, repackaged the genteel tradition, preaching cultural uplift, refinement, and taste in twentieth-century mass media, for twentieth-century mass consumption.[15] The modernist masculinization of high culture meant relinquishing claims to universality and retreating from the belief that culture was an avenue to class unity. The cultural politics of modernism cannot thus be simply figured as liberatory. The gender dynamics underwriting American modernism contributed to a formation that was not only masculinist but also elitist and antidemocratic. From hermetic, ironic assemblages to mystical, yet impenetrable, organic abstractions, modernists created art difficult for a popular audience to interpret, if not downright hostile to mass consumption. Overthrowing "feminine refinement" installed a constricted vision of an art that appealed only to the enlightened few.[16]

Theresa Bernstein painted contemporary urban life — the streets, the elevated railroad, employment waiting rooms, the beaches, suffrage parades. Public settings, many of them new, popular amusements, they would have been inaccessible to an older generation. Women artists of this older generation had been born between 1840 and the late 1860s and had entered art schools between 1860 and 1890.[17] It was a second generation of women who came of age in the 1890s and after, however, who became modernists.[18] Of course, like the majority of their male colleagues, many in this new generation continued to paint in academically influenced styles that sold more readily than modernism well into the twentieth century, despite the critical and popular attention modernism received. These women followed the paths set out by the previous generation, still able to draw on the market niches and achievements of their predecessors. Lilian Westcott Hale, for example, won many prizes, including a gold medal at the 1915 Panama-Pacific Exhibition; exhibited widely; and was elected to the National Academy of Design in 1927. Lilian Hale forged

her successful career from major exhibitions, portraiture, and the support of a network of women artists, still combining many of the same elements her sister-in-law Ellen Day Hale had drawn on, even though Lilian Hale, born in 1880, was twenty-five years younger.[19]

Women artists of this second generation who embraced greater aesthetic experimentation joined a generation of New Women exploring a world beyond the respectable confines of genteel society. Much of this exploration took place in the radical atmosphere of New York's Greenwich Village, where avant-garde artists of both sexes participated in the simultaneous loosening of academic standards and the unfettered talk, social liberation, and political activism that characterized Village mores. Women modernists thus belonged to a generation of women and to a generation of artists.

As New Women, they were members of the generation interested in feminism, in flouting conventions, and in deliberately undermining the ideal of the true woman. The expansion of higher education, the many college graduates entering the professions, a growing female waged labor force, and mounting strength in the suffrage movement all signaled widening opportunities for women. These young women in turn self-consciously rejected Victorian womanhood. As labor journalist and avant-garde Provincetown Player Mary Heaton Vorse trumpeted: "I cannot imagine anything that would affect better the moral health of any country than something which would blast the greatest number of that indecent, immoral institution—the perfect lady—out of doors and set them smashing and rioting."[20] The most radical of the New Women embraced sexual liberation and female economic independence—the two beliefs that most shaped the new movement called feminism. In the name of all women, feminism validated the full development of female selfhood and, significantly, the pursuit of individual aims. Speaking for the Feminist Alliance, Henrietta Rodman, the group's founder, declared that feminists wanted "the award of all rights and duties in all fields on the basis of individual capacity alone."[21] As historian Nancy Cott has summarized, "By the early twentieth century it was a commonplace that the New Woman stood for self-development as contrasted to self-sacrifice or submergence in the family. Individualism for women had come of age, so to speak."[22] Feminism's individualism reaffirmed the individualism that lay at the core of professionalism but legitimized, in addition, female autonomy and self-realization. Since self-realization and individuality were articles of faith for modernism, feminism helped authorize a female embrace of modernist aesthetics.

As artists, the women were the same age as the Ashcan and early modernist painters populating Greenwich Village circles.[23] It was this generation of

men who fully abandoned the genteel and academic modes of sympathy and sweetness in art, making Ashcan painters the first full exemplars of the new "virile" painting and modernists their ultimate successors. The Ashcan artists developed their ideas about art at the turn of the century, first in Philadelphia and then in New York. They argued that academic art was dead and that painters should take up the "real" life of the city exploding around them. Critic Helen Appleton Read recalled that "life seemed to the [students of this new movement] to flow stronger and fuller in Bowery bars and riverfront alleys than in the Knickerbocker Hotel or in the fashionable streets of the upper east side." [24] In Robert Henri Ashcan artists found an articulate leader, savvy about the mechanisms of publicity. His role reprised the part William Merritt Chase had played among the Victorians. He cultivated a loyal circle and devoted much of his time to teaching and promulgating his views on art. He stressed vigorous, rapid brushwork with "broad, loose brushstrokes" and opposed small brushes because they promoted "delicate detail" rather than overall effect and impact. Although Henri's subject matter took him far from the genteel scenes Chase had depicted, he shared with Chase "an affinity for rapid, virtuosic paint handling," tying him to the critical revaluation that stressed style and masculine vigor.[25] In his famous Saturday afternoon composition classes Henri would examine the students' scenes of the city around them. "I do not want to see how skillful you are—I am not interested in your skill," he would intone. What mattered was the individual truth of the picture. Stuart Davis recalled, "Art was not a matter of rules and techniques, or the search for an absolute ideal of beauty. It was the expression of ideas and emotions about the life of the time." [26] Henri even titled an article he wrote in 1909 "Progress in Our National Art Must Spring from the Development of Individuality of Ideas and Freedom of Expression: A Suggestion for a New Art School." [27] Throwing out the decades-long battle for academic standards and educated skill, Henri shifted the artist ideal from cool professional to forceful individualist.

Representations by Henri and other Ashcan artists of urban nightlife, commercial amusements, and boxing arenas appeared to many to embody the masculinity and virility called for in turn-of-the-century criticism. Henri played a paradoxical role here. He had many female students, supported woman suffrage, and socialized nightly with women aspiring to be artists, but ultimately preached artistic manhood. He inserted masculinity in the place of gentility and academicism. "Be a man first, be an artist later," Henri told his students, sending them to intensely male urban settings to find "real life." [28] From the

beginning, then, radical artists purveyed artistic manhood while ignoring the actual New Women sitting across café tables from them.

Ashcan realists attained their greatest notoriety in 1908 when they exhibited together as "The Eight" in protest over their exclusion from the 1907 National Academy exhibition. After 1910, however, Ashcan painters began to drift away from their most shocking urban realism, and the push toward innovation passed to a slightly younger group.[29] Modernist painting had come to America through several channels before 1910—expatriate collectors and the young artists who visited them, a few small galleries, and the little magazine *Camera Work*, edited by Alfred Stieglitz—but it did not attract real attention (or infamy) until the 1913 Armory Show. This exhibition included more than sixteen hundred European and American artworks and outlined the development of modernism through the most recent and the most radical fauve and cubist developments. Although known mostly for the shock it gave to bourgeois sensibilities, the Armory Show inspired American artists to experiment with modernist methods and established modernism as an important new direction in American art.[30]

As conduit to Europe, Alfred Stieglitz performed the role of impresario of modernism in pre–World War I America. Starting in 1907, his gallery showed the work of Rodin, Cézanne, Matisse, and Picasso, exposing many Americans to their work for the first time. Stieglitz and Henri were much alike. Both liked to proselytize; both cultivated circles of dedicated followers; and both called for an authentic art and true expression.[31] "The dry bones of a dead art are rattling," Stieglitz said, sounding like Henri. We are witnessing the "hopeful birth of a new art that is intensely alive."[32] Visitors to Stieglitz's 291 Gallery remembered an environment in which every aspect of art was up for grabs, in which there were no orthodoxies, and in which self-expression was prized above all else. "Why should you presume to tell an artist what to do? When he is working," Stieglitz avowed, "he is only satisfying a need of expressing something which is within him."[33] Like Henri, Stieglitz inflected self-expression with masculine overtones. He undoubtedly agreed with the prevailing perception that American art had been dangerously feminized. The critic Charles Caffin, a frequent contributor to *Camera Work* and tutor to Stieglitz in modern art, often emphasized the dangerous "superabundance of the feminine in painting" and expressed concern at the weakness of "force or conviction" in American art.[34] "I have always been a revolutionist," Alfred Stieglitz declared late in his life.[35] Revolution, however, had a distinctly gendered meaning, and Alfred Stieglitz would invest heavily not only in the overthrow

of a high culture of refinement but also in the promotion of a highly circum-scribed vision of the female avant-gardist. For him, Georgia O'Keeffe would famously embody this woman artist.

By the late teens, the American modernist art world had grown more com-plex, with a greater array of galleries showing the moderns, a developing base of patronage, and divisions among modernists becoming apparent. Alfred Stieglitz, well known for his discomfort with "vulgar" modern metropoli-tan life, promoted artists who countered materialism and commercialism with a symbolist, mystical-spiritual approach.[36] But others more readily em-braced the visible signs of modern consumerism and industrial capitalism that Stieglitz rejected. During World War I a number of French expatriates—among them, Marcel Duchamp, Francis Picabia, and Henri-Pierre Roché—led American artists to dadaism. With a strong ironic and witty sensibility, dadaists set themselves a task opposed to Stieglitz's idealized modernism: the "deliver[ance of] art from the clutches of its worshippers."[37] They made modern things such as the machine, the mass-produced factory product, and the billboard and advertisement the basis of art. Central to their celebra-tion of modern America was the young woman, with French artists priming American colleagues to view the American woman as independent, sexually dynamic (but untutored), and a useful correlate to the machine as a symbol of America's modernity. Ultimately, the gender politics of dada were not all that different from Robert Henri's or Alfred Stieglitz's: investigation of artistic male virility, greatest comfort with real women when they were dinner com-panions and lovers, and preference for the erotically charged woman rather than the masterful woman artist.[38]

The arrival of dadaism during World War I initiated a more fragmented modernist art world in the 1920s, with many groups—Stieglitz's circle, the da-daists, and, later in the decade, the precisionists—in tension over who would predominate and who, in an era of cultural nationalism, would make the true American art.[39] Although this chapter ranges across the two decades from 1910 to 1930, it does not relate the full story of these internecine rivalries; it does not attempt to be comprehensive in its history of modernism. Rather, it focuses on women artists and highlights continuities between the institutional and rhetorical formation of modernism and the art world encountered by the previous generation, linking the gender dynamics of the twentieth-century art world to the transformations wrought by the rise of female professionals in the nineteenth century. And because Alfred Stieglitz was so effective, so early on, at presenting Georgia O'Keeffe as the archetypal female modernist, the chapter privileges his circle and turns to O'Keeffe in order to explore one

last time how women, with O'Keeffe as exemplar, negotiated the construct "woman artist."

At the nexus of the New Woman and the new art was the female modernist. First in Paris and then in New York, avant-garde women loosened their dress, discarded Victorian morality, and turned a little "wild." Marguerite Zorach arrived in Paris in the fall of 1908 from Fresno, California, in time to see the Salon d'Automne, where dramatic fauve and postimpressionist paintings hung in the galleries. These paintings transformed her. Anne Goldthwaite remembered that when they met, Zorach "wore her tight little New England tailored suit over her slim form." Each day "her gray suit became a bit more flowing . . . and her blouse a little brighter blue."[40] During her first few months in Paris, Zorach visited Gertrude Stein and looked over her famous collection of modernist art, including works by Cézanne, Matisse, and Picasso. Zorach was one of many women who would drink tea with Stein and Alice Toklas and attend their salons, where they met Picasso and other avant-garde artists.[41] Zorach enrolled at a traditional academy, the Ecole de la Grande Chaumiere, but lost interest after a couple of months and began to work instead at the Académie de La Palette, where she studied under Scottish artist John Duncan Fergusson.[42]

Fergusson introduced Zorach to postimpressionist and fauve techniques, including strong, unmixed color; direct, energetic brushstrokes; and minimal modeling of form. Zorach embraced these methods. One work in progress, according to her future husband, William Zorach, was "a pink and yellow nude with a bold blue outline."[43] He "couldn't believe such a nice girl could paint such wild pictures."[44] Marguerite persuaded William of the value of modern art. "You look at things in such a big original way," he wrote her. "The wonderful thing you have taught me is to be myself and do my own thinking and not to worry about the laws and rules laid down hundreds of years ago and not to fear what other people that never use their brains think."[45] That freedom to "be myself" and discover one's own vision regardless of old "laws and rules" was quintessentially modern and something that Zorach cherished. "I don't mind if my things are a little wild over here," she declared; "there'll probably be enough restraining influences at work when I get home."[46] Other women also prized the liberating experiences of study in more advanced ateliers. Anne Goldthwaite helped found the Académie Moderne, where the fauves and Cézanne were influential. Painter and printmaker Blanche Lazzell would write her sister, "I like it very much at the Modern [sic] and feel that I am at last in my element."[47]

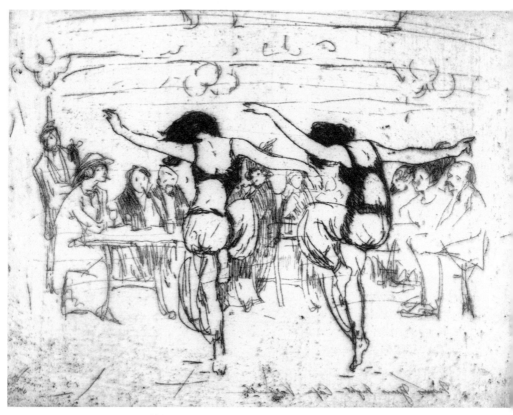

FIGURE 6.2. *Anne Goldthwaite,* At Montmartre, *etching on paper, ca. 1910. (Courtesy of the Montgomery Museum of Fine Arts, Montgomery, Ala. Gift of Lucy and Richard Goldthwaite.)*

Outside the atelier, these women participated in a community much less constrained by the demands of respectability than the previous generation. According to Anne Goldthwaite, avant-garde art students thought "that they were not 'living' unless they ate at the Chat Noir on the rue Odessa, or at least Boudet's Le Duc's," where they could "sit with young men at restaurants."[48] Goldthwaite's etching, *At Montmartre* depicted New Year's Eve at the Café Versailles around 1910 (fig. 6.2). The scene is hardly one of genteel refinement, as exotically clad dancers perform before tables of men and women. One young woman at the left of the picture has a cigarette hanging from her mouth, a wine glass set solidly in front of her. *At Montmartre* makes light of the missing chaperones that had kept Mary Cassatt from artists' parties and the fear of conveying the wrong impression that had kept Cecilia Beaux from men's studios. This etching places Goldthwaite in the café—an observer and, by her presence, a participant in the night's revelry.

Marguerite Zorach's friends included the Englishwoman Jessica Dismorr, with whom she shared a studio, and American Anne Estelle Rice, who had a long-term (although unmarried) relationship with John Fergusson. Rice, Zorach, and Dismorr became part of a mixed-sex artistic and social community. They joined Fergusson in illustrating and publishing an avant-garde little magazine called *Rhythm*, which featured work by leading French fauve artists. When Zorach returned to the United States and had her first one-woman exhibition in Los Angeles in the fall of 1912, she listed Rice along with Fergusson, Matisse, and Picasso as the artists influencing her.[49] Rice and Fergusson kept a regular table at the Café d'Harcourt, where they went every evening to sketch. Rice also went to artists' dinners that were long considered all-male affairs, to dance halls, and even to a brothel to see some works by Toulouse-Lautrec.[50] Still forbidden territory for all but the most adventurous, Rice's forays represented the Parisian experience possible in avant-garde circles.

Both Goldthwaite and Zorach submitted canvases to the 1913 Armory Show. They arrived in New York in time to see the show and to find avant-garde circles much smaller than in Paris but still challenging bourgeois conventions and promising new freedoms for women.[51] Young avant-garde women like Zorach and Goldthwaite joined men in the salons, cafés, and studio events. May Wilson Preston, Edith Dimock Glackens, and Florence Scovel Shinn gathered with male Ashcan artists at the Café Francis and Mouquin's. One evening, after many attempts, Edith Glackens finally succeeded at the popular "Frog Game" at the Café Francis. According to family lore, just as her iron disc finally landed in the frog's mouth, her drawers fell to the ground around her feet. With great aplomb, Glackens "stepped out of them, tucked them into her purse, and went right on to score again, amid great applause." May Preston, Edith Glackens, and another friend shared a studio in the Sherwood building and became known as "The Sherwood Sisters" for the fun and amusement at their weekly studio open house. Marjorie Organ Henri recorded her presence at the Thursday studio evenings she and her husband held with wry sketches of the male and female participants.[52] Some women met men in bedrooms as well as cafés and, along with other bohemians, made sexual experimentation part of the avant-garde life. Beatrice Wood recorded simultaneous love affairs with visiting Frenchmen Henri-Pierre Roché and Marcel Duchamp during World War I.[53]

Avant-garde artists mingled with other Greenwich Village bohemians at salons, the most famous of which was held by Mabel Dodge Luhan. She began holding her evenings in May 1913, with invitations that described her apartment as "a meeting place which will be in the nature of a club where both men

and women can meet to eat and drink and talk together."[54] Whatever the subject matter, however risqué the conversation, women and men both attended. At Luhan's soirees, people from New York's bohemian and reform circles gathered: avant-garde artists and writers, socialists, feminists, and progressive reformers. Each evening had an honorary theme for discussion. Anarchist and feminist Emma Goldman led one; the popular Freudian psychologist A. J. Brill was featured at another; Hutchins Hapgood refereed a discussion of sex antagonism; Carl Van Vechten brought in two performers from Harlem. "Dodge's Evenings," one historian has aptly noted, "were a combination of town meeting, bohemian Chautauqua, and cocktail party."[55] Art was not necessarily the centerpiece of the salon as it was at the Steins, but Luhan's involvement with modern art brought luminaries such as Alfred Stieglitz to her apartment, and modernist canvases hung on the wall.

As *saloniére*, Mabel Dodge Luhan made it her business to be well connected, publicizing the Armory Show, contributing to Alfred Stieglitz's *Camera Work*, organizing artists and radicals for the Paterson Strike Pageant in support of striking silkworkers in 1913, and, in the pivotal summer of 1915, joining the Provincetown Players.[56] Summer art colonies had long attracted both male and female artists and provided a more relaxed and open social environment. After 1911, the avant-garde made Provincetown on the tip of Cape Cod their favorite haunt, and by the summer of 1915, as the first exhibit of the Provincetown Art Association opened, the local newspaper reported four art schools and two hundred to three hundred artists in town.[57] Painter and printmaker Blanche Lazzell wrote her sister after the exhibition's opening, declaring delightedly, "The town is alive with artists. I was at the opening reception of the Exhibition of the Art Association of Provincetown yesterday. Saw some people I knew in Paris. A fine crowd. I was certainly in my element, among the artists, back from Europe."[58] The Provincetown Players, an amateur theatrical group, brought together once again a heady mix of artists, writers, and radicals. Among them were Mabel Dodge Luhan; radicals Max Eastman and John Reed; actress, lawyer, and sculptor Ida Rauh; writers Neith Boyce and Susan Glaspell; and modernist artists Marsden Hartley, Charles Demuth, and Marguerite and William Zorach. The Players' dramas explored free love and infidelity, satirized popular Freudianism, moralized about the conflict between old and new art, and allegorized political and social injustices. Hartley would later describe that summer as "really huge in import, and huge in various satisfaction."[59]

Luhan's energetic circulation through bohemian and avant-garde circles reveals the spirit of exploration, the self-conscious creation of heterosocial

worlds, and the disregard for codes of respectability that characterized Greenwich Village in the teens. Marguerite Zorach's perambulation through these same circuits reveals some of the ways the world of the progressive female artist had changed. In Provincetown in 1915, Marguerite Zorach and her husband were intimately involved in the Players' theatricals. There they shared ideas with painter friends Marsden Hartley and Charles Demuth. In this period, they also became involved with a little magazine devoted to new poetry, *Others*. The *Others* crowd met on Sunday afternoons in New Jersey for picnics, poetry readings, and editorial discussions. At the *Others* picnics, Zorach would have met Walter Arensberg, a dedicated modern art patron and *saloniére* himself; Alfred Kreymborg, the magazine's editor and a connection to the Charles Daniel Gallery, where Zorach was exhibiting; Marianne Moore, whose portrait Zorach would later paint; and dada artist Marcel Duchamp. Duchamp also provided a connection to the Stettheimer sisters. Etta, Florine, and Carrie Stettheimer held an upscale salon, with elaborate, proper dinners. Duchamp attended frequently, as did Gaston and Isabel Lachaise (who became one of Zorach's good friends), Marsden Hartley, and the Zorachs. Florine Stettheimer was a painter of limpid, brightly colored avant-garde portraits and tableaux that memorialized important events hostessed by the Stettheimers. In each, men and women in witty and pointed caricatures converse, party, and observe one another. Marguerite Zorach's connection to the Stettheimers is recorded in the miniature painting that hangs in the intricate and marvelous dollhouse created by Carrie Stettheimer.[60]

Marguerite and William Zorach made their home in the heart of Greenwich Village on West 10th Street, where they could not have missed its bohemian landmarks. Their own apartment was brightly and dramatically painted, with murals and batiks by Zorach (fig. 6.3). Walking out the door, they could have entered famous cheap eateries such as Polly's Restaurant, where patrons ate at trestle tables and mingled with other Village habitués. At night they could have attended costume balls and parties, such as a "Futurist Ball" or a "Red Revel," where dances were far from respectable and the hours were late. Floyd Dell would later remember those balls as marvelous affairs: "They were spontaneously joyous and deliberately beautiful, focusing in a mood of playfulness the passion for loveliness which was one of the things that had brought us to the Village." Many of these balls were sponsored by cooperative clubs and societies, such as the Liberal Club, whose male and female members organized marches, gossiped, looked at rotating exhibitions of advanced art, met with the feminist Heterodoxy Club, and held weekly lectures and symposia. Among the Liberal Club's members were the Zorachs and their good

FIGURE 6.3. *Marguerite Zorach in her studio, Greenwich Village, 1913–14.*
(Zorach Family Papers, Archives of American Art, Smithsonian Institution)

friends Marsden Hartley and Charles Demuth.[61] Zorach also exhibited with
the People's Art Guild, where she undoubtedly met Theresa Bernstein and her
husband, William Meyerowitz.[62] Zorach exhibited and worked with virtually
all of these people—men and women—at one time or another. The infor-
mal professional networks that had been sex-segregated in Paris and then in
America had shifted their tenor. Of course, male bonhomie still generated
barriers for women, but Greenwich Villagers were highly self-conscious about
gender roles, and the avant-garde provided women with unprecedented social
freedoms.

That self-consciousness translated into an engagement with feminism for
virtually all the artists. Neith Boyce's play *Constancy* delved into free love, in-
fidelity, and their effects on a woman tangled in an affair. It was the Province-
town Players' first play. Boyce and Susan Glaspell both wrote feminist plays
for the group, and other feminists including Mary Heaton Vorse (the jour-
nalist and activist who wanted to smash ladyhood to bits) were among the
members. Georgia O'Keeffe and her roommate and fellow art student Anita
Pollitzer had read Susan Glaspell's *Fidelity* and worried over the implications

of a book that validated sexual passion over traditional morality.[63] One of the leaders of the Liberal Club was Henrietta Rodman, a founder of the feminist Heterodoxy Club. The great, mass suffrage campaign of the teens received universal support among women artists. Theresa Bernstein described "working for the franchise for women, amid much activity and debate." At her clubs—the Women's Professional League and the Catherine Lorillard Wolfe Club—prominent speakers supported women's right to vote, and Carrie Chapman Catt, president of the National American Woman Suffrage Association, attended regularly. Bernstein attended meetings and suffrage parades, but, she explained, "My main weight in this direction was through my work, which was exhibited and discussed." [64] A series of suffrage pictures painted between 1914 and 1916 recorded her involvement in the suffrage campaign.

With feminism, this generation acquired a language and consciousness to make far more forceful declarations of discrimination against women artists than their earlier peers. In 1914, Georgia O'Keeffe studied art at Columbia Teacher's College with Anita Pollitzer. Although Pollitzer introduced O'Keeffe to Alfred Stieglitz's gallery, 291, and to modern art currents, she became a radical suffrage activist, getting arrested in protests at the White House and serving as a lifelong leader of the National Woman's Party.[65] Through Pollitzer's involvement, O'Keeffe became a founding member of the National Woman's Party and in March 1926 spoke at a dinner in honor of a party leader. She described the condition of the female artist: "If a woman painter paints differently from a man, they say, 'Oh, that is woman. That has nothing to do with painting.' They have objected to me all along; they have objected strenuously. It is hard enough to do the job without having to face the discriminations, too. Men do not have to face these discriminations." [66] An unstinting indictment, this testimonial bespeaks a consciousness wrought by feminism. O'Keeffe pinpointed arbitrary sex typing, emphasized outright male bias (carefully repeating, "objected strenuously"), and took up the modern rhetoric of discrimination.

Breaking with a restrictive aesthetic past seemed specifically meaningful to women, and female modernists equated aesthetic freedom with women's liberation. In this sense, the embrace of modernism was the embrace of the potential for women—for female liberation—embedded in the avant-garde milieu. Advanced art's proselytizers, from Robert Henri to Alfred Stieglitz, made freedom their *cri de coeur*. As Stieglitz gushed to the *New York Times* on the eve of the Armory Show, the new art was "a battle cry of freedom." [67] Like these men, progressive women believed that advanced art represented an invigorating release and wanted to liberate art and the self from stale soci-

etal standards. Theresa Bernstein chose to paint "the scene in which [she] was living, daily events of the New York streets," rather than refined settings or genteel academic compositions.[68] Her early works depicted immigrant neighborhoods, commercial amusements, and street scenes with the same gritty urban realism of male Ashcan artists. Concurring with Henri and Stieglitz, Bernstein conceived of nonacademic work as more vibrant, more directly expressive of the self, and more immediate and real.

Marguerite Zorach made a similar connection between avant-garde art and her own freedom. In July 1912, after returning to her family home in Fresno, California, from Paris the winter before, she began a month and a half of camping at Big Creek in the southern Sierra Nevada. Throughout her camping trip, Zorach felt a sense of personal release that the mountains appeared to foster. Wearing boys' clothes left behind by some of her camping companions, Zorach swam and climbed and never once had her skirts hung up on sticks and rocks. "It was great fun," she reported. "I never realized before how much freer one is in boy's clothes."[69] Zorach even felt free to transform herself into a postimpressionist canvas—wearing a vermilion middy, a sky blue hat, big tan boots, and a short blue skirt (fig. 6.4).[70] Built out of blocks of color, the clothing Zorach created for herself flouted respectable conventions. Throughout that summer, she carried on a dialogue with her future husband about their marriage, writing pointedly that she would never embody the ideal "wife" or fulfill the domestic ideal. At the same time, she completed a series of paintings that, with their compressed spaces, controlled compositions, and energetic use of color, represent the work of a confident artist. The fauve and postimpressionist style Zorach used registered freedom—of expression, of action, of the female self.

That dream of liberation propelled avant-garde art forward. Modernist women describe repeatedly a summer, a moment like Zorach's mountain idyll, when the dream was realized and the desire for liberation coalesced in aesthetic experimentation. But, in institutions and in rhetoric, that momentum dispersed: modern art galleries remained relatively inaccessible to women, and modernist aesthetic ideals impinged on the soaring sense of possibility. In three landmark early exhibitions of modern art, women had limited success. At the Armory Show, where exhibitors were accepted either by invitation or through a jury, women accounted for 16 percent of the exhibitors, about the same percentage that had been shown at the "conservative" National Academy of Design. In the Forum Exhibition of Modern American Painters three

FIGURE 6.4. *Marguerite Zorach to William Zorach, August 1912.*
(William Zorach Papers, Library of Congress Manuscripts Division)

years later, Marguerite Zorach was the only woman among the seventeen art-
ists included. And in the Museum of Modern Art's inaugural exhibition of
American artists in December 1929, the only woman among the "Paintings
by Nineteen Living Americans" was Georgia O'Keeffe.[71] Although this scant
presence could simply reflect slight interest in advanced art on the part of
women artists, the history of independent exhibitions makes such a neutral
interpretation unlikely. Hostility toward the National Academy of Design
led to the organization of a series of independent exhibitions modeled on
French Salons des Indépendants, which Americans believed nourished vitality
in French art. With "no jury–no prizes" the proclaimed philosophy of these
exhibitions, women had virtually open-door access. The first of these, the 1910
Exhibition of Independent Artists, responded to National Academy hege-
mony by exhibiting more than 500 antiacademic and modern works. Women
made up 25 percent of the 103 exhibitors.[72] When the Society of Independent
Artists was founded seven years later, its organizers included many who had

been associated with the "independents" movement, such as Ashcan artists George Bellows and William Glackens. But it was the extensive involvement of modernist avatars, including collector Walter Arensberg, dada artists who gathered regularly at his salon, and artists from Alfred Stieglitz's circle such as John Marin, that set the society apart. Conversations among the artists at Arensberg's salon provided the germ of the organization and brought together the extraordinary trio of Arensberg, Marcel Duchamp, and artist Katherine Dreier.

Dreier had exhibited at the Armory Show and over the next five years moved slowly toward abstraction in her art.[73] She also had enormous organizational talent and served on the Society of Independent Artists' board of directors. The society was highly democratic in its structure, and its openness meant immense exhibitions. At its first show, in 1917, more than twenty-five hundred works, organized alphabetically by artist, sprawled over two miles of aisles.[74] Women constituted 40 percent of the exhibitors and remained well over a third through the 1920s (see appendix, table 4). The society proved hospitable to women painting in modern modes, with Anne Goldthwaite, Georgia O'Keeffe, and Marguerite Zorach all exhibiting in the first show. Almost three-fourths of the women who later joined the New York Society of Women Artists for women modernists had works in the 1917 Society of Independent Artists' exhibition, with some returning for years. (Theresa Bernstein entered twenty-five Independent Artists exhibitions; Margaret Huntington, twenty-two; and Ethel Paddock, twenty.)[75] A similar organization, the Salons of America, formed in 1922 after a major disagreement among the officers of the Society of Independent Artists. Exhibitors, however, seemed to draw little distinction between the two, and the Salons drew many of the same exhibitors as the Independents (half the Salon's exhibitors in 1922 would show with the Independents in 1923).[76] Women exploited these unjuried exhibitions to their fullest, averaging a third of the Salons' exhibitors for the fourteen years they lasted.[77]

Katherine Dreier's involvement as founder and organizer of the Independents signaled a larger role for women in leading these independent societies than had been the case for older organizations. Women served as directors or exhibition organizers in every society. Katherine Dreier was one of three women who were on the original board of directors of the Independents. Dreier went on to organize and direct the Société Anonyme, a museum dedicated to modern art that she founded with Marcel Duchamp and American Man Ray in 1920.[78] Marguerite Zorach served as vice president of the Society

of Independent Artists in 1922 and as a director from 1922 to 1924; she was also active in the first Salon of America, serving as one of five on the publicity committee. Yet it is not clear how women felt about their involvement. Their numbers certainly did not match their exhibiting: among the Salons of America directors, just under 15 percent were women; of the Society of Independent Artists, the number of female directors was nearly the same—just over 15 percent.[79] Theresa Bernstein spoke forcefully and with a great deal of pride about her involvement in the Salons.[80] On the other hand, Marguerite Zorach expressed a certain detachment from her position as director of the Society of Independent Artists. She served during the split between the two societies and appears to have maintained ties with both groups. Writing to her friend Jessica Dismorr, Zorach described a male debate that she, very likely the only woman present, witnessed: "[At] a stormy meeting of Independent directors . . . at least ten men lost complete control of themselves and left nothing unsaid and only murder undone. I was intensely interested, and although a director, in no way concerned in the war. I find I can't be when each side is equally at fault in my eyes. I wonder how it would be to [be] in the row and desperate."[81] Zorach's rather wry comments evoke a vivid gender dynamic in which men forcefully debate and actively lead, while women, although "intensely interested," quietly participate on the side.

Much of this echoed the experience of previous decades. Women obtained some leadership roles but often disappeared in the avalanche of male words and decision making. In small, selective exhibitions opportunities were minimal, while large-scale, unjuried shows attracted many female exhibitors: the contrast between the Forum Exhibition of 1916, with Zorach the single woman included, and the Salons of America, with women averaging one-third of the exhibitors between 1922 and 1936, perfectly captures this pattern. Underlying these relatively limited exhibition opportunities was continued resistance to women artists by their male colleagues. Georgia O'Keeffe remembered that when Arthur Carles, a Philadelphia painter, came to see Alfred Stieglitz about borrowing some works for a show of modern art in Philadelphia, he told Stieglitz, "I don't want any goddamn women in the show." "It was hard going, as a woman," noted O'Keeffe, and throughout her life she pointed to the discomfort, awkwardness, and resistance she encountered among Stieglitz's male artists. In a 1968 interview O'Keeffe pointedly explained: "At first the men didn't want me around. They couldn't take a woman artist seriously. I would listen to them talk and I thought, my, they are dreamy. I felt much more prosaic but I knew I could paint as well as some of them who were sitting around

talking." In this brilliantly sly remark, O'Keeffe spoofs the "talk" of those decades, noting her exclusion but also establishing herself as a "prosaic" doer in contraposition to the "dreamy" talkers.[82]

Gender played as important a role in the shape of the modernist art market as it had in the 1890s. Dealers, as much as painters, reinforced the modernist credo of the individual male artist by making little room for women among the artists they promoted. Following the Armory Show, several new galleries opened to show and sell the work of modernists, and the number of modern art exhibitions tripled over the next four years. Most featured the European modernists that the Armory Show had introduced to newly awakened American collectors, with only the Daniel Gallery, started by Charles Daniel in December 1913, and Alfred Stieglitz's 291 devoting their walls primarily to Americans. Still, galleries such as the Carroll, Washington Square, and Bourgeois did exhibit some American work, occasionally showing work by women.[83] A 1923 Bourgeois Galleries show, for example, featured American painters and sculptors, including Georgia O'Keeffe among the ten painters exhibited.[84] It was also possible for women to receive a one-artist exhibition at these galleries: Anne Goldthwaite exhibited at the Berlin Photographic Company in 1915, and Marguerite Zorach showed at Montross in 1923.[85] Each of the American galleries seems to have promoted a single female artist. Alfred Stieglitz shaped Georgia O'Keeffe into the representative "woman artist"; Marguerite Zorach had regular exposure at the Daniel Gallery between 1915 and 1918, but always in conjunction with her husband, William Zorach. As had been true in galleries featuring more conventional work, progressive female artists obtained occasional opportunities but with a few exceptions appeared less frequently than men, especially in solo shows. Anne Estelle Rice encountered this indifference in the winter of 1914 when she returned to New York after many years of work—and success—in Europe. She made the rounds of dealers (Alfred Stieglitz, Charles Daniel, and Martin Birnbaum) and collectors (Arthur Jerome Eddy and John Quinn). None was willing to take her work. Rice raged to her husband, "The swines! It is very difficult for them to believe that a woman can be an artist. I'm learning this new to me objection."[86]

In the 1920s, another group of galleries, several of them run by women, opened. Gertrude Vanderbilt Whitney made the Whitney Studio Club (begun in 1918) an invaluable exhibition space through the 1920s, and Edith Halpert started the influential Downtown Gallery in 1926. The Whitney Studio Club and Downtown Gallery were by far the best known, but other gal-

leries, including the GRD Studio and Marie Sterner Gallery, managed to stay open during the decade. Women gallery owners tended to be aware of the difficulties women artists faced—Gertrude Whitney was herself a sculptor; Edith Halpert trained as an artist and exhibited at the Whitney Studio Club before turning entrepreneur; and Jean Roosevelt ran the GRD Studio in honor of her sister, Gladys Roosevelt Dick, an artist who had been killed in an equestrian accident. The GRD Studio welcomed the work of women artists, including pieces by the New York Society of Women Artists (whose membership consisted of modernist women artists), and held group shows, such as one in 1929 that featured Agnes Weinrich, Mildred Crooks, Adelaide Lawson, and Doris Rosenthal, all progressive artists.[87] Both Whitney and Halpert also supported women artists. The Studio Club welcomed male and female members on equal terms and regularly featured women artists in its galleries. Halpert's support was more equivocal: one-fourth of the painters she represented at the Downtown were women, but she paid limited attention to these women, offering women only 16 percent of one-artist exhibitions in the gallery's first decade and a half and often representing women because they were spouses of Downtown Gallery artists.[88] Women moderns faced a double set of obstacles. The successful galleries like the Downtown that welcomed them did not necessarily make women artists a top priority, while other galleries more overtly committed to women had a precarious existence, and only Halpert and Whitney kept their galleries open for more than a few years. The GRD studio lasted for just four years, and others were even more ephemeral.[89] In a 1963 talk, Edith Halpert described opening her gallery when, as far as she knew, there was only one other female gallery owner, Marie Sterner. "All the rest were men," she concluded, "and this continued for a long, long time."[90] Obviously Halpert's comments were not accurate, and they were undoubtedly self-serving, but they reflected the underlying marginality of most of the galleries that were the most hospitable to women.

A final option was to pursue noncommercial galleries and exhibition spaces, such as women's clubs and professional organizations that occasionally showed the work of avant-garde women artists, or cooperative galleries that held exhibitions organized by groups of artists themselves. Theresa Bernstein used these venues well. In the teens, she exhibited at the Women's University Club, at the Women's Professional League (where she was elected a member in 1916), at the Catherine Lorillard Wolfe Art Club (which was dedicated to women artists), and with two different groups of artists, one calling themselves the Eclectics and another, a group of women known as the Philadelphia Ten. She also showed regularly at the Macdowell Club. The Macdowell Club

was organized in 1911 by Robert Henri in order to provide nonacademic artists more outlets for their work and to escape the stale jurying system of the National Academy. In the 1918–19 season, Theresa Bernstein exhibited in April 1918, November 1918, December 1918, and April 1919. Several shows had overlapping members, and women ranged from three to eight of twelve exhibitors.[91] Nevertheless, Bernstein looked back at the previous twenty years in 1936 and insisted, "In important exhibitions the percentage of women has been at the most ten per cent. Comparatively few dealers handle the work of women artists. Prizes . . . are almost invariably given to artists not of the 'fair' sex. Purchases follow suit." [92] Bernstein starkly summarized the market implications of a system built around small, focused exhibitions and commercial galleries: few sales for women artists.

Confronted with this discrimination, many avant-garde women turned to women's art associations. The Woman's Art Club grew significantly and in 1914 renamed itself the National Association of Women Painters and Sculptors. Anne Goldthwaite remembered returning to the United States from Paris and encountering indifference from her former teacher at the National Academy of Design. His best advice: a woman's society to which her work "would be very well suited." Despite the condescension in his remark, Goldthwaite "took his advice and when invited, almost immediately, . . . became a member of the National Society of Women Painters and Sculptors." "I will always remember their hospitality and the prize that they awarded me." [93] However, the National Association of Women Painters and Sculptors sponsored annual exhibitions that seemed increasingly conservative and old-fashioned aesthetically to the modernists, and in 1925 a group of avant-garde women formed the New York Society of Women Artists to represent what observers called the "left wing of the feminine artistic movement." [94] They held their first exhibition in April 1926 at the Anderson Galleries, backed by a "reception committee" of twenty wealthy women, including Katherine Dreier and Jean Roosevelt (founder of GRD Studio). Styles ranged from the urban realism of Theresa Bernstein and Ethel Myers to the cubism of Blanche Lazzell and Agnes Weinrich. Most of the twenty-three painters and three sculptors were active professionals, exhibiting everywhere from the Armory Show to the Society of Independent Artists, from the Whitney Studio Club to downtown galleries.

Most prominent modernists joined the New York Society of Women Artists. (Georgia O'Keeffe was the major exception.) Members of the society spoke forcefully about the discrimination they faced. At the turn of the century, the Plastic Club and the Woman's Art Club feared a reputation as "ama-

teurs," and they struggled to assert their professional "authority." Twenty-five years later, the modern artists of the New York Society of Women Artists did not feel compelled to prove their professionalism. Feminism and the long campaign for women's rights had engendered a consciousness for a systematic critique of women's position. Theresa Bernstein commented, "People want to make comparisons between a woman's work and the work of a man. Of course, I don't think sex has much to do with it. . . . One has to understand that there are limitations not in one's expressions, but in one's status. The onus is there even when it isn't elucidated or emphasized." [95] Women bear the "onus" of a system, a burden both overt and unarticulated. Their position reflects not something biological—not "one's expression" or feminine capabilities—but an external social reality, "one's status." Earlier women's art organizations had appealed for an earned public recognition. Their achievements, they argued, merited notice. Now Bernstein and her colleagues positioned themselves differently. Not supplicants but entitled participants, they attacked a fundamentally unfair system.

Still, to organize by sex was as vexed for this generation as it had been for the previous. In fact, the direct stimulus for the New York Society of Women Artists was not gender but aesthetics. Society members expressed a remarkably familiar gender consciousness, what could be called a female professional gender consciousness that recognized discrimination, especially unfair opportunity, but found the label "woman artist" repugnant. "We want to speak to eyes and ears wide open and without prejudice, an audience that asks simply— is it good—not, was it done by a woman?" Anne Goldthwaite, vice president of the society, would say in the mid-1930s. Goldthwaite sounded remarkably like Cecilia Beaux pointing to the "millennium" when there "should be no sex in art." [96] For all the generational differences, rejecting the category "woman artist," that is, rejecting gender distinctions altogether, remained constant. Neither generation accepted the second-class status that "woman artist" connoted.

Perhaps Marguerite Zorach best represents the mix of promise and containment experienced by the modernists of this generation during the teens and twenties.[97] Zorach settled in New York in December 1912, and between 1913 and 1920 she and her husband, William, used their own studio-apartment as an exhibition space for their fauve- and cubist-inspired work. By 1915, they had established contacts with patrons and gallery owners and exhibited jointly at the Daniel Gallery on a regular basis between 1915 and 1918. In 1916, Zorach was included in the Forum Exhibition of Modern American Painters, but only because William Zorach insisted that her work be shown. She exhibited

in the Society of Independent Artists show in 1917 and served as an officer and director. The 1917 Independents' exhibition was an important turning point for Zorach. At that show she exhibited both an oil painting and a new, experimental medium, an embroidered tapestry rug; after 1917, Zorach concentrated on these tapestries. She found that they could be created in the time between caring for two small children (born in 1915 and 1917), and they sold. In one 1918 exhibition she made twelve hundred dollars in sales, and the tapestries became a primary source of family income.

In fact, throughout the twenties Zorach worked primarily in tapestries, receiving major commissions from Helen Brown (a connection made through Provincetown artist friends Lucy and Bill L'Engle), Mrs. Nathan Miller (a patron of Zorach's good friend artist Max Weber), and Abby Aldrich Rockefeller (a client of dealer Edith Halpert). The Rockefeller commission alone took her a year to conceive and three years to complete the 54" by 64" tapestry.[98] These works were a unique art form that allowed Zorach to carve out a market niche for herself, as she well realized. Yet she also knew that all too easily they could be categorized purely as a denigrated, traditionally female craft form, so she consistently referred to them as art, and in articles, interviews, and reviews, she actively sought to shape their reputation as (as one article titled them) "Modernistic Pictures Done in Wool."[99] *Maine Islands* transferred modernist form and structure to the tapestry, particularly in the bright unadulterated colors Zorach loved, the simplified and boldly outlined forms reminiscent of the fauve painters she admired, and the flattened perspective so typical of advanced art (fig. 6.5). Again calling them "pictures in wool," Zorach described her achievement in an article she wrote for *Art in America*:

> I want to write about embroideries as art—as paintings and sculpture and tapestries are art—and even then I do not wish to go back into the past; rather to write of my own embroidered tapestries which are an art expression unique with me and not like anything done before.
>
> They are related in spirit to the early art embroideries of America. But these were the expression of un-art-conscious people. Mine is the art expression of a developed artist, aware of and using the abstract qualities and new freedoms of this modern age in art. . . . In this medium, not used by artists, I found a peculiarly sympathetic form of expression, one that met my needs and utilized my talents and made all things possible.[100]

And it did make all things possible. The commissions Zorach received financed the family's summer home in Maine and helped carry them through

FIGURE 6.5. *Marguerite Zorach*, Maine Islands, *tapestry, 1919. (Courtesy of the National Museum of American Art, Smithsonian Institution. Gift of Dahlov Ipcar and Tessim Zorach.)*

the early years of the depression.[101] They also secured Zorach's continued visibility on the art scene. In the dry years without gallery representation, Zorach's only one-woman exhibition was of her embroideries. Yet when Edith Halpert began representing Zorach and gave her a solo show at the Downtown Gallery in 1928, Zorach exhibited only paintings and drawings, signaling her ambition to be known as a painter. Despite the prominence of her tapestries, Zorach had remained an active force in the art world in the twenties. She served her term as director and officer of the Society of Independent Artists and helped found the New York Society of Women Artists, serving as its first president. She exhibited paintings at the New Tendencies in American Art Exhibition in Philadelphia in 1920, at Independent exhibitions from 1921 to 1924, at the Salons of America in 1922, 1926, and 1927, and with the New York Society of Women Artists.

One of Zorach's paintings from this period, *Shore Leave*, fractured form and compressed perspective, using a cubist idiom (fig. 6.6). The painting depicts a sailor eyeing—possibly leering at—a woman who faces out from the canvas, her lips pursed, her face serious and composed, her hand raised surrenderingly. The only color in the painting is on the woman in her sunflower yellow dress and reddened lips; the rest of the canvas is muted grays, taupe, and browns. In the background is an architectural form whose Gothic arches and rising steeple suggest a church. This is an ambitious painting on several fronts. Zorach has experimented with and adapted modernist styles, and the cubist technique generates an emotionally taut and complex image.[102] The title, *Shore Leave*, implies the sailor in search of a prostitute, and much in the painting reads that way—the sailor's craned neck, the figures' overlapping bodies, and

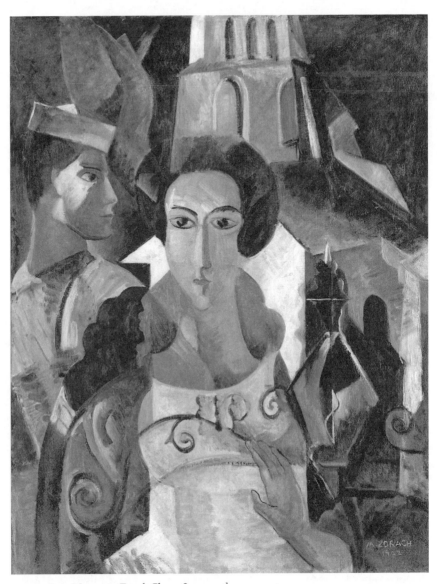

FIGURE 6.6. *Marguerite Zorach*, Shore Leave, *oil on canvas, 1922.*
(Courtesy of Private Collection, Maine)

the woman's made-up eyes and lips. Yet the female figure's raised hand and the looming church evoke the Madonna. Is she blessing the young man? Are they actually going to go together into the church? Is this a shotgun marriage? Or is the scene an ironic comment on religion, the ideal of the virginal woman, and sexual hypocrisy? The subtlety and ambiguity of Zorach's theme reveal

the continued ambitiousness of her painting even as the embroideries shaped her reputation.

The artistic partnership forged by Marguerite and William Zorach continued throughout their lives: as artists, they were equals, and their relationship has a quality of egalitarianism absent from many in the previous generation. Nevertheless, Marguerite Zorach established herself through this partnership, and it is not clear whether she would have gained access to gallery representation or important exhibition opportunities without that joint relationship. The Zorachs broke with the Daniel Gallery in 1918 after a quarrel over commissions. Marguerite then went without regular representation for nearly a decade. Moreover, the responsibility for family and children remained largely hers. In the short term, these responsibilities took her away from painting and into an artistic form associated with a tradition of female needlework and craft. The new medium and the hiatus from painting meant that even though William Zorach collaborated on early tapestries with Marguerite, and even though she inspired many of his sculptures, his career began to overshadow hers. The promise of avant-garde life—its experimentation, radical questioning, heterosocial worlds of work and play, and dedication to female economic independence—had shaped Zorach's early work and fostered her aesthetic innovations and departures. Nevertheless, her eventual sidestep reveals unresolved dilemmas created by family demands and profound art world biases, both of which echoed the difficulties encountered by the previous generation.[103]

In addition to the institutional barriers encountered by Zorach, modernist women also continued to confront the rhetoric of the "essentially feminine." In February 1919, W. H. de B. Nelson praised Theresa Bernstein for the "assurance and virility . . . [of this] woman painter who paints like a man" in the *International Studio*.[104] In November, she received her first substantial one-woman show at the Milch Gallery. A reviewer once again juxtaposed masculine to feminine: "There is nothing feminine about the paintings of Theresa Bernstein, now on view at the Milch Galleries. It is with a man's vision that this artist looks at her subjects in the streets, the elevated railroad trains, at the beaches, in the parks, in the lobbies of theatres, in seaport places or in a church. Then, having found what she wants, it is with a man's vigor that she gets it down to stay."[105] Both of these critics supported the modern movement in art and had been organizers of pivotal modern exhibitions.[106] Yet they regurgitated the same tired formula—a woman who paints like a man with its implied norm, the weak, limp, and lifeless essentially feminine. Re-

peating such stock characterizations well past the advent of modernism, they testify to the staying power of this discourse.

Modernist commentary idealized the heroic individual more than turn-of-the-century criticism had done and became even more invested in beliefs about sexual difference as the foundation of creativity. Drawing on contemporary psychology and sexology, which were well popularized among Greenwich Village circles, modernists stressed the sex-based nature of self-expression. Popular psychological thought preserved Darwinian ideas of sexual difference while relocating that difference to an unconscious where sexual desire shaped the self. Men, in this account, harnessed their unconscious sexual desire to their intellect, generating a unified self defined by an active role—in procreation and beyond. Women, on the other hand, had an organic sexuality that remained largely outside their conscious control but preeminent in their selfhood. At the same time, as sexologists reinscribed sexual difference, they gave sexuality new importance as a component of the self and a signifier of an individual's true nature. So, following a circular logic, true selfhood was sex-based, and thus self-expression was the expression of sex, which was, for women, the expression of sexuality.[107] This preoccupation with sex and the self helps explain the explorations of gender boundaries, and even androgyny, by early modernists, particularly the dadaists. To investigate the nature of sexuality could give form to the artist's truest self-expression. Moreover, witty, suggestive sex talk by male artists displayed a mastery that was particularly male: their "concept" controlled the erotic in their images. Male dadaists did not necessarily extend that same possibility to women artists. In teaching Beatrice Wood, Marcel Duchamp, known for his intellectualism, praised her work when it was the most unconscious, the least wedded to mind. "He liked the ones that were free expressions of the unconscious," she remembered. "I had no idea what they meant."[108]

Sex talk was also an important way for modernists to understand modernity itself. The sexualized woman symbolized both the vital forces of the modern order and the excesses it might generate. Francis Picabia's *Américaine* anthropomorphized the American woman as a light bulb, awaiting just the proper electrical force. The words "flirt" and "divorce" reflected in the glass of the bulb and suggested both enticement and entrapment.[109] The projection of female sexuality and selfhood that was such a prominent feature of avant-garde New York was integral to the construction of modernism itself. Historian Christine Stansell, writing more broadly about avant-garde circles, has poignantly summarized the effects of modernist sex talk: "The sexually free woman became a frame for propositions about the modern and the femi-

nine that reduced both to a matter of their effect on male authority. It was left for women to display their spiritual and erotic riches and others—men—to speak for them."[110]

Of all women modernists, male artists and critics subjected Georgia O'Keeffe to the most extensive and intensive characterization as a sexualized female painter.[111] As Camera Work's 1916 review of Georgia O'Keeffe's first exhibition reminded readers, her work provided "intense interest from a psychoanalytical point of view": never before had a woman "express[ed] herself so frankly on paper."[112] The most likely writer of this anonymous review was Camera Work's editor, Alfred Stieglitz, who had himself given O'Keeffe the exhibition at his gallery. Stieglitz's circle of American artists, including Georgia O'Keeffe, John Marin, and Arthur Dove, narrowed and solidified in the late teens as he moved from a fairly catholic exposition of modernism to the promotion of specifically American artists. Stieglitz's interest in O'Keeffe occurred within the context of rising cultural nationalism and competition between modernist circles to define a national art. Cultural nationalism had its roots in Robert Henri's turn-of-the-century calls for a "masterly freedom in expressing" ideas "native to the country" and then received a shot in the arm from French expatriates who reveled in American culture as a counterweight to a dead European tradition during World War I.[113] From Henri to Stieglitz and other cultural nationalists, the desire for a vital national art seeped out of opposition to genteel refinement and represented part of a strategy for distancing high culture from the supposed feminization of culture. Much of the twentieth-century invocation of virility in critical discourse tied virile work to the birth of a native tradition. In this sense, cultural nationalists like Stieglitz conducted their campaigns for cultural nationalism very much within the orbit of the art world's gender politics. O'Keeffe had a role to play in this muscular nationalism and making of American things, but it was not the same as men's. She, like Cecilia Beaux in the generation before, gained acceptance as the exceptional woman who excelled despite being a woman. She was a "trophy" to signal progress—liberation of art and women—but without real concession of male control.[114]

Looking for the direct expression of the unconscious self, Stieglitz expected differences in men's and women's works. Although he had shown the work of several women at 291 before his momentous show of Georgia O'Keeffe's drawings in 1916, he had not found the image and expression of "woman" to crystallize his ideas about sex in art. O'Keeffe provided him with this figure, and in a 1919 essay, "Woman in Art," he explained why and how she embodied authentic feminine self-expression. He began the essay with

his central premises about art and about sex: "Woman *feels* the World *differently* than Man feels it. And one of the chief generating forces crystallizing into art is undoubtedly elemental feeling—Woman's and Man's are differentiated through the difference in their sex make-up. . . . The Woman receives the World through her Womb. That is the seat of her deepest feeling. Mind comes second." Men's and women's "sex make-up" drove their creativity, with women's based in the womb. Stieglitz went even further than those identifying an "essentially feminine" presence in women's art and defined the feminine as sexuality. This did not, in Stieglitz's mind, represent inequality but rather progress, because women no longer needed to follow a male model of creation. He thus acknowledged that changing social relationships were releasing women, creating greater freedom for them, and opening creative doors. Women's art would always be "distinctively feminine," but it could "live side by side with male produced Art." O'Keeffe was proof of this: she was "the Woman unafraid." [115]

In the end, however, it was not the "side by side" qualities of men's and women's art that Stieglitz emphasized but the differences. O'Keeffe's work was different from men's because it was fully an expression of sexuality, eroticism, and female feeling. Stieglitz promoted sexual interpretations of O'Keeffe's work, highlighting her sexuality in his series of photographs of her that he exhibited in 1921, encouraging sexual readings of her work by critic friends, and resisting any attempt on O'Keeffe's part to shift her style away from the abstract imagery he used for his sexual interpretations. O'Keeffe claimed that Stieglitz had discouraged her from working on her enlarged flower paintings as well as her New York skyscraper series, both conscious attempts on her part to reformulate her style and position within the art world.[116]

Stieglitz's influential position as arbiter of modernism, source for critics, and publisher of his own magazine also meant that his image of O'Keeffe was taken up in other criticism. Two of Stieglitz's friends, critic Paul Rosenfeld and painter Marsden Hartley, published sexualized interpretations of O'Keeffe in the early twenties. In a typical passage, Rosenfeld announced that O'Keeffe's art was "gloriously female": "For here, in this painting, there is registered the manner of perception anchored in the constitution of the woman. The organs that differentiate the sex speak. Women, one would judge, always feel, when they feel strongly, through the womb." Critics from Edmund Wilson to Lewis Mumford reiterated this theme, repeating in a virtual mantra that, as painter Oscar Bluemner described it, O'Keeffe was the "priestess of Eternal Woman." [117] O'Keeffe filled the position of leading woman modernist

because critics could explain and contain her work within sexual interpretations. It is not accidental that other women modernists did not capture their attention. Marguerite Zorach's fauve and cubist works, for example, could not be read like O'Keeffe's more open-ended abstractions, nor could Elsie Driggs' precisionist paintings of industrial America be easily collapsed into a female sexuality. That Driggs, who gained notice in the mid-1920s, at the height of artistic cultural nationalism, for painting quintessentially American scenes in the distinctively American style of precisionism, could not stand in for the "true" woman artist suggests how deep-seated the essentially feminine had become.[118] It is also not accidental that other images—O'Keeffe as "American," as artistic innovator, or as skilled colorist—took a far second to her sexualized image. Interpretations that focused on the "side by side" aspects of men's and women's work, which did not take sexual difference as their central point of departure, would have acknowledged women's equal claim on the profession. Stieglitz's vision of O'Keeffe restricted female creativity and reduced vaunted modernist freedom to sexual meanings: a freed woman equaled an erotic woman, not one staking claims to creativity and power on the same terms as men.

Although women were not initially able to formulate a response to the language of the "essentially feminine"—in both its more genteel and its modernist forms—by the early twenties they had begun to develop the themes implicit in Mary Fanton Roberts's discussion of the "sex distinction in art." One of the most important responses was O'Keeffe's. She used the themes of freedom and individuality to transform the gendered idea of self-expression, not denying sex in art but rewriting its meaning. Art historian Barbara Buhler Lynes has convincingly shown that in the early twenties O'Keeffe deliberately began to articulate and promote an image of herself and her work quite different from the one created by Stieglitz.[119]

In 1915, while O'Keeffe was working on the abstract charcoal drawings that Stieglitz first exhibited at 291, she wrote a series of letters to her art school friend Anita Pollitzer in which she described her efforts to make a satisfying new art. She focused on expressing herself, writing Pollitzer that she had told herself, "Let them all be damned—I'll do as I please," and that she had "decided I wasnt going to cater to what anyone else might like—why should I—."[120] It was not until after she learned from Pollitzer that Stieglitz had responded to her drawings as a woman's work that she began to consider that her work expressed "essentially a womans feeling," and then only somewhat deprecatingly.[121] After 1921, when Rosenfeld's and Hartley's essays appeared, O'Keeffe acknowledged she disliked the sexualized image of her-

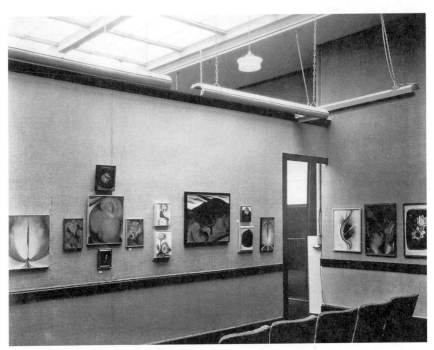

FIGURE 6.7. *Georgia O'Keeffe Exhibition, 1924. Photograph by Alfred Stieglitz. Mitchell Kennerly Papers. (Courtesy of the Manuscripts Division, The New York Public Library, Astor, Lenox and Tilden Foundations)*

self—the descriptions embarrassed her and left her with "a queer feeling of being invaded." [122] She cast about for women to review her work, writing in the mid-1920s to writer Mabel Dodge Luhan and critic Blanche Matthias in the hope that they might, as women, better understand her work. To the extent that she hoped a woman might comprehend her intentions, O'Keeffe seems to have agreed that her art embodied a woman's expression, but she vigorously resisted the label "woman artist" throughout her life. It was through a different tactic that O'Keeffe most effectively rewrote Stieglitz's script.

As O'Keeffe described it, she "got down to an effort to be objective." For her 1924 exhibition, she reduced the amount of abstraction in her work and began to depict flowers and other natural forms with descriptive realism (fig. 6.7). These paintings, she believed, could change critics' interpretations of her work, and she edited the statements in her exhibition catalogs, gave newspaper interviews, and continued her "objective" work in order to promote a new image of her art. Her efforts began to reap rewards as reviews started describing her in terms of her professionalism and innovation. [123]

With some distance from the sexualized image of her work, O'Keeffe attributed a new meaning to the idea of a woman expressing herself. Returning to the central theme of her 1915 letters, O'Keeffe articulated her core principle: to be an individual above all else. An interviewer reported in 1927 that O'Keeffe "believes ardently in woman as an individual—an individual not merely with the rights and privileges of man but, what is to her more important, with the same responsibilities. And chief among these is the responsibility of self-realization." [124] On a revealing page of her autobiography, O'Keeffe looked back at the early 1920s and retrospectively reviewed her new tactic. The text, opposite the austere pastel *Single Alligator Pear*, described that work in the context of a talky, analytical male world (fig. 6.8). [125] "It was in the time when the men didn't think much of what I was doing. They were all discussing Cézanne with long involved remarks about the 'plastic quality' of his form and color. I was an outsider." To O'Keeffe all those "analytical remarks" and "words piled on top of . . . [Cézanne's] poor little mountain" were excessive. She was an "outsider," apart from the torrent of words, the verbiage, produced by Alfred Stieglitz and his critic friends. Instead, she removed detail, eradicated emotion, and went for the essence of the object in a series of works with alligator pears. *Single Alligator Pear* was her favorite: "The best of the alligator pears was a pastel of my first lone dry pear on a white cloth. . . . I have always considered that it was one of the times when I did what I really intended to do." The pastel shows the dark oval of the alligator pear, its stem a new moon of white at the narrow end. A simple line demarcates table from wall. The alligator pear casts its shadow on the table in pale gray and on the wall in an aura of gray-blue. Concrete and specific, it was part of O'Keeffe's answer to her critics, and, as she emphasized, it was her self-expression, what she "intended to do."

O'Keeffe's next remarks in the autobiography returned to the theme of talk. Before each exhibition, she said, she put up the works and made up her mind about how good each work was. "After that the critics can write what they please. I have already settled it for myself so . . . I am quite free." Again O'Keeffe disentangled herself from the art establishment. In part, she conveniently positioned herself as an outsider (despite being in Stieglitz's inner circle). But she also insisted that the words of critics and the talk of the men were irrelevant to her individually defined artistic purpose. Rather than outright refutation of the men's talk—of Cézanne, of woman as womb—O'Keeffe redirected it. She did not reject the idea that her sex fundamentally shaped her self-expression, but she asserted that more than a sexualized femininity made up her artistic vision. "I am trying with all my skill to do painting

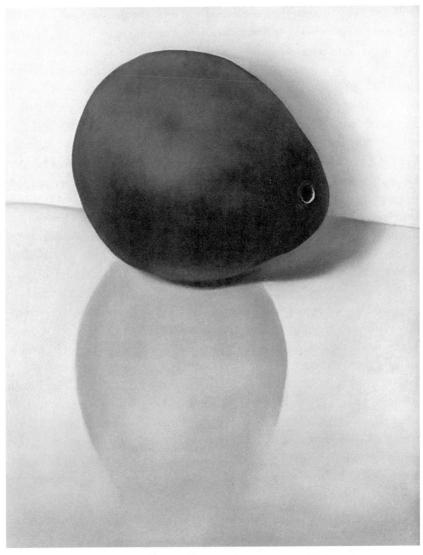

FIGURE 6.8. *Georgia O'Keeffe,* Alligator Pear, *pastel on paper, 1923. Also known as* Single Alligator Pear, *1922. (Courtesy of Private Collection, Paris, France)*

that is all of a woman as well as all of me," she would say in 1930.[126] Crucially, O'Keeffe distinguished "all of a woman" from "all of me" and added a hardly noticeable, yet significant, "as well as" to link them. She was envisioning additive, not equivalent, principles: all of a woman *plus* all of me. Downsizing her sex to just one element of her individual self-expression, O'Keeffe broke down the presumptions of biological genius.

By the late twenties, O'Keeffe's altered presentation of herself was only the most visible voice denying the totalizing notion of an essential femininity. Critic Helen Appleton Read had studied at the Art Students League and with Robert Henri, worked as art critic for the *Brooklyn Daily Eagle,* and commented extensively on women in art. She refuted the prevailing biological determinism: "The question as to whether creative genius of the highest order is incompatible with feminine psychology and physiology can not be argued with any degree of satisfaction. The facts are not forthcoming. Theories may be advanced that for a woman a full emotional life precludes creative expression, but this remains, after all, an unproved theory. History in this case is not an infallible gauge." [127] Essential femininity was only a theory; history, Read argued, might prove not women's evolutionary divergence from men but their convergence as the modern requirements of earning a livelihood generated pressure to perform and succeed. Still, like O'Keeffe, Read incorporated sex into self-expression. By the twenties, no one questioned the notion that sex and sexuality were fundamental indexes of the self. Indeed, many avant-garde women embraced this connection: sexual liberation was a tenet of feminism, and sexual agency signaled women's liberation—their status as freethinking, independent selves.

Read resisted, however, the reductionist equation of the feminine to unconscious sexuality. The feminine, she explained, could encompass many things. Reviewing the first exhibition of the New York Society of Women Artists, Read wrote, "American women artists are not academic and traditionally feminine, and do not, as George Moore said, carry the art of men across their fans. Feminine, if you will, since no art can be of the slightest significance unless it reflects personality, and personality carries with it the flavor of sex, but femininity which can be acrid and somber, lyric and gay according to the owner. Femininity can mean as many things as masculinity[,] not merely the traditional attributes." [128] Although Read took a more historical and sociological approach than O'Keeffe, the end result was the same. A self-expression that was as varied as masculine self-expression shaped women's art. Both Read and O'Keeffe proposed a more expansive definition of femininity. To do so, they emphasized individualism and privileged it over sexuality. In this logic, they were triply aided. First, they drew strength from feminism's commitment to women's individual self-realization as members of the "human race," as people developing their fullest potential without regard to preconceptions. The previous generation had also left a legacy of individualism for the moderns in a professionalism that put artistic ambition above Victorian ideals of womanhood. Finally, modernism itself aided them. Using modernism's own mantra

of individual creative liberation, O'Keeffe and Read insisted on a multidimensional self-expression. Read, in her review of the New York Society of Women Artists, repeated the modernist formula of individual self-expression but substituted "personality" for "individuality." It was a subtle, but important, signal. In social scientific and psychological thought, the social environment produced personality, making correlations between sex and particular traits seem more a matter of circumstance than inheritance.[129] "Personality" implied variability in ways "individuality" did not. Sex, as Read set it up, was a "flavor."

In differing ways, O'Keeffe and Read resisted the reductionism of biological equations between self and the canvas but not the premise. They came to terms with the biological genius that had stymied women for thirty years by recasting it from within. Whether you called it the "flavor of sex" or work that is "all of me" (as well as "all of a woman"), a female self-expression could be as wide-ranging as men's. This revision of self-expression's meaning allowed O'Keeffe and Read to conceive of women artists as simultaneously professional and female, a conceit unavailable to the previous generation, for whom a professional identity meant adopting male traits and roles. Modernist women, from O'Keeffe to Theresa Bernstein and Marguerite Zorach, embraced the modernist equation between self-expression and aesthetic expression because, in the end, they saw it as a way to be artists and women. "Painting is my life," Marguerite Zorach wrote late in her life. "I am interested in expression through art."[130] Within this formulation lay remarkable promise for the modernist generation to integrate professional and sexual identities in ways never open to their nineteenth-century colleagues.

EPILOGUE

A woman holding the tools of her trade perches on the back of a chair. She sits, almost casually, in front of a large skeleton (fig. E.1). Is this young student really supposed to look as if she is riding that horse skeleton? It's incongruous: the oh-so-serious art student with the horse's grinning jaw and vacant eye jutting out behind her. Made at the Pennsylvania Academy of the Fine Arts around 1883, the photograph belongs to a series of comic photographs. This woman and fellow students (both female and male) parodied art school pretensions and current artistic fads.[1] Carefully posed with the tools of the trade—brushes, palette, maulstick—she is part of the joke, not the object of it. In fact, the photograph takes her quite seriously. The horse skeleton, along with the bust of Caesar and the partially finished sculpture behind her, symbolizes the academic program she has mastered, from antique drawing to anatomy and modeling classes. Enough of an insider at the Pennsylvania Academy to be part of the joke and surrounded by the signs of her professional training, this young artist is a symbol of the ambitions expressed and pursued by American women artists at the turn of the century. Like Mary Cassatt's dream of glory, this photograph situates women artists within the highest reaches of the profession. Expert rather than inept, working on canvas rather than china, and desiring recognition rather than demurely retiring, women like Cassatt and this student at the Pennsylvania Academy reshaped the American art world. Their ambitions unsettled the genteel cultural tradition and gave birth to the modern art market and twentieth-century aesthetic ideologies.

In art academies, women joined men after the Civil War in directing the American art world toward professionalism. Schools stressed standards and credentials at the same time that they increasingly segregated amateurs from the "serious" students, all steps toward moving art within the orbit of the late-nineteenth-century culture of professionalism. As a majority of art students by the early 1880s, women were a visible constituency in this transformation. At one level, the professionalization of art academies functioned to

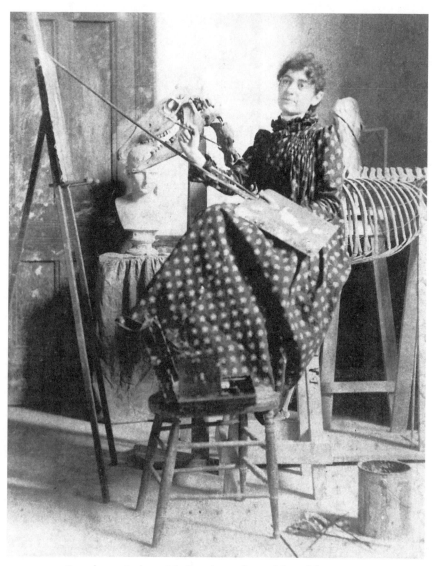

FIGURE E.1. *Pennsylvania Academy of the Fine Arts student with horse skeleton, ca. 1883.*
(Thomas Anshutz Papers, Archives of American Art, Smithsonian Institution)

exclude women, but serious women students engaged with and influenced the professionalization of art, including the dismissal of "lady amateurs."

The final, critical step for professional "credentials" was honing academic skills in Paris. In Paris, women artists asserted their autonomy from other claims on them as women. And there they made the transition from student to professional. However, in Paris, unlike in America, art education was sex-

segregated. Women returned from Paris outside a male world of camaraderie and colleagues, excluded from the male alliances that would form the informal backbone of the profession in America. Paris thus represented a crucial disjunction for women artists: essential individual development, but the beginnings of collective segregation.

When they returned to America, young artists encountered a booming market—but only for European art. To manage their uncertain prospects, male and female artists turned to two strategies in the 1870s and 1880s. First they established societies and exhibiting associations that featured the younger academically trained artists and extended the new professionalism. Women became active exhibitors with these groups, although they were less successful in gaining membership. Second, artists explored "lesser" media such as watercolor and pastel, many of which were associated with female amateurship. Through the ideal of refinement, professional artists (both male and female) appropriated these more informal media, taking advantage of their lower prices and popularity, especially at the height of the decorating craze of the late 1870s and 1880s. This led to a strangely cross-dressing, cross-gendered artistic practice: men making watercolors while women painted figure compositions for major, juried exhibitions.

By the 1890s, this tandem pursuit of professionalization and refinement dissolved. The market reconfigured and reconsolidated around new institutions shaped in important ways by a reaction to female artists and feminized male practice. The gallery and dealer system served smaller, more selective groups of artists—groups that more often excluded women than the large exhibition forums of the previous twenty years. Galleries also used sales tactics that promoted the "individual" artist in a way that firmly made femininity the marker of the woman artist's individuality. To counter the discrimination they experienced in the market, women artists established separate female art societies.

As galleries sold the "individual" artist, they began to turn the definition of high culture away from refinement and elevation and more toward a new framework of individual self-realization. Art criticism decisively deepened this shift. In the 1870s and 1880s, Gilded Age critics called on American artists to make art that was academically skilled and refined in sentiment, expecting men and women to demonstrate both qualities. Rejecting refinement as too "feminine" and technique as too mechanical in the 1890s, critics called for greater individuality, "masculine strength," and virility in American art. However, only men could create this art. Women were to express the "essentially feminine," something fundamentally different, something biologically

determined, and something almost always lesser. The new criticism hardened a set of gender divides, which in turn became embedded in modern notions of culture that affirmed the importance of a heroic (and, in early-twentieth-century terms, virile) self-expression.

Modernists carried forward the rewriting of ideas of culture and cemented them for the twentieth century. Women artists sought to participate in an avant-garde in which male modernists and critics relied on the gendered institutions and rhetoric produced by the previous generation. When Alfred Stieglitz described Georgia O'Keeffe famously, and probably apocryphally, as "a woman on paper," he envisioned her work as the embodiment of an unfettered womanhood. Yet an atmosphere of liberation from Victorian constraints and a surging feminism put artistic experimentation in a very specific context for women. Within the individualism shared by professionalism, feminism, and the new ideas of culture lay avenues for women to reconceptualize their place in art and culture. Georgia O'Keeffe's response to Alfred Stieglitz's characterization of her in the 1920s represented a new generation's first effective challenge to the "essentially feminine." Rather than repudiating the definition of her art as a product of her sex, O'Keeffe reduced sex to just one aspect of her art. She incorporated her femininity into a much larger vision of her individual self-expression as an artist. In the process, O'Keeffe was finally able to use modernism's own aesthetic ideology to get around the seemingly intractable biological aesthetic of "virile" art that had stymied women since the 1890s.

O'Keeffe's struggle to escape the stranglehold of essential femininity evolved out of the complex gender politics of the Gilded Age and turn-of-the-century art world. Those contests over the meaning and the control of the production of high culture shaped modernism, not just as an artistic movement but also as the dominant cultural formation of much of the twentieth century. The shake-up in cultural categories across the late nineteenth and early twentieth centuries was a gendered process. And, more important, it was a gendered process with unequal implications that have not always been fully understood. Key modern tenets such as selfhood, individuality, and self-expression developed masculine overtones—and modernists, as we have seen, worked hard to secure those meanings. As concepts that underpinned assertions of cultural authority, these tenets inflected American society beyond any narrow boundaries we might draw around the art world. Popular female achievers drew much attention in the 1920s and 1930s, for example, yet their "individuality"—and their ability to symbolize female achievement—could often only be secured against a backdrop of essential femininity.[2]

Other than lesser intellectual and creative ability, the meanings assigned to essential femininity also mutated as the new meanings of high culture solidified. Unconscious sexuality competed with charm and refinement to embody female selfhood. With the emergence of mass media, particularly the movies, and the pervasive extension of consumer culture, cultural arbiters bound the female consumer, female desire, and the "lowbrow" in a self-perpetuating circle. Yet the reorganization of cultural categories cannot simply be parsed as highbrow/masculine, lowbrow/feminine and attributed solely to the growth of mass culture. The redefinition of high culture as individual self-realization (rather than genteel refinement) emerged as middle-class, professionalizing, male and female artists struggled over the production of art. The meanings of high culture that we know today—that is, the social purposes we assign to art and literature—are a product of this struggle between men and women.

The shape and outcome of the contest over high culture matter—and not just to cultural historians, art historians, or gender historians. We should not, of course, idealize the class- and race-bound instrumentality of genteel beliefs about culture, but a democratic impulse in the desire to educate and uplift all did exist. Twentieth-century makers of high art relinquished that impulse. The perception of hermeticism, elitism, and even irrelevance that colors the reactions of many to modernist culture has its roots in the early twentieth century. The persistence of this hostility toward high culture has, additionally, sharpened the divide between high and low, making it more difficult for works of high culture to engage and critique mass culture fruitfully.

The masculinist impulse of the early twentieth century has continued to inflect American modernism. Abstract expressionism succeeded after World War II in part because it was so easily assimilated to a masculinized discourse.[3] The continued construction of the modernist enterprise as the expression of a male self was still by no means totalizing. The kind of subjectivity Georgia O'Keeffe, Marguerite Zorach, and Helen Read proposed in the 1920s allowed women to create an artistic identity and to make art in spite of the dominant thrust of modernism. Lee Krasner, one of the women active in abstract expressionism, sounded not unlike O'Keeffe in describing her artistic philosophy. "If the alphabet is A to Z," Krasner told an interviewer, "I want to move with it all the way, not only from A to C. For me, all the doors are open."[4] While Krasner's male colleagues fixed their artwork into a signature style, Krasner altered her work throughout her career. To be fixed between A and C would have risked being classed by her gender. Keeping "all the doors . . . open," Krasner retained the possibility of an artistic self not defined by her sex. Creating an artistic identity and garnering professional recognition remained difficult,

but Krasner and more artists than we typically remember borrowed from the preceding generation and charted a way through the postwar art world.

As I was finishing this book, I interviewed Theresa Bernstein. She was 109. Her dealer took me to the studio on Manhattan's Upper West Side where Bernstein has lived for decades. Lively and forceful in her opinions, Bernstein had strong, if not always precise, recollections of the early-twentieth-century art world. As I listened, feeling the hot edges of the June afternoon, I looked around Bernstein's studio. A path had been cleared from the small kitchen in the back to the hospital bed in the middle of the room where Bernstein is confined, but the rest of the space was filled to head height with canvases, stacked boxes, drawings, painting tools, and paraphernalia. Those signs of a lifetime's work testify to the women in this book. Like the woman posed before a horse skeleton, and like two generations of her peers, Bernstein claimed artist's tools and an artist's identity.

APPENDIX

Table 1. Women as Percentage of Total Exhibitors, National Academy of
Design, Boston Art Club, and Pennsylvania Academy of the Fine Arts,
1880–1900

	1880	1885	1890	1895	1900
NAD	14%	15%	17%	17%	17%
BAC [1]	21	—	—	—	19
PAFA	21	33	36	37	31

Sources: Archives of American Art, Smithsonian Institution, Washington, D.C. National
Academy of Design: Annual Exhibition Catalogs for 55th Annual Exhibition, 1880; 60th
Annual Exhibition, 1885; 65th Annual Exhibition, 1890; 70th Annual Exhibition, 1895; and
75th Annual Exhibition, 1900 (reel N543: #638–52, and reel N544: #25–49, #153–78, #374–
451, #663–711). Pennsylvania Academy of the Fine Arts: Catalog of Annual Exhibition for
51st Annual Exhibition, 1880; 56th Annual Exhibition, 1885; 60th Annual Exhibition, 1890;
65th Annual Exhibition, 1895; and 69th Annual Exhibition, 1900 (reel P42: #368–97, #539–
71, #675–708, #867–917, and reel P43: #58–116). Boston Art Club: Catalogs of the 22nd
Exhibition of Paintings, April 16–May 8, 1880, and the 61st Exhibition of Oil Paintings
and Sculpture, 1900 (reel MB505: #5870–80, #6766–84.

Note: NAD = National Academy of Design; BAC = Boston Art Club;
PAFA = Pennsylvania Academy of the Fine Arts

[1] Only 1880 and 1900 exhibition catalogs reviewed

Table 2. Genres of Paintings Exhibited by Men and Women at the National Academy of Design, the Pennsylvania Academy of the Fine Arts, and the Boston Art Club, 1880–1900 (expressed as a percentage of the total works exhibited by each sex)

	1880	1885	1890	1895	1900
Women at the National Academy of Design					
Still life/flower	26%	40%	23%	15%	6%
Landscape	26	17	18	14	15
Figure subjects	20	33	38	47	27
Portrait	26 [1]	9	18	22	53
Men at the National Academy of Design					
Still life/flower	7%	13%	7%	2%	1%
Landscape	41	39	43	44	47
Figure subjects	34	33	34	37	33
Portrait	13	10	9	9	10
Women at the Pennsylvania Academy					
Still life/flower	24%	26%	32%	13%	6%
Landscape	42	32	25	29	21
Figure subjects	14	26	24	35	26
Portrait	16	10	14	19	28
Men at the Pennsylvania Academy					
Still life/flower	6%	8%	7%	3%	3%
Landscape	42	42	41	44	40
Figure subjects	29	35	30	32	28
Portrait	8	9	7	12	18
Women at the Boston Art Club					
Still life/flower	28%	—	—	—	17%
Landscape	35	—	—	—	30
Figure subjects	16	—	—	—	40
Portrait	19	—	—	—	13
Men at the Boston Art Club					
Still life/flower	6%	—	—	—	5%
Landscape	37	—	—	—	44
Figure subjects	29	—	—	—	24
Portrait	9	—	—	—	6

Sources: See Table 1.

Note: These tables show the range of genres exhibited by each sex, based on the titles listed in annual exhibition catalogs. Without a complete reconstruction of the works in each exhibition (many of which included more than six hundred works), it was impossible to assign each painting definitively to a category based on title alone, so I have used my best judgment. As a result, these figures should be taken as indications of general trends in exhibiting patterns rather than definitive totals.

Given the shifting boundaries of genres in this period, I have loosely grouped history, figure, and genre painting under the category "figure subjects," since in many cases it was impossible to distinguish them, not only by title but also by what was represented in the work. Moreover, I was interested in the overall shift toward figure painting, as compared with landscape, as much as in the details of type. Finally, as landscape painting incorporated impressionist techniques later in this period, figures began to appear in many of them, so the numbers indicated in these tables may be somewhat high and do not fully capture the changing boundaries of the genre.

[1] Totals in all of Table 2 do not add up to 100% because of rounding and a small number of paintings that do not fall into any of these categories.

Table 3. Work of American Women Artists, 1904

Principal Work, by Genre

	Number[1]	Percentage[2]
Flower/still life	3	4
Figure subjects[3]	17	25
Portraits	19	28
Miniature	3	4
Landscape	11	16
Street/city scenes	1	1
Animal	2	3
Etching	3	4
Illustration	5	7
Decoration/mural	4	6

Role of Portraiture

	Number	Percentage
Paints portraits only	12/68	18
Portraits as second field	11/68	16
Portraitists with figure subjects as second field	9/19	47
Figure painters with portraits as second field	8/17	47

Source: Waters, *Women in the Fine Arts.*

[1] Number = 68. Drawn from the women listed in Clara Waters's *Women in the Fine Arts.* Number limited to Americans and those whose principal work could be determined.
[2] Does not add up to 100% because of rounding
[3] As described in Table 2

Table 4. Women Exhibitors at the Society of Independent Artists, 1917–1929

Year	Female Exhibitors[1]	Total Exhibitors	Women as Percentage
1917	454	1,131	40
1918	239	560	43
1919	142	354	40
1920	179	503	36
1925	233	657	35
1929	212	554	38

Source: Marlor, Society of Independent Artists.

[1] Gender could not be determined for some artists. They have been excluded from the female exhibitors, but not from the total exhibitors.

NOTES

INTRODUCTION

1. Mary Cassatt to Eliza Haldeman, March 18, [1864], in Mathews, *Cassatt and Her Circle*, 34.

2. The Metropolitan Museum of Art in New York and the Museum of Fine Arts in Boston were both organized in 1870; the Art Institute of Chicago was founded in 1879. On collecting, museums, and the wealth flowing into art, see Constable, *Art Collecting in the United States*; Saarinen, *Proud Possessors*; and the description of museum development in Levine, *Highbrow/Lowbrow*, 146–60. For overviews of nineteenth-century American art before the Civil War, see Harris, *Artist in American Society*; Johns, *American Genre Painting*; Miller, *Empire of the Eye*; and Novak, *American Painting of the Nineteenth Century*.

3. Sarah Burns discusses the *Times* article in "Old Maverick to Old Master," 36.

4. William C. Brownell calls for "aesthetic evangelists" in "Art Schools of New York," 765. On magazines, see Mott, *History of American Magazines*. On criticism, see Morgan, *New Muses*, 39–48.

5. I am echoing here an interpretation of the Gilded Age proposed by Neil Harris. He has suggested that one way to understand the Gilded Age may be "to pick up on Lewis Mumford's neglected point that the generation of the 1870s and 1880s was especially skillful at employing the visual and plastic arts as expressions of value. Here, rather than in literary reevaluation or political revision, we can come closer to understanding [the period's] energies and divisions." Harris, "Gilded Age Reconsidered Once Again," 15. On art education, see Boris, *Art and Labor*, 82–83; on the Centennial and the aesthetic movement, see Yount, "'Give the People What They Want'"; McCarthy, *Women's Culture*, 40–56; and Burke, *In Pursuit of Beauty*; on world's fairs, see Richard Guy Wilson, "Challenge and Response: Americans and the Architecture of the 1889 Exposition," in Annette Blaugrund, *Paris, 1889: American Artists at the Universal Exposition* (Philadelphia: Pennsylvania Academy of the Fine Arts in association with Henry N. Abrams, New York, 1989), 93–97; and Kasson, *Amusing the Million*, 17–23.

6. Davies, *Woman's Place Is at the Typewriter*, table 4, "Women in Selected Occupations, 1870–1930," 182–83, and Levy, "Directory of Painters," in *American Art Annual*, 1:420–501. The latter source shows women as 513 of the 1708 painters listed. Both of these sources have some problems as measures of women's participation in art. The census figures are

obviously quite inclusive and do not distinguish among different types of artists (although they do exclude designers and draftsmen) and do not account for those who combined teaching with art making (as did many male and female artists in this period). The *American Art Annual* derived its list from exhibition catalogs of the previous year and is thus already selective in its pool. It also apparently undercounts the number of painters in the country, since the 1900 census shows 24,873 artists and art teachers. Even with painters representing an "elite" of this category, the *Art Annual* still seems to underestimate their census numbers. I am, however, encouraged to think that growth in the relative proportion of women in art is accurate by another correspondence between the 1880 census, which shows women as 22.6 percent of artists, and an 1882 art directory, which shows women as just over 20 percent of the painters. "Artists' Directory," in Koehler, *United States Art Directory*, 95–123. Koehler's directory, which was also based on exhibition catalogs from the previous year, lists 1,463 artists and architects, 1,328 of whom were artists. Two hundred seventy-seven of the artists were women, making 20.8 percent. For further census figures, see also U.S. Bureau of the Census, *Occupational Trends in the United States: 1900 to 1950*, by David L. Kaplan and M. Claire Casey (Washington, D.C., 1958), tables 6 & 6b, pp. 10, 22; and "Women in Selected Professional Occupations, 1910–1991," in Nancy Woloch, *Women and the American Experience*, 2d ed. (New York: McGraw-Hill, 1994), 590.

7. White, "Younger American Women in Art," 538.

8. Women's historians have tended to find evidence of women's public activity and changing roles in the "harder" arenas of social welfare and social reform. Here, women used the ideology of female maternal nature to justify a "social housekeeping" that extended to caring for women and children and securing the morality and purity of streets and public spaces. It is not entirely evident why women's historians have not studied women artists, although disciplinary boundaries and the pervasive presumption of female amateurishness have most likely shaped their decisions. Upper- and middle-class women's involvement with culture continues to carry connotations of dilettantism and empty refinement: the female cultural guardian is imagined as an even more class-bound, irrelevant figure than the charitable lady bountiful once was. Art has also not been conventionally seen as a "profession," so recent influential work on women in the professions has not looked in the direction of women artists. Those interested in women artists have, instead, been art historians, and they have been recovering the names and accomplishments of women artists for the past twenty-five years. Their concern, however, has been with art — with the development of styles and patterns of artistic influence — rather than with the history of women or even the history of art world institutions. This literature is now quite extensive. I have found the best overviews to be Rubinstein, *American Women Artists*, and Tufts, *American Women Artists*. For comparisons with American women's situation, see Garb, *Sisters of the Brush*, and Cherry, *Painting Women*.

9. On women's cultural activities, see McCarthy, *Women's Culture*; Blair, *Torchbearers*; Boris, *Art and Labor*; and Roger B. Stein, "Artifact as Ideology: The Aesthetic Movement in its American Cultural Context," in Burke, *In Pursuit of Beauty*, 22–51.

10. On the unpredictability and unevenness of gender as a historical category, see Poovey, *Uneven Developments*, 1–23, and Scott, *Gender and the Politics of History*, 2–11, 28–50.

11. Christine Stansell makes the point about academic training in "Women Artists and the Problems of Metropolitan Culture: New York and Chicago, 1890–1910," in Corn, *Cultural Leadership in America*, 29–30.

12. Bledstein, *Culture of Professionalism*; Haber, *Quest for Authority and Honor*; and the essays in Haskell, *Authority of Experts*.

13. Art has typically been excluded from discussions of professionalization because it does not have some of the characteristics presumed to determine a profession, particularly a scientific method and an overt service mission. I would argue, though, that art has its own versions of method and mission and that to the extent that it fit, art did adopt "standard" professional structures. In this sense, I share Laurence Veysey's argument that the humanities and fine arts call into question the presumption of a single, paradigmatic path of professionalization. Laurence Veysey, "The Plural Organized Worlds of the Humanities," in Oleson and Voss, *Organization of Knowledge*, 59–62. On the definition of profession, see Dorothy Ross, "The Development of the Social Sciences," in Oleson and Voss, *Organization of Knowledge*, 117–18, and I. Waddington, "Professions," in *The Social Science Encyclopedia*, ed. Adam Kuper and Jessica Kuper (Boston: Routledge and Kegan Paul, 1985), 650–51.

By stressing art's orientation to professionalism, I am also proposing a reinterpretation of an argument proposed by Neil Harris in 1966. He argued that the early-nineteenth-century romantic image of the artist was replaced by an ideal of a success-oriented, career man. I argue, instead, that the shift is rooted in the growth of the professions and that the ways that prestige and status were defined in art had more to do with a fundamental cultural reorientation toward the professions than with a pragmatic business ethic. Harris, *Artist in American Society*, 218–20.

14. On the structural biases against women, see Glazer and Slater, *Unequal Colleagues*; Rossiter, *Women Scientists in America*; Morantz-Sanchez, *Sympathy and Science*; and Walsh, *"Doctors Wanted."* For work on female-dominated professions, see Muncy, *Creating a Female Dominion*, and Kunzel, *Fallen Women, Problem Girls*.

15. Trachtenberg, *Incorporation of America*, 140–61, and Levine, *Highbrow/Lowbrow*, 200–206, 219–25. The root of these interpretations is in Raymond Williams's formative study of English thinkers, *Culture and Society*.

16. "Refined" culture belonged as well to the discourse of "civilization" that, as Gail Bederman and others have shown, celebrated white, Anglo-Saxon society and culture and legitimized racial hierarchies. Bederman, *Manliness and Civilization*; Pyne, *Art and the Higher Life*. There is much to be said about race and the turn-of-the-century American art world. See, for example, Boime, *Magisterial Gaze*; Truettner, *The West as America*; and Nemerov, *Frederic Remington and Turn-of-the-Century America*.

17. Levine, *Highbrow/Lowbrow*, 171–77; Kasson, *Amusing the Million*; Peiss, *Cheap Amusements*; Rosenzweig, *Eight Hours for What We Will*; Sklar, *Movie-Made America*, 3–32; and Ogren, *Jazz Revolution*, 56–86.

18. Higham, "Reorientation of American Culture," 73–102; Bederman, *Manliness and Civilization;* Rotundo, *American Manhood,* 222–46; Kimmel, *Manhood in America,* 117–55; and Chauncey, *Gay New York,* 111–20.

19. The reorientation of the art world has often been read principally through male artists' crisis of masculinity: women artists appear peripheral to the changes in the art world because they rarely occupied substantial positions of power in the art world, such as on juries, in artists' associations, or even in art schools. By this account, the problem was with white middle-class male artists and their anxiety over their manhood in an industrial society. Burns, *Inventing the Modern Artist,* 160.

20. Late-nineteenth-century Americans regularly described the dawning of a new "woman's era" as education, the professions, social reform, and cultural work all brought women into public prominence. These public roles represented a substantial challenge to men's authority in arenas across American society and culture. For an overview, see Satter, *Each Mind a Kingdom,* 21–23, 221–33. See also Dawley, *Struggles for Justice,* 288.

21. On Bonheur's auction success, see Dijkstra, *Georgia O'Keeffe and the Eros of Place,* 73.

22. Charles M. Kurtz, "Women in Art," *New York Star,* October 6, 1889, Scrapbook: *The Star,* vol. 2, box 23, Charles M. Kurtz Papers, Archives of American Art, Smithsonian Institution, Washington, D.C. For other examples of suspicion at women's involvement in art, see "Art as a Steady Diet," 438–39, and Charles M. Kurtz's description of a studio reception in "What Artists Are Doing," [n.d.—1882?], Scrapbook: *[New York] Tribune—1882,* box 23, Kurtz Papers.

23. Singal, "Towards a Definition of American Modernism," 7–26; Douglas, *Terrible Honesty,* 217–53. Rita Felski shows the subtle (and contradictory) shading in the construction of ideas of modernity around *both* the repudiation of a dead, female tradition and the anxiety over a passive, feminized consumer society. Felski, *Gender of Modernity.*

24. "Do You Strive to Capture the Symbols of Your Reactions?," 10. I am indebted to Sandra M. Gilbert and Susan Gubar, who introduced me to this quotation when they used it as the epigraph of their book *No Man's Land.*

25. The therapeutic mode emerged at the turn of the century. It stressed self-fulfillment to be obtained through intense, authentic experience. For all that modern avatars of high culture sought to segregate themselves from mass culture, an ironic congruence links high culture and twentieth-century consumer capitalism. The therapeutic ethos is, as T. J. Jackson Lears has pointed out, remarkably similar to consumer capitalism's stress on self-fulfillment and self-realization. Nevertheless, the gendered roots of new notions of art and high culture suggest that the therapeutic worldview may be a response to a specifically *male* search for meaning and authentic experience. Many American women at the turn of the century had the inverse experience to men's: a validation of self in new careers, an energizing visibility, and qualms about being associated with the uncontrollable desires of the stereotyped female consumer. The conjunction between a therapeutic ethic and concepts of culture needs closer examination from a gender perspective. Lears, *No Place of Grace,* xvi, xix, 55–56, 302–4.

26. Huyssen, "Mass Culture as Woman," 44–62; Levine, *Highbrow/Lowbrow.*

27. What work has been done on women in other areas of art shows important similarities to the experiences of women painters. See particularly Bogart, "Artistic Ideals and Commercial Practices," 225–81; Walls, "Educating Women for Art and Commerce," 329–55; Peet, "Emergence of American Women Printmakers"; and Dwyer, "Nineteenth-Century Regional Woman Artists." There was also a long-standing and active community of women sculptors. See Rubinstein, *American Women Sculptors;* Gerdts, *White Marmorean Flock;* and Aronson, "Bessie Potter Vonnoh."

CHAPTER ONE

1. Cox, "Louise Cox at the Art Students League," 12.

2. Wheeler, "Art Education for Women," 82.

3. Cox, "Louise Cox at the Art Students League," 13.

4. The process of professionalization is most often described in terms of the development of formalized and regularized training programs, required credentials such as degrees and licenses, and the formation of independent professional associations. See Oleson and Voss, *Organization of Knowledge,* and Haskell, *Authority of Experts.*

5. The gendered character of the ideal professional has been well documented. For summary statements, see Cott, *Grounding of Modern Feminism,* 217; Glazer and Slater, *Unequal Colleagues,* 3; Melosh, *"Physician's Hand,"* 20, 26–27; and Rossiter, *Women Scientists in America,* 73–99.

6. Taylor, *Fine Arts in America,* 125. Schools continued to be established throughout the late nineteenth century, for example, in Cincinnati; Buffalo, N.Y.; and Washington, D.C. For notice of this art school boom at the time, see Harwood, "Art Schools of America," 27–34. Harwood also records the rising popularity of these schools, citing striking statistics about enrollment increases.

7. Brownell, "Art Schools of New York," 765. Emphasis in original. See also, for example, Brownell, "Art Schools of Philadelphia," 737–50.

8. Fink and Taylor, *Academy,* 29, 34–37.

9. Harris, *Artist in American Society,* 181, 262, 274.

10. On the American Art Union, other art unions, and the position of the National Academy, see Harris, *Artist in American Society,* 262–63; Fink and Taylor, *Academy,* 41–47; and Miller, *Patrons and Patriotism,* 160–72.

11. Cummings, *Historic Annals of the National Academy of Design,* 50.

12. Allen Tucker, "The Art Students' League, an Experiment in Democracy" in *Fiftieth Anniversary Exhibition of the Art Students League of New York* (1925), reel NY59-20: #34, Art Students League Records, Archives of American Art, Smithsonian Institution, Washington, D.C. (hereafter cited as ASL Records).

13. President's Annual Address, April 1883, reel NY59-24: #306, ASL Records; and Report of the Corresponding Secretary, April 1883, reel NY59-24: #314, ASL Records.

14. Constitution, October 1875, reel NY59-24A:no frame number; Annual Meeting,

Minutes, October 16, 1876, reel NY59-24A: #186–88; and Certificate of Incorporation, reel NY59-20: #9. All ASL Records.

15. On Schussele and the decision to hire him, see Onorato, "Pennsylvania Academy of the Fine Arts and the Development of an Academic Curriculum," 74–80, 89.

16. Sheehan, "Boston Museum School," 18–19.

17. The differences between the careers—and power bases—of Asher B. Durand and William Merritt Chase provide an instructive example of the shifting terrain of an artist's career in these decades. Durand, born in 1796, never attended an art academy, although he helped found the National Academy of Design and was its president from 1845 to 1861. A leader of the dominant Hudson River School, Durand used his position to shepherd his friends through the academy annual exhibitions. Born just over fifty years later in 1849, William Merritt Chase studied at the National Academy of Design in the late 1860s and then went on to Munich and Paris to complete his training. He taught throughout his career, most consistently at the Art Students League, and eventually founded two art schools of his own. Based on his growing reputation, both the Pennsylvania Academy of the Fine Arts and the Chicago Art Institute asked him to teach in the 1890s. Unlike Durand, who spent his summers camping in the Catskills with other artist friends, Chase spent a dozen summers leading groups of students through Europe. For Chase, teaching promised the financial rewards and legacy building of many devoted students that Durand had found in the National Academy of Design. Leading names of their generations, Chase and Durand understood the requirements for becoming an artist as well as their professional duties and obligations in very different terms. Information on Durand in Novak, *American Painting of the Nineteenth Century*, 323, and Harris, *Artist in American Society*, 274. Information on Chase in Bryant, *William Merritt Chase*.

18. For a similar overview perspective on the importance of schools in the post–Civil War art world, see Taylor, *Fine Arts in America*, 119–20, 125. On the shift away from genius, see Harris, *Artist in American Society*, 245–46.

19. See Annual Reports, Pennsylvania Academy of the Fine Arts, reel 4338: #452, #470, and reel P51: #186–202, #208, #218, Records of the Pennsylvania Academy of the Fine Arts, Archives of American Art, Smithsonian Institution, Washington, D.C. (hereafter cited as PAFA Records). The enrollment figures are as follows: 1877—100 men/51 women, women are 34 percent of total; 1878—149 men/81 women, women are 35 percent of total; 1881–82—129 men/106 women, women are 45 percent of total; 1882–83—106 men/97 women—women are 48 percent of total; 1883–84—109 men/105 women, women are 49 percent of total; 1884–85—120 men/104 women, women are 46 percent of total; and October 1885–February 1886—82 men/90 women, women are 52 percent of total.

20. "Some Lady Artists of New York," *Art Amateur* 3 (July 1880): 27, as quoted in Green, "Women Art Students in America," 64–65. In May 1883, the membership of the League was 63 women and 58 men; the student body included 272 women, 193 men. Minutes, Members' Meeting, May 25, 1883, reel NY59-24: #381–82, ASL Records.

21. Museum of the Fine Arts School of Drawing and Painting, First Annual Report of the Permanent Committee in Charge of the Schools, 1877, pp. 7–8, Records of the Mu-

seum of Fine Arts School of Drawing and Painting, Boston (hereafter cited as First Annual Report, Second Annual Report, etc., and Museum School Records); Minutes of the Permanent Committee, January 3, 1877, Museum School Records; and Twentieth Annual Report, August 5, 1896, p. 6, Museum School Records.

22. The phrase "elegant amusement" comes from "A Mother," *Thoughts on Domestic Education* (1829), 24–25, as quoted in Withers, "Artistic Women and Women Artists," 330. On Ruskin and women's cultural guardianship, see Stankiewicz, "'Eye Is a Nobler Organ,'" 54, and McCarthy, *Women's Culture*, 43. For the eighteenth-century roots of this association between women, artistic accomplishments, and the refinement of society, see Zagarri, "Morals, Manners, and the Republican Mother," 192–215.

23. Muncy, *Creating a Female Dominion*, 20. On ideals of womanhood and a feminine professional identity, see also Glazer and Slater, *Unequal Colleagues*, 199–203; Morantz-Sanchez, *Conduct Unbecoming a Woman*; Morantz-Sanchez, *Sympathy and Science*; and Garrison, *Apostles of Culture*.

24. On women's entry into the professions generally, see Glazer and Slater, *Unequal Colleagues*; Cott, *Grounding of Modern Feminism*, 215–39; and Brumberg and Tomes, "Women in the Professions," 275–96.

25. What's new about this is the focus on middle-class women by middle-class writers. Working-class women had been encouraged to obtain art training as a wage-earning skill throughout the nineteenth century. Midcentury drawing manuals included women who were "compelled to toil" among the users of their books. In his introduction to his *American Drawing-Book* (New York: J. S. Redfield, Clinton Hall, 1847), J. G. Chapman noted:

> The natural refinement and delicacy of the female mind renders it a fruitful soil, that should not be neglected or let run to waste, when its cultivation might realize such rich advantages, not only to themselves, but to their country. Give them the advantages of education in Drawing; begin in your public schools; let them carry it to their looms, to the manufacture of articles of taste and fancy, to their firesides, to the early education of their children;—and more, if they possess the talent,— . . . and we shall soon see the broken-hearted victim of incessant toil worth the wages of men in departments of industry and usefulness for which they are by nature so well adapted. (8)

At the same time that Chapman drew on the rhetorical convention of the "dependent female" to justify women's artwork, he also began to formulate an ideal of harmony between women's "refinement" and "art" that became crucial in later defenses of middle-class women's access to art.

26. "Woman's Position in Art,"; Craik, *Woman's Thoughts about Women*, 44; and "Painting as a Profession for Women," 87. The majority of the women students in art academies were most likely middle class, although detailed research has not yet been done. My informal survey of women artists supports this view. For similar evidence and conclusions, see McCarthy, *Women's Culture*, 94, and Walls, "Educating Women for Art and Commerce," 330, 336.

27. Walls, "Art and Industry in Philadelphia," 176–99; Walls, "Educating Women for Art and Commerce"; and McCarthy, *Women's Culture*, 28–32.

28. On women in higher education, see Solomon, *In the Company of Educated Women*, and Gordon, *Gender and Higher Education in the Progressive Era*. Historians have typically focused on the 1890s–1910s as the crucial years for women's entry into professional schools with important separatist initiatives in the preceding decades, particularly in medicine. Art remains unusual in developing coeducation and professionalism simultaneously as early as the 1860s. On women and professional training, see Rossiter, *Women Scientists in America*, 1–50; Morantz-Sanchez, *Sympathy and Science*, 64–89; Muncy, *Creating a Female Dominion*, 66–92; and Antler, "Educated Woman and Professionalization," 47–50, 65–68. On Charlotte Perkins Gilman, see Ann J. Lane, *To Herland and Beyond: The Life and Work of Charlotte Perkins Gilman* (New York: Pantheon Books, 1990), 63.

29. Miller, *Empire of the Eye*, 248. Not all mountain travel remained rough and tumble. Accessible tourist facilities developed quickly, especially in New York's Catskill Mountains. But the sketching tramp to the highest, most remote points remained largely masculine in both practice and overtones. On antebellum landscapists' summer expeditions, see, for example, *American Paradise*, 103–40, 238–65.

30. "Programme of Classes, for Season of 1885–6," reel NY59-20: #8, ASL Records. For development of the school's curriculum, see "School History," reel NY59-20: #16–18, ASL Records.

31. Winthrop Peirce, a student at the opening of the Museum School, remembered, "The trouble was the lack of any general understanding of the need of a systematic education for artists, such as was required for any other profession or trade. . . . As a community, in questions of art education, Boston was still in the eighteenth century." Peirce, *History of the School of the Museum of Fine Arts*, 15. Carol Troyen identifies a "Boston tradition," beginning with Washington Allston and extending to William Morris Hunt and John La Farge in the 1860s and 1870s. Carol Troyen, *Boston Tradition*, 25, 29.

32. William Morris Hunt, *Talks on Art*, vol. 2 (Boston, 1883), 53, as quoted in Hoppin, "Women Artists in Boston," 19.

33. On Hunt's vision for the school, see Sheehan, "Boston Museum School," 17. On Hunt's teaching method, see Hoppin, "Women Artists in Boston," 19.

34. Millet, "Mr. Hunt's Teaching," 191.

35. See descriptions of course program in First Annual Report, 1877, pp. 7–8; Second Annual Report, 1878, p. 3; and Third Annual Report, 1879, pp. 5–7, Museum School Records.

36. Fourth Annual Report, 1880, pp. 3–4, 7–17, Museum School Records. See especially the appendix, pp. 8–14, reprinting an article that explained and defended the changes.

37. Onorato, "Pennsylvania Academy of the Fine Arts and the Development of an Academic Curriculum," 97. On the Art Students League curriculum, see "School History," reel NY59-20: #16–18, ASL Records, and Brownell, "Art Schools of New York." On the Museum School curriculum, see Peirce, *History of the School of Fine Arts*, and Sheehan, "Boston Museum School."

38. Minutes, Committee on Instruction, January 9, 1879, reel P47: #690, PAFA Records.

39. See Permanent Committee Meetings, 1881–88, Secretary's Record, November 23, 1881, December 6, 1881, February 7, 1882, March 7, 1882, October 3, 1882, and October 31, 1882, Museum School Records.

40. On Eakins's methods and tenure at the Pennsylvania Academy, see Brownell, "Art Schools of Philadelphia," 737–50; Goodrich, *Thomas Eakins*, 1:167–89; and Onorato, "Pennsylvania Academy of the Fine Arts and the Development of an Academic Curriculum," 111–18.

41. On Eakins's resignation and the circumstances surrounding it, see the recent explanation based on newly discovered manuscripts in Foster and Leibold, *Writing about Eakins*, 69–79. See also Goodrich, *Thomas Eakins*, 1:281–95. The quotation is from Alexander Stirling Calder, in Onorato, "Pennsylvania Academy of the Fine Arts and the Development of an Academic Curriculum," 143.

42. "Programme of Classes for Season of 1885–6," reel NY59-20: #7–8, ASL Records; Sheehan, "Boston Museum School," 51–53.

43. Minutes, Members' Meeting, March 4, 1884, reel NY59-24: #412–14, ASL Records.

44. Foster, "Makers of the American Watercolor Movement," 382–83, 388, and Bienenstock, "Formation and Early Years of the Society of American Artists."

45. Report, February 1886, reel NY59-20:#20, ASL Records. Concurrently, leading commentators began to warn of the dangers of oversupply and to encourage restricting art study. Foster, "Makers of the American Watercolor Movement," 391–92.

46. Seventh Annual Report, 1883, p. 6, Museum School Records, and Programme of Classes for Season of 1885–86, reel NY59-20: #7, ASL Records. The League regularly reported with growing satisfaction on the "standard" of work in the school. In 1883, the president announced, "The general average is higher than it has ever been before." In 1886, the school program asserted, "The work done by the students is the highest in standard the League has ever known." And by 1895, the board was continuing to "enlarg[e] the scope and rais[e] the standard of the school." President's Annual Address, 1883, reel NY59-24: #301; Programme of Classes for Season of 1885–86, reel NY59-20: #7; and President's Address, 1895, reel NY59-26: #171–72, ASL Records.

47. Fairman Rogers, "The Schools of the Pennsylvania Academy of the Fine Arts," *Pennsylvania Monthly* 22 (June 1881): 453–62, reel 4320: #529–36, PAFA Records.

48. "Report," February 1886, reel NY59-20: #22–23, ASL Records. For similar efforts at the Museum School, see Fifth Annual Report, 1881, and Sixth Annual Report, 1882, Museum School Records.

49. Tamar Garb has argued that in Paris women were excluded from the Ecole des Beaux Arts until the 1890s for exactly these reasons—because they threatened male bonding and the painting of grand figure compositions that guaranteed male artists' stature. Garb, "Forbidden Gaze," 148, 150.

50. Cox, "Louise Cox at the Art Students League," 17.

51. First Annual Report, 1877, p. 9, and Thirteenth Annual Report, 1889, p. 13, Museum School Records.

52. On similar pressures at universities in the Midwest and West, see Rosenberg, *Beyond Separate Spheres*, 30.

53. See, for example, "Some Lady Artists of New York," 27.

54. T., "Disciples of William Morris Hunt," 41, and Clarence Cook, as quoted in McCarthy, *Women's Culture*, 86. Hoppin says that it is unclear whether Hunt originally meant the class to be for women alone. Hoppin, "Women Artists in Boston," 18–19.

55. Millet, "Mr. Hunt's Teaching," 191, 189; "imitative individualism" is from Fairbrother et al., *Bostonians*, 43. For a similar description of Hunt's influence, see Brownell, "Younger Painters of America.—III," 327.

56. Rogers, "Schools of the Pennsylvania Academy," reel 4320: #529–36, PAFA Records.

57. "The Decline of the Amateur," *Atlantic Monthly* 73 (1894): 859, as quoted in Levine, *Highbrow/Lowbrow*, 140. On the meaning of amateur, see also Bledstein, *Culture of Professionalism*, 31; Bender, *New York Intellect*, 125–28. Kathleen Foster shows how gendered ideas about amateurism also forced women out of the American Watercolor Society, an organization initially hospitable to women engaged in this traditional female pursuit. Foster, "Makers of the American Watercolor Movement," 389–90. For a similar discussion of the position of women artists, see Parker and Pollock, *Old Mistresses*, 80–81.

58. Report of the Committee on Instruction, October 11, 1869, reel P47: #664, PAFA Records.

59. Report of the Committee on Instruction, April 13, 1868, reel P47: #658, PAFA Records; and Board of Directors, Minutes, March 9, 1868, reel P44: #537, PAFA Records.

60. Edith Mitchill Prellwitz Diaries, December 8–9, 1884, and December 17, 1884, as quoted in Pisano, *Henry and Edith Mitchill Prellwitz*, 13.

61. Petition to Mr. Fairman Rogers, November 2, 1877, reel 4337: #381–82, PAFA Records. Female academy students demanded more life study on other occasions. See "Petition of Students for Woman's Life Class," n.d. [probably late 1880s], reel 4337: #342–43, PAFA Records. Women also insisted on more life training at other schools. For example, the League added a second woman's life in the spring of 1883 in response to increased numbers and threats from women students that they would leave the class if there weren't better arrangements. With this class, the number of women attending life classes exceeded the number of men. Minutes, Board of Control, February 2, 1883, and February 20, 1883, reel NY59-24: #433–36, ASL Records.

62. Petition to Mr. Fairman Rogers, November 2, 1877, reel 4337: #381–82, PAFA Records.

63. "Alice Stephens Works 45 Years without a Halt," unidentified clipping, reel 4152: #345, Alice Barber Stephens Papers, Archives of American Art, Smithsonian Institution, Washington, D.C. At the time, though, Stephens also expressed some ambivalence about Eakins's teaching after modeling nude for him. Foster and Leibold, *Writing about Eakins*, 70–71.

64. Cox, "Louise Cox at the Art Students League," 17–18, 20, and Secretary's Scrapbook, Letter, 1887, as quoted in Green, "Women Art Students," 175.

65. Bishop, "Young Artists' Life in New York," 355.

66. Minutes, Members Meeting, March 4, 1884, reel NY59-24: #412–14, ASL Records, and Grace Fitz-Randolph to the Members of the Art Students' League, May 3, 1887, reel NY59-25: #177, ASL Records.

67. Morantz-Sanchez, *Sympathy and Science*, 72–81; Melosh, *"Physician's Hand,"* 29–33; Muncy, *Creating a Female Dominion*, 76–79; and, on design schools, see discussion of Emily Sartain at the Philadelphia School of Design for Women in Walls, "Art, Industry, and Women's Education," 323–29.

68. Miscellaneous Note, [November 1877], reel 4377: #404, and Catherine Ann Janvier to Mr. Corliss, February 8, 1879, reel 4377: #408–9, PAFA Records. For explorations of the conflicts among women over professionalization, see Kunzel, *Fallen Women, Problem Girls*, and Melosh, *"Physician's Hand."*

69. Morantz-Sanchez, *Sympathy and Science*, 184–202, and Morantz-Sanchez, "Gendering of Empathic Expertise," 40–58. Laura Prieto Chesterton has identified an antebellum domestic-based female professionalism among women artists that academic training critiqued and supplanted. Many of these women resented being relegated to the category of amateur by the rising (and ambitious) generation. Although I would argue (unlike Chesterton) that academic professionalism won out among this generation, significant fracturing and struggle to define the legitimate female artist clearly existed among women themselves. Chesterton, "Cultural History of Professional Women Artists," 190–91.

70. For examples of the conception of the "girl art student," see "The Girl Art Student. She Is an Interesting Creature—How She Lives and How She Works," *New York Sun*, February 9, 1890, in Art Students League Scrapbook, reel NY59-24A: no frame number, ASL Records, and E. E. Newport, "Society and the Art," *Corcoran Art Journal* 3 (March 1894): 5, as quoted in Green, "Women Art Students," 215–16.

71. Landgren, *Years of Art*, 50–51. "Jennie June" was the pen name of Jane Cunningham Croly, journalist and founder of the General Federation of Women's Clubs.

CHAPTER TWO

1. Nieriker, *Studying Art Abroad and How to Do It Cheaply*, 43. The chapter title is adapted from Henry T. Tuckerman, *Papers about Paris* (New York: G. P. Putnam and Son, 1867), 87, as quoted in Weinberg, *Lure of Paris*, 70.

2. Natt, "Paris Art Schools," 269. Gilded Age American artists traveled to other European art centers, most notably Munich, but Paris surpassed all others in size and importance. According to Barbara Dayer Gallati, only three hundred Americans studied in Munich between 1870 and 1885. Gallati, *William Merritt Chase*, 18.

3. Holland, "Lady Art Student's Life in Paris," 225.

4. Weinberg, *Lure of Paris*, 7–8, 79. It is not possible to trace Weinberg's figure of one-third women across time, so we do not know if the percentage increased as women's attendance in art schools increased. For a fuller discussion of the changes in the journey to Paris, see Quick, *American Expatriate Painters of the Late Nineteenth Century*, 16–17.

5. Examples of articles on Parisian art study include Natt, "Paris Art Schools," 269–76; Wright, "Art Student Life in Paris," 70–71; Peterson, "American Art Student in Paris," 669–76; Linson, "With the Paris Art Student," 289–302; Hooper, "Art Schools of Paris," 59–62; and Holland, "Student Life in the Quartier Latin," 33–40. For the Museum School guide to the city, see Boston Art Students' Association, *The Art Student in Paris* (1887), reel N47: #2–28, New York Public Library Collection, Archives of American Art, Smithsonian Institution, Washington, D.C.

6. Greene, "Girl Student in Paris," 286–87; Belloc, "Lady Artists in Paris," 371–84; and Nieriker, *Studying Art Abroad and How to Do It Cheaply.* For other accounts, see Wright, "Atelier Des Dames," 21–29; Sutherland, "Art Student's Year in Paris," 52, 86, 108; Aylward, "American Girls' Art Club in Paris," 598–605; de Forest, "Art Student Life in Paris," 628–32; Rowland, "Study of Art in Paris," 756–61; and Holland, "Lady Art Students' Life in Paris," 225–33.

7. Nobili, "Académie Julian," 751–52.

8. On what Paris represented to artists, see Fink, *American Art*, 66, 89–90, 92.

9. On the change in market taste, see Weinberg, *Lure of Paris*, 78. Barbizon painting refers to the school of French landscape painters (including Jean François Millet and Thomas Couture) who worked in the village of Barbizon outside Paris. They experimented with plein air painting and looser, freer brushwork.

10. On the fragmentation and restructuring of the Parisian art world, see Boime, *Academy and French Painting in the Nineteenth Century*, 15–21; Rewald, *History of Impressionism*; Jensen, *Marketing Modernism*; and Garb, *Sisters of the Brush*, 32–37. On American artists' reluctance to join the modern art movement, see Gerdts, *American Impressionism*, 25.

11. On avant-garde art's dangers for respectable women, see Griselda Pollock, "Modernity and the Spaces of Femininity," in Pollock, *Vision and Difference*, 50–90.

12. Belloc, "Lady Artists in Paris," 383.

13. See, for example, Ellen Day Hale to Edward Everett Hale, March 20, 1877, April 15, 1877, and April 17, 1877, box 45, folder 1059, Hale Family Papers, Sophia Smith Collection, Smith College, Northampton, Mass. (hereafter cited as Hale Papers/Smith).

14. Mary Cassatt to Emily Sartain, July 10, [1871], in Mathews, *Cassatt and Her Circle*, 75. On Cassatt's financial situation, also see Mathews, *Cassatt and Her Circle*, 65–66. Similarly, May Nieriker partially titled her book on foreign art study *How to Do It Cheaply*, defining her audience as women who were "poor, like so many of the profession, wishing to make . . . the little bag of gold last as long as possible." Nieriker, *Studying Art Abroad and How to Do It Cheaply*, 6–7.

15. Emily Sartain to John Sartain, July 22, 1875, reel 2727: #582–84, Sartain Family Papers, Archives of American Art, Smithsonian Institution, Washington, D.C. (hereafter cited as Sartain Papers). On Sartain's financial arrangements, see also Emily Sartain to John Sartain, July 10, 1874, reel 2727: #470–74, and Emily Sartain to John Sartain, May 25, 1875, reel 2727: #561–66, Sartain Papers.

16. Elizabeth Graham Bailey documents Cecilia Beaux's funding in "Cecilia Beaux

Papers," 15. In another instance, Lydia Field Emmet was able to study in Paris after receiving an inheritance from a cousin. Bache Whitlock to Cousin Julia [Julia Emmet], November 3, 1884, Correspondence, box 1, Emmet Family Papers, Archives of American Art, Smithsonian Institution, Washington, D.C. (hereafter cited as Emmet Papers). These papers have been subsequently microfilmed, but all correspondence can be located by date.

17. William Biddle to Cecilia Beaux, October 10, 1888, as quoted in Tappert, "Choices," 197. Families made similar calculations for men. Kenyon Cox's parents agreed to fund his study in Paris in lieu of college and with the implicit assumption that he would not receive an inheritance later. Men may have had a wider net to cast in locating money than women, since patrons and community leaders occasionally funded foreign study for promising young men. J. Alden Weir, for example, studied in Paris with the assistance of a family friend and patron. Even with these extra funding sources and a greater presumption that men should receive family funds to prepare them for a profession, men and women still shared the calculations of a family economy. On Cox and Weir, see Morgan, *American Art Student in Paris*, 7, and Young, *Life and Letters of J. Alden Weir*, 17, 33–34, 51–53.

18. Rowland, "Study of Art in Paris," 757.

19. Eliza J. Haldeman to Mrs. Samuel H. Haldeman, March 8, 1867, reel 3658: #1097–98, Eliza Haldeman Correspondence, Archives of American Art, Smithsonian Institution, Washington, D.C. (hereafter cited as Haldeman Correspondence). Letter also reprinted in Mathews, *Cassatt and Her Circle*, 43–44. For a similar pattern of growing confidence and control, compare Emily Sartain to John Sartain, January 26, 1872, and Emily Sartain to John Sartain, July 17, 1874, reel 2727: #317–19, #470–74, Sartain Papers.

20. Eliza Haldeman to Mrs. Samuel Haldeman, February 19–20, 1867, reel 3658: #1095–96, Haldeman Correspondence. Also in Mathews, *Cassatt and Her Circle*, 41–42.

21. Eliza Haldeman to Mrs. Samuel Haldeman, September 5, 1867, reel 3658: #1101–2, Haldeman Correspondence. Also in Mathews, *Cassatt and Her Circle*, 47–48.

22. Cecilia Beaux to William Biddle, September 30, 1888, as quoted in Tappert, "Choices," 195–96. Elizabeth Gardner wrote to her sister after her engagement to French painter William Bouguereau that they would not be married for some time: "I have long been accustomed to my freedom. I am beginning to attain a part of the success for which I have struggled so long." Gardner remained engaged for twenty years in part because she feared losing the freedom to focus on her work that Paris gave her. Elizabeth Gardner to Maria Gardner, June 8, 1879, as quoted in Fidell-Beaufort, "Elizabeth Jane Gardner Bouguereau," 5.

23. Elizabeth Gardner Bouguereau to Mother, January 21, 1866, reel 3464: #21–22, Elizabeth Gardner Bouguereau Papers, Archives of American Art, Smithsonian Institution, Washington, D.C. (hereafter cited as Bouguereau Papers); Eliza J. Haldeman to Mrs. Samuel J. Haldeman, May 28, 1868, reel 3658: #1119–20, Haldeman Correspondence.

24. Jacobs, *Good and Simple Life*, 17–87.

25. For example, see Emily Sartain's and Mary Cassatt's schedule in 1872–73, detailed in Mathews, *Cassatt and Her Circle*, 343–44; Cecilia Beaux's schedule in 1888–89, detailed in

Bailey, "Beaux Papers," 15–16, and Tappert, "Choices," 165–66, 177–78, 198; and Lilla Cabot Perry's schedule in 1888–89, detailed in Martindale, *Lilla Cabot Perry*, 20–21.

26. Ellen Day Hale to Miss Curtis, May 14, 1887, box 45c, folder 1085, Hale Papers/Smith.

27. On women's classes, see Fink, *American Art*, 136–37; Belloc, "Lady Artists in Paris," 379–80; and Boston Art Students' Association, *Art Student in Paris*, 28–38.

28. On the Académie Julian, see Nobili, "Académie Julian," 746–52; Hooper, "Art Schools of Paris," 60–62; Fehrer, *Julian Academy*; Fehrer, "New Light on the Académie Julian," 207–16; Fehrer, "Women at the Académie Julian in Paris," 752–57; and Weisberg and Becker, *Overcoming All Obstacles*.

29. Lida Rose McCabe, "Madame Bouguereau, Pathfinder," *New York Times Book Review and Magazine*, February 19, 1922, reel 3464: no frame number, Bouguereau Papers.

30. Nancy Mowll Mathews, "American Women Artists at the Turn of the Century: Opportunities and Choices," in Martindale, *Lilla Cabot Perry*, 109; and Emmet family correspondence, generally December 1884–March 1885, Correspondence, box 1, Emmet Papers.

31. Beaux, *Background with Figures*, 122. On Parisian classrooms in general, see Mathews, "American Women Artists," 122.

32. Sutherland, "Art Student's Year in Paris," 52.

33. For the intense anticipation of criticism, see Sutherland, "Art Student's Year in Paris," 52, and Natt, "Paris Art Schools," 275.

34. Rosina Emmet [Sherwood] to Julia Emmet, January 30, 1885, Correspondence, box 1, Emmet Papers.

35. This is not to deny that a current of desire and seduction existed in some cases. Certainly, the many marriages of artists to their students is contrary evidence; however, my point that women traversed these relationships cautiously and that they tried to construct them to their advantage remains. After all, marriage to an artist was frequently an advantage for women who wanted continued support for their artistic work.

36. Ellen Day Hale to Miss Curtis, May 14, 1887, box 45c, folder 1085, Hale Papers/Smith.

37. "Address of Miss Ellen Day Hale," Washington Club, April 10, 1917, box 44, folder 1052, Hale Papers/Smith.

38. Emily Sartain to John Sartain, October 13, 1872, reel 2727: #384–89, Sartain Papers.

39. Emily Sartain to John Sartain, March 7, 1873, reel 2727: #412–17, Sartain Papers.

40. Emmet added, "Fleury is so much brisker and more severe and decided besides being very inspiring." Lydia Field Emmet to Julia Emmet, January 5, 1885, Correspondence, box 1, Emmet Papers. For a less enthusiastic assessment of Fleury but a similar evaluation of different teachers, see Cecilia Beaux to William Biddle, September 9, 1888, as quoted in Tappert, "Choices," 187.

41. Ellen Day Hale to Miss Curtis, May 14, 1887, box 45c, folder 1085, Hale Papers/Smith. Similarly, Lilla Cabot Perry remembered Gustave Courtois criticizing her at Colarossi's atelier:

I was discouraged by him. Not by what he said but because he does not seem to take the slightest interest in the work of the students, and his criticism seemed to me very careless—mere snap shots.

For instance when he said my shoulders were too low, the model was entirely out of pose. . . . I changed the color a little bit, but did not alter the shoulders, as I thought he was wrong.

Like the Emmets, Perry assessed the seriousness of the master's teaching. She felt free to dismiss, quite decisively, his criticism in order to make her own judgments about her drawing. Lilla Cabot Perry, "Memoirs," in Martindale, *Lilla Cabot Perry,* 129.

42. Women attained entry only after they had been hounded out of the school by male students with shouts of "Down with women." See Garb, "Forbidden Gaze," 151.

43. Letter fragment from Rosina Emmet, n.d. [probably December 1884], Correspondence, box 1, Emmet Papers; Cecilia Beaux to Grandma Leavitt, [February–March 1888], as quoted in Tappert, "Choices," 156; Cecilia Beaux to [Family], [February–March 1888], as quoted in Tappert, "Choices," 160; and Thomas Eakins to father, as quoted in Weinberg, *Lure of Paris,* 94–95. On the unequal opportunities for women in Paris, see Fink, *American Art,* 136, and Boston Art Students' Association, *Art Student in Paris,* 5–6, 28.

44. Natt, "Paris Art Schools," 273; Nieriker, *Studying Art Abroad and How to Do It Cheaply,* 50, 49; and on mixed-sex classes, Sutherland, "Art Student's Year in Paris," 108.

45. Elizabeth Gardner to Maria Gardner, May 25, 1868, reel 3464: #36–37, Bouguereau Papers, and Eliza Haldeman to Sister, May 13, 1868, reel 3658: #1113–14, Haldeman Correspondence. On the Salon's draw for art students, see Peterson, "American Art Student in Paris," 674–76, and Linson, "With the Paris Art Student," 300–301. On the positive effects of the Salon, see Dwyer, *Anna Klumpke,* 35–45; Weinberg, *Lure of Paris,* 70; and Fink, *American Art,* 274–75. On the percentage of women exhibitors, see Fink, *American Art,* 135.

46. Cecilia Beaux to William Biddle, [early 1888], as quoted in Bailey, "Beaux Papers," 15.

47. Cecilia Beaux to Grandma Leavitt, Thanksgiving, 1888, as quoted in Tappert, "Choices," 202. See also Cecilia Beaux to William Biddle, September 30, 1888, in ibid., 196. Ellen Day Hale also advised a strategic approach to the Salon: "If your friend has any intention of exhibiting at the Salon, that business is systematized at Julian's to an amazing extent. The pupils who mean to exhibit show their work to the professors who are pretty severe about giving or withholding their permission to do so. But if the permission is once given, the professors do their best for the pupils by their votes as members of the jury." Ellen Day Hale to Miss Curtis, May 14, 1887, box 45c, folder 1085, Hale Papers/Smith.

48. Cecilia Beaux to Family, [February 1889], as quoted in Tappert, "Choices," 213; Cecilia Beaux to Family, February 11, 1889, as quoted in ibid., 214; and Cecilia Beaux to Jamie and Etta Drinker, March 14, 1889, as quoted in ibid., 217.

49. Women's historians have long stressed the importance of communities of women in sustaining female activists and professionals. Sklar, "Hull House in the 1890s," 658–77;

Freedman, "Separatism as Strategy," 512–29; and Cook, "Female Support Networks and Political Activism," 43–61.

50. Tappert, "Choices," 145–46, and Fidell-Beaufort, "Elizabeth Jane Gardner Bouguereau," 3.

51. Rosina Emmet Sherwood to Julia Emmet, January 8, 1884 [probably 1885]; Rosina Emmet Sherwood to Julia Emmet, December 3, 1884; and Lydia H. Emmet to Julia Emmet, January 6, 1885, all Correspondence, box 1, Emmet Papers.

52. Aylward, "American Girls' Art Club," 598, 599, 603.

53. Rowland, "Study of Art in Paris," 758.

54. Aylward, "American Girls' Art Club," 604–5.

55. On the development of the expatriate community in Paris, see Weinberg, *Lure of Paris*, 70, 76.

56. Lydia H. Emmet to Julia Emmet, [January] 24, [1885], and Rosina Emmet to Mother [Julia Emmet], January 1885, Correspondence, box 1, Emmet Papers.

57. Cecilia Beaux to Grandma Leavitt, Thanksgiving 1888, as quoted in Tappert, "Choices," 202 [Tappert's elisions]. See also 166–67.

58. Bailey, "Beaux Papers," 16. Quotation is from letter facsimile illustrated on p. 16.

59. Emily Sartain to John Sartain, Paris, March 8, 1874, reel 2727: #448–55, Sartain Papers. Louisine Elder Havemeyer later became a major collector of impressionist art, largely because of her friendship with Mary Cassatt, who had been introduced to Havemeyer by Sartain.

60. Mary Cassatt to Emily Sartain, June 7, [1871], in Mathews, *Cassatt and Her Circle*, 72–75.

61. Emily Sartain to John Sartain, May 8, 1873, in ibid., 117–21.

62. Ibid.

63. Wright, "Atelier des Dames," 26. Extensive albums of caricatures from the Julian Academy survive. See Weisberg and Becker, *Overcoming All Obstacles*, 17.

64. See, for example, Lydia F. Emmet to Julia Emmet, January 6, 1885, and Rosina Emmet to Billy Emmet, December 31, 1884, Correspondence, box 1, Emmet Papers.

65. On Sartain's studio, see Emily Sartain to John Sartain, November 1, 1874, reel 2727: #498–502, Sartain Papers. Both quotations are from Emily Sartain to John Sartain, October 13, 1874, reel 2727: #493–97, Sartain Papers.

66. Nieriker, *Studying Art Abroad and How to Do It Cheaply*, 5–6;

67. Ellen Day Hale to Miss Curtis, May 14, 1887, box 45c, folder 1085, Hale Papers/Smith; Tappert describes Hale's letter for Beaux in "Choices," 147; and Hale describes Julian's offer in Ellen Day Hale to Emily Perkins Hale, April 26, 1885, box 45a, folder 1064, Hale Papers/Smith. In a similar vein, Elizabeth Boott wrote, "Tell [Miss Norcross] that her letters were both received & have been of the greatest help to me, in fact without her aid, I don't see how I should have been able to accomplish anything." Elizabeth Boott to Hunt Class, "Letter No. 1," June 14, 1876, reel 1097: #238–45, Frank Duveneck Papers, Archives of American Art, Smithsonian Institution, Washington, D.C. (hereafter cited as F. Duveneck Papers).

68. Elizabeth Boott to Hunt Class, "Letter Number 1," June 14, 1876, reel 1097: #238–45, F. Duveneck Papers. There are eleven letters in all, all on reel 1097.

69. On Chase and friends, see Bryant, *William Merritt Chase*, 25; on Brush and friends, see Weinberg, *Lure of Paris*, 119; and on Cox and Robinson, see Morgan, *American Art Student in Paris*, 15, 16, 140. For a good description of the male student's life, in and out of the classroom, see Linson, "With the Paris Art Student," 289–302.

70. "Rabelaisian conversation" is from a student, quoted in Weinberg, *Lure of Paris*, 210. On hazing, see Linson, "With the Paris Art Student," 295–98; Whiteing, "American Student at the Beaux-Arts," 263–66; and Morgan, *American Art Student in Paris*, 88–90.

71. Hooper, "Art Schools of Paris," 61.

72. On men's socializing with their teachers see, for example, Morgan, *American Art Student in Paris*, 61, 64–65, and Young, *Life and Letters of J. Alden Weir*, 58–59.

73. Holland, "Student Life in the Quartier Latin," 39–40. Griselda Pollock argues that much of the dynamic of men entering the streets and cafés was both erotic and cross-class: middle-class men found working-class women available for their pleasure. Pollock, "Modernity and the Spaces of Femininity," 56, 69.

74. Martindale, *Lilla Cabot Perry*, 22–30; Pollock, "Modernity and the Spaces of Femininity"; Pollock, *Mary Cassatt*, 121–55; Judith A. Barter, "Mary Cassatt: Themes, Sources, and the Modern Woman," in *Mary Cassatt: Modern Woman*, 45–81; Higonnet, *Berthe Morisot*; and Adler and Garb, *Berthe Morisot*, 80–104.

75. Miss Annie E. Wadsworth to Francis B. Duveneck, reel 1150: no frame number, Frank and Elizabeth Boott Duveneck Papers, Archives of American Art, Smithsonian Institution, Washington, D.C. (hereafter cited as F&E Duveneck Papers).

76. Eliza Leavitt to Cecilia Beaux, April 1, 1888, as quoted in Tappert, "Choices," 174.

77. Cecilia Beaux to Eliza Leavitt, April 12, 1880, as quoted in Tappert, "Choices," 174.

78. Morgan, *American Art Student in Paris*, 23. For related discussions of the problems of respectability facing women artists, see Pollock, *Vision and Difference*, 66–70, and McCarthy, *Women's Culture*, 89–93.

79. Cox, "Louise Cox at the Art Students League," 14.

80. On Chase and Beckwith, see Bryant, *William Merritt Chase*, 54; on Cox and Robinson, see Morgan, *American Art Student in Paris*, 192, 213.

CHAPTER THREE

1. Biographical information on Ellen Day Hale (1855–1940) from Ellen Day Hale, "Biographical Statement," for Architect of the Capital, 1911, in Vertical File, National Museum of American Art, Washington, D.C.; "Ellen Day Hale," in Leonard, *Woman's Who's Who*, 352; Hoppin, "Women Artists in Boston," 37–38; "Ellen Day Hale," in Peet, *American Women of the Etching Revival*, 58; *Ellen Day Hale, 1855–1940*; and generally from Hale Family Papers in the Archives of American Art, Smithsonian Institution, Washington, D.C. (hereafter cited as Hale Papers/AAA), and in Hale Papers/Smith.

2. Beaufort and Welcher, "Some Views of Art Buying," 53, and Bermingham, *American Art in the Barbizon Mood*, 17, 87–88. For a contemporary account of the capital flowing to French art, see "Commerce in Art," 6. On changing patterns of patronage, see Skalet, "Market for American Painting," 39, 127–29; Truettner, "William T. Evans," 51, 65; Neil Harris, "Collective Possession: J. Pierpont Morgan and the American Imagination," in *Cultural Excursions*, 250–75; Beaufort and Welcher, "Some Views of Art Buying," 48–55; and Collin, "Public Collections and Private Collectors," 448–61.

3. Cooper, *Winslow Homer Watercolors*, 17; Foster, "Makers of the American Watercolor Movement," 1–5; Pilgrim, "Revival of Pastels," 43–62; Bogart, "Artistic Ideals and Commercial Practices," 225–81; and Bogart, *Artists, Advertising, and the Borders of Art*.

4. Tiffany quoted in McCarthy, *Women's Culture*, 66–67. On the aesthetic movement and the popularity of the decorative arts in the Gilded Age, see also McCarthy, *Women's Culture*, 37–79; Burke, *In Pursuit of Beauty*, and especially in this volume Roger B. Stein, "Artifact as Ideology: The Aesthetic Movement in Its American Cultural Context," 22–51; Boris, *Art and Labor*, 54–57; and Blanchard, "Oscar Wilde's America."

5. Skalet, "Market for American Painting," 24. The National Academy of Design contributed to the fluid gendering of the art market in the Gilded Age by welcoming academic genre painting. Genre painters produced highly sentimental works designed to provoke the emotions and moral outlook of a refined, cultivated middle class. Yet sentimental genre served male artists whose careers joined the professional stature of the academic with the broader, class-based ideals of refinement. Wright, "Men Making Meaning," 1–49.

6. Some of the most important organizations include Society of American Artists, 1877; New York Etching Club, 1878; Salmagundi, 1871 (began annual exhibitions 1878); Philadelphia Society of Artists, 1878; Philadelphia Society of Etchers, 1880; Boston Etching Club, 1880; Paint and Clay Club (Boston), 1880; Society of American Painters in Pastel, 1884; and National Society of Mural Painters, 1895. For listings of art societies, see Koehler, *United States Art Directory*, and Levy, *American Art Annual*, vol. 1.

7. On the Society of American Artists, see *One Hundred Years*, 9; and on the New York Etching Club, *A Publication by the New York Etching Club*, February 1891, New York Etching Club Records, reel 3097: #122–60, Archives of American Art, Smithsonian Institution, Washington, D.C.

8. On the development of the Society of American Artists, see Skalet, "Market for American Painting," 29–32, and Bienenstock, "Formation and Early Years of the Society of American Artists."

9. May 28, 1890, as quoted in Foster, "Makers of the American Watercolor Movement," 384.

10. *One Hundred Years*, 6, 9.

11. [March 1875?] and [December 1877?], Gilder Diary, reel 285: #506 and #109 (microfilmed out of sequence), Richard Watson and Helena de Kay Gilder Papers, Archives of American Art, Smithsonian Institution, Washington, D.C. (hereafter cited as Gilder Papers). La Farge's refusal to second Dewing is all the more extraordinary given that he had been her teacher.

12. Constitution and Minutes, 1880–1903, Philadelphia Society of Etchers, reel 4408: #199–209 and #271–73, Philadelphia Society of Etchers Records, Archives of American Art, Smithsonian Institution, Washington, D.C. On women's exclusion from professional societies, see Rossiter, *Women Scientists in America*, 73–99; Morantz-Sanchez, *Sympathy and Science*, 179–80; and Moldow, *Women Doctors in Gilded-Age Washington*, 94–113. Moldow has a case study of women doctors' fight to enter the District of Columbia's medical societies.

13. This event and the reviews are described in Tappert, "Choices," 114–19. Juries and hanging committees were a point of contention in the art world throughout this period. Juries were typically made up of artists who selected the paintings accepted for exhibition; hanging committees determined a work's position within the exhibit and the overall feel of the show. Works could be shown "on the line" (at eye level and easily seen) or "skied" (hung high on the wall and crowded among others). It was not an anonymous review process, and charges of favoritism and conservatism were regularly leveled against these committees. In keeping with the new professionalism, there were continuous efforts to improve the "merit" and objectivity of juries in order to increase fairness and keep the standard high. On this latter issue, see the discussion in Fink and Taylor, *Academy*, 87.

14. Koehler, *United States Art Directory*, 60; Skalet, "Market for American Painting," 109–13. In Boston, the Tavern Club was organized in 1884. The club's mostly young, unmarried men—artists, professionals, and businessmen—met at inexpensive restaurants or hired rooms for dining and entertainment. Artist Dennis Miller Bunker used the club not only to meet other artists but also to garner portrait commissions. Hirshler, *Dennis Miller Bunker*, 48–50.

15. On the Tile Club, see Koehler, *United States Art Directory*, 62, and McCarthy, *Women's Culture*, 65–66. McCarthy quotes Edward Strahan on the Tilers' strategy of "stealing from the ladies." For the publicity on the Tile Club, see, for example, Laffan and Strahan, "Tile Club Afloat," 641–71. For parallels in Boston and Philadelphia, see Koehler's description of Boston's Paint and Clay Club and the Philadelphia Society of Artists, pp. 17 and 72. Margaret Rossiter has an eloquent description of the effects of the informal culture of scientific societies on women. Rossiter, *Women Scientists in America*, 92–94.

One remaining opportunity for women to interact with male colleagues was art school alumni associations, which offered fellowship, conversation, and sometimes exhibitions. Here women were able to take advantage of their numbers and their institutional base to gain access to mixed-sex artists' societies. Women served as officers, board members, and committee members not only for the Copley Society of the Museum School in Boston but also for the Fellowship of the Pennsylvania Academy, which was founded in 1897. On the Copley Society see Peirce, *History of the School of the Museum of Fine Arts*; on the Fellowship of the Pennsylvania Academy, see Brown, *Alice Barber Stephens*, 26.

16. Skalet, "Market for American Painting," 76–102.

17. On the Lotos Club, see ibid., 97–101. On the St. Botolph Club, see Troyen, *Boston Tradition*, 36–37, and McCarthy, *Women's Culture*, 100.

18. Evans collection listed in Truettner, "William T. Evans," 72–79. Of the 179 painters from whom Evans bought, only 11 were women.

19. By contrast, the Havemeyer collection contained fourteen oils by Degas, eight by Monet, and six by Manet. Havemeyer bought a total of 134 works in a number of media by Degas, twenty-eight oils by Monet, twenty-three by Manet, and twenty by Cassatt. Havemeyer did, therefore, foster Cassatt's work by purchasing it, exhibiting it, and promoting it, even though her support remained relatively less for Cassatt than for other impressionists. On Havemeyer and Gardner's patronage, see McCarthy, *Women's Culture*, 108, 163–65, and Faxon, "Painter and Patron," 15.

I am reluctant to extend Kathleen McCarthy's implication that women patrons *should* have patronized women painters. For women patrons, the avenue to a strong—and powerful—collection was through male artists. It is important to see them competing with male patrons for the best collections even if such a strategy accepted assumptions about women artists and contributed to their marginalization.

20. Dwyer, *Anna Klumpke*, 53, 69–70, and McCarthy, *Women's Culture*, 106.

21. McCarthy, *Women's Culture*, 104; Chiarmonte, *Women Artists in the United States*, 14–19; Karen J. Blair, "Women's Philanthropy for Women's Art, Past and Present," in Corn, *Cultural Leadership*, 39–51; and Blair, *Torchbearers*, 38, 86, 89.

22. Deborah Cherry has argued that nineteenth-century women artists in Britain participated in a pattern of women's patronage, which she calls "matronage," whereby a "support system" of "women friends, relatives, and clients" formed an interactive network of cultural production and consumption by women. Although Cherry's work is suggestive, much more research needs to be done to verify such a network in the United States. In her study of American women's patronage of the arts, Kathleen McCarthy found little evidence of women patronizing women painters and sculptors; however, she does not concentrate on more informal networks of relatives and friends. Cecilia Beaux, for example, seems to have found her earliest portrait patrons among neighbors, schoolmates, and church members. Anna Klumpke found considerable support among both aristocratic and self-supporting Boston women, most of whom she met through personal connections. It may also be useful to consider patronage by burgeoning women's institutions. For example, did newly founded women's colleges patronize women artists? Karen Blair argues that there was a consciousness among women's arts clubs of a special duty to women artists, but she does not examine the extent or quantity of their support.

Cherry also does not make any claims for the extent or significance of "matronage" in Britain (in terms of either dollars spent or power accrued), and my work, McCarthy's, and Blair's on the United States all suggest that, relative to men, women's power as patrons remained limited. Nevertheless, a more thorough study of women's formal and informal patronage than this book can undertake may help us understand the extent and role of "matronage" in the United States. We may be able to discover whether it provided the core of support (as for Klumpke), a crucial launching point (as for Beaux), fall-back and survival income, or even an explicit challenge to men's failure to support women artists. Cherry, *Painting Women*, 102–4; McCarthy, *Women's Culture*; Tappert, "Choices," 137; Dwyer, *Anna Klumpke*, 68–85; Blair, *Torchbearers*; and Blair, "Women's Philanthropy."

23. See, for example, "Some Lady Artists of New York," 27–29, and Brownell, "Younger

Painters of America.—III," 321–34. Charles M. Kurtz, "Women in Art," *New York Star*, October 6, October 13, October 20, and October 27, 1899, in Scrapbook: *The Star*, vol. 2, box 23, Charles M. Kurtz Papers, Archives of American Art, Smithsonian Institution, Washington, D.C.

24. Hoppin, *Emmets*, 22, 37; Leonard, *Woman's Who's Who*, 276.

25. Goodman, "Emily Sartain," 63; "Emily Sartain, Artist," 1–8; and Koehler, *United States Art Directory*, 116.

26. On both Curtis and Wadsworth, see Hoppin, "Women Artists in Boston," 43–44, and Koehler, *United States Art Directory*, 101, 121.

27. These patterns reflect my focus on the major East Coast art centers. Other regional art centers may have had a similar pattern: attracting regular contributions from women in the region with periodic submissions to major national and international exhibitions. Britta Dwyer's work on Pittsburgh has shown that a number of women active there also exhibited quite regularly in Philadelphia but that only two Pittsburgh women entered the National Academy in the late nineteenth century. It may be, therefore, that outside major art centers such as New York and Philadelphia, women did not exhibit in any sustained or regular way beyond their regional orbit. Clearly, more research needs to be done examining differences in women's careers and opportunities both by region and by reliance on local or national art centers. Dwyer, "Nineteenth-Century Regional Woman Artists."

28. Anna Lea Merritt to William Macbeth, March 2, 1898, and April 30, [1898], reel NMc9: #859–60, #863–64, Macbeth Gallery Records, Archives of American Art, Smithsonian Institution, Washington, D.C. (hereafter cited as Macbeth Records).

29. Mary Fairchild MacMonnies [Low] to William Macbeth, November 5, 1895; February 21, 1896; March 15, 1896; January 5, 1902; February 4, 1902; April 21, 1902; and July 23, 1902, reel NMc9: #305–10, #313–21, Macbeth Records.

30. On Pennsylvania Academy attendance, see *In This Academy*, 38. The most important women's prizes were the Mary Smith Prize at the Pennsylvania Academy, the Shaw Prize at the Society of American Artists, and the Dodge Prize at the National Academy of Design. Other prizes had no specific sex designation, but women did not win a major prize until the National Academy awarded Mary Hazleton the Hallgarten Prize in 1896 and Amanda Brewster Sewell the Thomas Clarke Prize in 1903. On prizes, see *One Hundred Years*, 7.

31. I have calculated these figures based on exhibition catalogs, some of which were illustrated but many of which required assuming a genre based on the painting's title. Under figure paintings I have loosely grouped history, genre, and figure subjects because I could not readily distinguish them from title alone. Moreover, the categories themselves were somewhat fluid, and even the "lowest" of these genres, genre painting, had moved away from its midcentury emphasis on American types to more evocative and idealized images closely related to the "higher" figure subjects. Given this blurring of genre boundaries, this loosely grouped category reliably reflected the overall commitment to representing the figure (rather than the landscape) that I was interested in exploring. On the changing status of genre painting after the Civil War, see Johns, *American Genre Painting*,

197–98, and Wright, "Men Making Meaning." For a more complete description of these calculations, see appendix, table 2.

32. These conclusions are based on paintings hung in the exhibition; it may be that juries selected out certain kinds of work. The change across time in the displayed works of women as well as the differences with men suggest that what was accepted was a reasonable cross section of what women submitted. Even if this is not the case, it does not change the fact that women submitted significant numbers of figure and portrait works, rather than a token smattering as has been conventionally assumed.

33. "The Painters in Pastel," *New York Times*, March 17, 1884, 5, as quoted in Pilgrim, "Revival of Pastels," 47.

34. "Art and Art-Life in New York," 599. The same article makes the point specifically that of five "high art" societies in New York, the American Watercolor Society and the New York Etching Club are two of them.

35. Quoted in Kathleen Foster, "John La Farge and the American Watercolor Movement: Art for the 'Decorative Age," in *John La Farge*, 125.

36. Pilgrim, "Revival of Pastels," 48; Koehler, *United States Art Directory*, 47; and Levy, *American Art Annual*, vol. 11 (New York: American Art Annual, 1914), 204, 254–55. Women did not gain significant membership in a watercolor society, perhaps the genre most associated with female amateur accomplishments, until the New York Water Color Club was founded in 1890. It had 53 women members out of 160 total in 1914.

37. Foster, "Makers of the American Watercolor Movement," 35–36. The average price at the end of the decade was around $75–100. (Calculation based on sales and receipts at the American Watercolor Society exhibitions, as recorded by Foster, "Makers of the American Watercolor Movement," 19–20). In 1875, Winslow Homer priced his watercolors at the American Watercolor Society between $30 and $75, although more established watercolorists could command in the thousand-dollar range. Cooper, *Winslow Homer Watercolors*, 48 n. 17. Collectors Louisine and H. O. Havemeyer, for example, although well able to afford quite expensive paintings, also bought works from the Watercolor Society's annual exhibition, including two works in 1888 by Henry Ward Ranger still affordably priced at $125 each. Frelinghuysen et al., *Splendid Legacy*, 371.

38. Foster, "Makers of the American Watercolor Movement," 45–46, and Cooper, *Winslow Homer Watercolors*, 29, 34.

39. Foster, "Makers of the American Watercolor Movement," 45–46.

40. Ibid., 317–18; Rubinstein, *American Women Artists*, 61–62; McClinton, *Chromolithographs of Louis Prang*, 84, 95–101; and Edward T. James, Janet Wilson James, and Paul S. Boyer, eds., *Notable American Women, 1607–1950* (Cambridge: Harvard University Press, Belknap Press, 1971), 1:237–39.

41. Foster, "Makers of the American Watercolor Movement," 374.

42. Ibid., 19, 388–90.

43. Wright, *With Pen and Graver*, 8–9; Walls, "Art, Industry, and Women's Education," 269–70.

44. Bolger, *American Pastels*, 9. On the positive associations increasingly given to these "sketchy" media, see Gerdts, *American Impressionism*, 44–48.

45. For a chronology of Weir's activities, see Burke, *J. Alden Weir*, 295–98. The details of his 1889 Fifth Avenue Art Galleries exhibition appear in Bolger, *American Pastels*, 69 n. 6.

46. Peet, *American Women of the Etching Revival*, 13. On women's entry into the etching revival, see Peet, "Emergence of American Women Printmakers," 18–22.

47. Peet, *American Women of the Etching Revival*, 13, 16–17.

48. Bishop, "Young Artists' Life in New York," 362.

49. "Culture and Progress: Cottier and Company," *Scribner's Monthly* 8 (August 1874): 500–501, as quoted in Burke, *In Pursuit of Beauty*, 415.

50. See the biography of Clarence Cook in Burke, *In Pursuit of Beauty*, 412–14.

51. McCarthy, *Women's Culture*, 49–50. The following discussion of decorative arts societies is drawn largely from McCarthy, *Women's Culture*, 37–56.

52. Boston Society of Decorative Art, *Annual Report*, 6, as quoted in McCarthy, *Women's Culture*, 52.

53. From *Harper's Weekly*, 1881, as quoted in Foster, "John La Farge," 151.

54. *John La Farge*.

55. Burke, *In Pursuit of Beauty*, 310–11; Broun, *Albert Pinkham Ryder*, 42–55.

56. For a different interpretation that emphasizes the essentially conservative outcomes of the decorative arts movement, see McCarthy, *Women's Culture*.

57. For the adoption, spread, and meaning of aesthetic dress, see Blanchard, *Oscar Wilde's America*, 144–71, and Blanchard, "Oscar Wilde's America," 131–74.

58. Peet, "Emergence of American Women Printmakers," 435–36 n. 128. Maria Oakey Dewing published a book, *Beauty in Dress* (1881), on aesthetic dressing. The phrase "mysteries of artistic costumes" comes from a review of the book. See Burke, *In Pursuit of Beauty*, 420.

59. *American Paintings at the High Museum of Art*, 142–43.

60. Cox, "Should Woman Artists Marry," 6–7.

61. Blanchard, *Oscar Wilde's America*, 188–207, and Blanchard, "Oscar Wilde's America," 220–47. I am indebted to Blanchard for my interpretation of the *Art Interchange*.

62. *Art Interchange* 15 (August 27, 1885): front page, as quoted in Blanchard, "Oscar Wilde's America," 224.

63. Blanchard, "Oscar Wilde's America," 228–29.

64. *Art Interchange* 13 (March 30, 1882): front page, as quoted in Blanchard, "Oscar Wilde's America," 225.

65. Blanchard, "Oscar Wilde's America," 230–31.

66. On Candace Wheeler, see Blanchard, *Oscar Wilde's America*, 45–85; Burke, *In Pursuit of Beauty*, 481–83; and McCarthy, *Women's Culture*, 37–45.

67. Hoppin, *Emmets*, 16.

68. On Cox, see "Clever Women Artists: They Live in New York and Have Brains as Well as Beauty," clipping [ca. 1890], Vertical File, National Museum of American Art,

Washington, D.C. On Lamb, see *One Hundred Years*, 60. And on Oakley, see Likos, "Ladies of the Red Rose," 11–15, and Rubinstein, *American Women Artists*, 159–61.

69. "Biographical Sketch," ms. [in Margaret Redmond's hand], March 15, 1940, Margaret Redmond Papers, reel 876: #691–92, Archives of American Art, Smithsonian Institution, Washington, D.C. (hereafter cited as Redmond Papers).

70. I have reconstructed this list from Redmond's papers; it is highly likely that it is incomplete. "Biographical Sketch," "Windows Designed and Executed by Margaret Redmond," "Contract for Windows in Trinity Church, Copley Square, Boston, MA," and several contracts for churches in Massachusetts and Maine, reel 876: #785–92, Redmond Papers.

71. Wheeler, "Art Education for Women," 87.

72. Waters, *Women in the Fine Arts*, 93–94.

73. Biographical information on Lippincott from Waters, *Women in the Fine Arts*, 213; Petteys, *Dictionary of Women Artists*, 444; and Levy, *American Art Annual* vols. 1–7 (New York: Macmillan, 1899; New York: Art Interchange Co., 1899; Boston: Noyes, Platt, and Co., 1900; and New York: American Art Annual, 1903–10) and the obituary in vol. 10 (New York: American Art Annual, 1913).

74. Nancy Mowll Mathews comes to a similar conclusion in "American Women Artists at the Turn of the Century: Opportunities and Choices," in Martindale, *Lilla Cabot Perry*, 112–13.

75. Occasionally Emmet painted portraits for up to $200. "Account Book of Lydia Field Emmet, 1880–1945," Business Records, Emmet Papers. Gabrielle Clements and Ellen Day Hale still asked only $5–$40 for their etchings in the 1930s. "Financial Material, 1929–1941," reel 4212: #322–61, Gabrielle de Veaux Clements Papers, Archives of American Art, Smithsonian Institution, Washington, D.C. (hereafter cited as Clements Papers).

Although it is beyond the scope of this book, another important option for women was to establish themselves as expatriate painters. These women were among some of the best-known American women artists at the turn of the century and included Mary Cassatt, Elizabeth Gardner Bouguereau, Elizabeth Nourse, Anna Lea Merritt, and Elizabeth Boott Duveneck. Many of them retained extensive ties to the United States.

76. Burke, *J. Alden Weir*, and Reynolds, *Irving R. Wiles*, 14–18.

77. A variety of sources indicate the expectation that women should pursue portraiture. In 1859, in one of the first books on women artists, Elizabeth Ellet wrote, "The kind of painting in which the object is prominent has been most practised by female artists. Portraits, landscapes and flowers, and pictures of animals are in favour among them." It was often assumed that women who wanted to become artists would be portraitists. Mary Cassatt's friend Eliza Haldeman wrote that Cassatt's mother "wants her [Cassatt] to become a portrait painter as she has a talent for likenesses and thinks she is very ambitious to want to paint pictures." The idea that women should paint women and children was commonplace. Critic Arthur Hoeber, for example, claimed that portraits of women and children, "in America at least, seem to be better handled by women painters." He went on to extol the "superiority" and "sympathy" of a woman's understanding of children. Ellet,

Women Artists in All Ages and Countries, 3; Eliza Haldeman to Mrs. Samuel Haldeman, May 15, 1867 in Mathews, *Cassatt and Her Circle*, 45–46; and Hoeber, "Famous American Women Painters," n.p.

78. On portraiture's popularity and late-nineteenth-century portraiture styles, see Tappert, "Choices," 240–41; Danly, *Facing the Past*, 21–23; and Simon, *Portrait in Britain and America*, 32, 49. In midcentury, the daguerreotype had taken the place of painted portraits, particularly portrait miniatures, but had retained the status of unique object that a painting had. As new photographic technologies changed photographs into mass-produced images, commercial products, and amateur enterprises, photographic portraits changed meaning, losing status and clientele. By the mid-1880s, commercial portrait photographers were in severe crisis; their crisis proved a boon for painters, however, as the painted portrait received new attention. Moreover, the new wealth and emerging conspicuous consumption of the Gilded Age made such self-display all the more attractive. On daguerreotypes and the crisis in photography, see the essays in Sandweiss, *Photography in Nineteenth-Century America.*

79. Bryant, *William Merritt Chase*, 128–29; and *George de Forest Brush, 1855–1941*, 31.

80. The sample pool is sixty-eight American women painters active in New York, Philadelphia, and Boston. I have determined their fields of interest either from Waters's entry or from other biographical dictionaries and information. It is impossible to tell at this point whether Waters's selection criteria excluded a group of women who would significantly change the conclusions I draw here, but, because of the correspondence between the women in Waters's book, exhibition statistics, and the personal papers I have examined, I think these are generally reliable conclusions for the overall direction of women's work.

81. Rosina Emmet Sherwood to Lydia Field Emmet, [1892], Correspondence, box 1, Emmet Papers.

82. Assorted correspondence, 1908–30, reel 4071, Marie Danforth Page Papers, Archives of American Art, Smithsonian Institution, Washington, D.C. (hereafter cited as Page Papers); "Account Book of Lydia Field Emmet, 1880–1945," Business Records, Emmet Papers. On portraiture as source of family support, see Hoppin, *Emmets*, 13, and Martindale, *Lilla Cabot Perry*, 19. Anna Klumpke wrote her father that her earnings in Boston in 1892 totaled five thousand dollars. Dwyer, *Anna Klumpke*, 67.

83. Hoppin, "Women Artists in Boston," 36.

84. Guild of Boston Artists, Marie Danforth Page Profile, reel 4071, Page Papers. It is suggestive to compare this division of labor to that which assigned women in medicine and settlement work to the more hands-on, messier care of women and children. Certainly, much of the discussion of women painting women and children has to do with their better ability to handle the "front line" demands of entertaining, posing, and representing fickle female and child sitters.

85. Hoppin, *Emmets*, 28. Lilla Cabot Perry's dislike is described in "Painter's Family Album," 118, and Lilla Cabot Perry to Bernard Berenson, August 23, 1929, in Martindale, *Lilla Cabot Perry*, 92.

86. Merritt, *Love Locked Out*, 92–93, 139, 141, and "Boston Artists and Sculptors in Intimate Talks. XI.—Marie Danforth Page," unidentified clipping, reel 4072: #742, Page Papers.

87. Eaton, "Lydia Field Emmet—A Sincere Painter," *Delineator* (February 1911), as cited in Hoppin, *Emmets*, 28.

88. Tappert, "Choices," 255.

89. Hoppin, "Women Artists in Boston," 37–38; Peet, *American Women of the Etching Revival*, 58–59.

90. "Account Book of Lydia Field Emmet, 1880–1945," Business Records, Emmet Papers. In 1891, she recorded $80 for a winter class and $278 for the summer; in 1892, it was $70 and $500, respectively; in 1893, she only wrote in a summer class for $377; and in 1894, for half a year of lessons, $225. Her account book shows no income for teaching after 1894.

91. Goodman, "Emily Sartain," 64.

92. Cecilia Beaux to Rosina Emmet Sherwood, n.d. [1895 or 1896], Correspondence, box 1, Emmet Papers.

93. Fairbrother et al., *Bostonians*, 233–35.

94. Gabrielle Clements to Margaret Lesley Bush-Brown, October 4, 1885, as quoted in Peet, "Emergence of American Women Printmakers," 412.

95. Ellen Day Hale to Philip Hale, January 20, 1893, as quoted in Peet, "Emergence of American Women Printmakers," 415. My ellipsis.

96. These included two miniature etching portfolios for Louis Prang and Company in the late 1880s and a very popular series of Baltimore etchings in the 1920s. An article at Clements's death in the *Baltimore Sun* noted that the Baltimore series "achieved an immediate and wide popularity, and are to be found in many homes and offices in the town." Chesney, "An Artist Whose Talent Enriched Baltimore," *Baltimore Sun*, April 11, 1948, reel 4213: no frame number, Clements Papers, and Peet, *American Women of the Etching Revival*, 29.

97. Biographical information on Gabrielle de Veaux Clements (1858–1948) from reel 4212: #474–82, and Chesney, "Artist Whose Talent Enriched Baltimore," both Clements Papers. Nancy Hale, Ellen Day Hale's niece, has written a memoir that describes Hale and Clements's home in Gloucester, Massachusetts, and their life there. Hale, *Life in the Studio*, 99–114.

98. Hale, *Life in the Studio*, 111.

99. Sketchy records of Hale's work indicate that she continued to paint figure subjects, portraits, and landscapes, although her work in these genres gradually decreased after the turn of the century.

100. See series of letters, Ellen Day Hale to Gabrielle Clements, 1916–19, in folder 1084, box 45c, Hale Papers/Smith.

101. See, for example, two untitled poems, n.d. [February 14] and February 14, 1913, and poem, "Thoughts inspired by E. H.," n.d., folder 1209, box 46, Hale Papers/Smith.

102. "Letter of Instructions," November 23, 1926, folder 1206, box 45f, Hale Papers/Smith. For another network of women artists, see the description of the home, studio,

and work created by Violet Oakley, Elizabeth Shippen Green, and Jessie Wilcox Smith in Likos, "Ladies of the Red Rose," 11–15.

103. Hale, *Life in the Studio*, 36. For further biographical information, see *Philip Leslie Hale, A.N.A.*, and Hirshler, "Lilian Westcott Hale (1880–1963)."

104. Hale, *Life in the Studio*, 13–14.

105. Ibid., 104.

106. I determined the marital status of sixty-seven women (out of sixty-eight in the original sample): thirty-five were married (52 percent); two were widowed and self-supporting (3 percent); and thirty were single (45 percent). I have not yet been able to determine either age of marriage or precisely what proportion of women continued to paint after marriage—both of which would influence the interpretation of artists' marriage patterns. I do know that at least twenty-three of the thirty-five married women continued to paint (almost two-thirds and still one-third of the entire sample). Closer analysis of this pool needs to be done before I can say with more precision how many women painters combined careers and marriage. For a comparison with women in other professions, especially medicine, where there were similarly high rates of marriage, see Morantz-Sanchez, *Sympathy and Science*, 135–37.

107. Will H. Low to Mr. [William] Macbeth, April 9, 1911, reel NMC9: #328, Macbeth Records. Ironically, however, Low also did his wife a major disservice when he lost a collection of her works on a tour he managed. Smart, "Sunshine and Shade," 25.

108. Susan Macdowell Eakins to Mr. [Walter] Pach, October 16, 1935, and Susan Macdowell Eakins to Julius Rauzin, April 2, 1936, reel 4235: 1009 and 1013, Julius Rauzin Papers, Archives of American Art, Smithsonian Institution, Washington, D.C. On Susan Eakins, see Adelman, *Susan Macdowell Eakins.*

109. Maria Oakey Dewing to Nelson C. White, August 30, 1927, as quoted in Martin, "Portraits of Flowers," 116. On Maria Oakey Dewing, see also Martin, "Rediscovery of Maria Oakey Dewing," 24–27, and the entries for Maria Oakey Dewing and Thomas Wilmer Dewing in Burke, *In Pursuit of Beauty*, 419–21.

110. Hale, *Life in the Studio*, 111–12.

CHAPTER FOUR

1. Ford, *Art*, 12, 13.

2. Skalet, "Market for American Painting," 131–35; Truettner, "William T. Evans," 50–51; and Weinberg, "Thomas B. Clarke," 67–68.

3. Ford, *Art*, 26.

4. The *New York Times* had deplored the speculative character of the art market as early as 1882 in "Commerce in Art," 6, and "Rewards of Painters," 8. The best work on the rise of a gallery system has concentrated on France; to date, there is little on the overall development of a gallery-dealer system in the United States. On France, see Green, "Circuits of Production, Circuits of Consumption," 29–34; Green, "Dealing in Temperaments," 59–

78; White and White, *Canvases and Careers*; and Jensen, *Marketing Modernism*. On early dealers in the United States, see Fink, "French Art in the United States," 87–100, and Fidell-Beaufort and Welcher, "Some Views of Art Buying," 48–55. See also Crane, *Transformation of the Avant-Garde*, 110–18.

5. Gallati, *William Merritt Chase*, 50; Cikovsky, "William Merritt Chase's Tenth Street Studio," 2–14; and Blaugrund, *Tenth Street Studio Building*, 105–16.

6. Annette Blaugrund has recently remarked, however, on the active quality in Chase's later studio interiors (1884–85). Blaugrund, *Tenth Street Studio Building*, 120. For the reading that views women in Chase's paintings as aesthetic object, see Roger Stein, "Artifact as Ideology: The Aesthetic Movement in Its American Cultural Context," in Burke, *In Pursuit of Beauty*, 41, 46, and Gallati, *William Merritt Chase*, 47–49. For other interpretations of the images, which stress the advertising and commodity value of the studio paintings, see Bryant, *William Merritt Chase*, 70–74; Burns, *Inventing the Modern Artist*, 67–68; and Cikovsky, "Chase's Tenth Street Studio."

7. Bishop, "Young Artists' Life in New York," 364–65; "Picture of Commerce," 403; Bermingham, *American Art in the Barbizon Mood*, 71, 88; and Zalesch, "What the Four Million Bought," 77–109.

8. Marzio, *Democratic Art*.

9. Phillips, "Art for Industry's Sake," 1–3; 36–39; 55–63, and Neil Harris, "Iconography and Intellectual History: The Halftone Effect," in *Cultural Excursions*, 304–17.

10. Phillips, "Art for Industry's Sake," 157–58. For the negative reaction to mass visual culture, see Marzio, *Democratic Art*, 1–2; Harris, "Iconography and Intellectual History," 309–13; and Phillips, "Art for Industry's Sake," 152–56.

11. Bogart, "Artistic Ideals and Commercial Practices," 242. As the "painter-illustrator" became a problematic identity, the field's feminization loomed larger. By the turn of the century, most trained illustrators came not out of the art academies, with their life classes and professionalizing drives, but out of the schools of design, whose students were principally women. Women dominated the field. Bogart also documents the efforts of leading male illustrators to recoup the profession for masculine authority, on a par with fine art.

12. Huyssen, "Mass Culture as Woman," 47, and Felski, *Gender of Modernity*.

13. Foster, "Makers of the American Watercolor Movement," 365, 373, 377, 389.

14. "Society of American Artists," *New York Evening Post*, April 3, 1897, 8, as quoted in *Ten American Painters*, 11.

15. On the Ten, see Milroy, *Painters of a New Century*, 42–44.

16. *Ten American Painters*, 13–14. The review comment comes from "Ten American Painters," *Art Amateur* 38 (May 1898): 133.

17. On the Eight, see Milroy, *Painters of a New Century*; Homer, *Robert Henri and His Circle*; Doezema, *George Bellows and Urban America*; and Zurier, Snyder, and Mecklenburg, *Metropolitan Lives*.

18. Milroy, *Painters of a New Century*, 46.

19. Ibid., 91. Quote from club constitution.

20. These numbers come from the *American Art Annual*'s Directory of Dealers. I have

excluded all those listed for dealing in frames, artists' supplies, art books, decorative objects, and so on and included those listed as dealing in paintings, pictures, or etchings. While framers and artists' suppliers long displayed works of art, the rising number of dealers who identified themselves as handling paintings reflects the long-term change in the marketplace. Levy, *American Art Annual*, 1:534–38; and Levy, *American Art Annual*, vol. 4 (New York: American Art Annual, 1903).

21. Gwendolyn Owens, "Art and Commerce: William Macbeth, the Eight, and the Popularization of American Art," in Milroy, *Painters of a New Century*, 64. The following account of Macbeth is based on Owens, "Art and Commerce," 61–84, and Wexler, "Creating a Market in American Art," 245–55.

22. *Art Notes* 3 (January 1897), reel 3091: #493, Macbeth Records. See also *Art Notes* 7 (March 1898), 11 (November 1899), 12 (February 1900), 40 (March 1910), reel 3091: #529–30, #561, #564–65, #786, Macbeth Records.

23. Wexler, "Creating a Market in American Art," 246; Oaklander, "Clara Davidge's Madison Art Gallery," 20–37.

24. Skalet, "Market for American Painting," 311–12.

25. Ibid.; Owens, "Art and Commerce," 69–71; and Scrapbooks, reel NMc: #331, #382, and *Art Notes*, reel 3091: #478, #680, #693, Macbeth Records.

26. Exhibition Catalogs, 1913–25, reel NDR1: #26–27, #119, #213–14, #262–63, #271, #307–8, #598, Doll and Richards Records, Archives of American Art, Smithsonian Institution, Washington, D.C. (hereafter cited as Doll and Richards Records); and "Figures on the Sand" [ca. 1917], Babcock Art Galleries, reel 4858: #403–4, Exhibition Catalog Collection, Archives of American Art, Smithsonian Institution, Washington, D.C. For similar support, see records of Mary Macomber's representation by the Vose Galleries of Boston. Paintings in Stock, September 1906, reel 3938: #202–302; clippings, reel 4594: #89–106, Vose Galleries of Boston Records, Archives of American Art, Smithsonian Institution, Washington, D.C.

27. For a record of their relationship, see Correspondence, reel NMc9: #390–458 and reel 2609: #85–105; and *Art Notes* 3 (January 1897) and 11 (November 1899), reel 3091: #498, #557, Macbeth Records; and Skalet, "Market for American Painting," 311–14. On McChesney, see "Artists in their Studios. III." *Godey's Magazine* 130 (May 1895): 466–69; Champney, "Woman in Art," 113–14; and Petteys, *Dictionary of Women Artists*, 458.

28. Skalet, "Market for American Painting," 287–326, and Gerdts, *Ten American Painters*, 26–28, 177.

29. Exhibition Catalogs and Checklists, 1917–29, reel 4454: #960–1249; Scrapbooks, 1912–23, reel 4454: #833–959; and Milch Gallery Finding Aid, pp. 29–32, all Milch Gallery Records, Archives of American Art, Smithsonian Institution, Washington, D.C. (hereafter cited as Milch Records). On Helen Turner, see *Helen M. Turner, N.A. (1858–1958)*.

30. Exhibition Catalogs, 1912–20, reel NDR1: #1–376, Doll and Richards Records.

31. *Art Notes* 41 (December 1910), reel 3091: #799, Macbeth Records.

32. Lydia Field Emmet to Robert McIntyre, n.d. [?1923], reel 2589: #415–16, Macbeth Records.

33. Untitled clipping, December 17, [1918?], *New York Herald*, Milch Gallery Scrapbook, 1912–23, reel 4454: #849, and "Annual Holiday Exhibition of Selected Paintings of Limited Size By American Artists," December 18, 1918–January 16, 1919, Exhibition Catalogs and Checklists, reel 4454: #975–77, Milch Records.

34. *Art Notes* 11 (November 1898), reel 3091: #538, Macbeth Records.

35. *Art Notes* 5 (November 1897), reel 3091: #511, Macbeth Records. See also *Art Notes* 6 (January 1898), reel 3091: #516, Macbeth Records.

36. *Art Notes* 7 (March 1898), reel 3091: #530, Macbeth Records.

37. "Arthur B. Davies," March 9–21, 1896, Macbeth Galleries, reel NMc1: #331, Macbeth Records.

38. *Art Notes* 28 (November 1905), reel 3091: #688–89, Macbeth Records. On the sales strategies of galleries, see also Jensen, *Marketing Modernism*, 40–48.

39. Clipping, *New York Times*, February 5, 1895, reel NMc1: #317, Macbeth Records.

40. Milch Gallery Finding Aid, p. 31, Milch Records.

41. "Catalogue of Pictures by The Group" March 6–19, 1918, and "A Catalogue of Pictures by 'The Group'" October 8–21, 1919, reel NDR1: #262–63, #307–8, Doll and Richards Records. The women included Margaret Patterson, Elizabeth Wentworth Roberts, M. Bradish Titcomb, Laura Coombs Hills, Lucy Conant (1918 only), Jane Peterson, Felicie Waldo Howell (1919 only), and Lilian Westcott Hale (1919 only).

42. *One Hundred Years*, 8–10; Skalet, "Market for American Painting," 311–14; Berta Briggs, "History of the National Association of Women Painters and Sculptors, 1889–1939," reel N134: #659–76, New York Public Library, PB File, Archives of American Art, Smithsonian Institution, Washington, D.C.

43. Clippings, "Rosina Emmet Sherwood," November 19–December 1, 1900, Scrapbook 1892–1901, reel NMc1: #383–85, Macbeth Records.

44. Clippings, "Paintings by Helen M. Turner," January 15–27, 1917, Milch Scrapbook, 1912–23, reel 4454: #855, Milch Records.

45. Numerous books and exhibition catalogs describe this shift in post–Civil War painting. I have found most helpful two short articles, Weinberg, "Late-Nineteenth-Century American Painting," 19–26, and Van Hook, "Decorative Images of American Women," 45–69.

46. Constitution and By-Laws of the Ladies Art Association, 1871, reel 3592: #77–85, Ladies Art Association Records, 1867–1914, Archives of American Art, Smithsonian Institution, Washington, D.C. (hereafter cited as LAA Records). Several stillborn associations antedated the Ladies Art Association: for example, in 1859 Elizabeth Ellet proposed a Society of Lady Artists, which would hold salons to foster patronage of women artists, and in 1866 a Women's National Art Association held an exhibit and auction of all kinds of women's artwork. Both clubs never materialized past their initial organization. McCarthy, *Women's Culture*, 100–101.

47. Constitution and By-Laws of the Ladies Art Association, 1871, reel 3592: #77–85, LAA Records.

48. Programme of Courses, n.d. [after 1877], reel 3592: #100–103, LAA Records. On Ladies Art Association activities and exhibitions, see also McCarthy, *Women's Culture,* 101, and Sylvester Rosa Koehler, *United States Art Directory,* 53–54.

49. Blair, *Clubwoman as Feminist;* Scott, *Natural Allies;* and Blair, *Torchbearers.*

50. Scott, *Natural Allies,* 113–17.

51. Briggs, "History of the National Association of Women Painters and Sculptors."

52. *New York Times,* February 26, 1892, clipping in Historic Lists/Catalogs, National Association of Women Artists Archives, New York (hereafter cited as NAWA Archives). On the Woman's Art Club and its exhibition, selection, and hanging committees, see also *National Association of Women Artists, Inc.: Constitution and By Laws, Revised Issue, 1989* and *History of the Association, 1889–1989,* NAWA Archives, and *One Hundred Years,* 6.

53. *New York Times,* February 26, 1892, in Historical Lists/Catalogs, NAWA Archives. On exhibition reviews in general, *One Hundred Years,* 8–9.

54. Briggs, "History of the National Association of Women Painters and Sculptors."

55. Mary Cassatt to Paul Durand-Ruel, January 22, [ca. 1898], in Mathews, *Cassatt and Her Circle,* 266–67. Beaux was the honored guest at the opening of the 10th Annual Exhibition in 1889; she was involved with the Woman's Art Club occasionally after that. Tappert, "Choices," 418–19.

56. Mary Cassatt was born in 1844 and Cecilia Beaux in 1855. Amanda Brewster Sewell (1859–1926) was the closest in age, while the rest were born in the 1860s: Louise Cox (1865–1945), Ella Condie Lamb (1862–1936), and Edith Mitchill Prellwitz (1865–1944). For biographical information on Cox, Lamb, Prellwitz, and Sewell, see *One Hundred Years,* 42, 60, 76, and 81.

57. The Woman's Art Club continued to grow in numbers, with one hundred members in 1905. In 1913 it changed its name to the Association of Women Painters and Sculptors, and three years later, after adding four hundred more members for a total membership of more than five hundred, it became the National Association of Women Painters and Sculptors.

58. Clipping, *Evening Bulletin,* May 10, 1897, Scrapbook, 1897–1903, reel 2537: #75, Plastic Club Records, Archives of American Art, Smithsonian Institution, Washington, D.C. (hereafter cited as Plastic Club Records).

59. Sarah Crumb, "Reminiscences of events and personalities of the Plastic Club," as quoted in Goodman, "Plastic Club," 100. Interestingly, the Plastic Club brought together women from a wide variety of arts, including illustration, photography, painting, and sculpture. The Plastic Club seems to have been able to draw on the interest in professionalism among Philadelphia's "commercial" artists to bridge the gaps that the Ladies Art Association had not done. Emily Sartain provided a powerful unifying force around professional standards in her position as a respected painter and the principal of the School of Design.

60. Constitution and By-Laws of the Plastic Club, 1897, reel 2536: #5, and Plastic Club Report and Programme, Seasons 1897–98–99, p. 6, reel 2536: no frame number, Plastic

Club Records. On Plastic Club activities, see Plastic Club Report and Programme, Seasons 1897–98–99; and Second Annual Report, Season 98–99–1900, reel 2536: no frame number; and Goodman, "Plastic Club," 100–103.

61. Second Annual Report and Announcement Seasons '98–'99–'1900.

62. Ibid.

63 Other women's organizations include the Water Color Club in Boston (1881), "Ten Philadelphia Painters" (1917), Art Workers' Club for Women (1898), Catherine Lorillard Wolfe Art Club (1896), and Pen and Brush Club (1893). (The last three were all in New York.) These groups had a variety of founders and purposes, but they all represent organizing efforts on behalf of women artists.

64. Plastic Club, Report and Programme, Seasons 1897–98–99. On organizations in other professions, see Drachman, *Women Lawyers*, and Morantz-Sanchez, *Sympathy and Science*, 180–82.

65. On the reluctance of professional women to organize, see Cott, *Grounding of Modern Feminism*, 230–34.

66. Unidentified clipping, Plastic Club Scrapbook, 1897–1903, reel 2537: #75, Plastic Club Records.

67. Weimann, *Fair Women*, 264–66.

68. On the ways that the Woman's Building and Chicago Fair represented a similar crossroads for other areas of women's advancement, see Scott, *Natural Allies*, 128–34; Rossiter, *Women Scientists in America*, 96–98.

69. Except for Fuller's, the murals are reproduced in Weimann, *Fair Women*, 311–19. Weimann reverses the two Emmet murals and misspells their names. All but Fuller's have subsequently been lost and are now known only by reproduction. Lucia Fairchild Fuller's mural has recently been rediscovered in New Hampshire. See Garfinkle, "Lucia Fairchild Fuller's 'Lost' Woman's Building Mural," 2–7.

70. Weimann, *Fair Women*, 211.

71. Bertha Potter Palmer to Sara Hallowell, as quoted in ibid., 190–91.

72. Quotations from *Chicago Tribune* and *Record* reviews of the Exposition, as cited in Preato, *Genius of the Fair Muse*, 15, and Hutton, "Picking Fruit," 318–48. On Cassatt's mural, see also Judith A. Barter, "Mary Cassatt: Themes, Sources, and the Modern Woman," in *Mary Cassatt: Modern Woman*, 87–96; Pollock, *Mary Cassatt*, 35–67; and Carr and Webster, "Mary Cassatt and Mary Fairchild MacMonnies," 52–69.

73. Regina Morantz-Sanchez, *Conduct Unbecoming a Woman*.

74. "Exhibits Which Prove That the Sex Is Fast Overhauling Man," *New York Times*, June 25, 1893, as quoted in Weimann, *Fair Women*, 427. All elisions Weimann's.

75. Mary Danforth Page, n.d., reel 4071: no frame number, Page Papers. See also Margaret Redmond to Mr. Skinner, March 15, 1940, reel 876: #689–90, Redmond Papers.

76. Merritt, "Letter to Artists," 467.

77. *Helen M. Turner, N.A.*, 6.

78. Tappert, "Choices," 431.

79. Homer Saint Gaudens, "Cecilia Beaux," 39, as quoted in Tappert, "Choices," 414.

80. Rossiter, *Women Scientists in America*; Cott, *Grounding of Modern Feminism*, 215–39; Morantz-Sanchez, *Sympathy and Science*; Moldow, *Women Doctors in Gilded-Age Washington*, 94–113; and Goggin, "Challenging Sexual Discrimination in the Historical Profession," 769–802.

81. Morantz-Sanchez, "Gendering of Empathic Expertise," 40–58; Morantz-Sanchez, "Entering Male Professional Terrain," 201–21; Morantz-Sanchez, *Sympathy and Science*, 184–202; Drachman, *Women Lawyers*, 16–32; and Cott, *Grounding of Modern Feminism*, 230–38.

CHAPTER FIVE

1. E. S., "Society of American Artists," 258, and Laurvik, "Annual Exhibition of the Pennsylvania Academy of the Fine Arts," xxxvi.

2. Art historians have typically focused on the period after 1890. For recent studies, see Doezema, *George Bellows and Urban America*, and Burns, "'Earnest, Untiring Worker,'" 36–53. The most comprehensive discussion of late-nineteenth-century American art criticism is Docherty, "Search for Identity."

3. Sturgis is quoted in Simoni, "Art Critics and Criticism," 36–38. For examples of the articles on criticism, see S. G. W. Benjamin, "Art-Criticism," *Art Journal* 5 (January 1879): 29–31; "Art Criticism," *Scribner's Monthly* 18 (May 1879): 135–36; and Mary Logan, "The New Art Criticism," *Atlantic Monthly* 76 (August 1895): 265. The following discussion of the development of criticism is based on Simoni, "Art Critics and Criticism"; Docherty, "Search for Identity," 39–41, 50, 197–223; and Morgan, *New Muses*, 40–45.

4. Weiss, "Clarence Cook"; "Clarence Chatham Cook (1828–1900)," in Docherty, "Search for Identity," 199–201; and "Clarence Cook," in Burke, *In Pursuit of Beauty*, 412–14.

5. Kinnard, "Mariana Griswold Van Rensselaer," 181–205, and "Mariana Griswold Van Rensselaer (1851–1934)," in Docherty, "Search for Identity," 218–20. Docherty describes Van Rensselaer's "conscientious professionalism" on 218.

6. Levine, *Highbrow/Lowbrow*, 224.

7. On Gilded Age cultural categories, see Trachtenberg, *Incorporation of America*, 140–61, and Levine, *Highbrow/Lowbrow*, 176–77, 200–231.

8. Bederman, *Manliness and Civilization*, and Pyne, *Art and the Higher Life*.

9. Levine, *Highbrow/Lowbrow*, 200–201.

10. "Certain Dangerous Tendencies in American Life," *Atlantic Monthly* 42 (october 1878): 385–402, as quoted in Levine, *Highbrow/Lowbrow*, 203–4.

11. Although the relationship between elite leadership of and middle-class allegiance to Gilded Age ideals of culture has not been studied in depth, it is clear that it was not simply an upper-class interest. Some of the most striking evidence of day-to-day middle-class involvement in these ideals of culture is the extensive participation of women in art schools, decorative arts societies, amateur art clubs, museum education, and the school-picture movement. More research is needed on this range of activity to understand fully the role of visual culture, as well as culture in general, in everyday middle-class life.

12. On antebellum American art, see Johns, *American Genre Painting*; Burns, *Pastoral In-*

ventions; Wolf, "All the World's a Code," 328–37; Husch, "George Caleb Bingham's 'The County Election,'" 4–22; Groseclose, "Painting, Politics, and George Caleb Bingham," 4–19; Miller, *Empire of the Eye;* and Novak, *Nature and Culture.*

13. "Morals in Art and Literature," 474. See also Larned, "Millet and Recent Criticism," 392.

14. Will Low is quoted in Skalet, "Market for American Painting," 34; Merritt, *Love Locked Out,* 205.

15. For this study, I have used a twofold methodology. I have read discussions of the progress and direction of art in America and debates related to the art world in popular magazines, art journals, and selected books. I have also surveyed reviews for the National Academy of Design, Society of American Artists, Pennsylvania Academy, and Boston Art Club annual exhibitions from 1880, 1890, and 1900. For this survey, I looked at the following magazines: *American Architect and Building News, Art Amateur, American Art Review, Nation, Critic, Independent, Scribner's Monthly, Century Magazine,* and *Harper's Weekly.* For a sense of local reactions, I selected one newspaper for each city — the *Boston Transcript,* the *Philadelphia Inquirer,* and the *New York Tribune.*

In my discussion of critical rhetoric, I rely on the meanings most often attributed to the words and my interpretation of the general thrust of criticism. This can at times be quite difficult to disentangle because words were frequently used to mean different (and contradictory) things in different contexts or by different critics. "Science," for example, could be a negative description of antebellum Hudson River painters for producing paintings that were transcriptions of nature, but it could also be used positively to praise careful study and well-developed technique. I have focused on the overall tone of criticism rather than these contradictions.

For the most part, I read criticism independently of images in order to resist an essentialist notion of a masculine or feminine touch. I am interested in the spaces allotted to female artists within critical rhetoric. In fact, the gendered language of critical discourse was highly mobile and often invoked independently of artist or style. Reviewers put William Merritt Chase, for example, to work for both critical agendas. Broadly speaking, however, finished academic work and aestheticism drew praise under the calls for technique and sympathy, while realism and energetically brushed canvases received positive ratings for individuality and virility.

16. Van Rensselaer, "Some Aspects of Contemporary Art," 707.

17. Greta, "Boston Correspondence," *Art Amateur* 4 (December 1880): 6–7, as quoted in Docherty, "Search for Identity," 97.

18. "New Departure in American Art," 766. See also Brownell, "Art Schools in New York," 781.

19. "Greta," "Boston Correspondence," *Art Amateur* 2 (May 1880): 118.

20. Brownell, "Younger Painters of America. — III," 327–28.

21. "Paintings by Miss Elizabeth Boott," *Boston Post,* in Duveneck Scrapbook, reel 1151: #645, F&E Duveneck Papers.

22. "The Academy Pictures. The Approaching Close of the Exhibition — Autumn

Prospects," *North American* (May, 25 [1881]), in Pennsylvania Academy of the Fine Arts Scrapbook: 1877–92, reel P53: #258, PAFA Records.

23. "Fifty-first Annual Exhibition of the Academy," *Philadelphia Inquirer*, April 9, 1880.

24. "Greta," "Art in Boston," *Art Amateur* 16 (January 1887): 28, as quoted in Fairbrother et al., *Bostonians*, 44.

25. John C. Van Dyke, *How to Judge of a Picture* (New York: Eaton and Mains, 1889; Cincinnati: Jennings and Pye, 1889), 15–16, as quoted in Docherty, "Search for Identity," 82. Ellipsis is Docherty's. For a similar view, see "Picture Criticism," *Art Amateur* 13 (August 1885): 46, also quoted in Docherty, "Search for Identity," 48.

26. Benjamin, *Art in America*, 133. See also Sheldon, *American Painters, Enlarged Edition*, 228; Palgrave, "Women and the Fine Arts," 216; and Whiteing, "American Student at the Beaux-Arts," 272.

27. The polemical call for "art for art's sake" that emerged in the late nineteenth century, most infamously with Whistler's *Ten O'clock Lecture* (1885), had set off vigorous contention over the relationship between art and society and the import of the artist's singular vision. "Art for art's sake" provided a moving punching bag for critics to attack young artists and new styles for having degraded the proper purposes of art or to praise them for having revealed true aesthetic meaning and transcended earth-bound narrative. Until the turn of the century, the loose (and continually contested) resolution of this debate was the belief that aesthetic effects were primary, but they conveyed a higher meaning that served the ends of refinement, uplift, and civilization. On Whistler, see Baigell, *Concise History of American Painting and Sculpture*, 143. Burns, *Inventing the Modern Artist*, 79–80, 108–10, is also helpful.

28. Greta, "Boston Correspondence," *Art Amateur* 2 (February 1880): 48.

29. Ibid. See also "Pictures At Goupil's."

30. Brownell, "Younger Painters of America—First Paper," 7; and Mariana Van Rensselaer, "The Water-Color Exhibition in New York," *American Architect and Building News* 7 (February 28, 1880): 81, as quoted in Kathleen Foster, "John La Farge and the American Watercolor Movement: Art for the 'Decorative Age,'" in *John La Farge*, 157 n. 60.

31. The first of these is from Clarence Cook (in 1874) as quoted in Weiss, "Clarence Cook," 109; the last three are from Benjamin, *Art in America*, 103, 106, and 116.

32. "National Academy of Design.—Fifty-Fifth Annual Exhibition.—II," *Nation* 30 (April 29, 1880): 334. For similar rhetoric, see also "At the Private Review," [*Philadelphia?*] *Times*, October 24, 1885, and "Academy Pictures. Concluding Review of the 'Genre' and Landscape of the Current Exhibition," [*Philadelphia?*] *Times*, November 22, 1885, both in PAFA Scrapbook, reel P53: #359, #376, PAFA Records.

33. "The Society of American Artists," *Critic* 1 (April 9, 1881): 99, and Brownell, "Art Schools of New York," 781. Boldness, breadth, and strength were not universally doubted, but they usually received praise only in contrast to antebellum landscape painting. They represented going beyond literal transcription to the more general and suggestive effects critics were idealizing. For a positive use of these words, see Benjamin, "Present Tendencies of American Art," 481–96.

34. For the French case, see Garb, "'L'art Feminin,'" 39–65.

35. Brownell, "Younger Painters—III," 333.

36. *Boston Herald*, n.d., Duveneck Scrapbook, reel 1151: #645, F&E Duveneck Papers.

37. "Art and Artists," *Boston Transcript*, n.d., Duveneck Scrapbook, reel 1151: #648, F&E Duveneck Papers.

38. Brownell, "Younger Painters—III," 330–32.

39. Cook, "Some Present Aspects of Art in America," 602.

40. Caffin, "Some American Portrait Painters," 36. In the same article, Cecilia Beaux provided Caffin with another opportunity to voice the same distinctions. Beaux, he wrote, "has the masculine breadth of technique, allied to a point of view exclusively feminine" (42). Caffin (1854–1928) and Cook (1828–1900) provide a good sense of the appeal of the new rhetoric to two generations of critics. Cook had been an active critic since the 1850s and someone whose criticism often captured the spirit of the moment. Before his death in 1900 he had incorporated the latest shift into his criticism. Caffin wrote for genteel publications such as *Century Magazine* and for modernist little magazines such as Alfred Stieglitz's *Camera Work*. Bridging the two traditions, Caffin had come to doubt the "femininity" of current art by 1900. In 1916, he reflected on his change of heart, "Poor old fin-de-siècle exquisitiveness, how completely everybody but the artist [Thomas Wilmer Dewing] has grown beyond you." Not all critics followed Caffin's path. Others defended "traditional" art against the excesses of the moderns. Ironically, the very vocal conflict among critics probably helped publicize the "new" art and rhetoric and move the art world more generally toward its premises. On Charles Caffin, see Loughery, "Charles Caffin and Willard Huntington Wright," 103–9 (quotation from 105). On the "traditionalists," Morgan, *Keepers of Culture.*

41. Laurvik, "Annual Exhibition of the Pennsylvania Academy," xxxi–xxxii. For a good discussion of this article and the new rhetoric of virility in American art in the context of the Ashcan school, see Doezema, *George Bellows and Urban America*, 89–90. Known for their relatively gritty urban scenes, the Ashcan artists were a group of painters (their numbers hovered between five and eight) who gained prominence in the first decade of the twentieth century. Lois Fink has also pointed out that "virile" and "virility" became new terms of praise for artists at the turn of the century. Fink, *American Art*, 287.

42. Cook, "Some Present Aspects of Art in America," 601, and Cook, "Art in America in 1883," 312.

43. "Work of Philadelphia's Women Artists Dominates the Pages of America's Leading Magazines," *Philadelphia Press*, August 11, 1901, and "Royal Race for the Greatest Art Prize Ever Offered," *Philadelphia Sunday Press*, July 13, 1902, both as quoted in Likos, "Ladies of the Red Rose," 12.

44. Chase, "Women's Chances as Bread-Winners," 37.

45. The literature of "girl art student" and "woman artist" is immense and varied. Novels with women artists at the center range from Nathaniel Hawthorne's *Marble Faun* and William Dean Howell's *The Coast of Bohemia* to Elizabeth Stuart Phelps's *The Story of Avis*, Louisa May Alcott's novella based on her sister's life, *Diana and Persis*, and Kate Chopin's *The*

Awakening. On women writers with women artists as "painter-heroine," see Barker, "Painting Women." Newspapers, as we have seen, covered women regularly, particularly noting their prize winning and dominance in art schools. Illustrated magazines included fiction and accounts of the girl art student's life. See chapter 2 for the extensive articles on women in Paris, and Burns, " 'Earnest, Untiring Worker,' " 43–45, for an introduction to the magazine fiction. A series of other incidents and fads brought extensive notice and discussion, including the publication of Marie Bashkirtseff's diary (as I discuss later in this chapter), the novel *Trilby*, and the introduction of a mixed-sex life class at the Art Students League in 1890. The last incident was typical: it was described and debated in papers all across the country and used as an occasion to discuss women's art training and endeavors. See Art Students League Clippings, 1889–92, reel NY59-24A, Art Students League Records, Archives of American Art, Smithsonian Institution, Washington, D.C.

46. Higham, "Reorientation of American Culture," 73–102; Rotundo, *American Manhood,* 222–46; and Kimmel, *Manhood in America,* 126–41.

47. Quoted in Doezema, *George Bellows and Urban America,* 89. For another example, see Swift, "Revolutionary Figures in American Art," 534–36.

48. Randall, "Artistic Impulse in Man and Woman," 415–20. Sarah Burns also discusses this discourse, " 'Earnest, Untiring Worker,' " 42–43.

49. Two Brothers, "Art and the Woman," 29–34.

50. For development of evolutionary ideas about women's intellectual abilities and the widespread scientific discussion on genius, see Russett, *Sexual Science,* 10–12, 74–75, 92–97.

51. Two Brothers, "Art and the Woman," 29–34.

52. Sparrow, *Women Painters of the World,* 11.

53. Randall, "Artistic Impulse in Man and Woman," 415–20; Grant Allen, "Woman's Intuition," 333–40; and Ward, "Genius and Woman's Intuition," 401–8.

54. Palgrave, "Women and the Fine Arts," 220. Much of the antebellum discussion of the suitability of certain types of artistic production for women also made assumptions about women's "nature"; however, it did not typically deny the possibility of genius for women. Generally, it developed out of a very different set of motivations and problems — finding suitable employment for working-class girls, rather than battling over control of the profession and protection of middle-class cultural authority.

55. Allen, "Woman's Intuition"; Ward, "Genius and Woman's Intuition"; Seawell, "Absence of the Creative Faculty in Women," 292–94; responses and letters in the *Critic* 19 (December 26, 1891): 374–75, and 20 (January 16, 1892; January 23, 1892; February 6, 1892; February 13, 1892; February 20, 1892; and March 19, 1892): 41–42, 55–56, 89–90, 103–5, 117–18, 120–21, and 172–73; Partridge, "Manhood in Art," 281–88; and D. S. M., "Women Artists," 730–32.

56. Barnes, "Feminizing of Culture," 770. See also Conger-Kaneko, " 'Effeminization' of the United States," 7521–24, and Merwin, "On Being Civilized Too Much," 836–46. See also Rotundo, *American Manhood,* 248–55, and Kimmel, *Manhood in America,* 120–21. On civilization as a critical discursive category at the turn of the century, see Bederman, *Manliness and Civilization.*

57. Barnes, "Feminizing of Culture," 772.

58. Charles Caffin, "The Story of American Painting: French Influence," *American Magazine* 61 (March 1906): 597, as quoted in Doezema, *George Bellows and Urban America*, 94. Ellipsis in Doezema.

59. Quoted in Morgan, *New Muses*, 34.

60. Rotundo, *American Manhood*, 255 On sports enthusiasm, militarism, and so on, see also Higham, "Reorientation of American Culture."

61. Sylvester Rosa Koehler, *Exhibition of American Etchings*, (Boston: Museum of Fine Arts, 1881), as quoted in Peet, "Emergence of American Women Printmakers," 19.

62. Millet, "What Are Americans Doing in Art?," 46.

63. Quoted in Docherty, "Search for Identity," 190. See also Lathrop, "Progress of Art in New York," 744, 748.

64. Van Rensselaer, "Aspects of Contemporary Art," 710. See also Docherty, "Search for Identity," 92.

65. See, for example, "The Society of American Artists Exhibition," *Art Amateur* 23 (June 1890): 3, and "Society of American Artists," *Nation* 50 (May 8, 1890): 381.

66. Stillman, "Revival of Art," 251.

67. Brownell, "Recent Work of Elihu Vedder," 158, 164.

68. Weinberg, "Late-Nineteenth-Century American Painting," 19, 21; Docherty, "Search for Identity," 97–98; and Corn, *Color of Mood.*

69. Sadakichi Hartmann, *A History of American Art* (1901), as quoted in Van Hook, "Decorative Images of American Women," 56.

70. Pène du Bois, "Essentially Feminine Art," 1.

71. Ibid., 2–3. Emphasis added.

72. Sadakichi Hartmann, "Nineteenth Exhibition of the Society of American Artists," *Art News* 1 (May 1897): 1–4, as excerpted in Weaver, *Sadakichi Hartmann*, 77. Emphasis added.

73. "Society of American Artists Exhibition," 3, and "The Society of American Artists. (First Notice.)," *Critic*, n.s., 13 (May 3, 1890): 225.

74. Susan Ward, "Notes on the Late Exhibition of the American Artists," *Independent* 42 (June 12, 1890): 7, and "Society of American Artists Exhibition," 3.

75. "Society of American Artists. (First Notice.)," 225, and "Society of American Artists Exhibition," 3.

76. "Society of American Artists," *Nation* 50 (May 8, 1890): 381; "Society of American Artists. (First Notice.)," 224–25; and Ward, "Notes on the Late Exhibition of the American Artists," 7. Also see the language used to describe Sargent in Burns, "'Earnest, Untiring Worker.'"

77. Caffin, "Some American Portrait Painters," 36.

78. Pène du Bois, "Essentially Feminine Art," 3; Caffin, "Some American Portrait Painters," 42; and Saint Gaudens, "Cecilia Beaux," 39.

79. Frederick W. Webber, "A Clever Woman Illustrator," *Quarterly Illustrator*, n.d., in Clippings, reel 4152: #328–33, Alice Barber Stephens Papers, Archives of American Art, Smithsonian Institution, Washington, D.C.

80. Part of a description of Cecilia Beaux, as quoted in Burns, "'Earnest, Untiring Worker,'" 50.

81. On the unevenness of gender formations, see Poovey, *Uneven Developments*, 3–4.

82. Burns, "Old Maverick to Old Master," 36; Burns, *Inventing the Modern Artist*, 221–46; and Doezema, *George Bellows and Urban America*, 2–3.

83. "Woman at the Easel," 370.

84. E. E. G. [Eleanor Greatorex], "Among the Oils," *New Century for Women* 12 (July 29, 1876), as excerpted in Waller, *Women Artists in the Modern Era*, 243.

85. Ibid., 245. Sartain expressed this sentiment even more succinctly: "The alphabet must precede the reader." "Woman at the Easel," 370.

86. "Woman at the Easel," 370.

87. Beaux, "Why the Girl Art Student Fails," 221.

88. M. J. Curl, "Boston Artists and Sculptors in Intimate Talks. XI.—Marie Danforth Page," n.d., in Clippings, reel 4072: #742, Page Papers.

89. Maria Oakey Dewing, "Flower Painters, and What the Flower Offers to Art," *Art and Progress* 6 (June 1915): 255–62, on reel 1124: #654–58, Edwin C. Shaw Papers, Archives of American Art, Smithsonian Institution, Washington, D.C.

90. Merritt, "Letter to Artists," 464. See also Beaux, "Why the Girl Art Student Fails," 221.

91. "Two Views of Marie Bashkirtseff," 28. The second of these views was not much more favorable. It, too, complained of Bashkirtseff's self-absorption, which "leav[es] us in the end ignorant of the most important factor in a woman's life—the impression which she has made on others" (29).

92. Merritt, "Letter to Artists," 467.

93. Ibid.

94. See biographical information in her autobiography, "Point of View," and collected in her papers, reel D161: #2–4 and #11–59, Mary Fanton Roberts Papers, Archives of American Art, Smithsonian Institution, Washington, D.C. (hereafter referred to as Roberts Papers). See also her chapter on the fine arts in Doris E. Fleischman, ed., *An Outline of Careers for Women* (as described in Doris E. Fleischman, "Women in Business," *Ladies Home Journal* (1930), on reel D161: #677–81, Roberts Papers).

95. Roberts, "Sex Distinction in Art," 239–50, and "Quality of Woman's Art Achievement," 292–98. The latter article is excerpted in Waller, *Women Artists in the Modern Era*, 262–65.

96. Roberts, "Sex Distinction in Art," 240–42.

97. Roberts, "Quality of Woman's Art Achievement," as excerpted in Waller, 262–65.

CHAPTER SIX

1. Writings [no title], reel D285: #413, William Meyerowitz and Theresa F. Bernstein Papers, 1915–78, Archives of American Art, Smithsonian Institution, Washington, D.C.

(hereafter cited as Bernstein Papers). On Theresa Bernstein, see her papers and Theresa Bernstein, interview with author, June 22, 1999 [tape in author's possession]; Bernstein Meyerowitz, *Journal*; *Theresa Bernstein (1890–): A Seventy Year Retrospective*; "Bernstein (Meyerowitz), Theresa," in Heller and Heller, *North American Women Artists of the Twentieth Century*, 65–66; *Echoes of New York*; Burnham, "Theresa Bernstein," 22–27; *Theresa Bernstein: Expressions of Cape Ann and New York*; *Paintings and Etchings of William Meyerowitz and Theresa Bernstein*; and *Theresa Bernstein* (Smith-Girard, 1985).

2. The term "modern movement" encompasses what contemporaries would have described as "modern," "progressive," or "advanced" art. These were concepts substantially broader than modernism alone, primarily drawing a distinction with academic art. The moderns could cover a broad spectrum of styles, including the urban realism practiced by Bernstein and artists associated with the Ashcan school and the postimpressionist and modernist works supported in avant-garde circles. Leadership of the aesthetic debate would pass to the modernists, and this chapter is primarily about the shape of modernist practice and ideology. Yet I want to emphasize the continuities between all the threads of progressive art and the critical and aesthetic discourse across the late nineteenth and early twentieth centuries. I also use the terms "avant-garde" and "avant-garde art" to describe the early-twentieth-century American art world. These terms have the advantage of suggesting both the deep challenge to the Victorian cultural order embedded in much modernist work and the larger circles of political and social ferment to which American modernists belonged.

3. John Sloan's diary is quoted in *Theresa Bernstein* (Smith-Gerard, 1985), 1. The comparison to Sloan and Ashcan artists is noted in *Echoes of New York*, n.p.

4. Many recent histories of American modernist art still scarcely mention women artists and make only passing reference to the gender politics of the art world. Georgia O'Keeffe is the major exception, and she remains the only widely known female American modernist. For examples of the ways that women's presence is minimized and the gender politics ignored or downplayed, see Hughes, *American Visions*, 339–95, and Haskell, *American Century*, 93–129. For thinking about the gender dynamics of modern movements, I am particularly indebted to Doezema, *George Bellows and Urban America*, 1–2; Todd, *"New Woman" Revised*, 18–19; Dijkstra, *Georgia O'Keeffe and the Eros of Place*; Wagner, *Three Artists (Three Women)*; and Corn, *Great American Thing*. Literary scholars have more thoroughly explored the impact of gender on modernism. Sandra Gilbert and Susan Gubar have, for example, argued that modernism was a product of "an ongoing battle of the sexes that was set in motion by the late nineteenth-century rise of feminism and the fall of Victorian concepts of 'femininity.'" Gilbert and Gubar, *No Man's Land*, 1:xii.

5. Writings ["Printed in the Art Digest"], reel D285: #412, Bernstein Papers.

6. Daniel Joseph Singal writes, for example, that the "motor source" of modernism was "a response to the cultural malaise brought about by late Victorian repression." Singal, "Towards a Definition of American Modernism," 12. See also Lears, *No Place of Grace*, xii, and Douglas, *Terrible Honesty*, 217–53. A useful survey of literary modernism and its historical context is Bradbury and McFarlane, *Modernism, 1890–1930*.

7. For works that have begun to explore women and feminism as causal force in the social and cultural upheaval at the turn of the century, see Rotundo, *American Manhood;* Kunzel, *Fallen Women, Problem Girls;* and Dawley, *Struggles for Justice.* For an important theorization of the place of gender in conceptions of modernity, see Felski, *Gender of Modernity.* For parallels to Europe, see Tickner, "Men's Work?," 42–82, and Carol Duncan, "Virility and Domination in Early Twentieth-Century Vanguard Painting," in *The Aesthetics of Power: Essays in Critical Art History* (New York: Cambridge University Press, 1993), 81–108.

8. Stansell, *American Moderns,* 7.

9. Ibid., 225.

10. Bederman, *Manliness and Civilization,* 10–20; Rotundo, *American Manhood,* 222–46; and Kimmel, *Manhood in America,* 119–20.

11. Hoganson, *Fighting for American Manhood,* and Kaplan, "Black and Blue on San Juan Hill," 219–36.

12. Theodore Roosevelt, "A Layman's View of an Art Exhibition," *Outlook* (March 22, 1913), as reprinted in *1913 Armory Show,* 160–62.

13. Raymond Williams has described this "deep emphasis on the liberation of the creative individual" as a central trait of modernism. Williams, *Politics of Modernism,* 57. See also Bradbury and McFarlane, *Modernism, 1890–1930,* 71–93.

14. Corn, *Great American Thing,* 55–67, and Barbara Zabel, "The Machine and New York Dada," in Naumann and Venn, *Making Mischief,* 280–85.

15. On lowbrow culture, see Huyssen, "Mass Culture as Woman," 44–62. On the rise of middlebrow culture, see Rubin, *Making of Middlebrow Culture;* Radway, *Feeling for Books;* and Radway, "Gender of the Middlebrow Consumer," 871–93.

16. Raymond Williams has shown that while avant-garde movements tended toward a politics that challenged established social hierarchies, the full spectrum of political positions could emerge out of modernist work. Williams, "Politics of the Avant-Garde," in *Politics of Modernism,* 49–63. Christine Stansell has recently identified a highly generous, democratic spirit among the American avant-garde, with an openness to radical politics and a desire to foster cross-class action and radical change. Although some segments of the artistic avant-garde fit this characterization (most notably the Ashcan artists and those involved in the magazine *The Masses*) and many more professed liberal political views, I see much of the modernist avant-garde much more reluctant to embrace the popular in their actual works. Even when they did traverse the realms of popular culture, as among the dadaists, I am not persuaded that their works either had the goal of "universality" that genteel artworks had or succeeded in being anything but rather elitist. Stansell, *American Moderns,* 7–8 and, for example, her discussion of the Ferrer Center, 95–100.

17. No consistent definition of generational boundaries has been developed by historians. Barbara Solomon establishes three generations of college students—those that attended from the 1860s to 1890s, those in the 1890s and 1900s, and those in 1910s and 1920s. Lynn Gordon has grouped the period 1890–1920 together as the decades a second generation of students was in college. Carroll Smith-Rosenberg sees a world of mothers who came of age before the 1890s, those who came of age in the 1890s as a first gen-

eration of New Women, and those who came of age after 1900 as a second generation. What they all share is agreement that a break occurred for those who came of age around 1890.

None of these studies defines birth cohorts. Based on Janet James's introduction to *Notable American Women*, which also makes 1890 a transition point in women's history, Eileen McDonagh has identified two birth cohorts for this period—those born 1841–70 and those born 1871–1900. I might further distinguish two generations of artists born between 1841 and 1870, with the split around 1855 because it seems to me that those born in the 1840s had a different experience than, and set the stage for, those born after 1855, who encountered far more women already in art. For a sense of this generation: Mary Cassatt and Emily Sartain were born in the 1840s; Cecilia Beaux and Ellen Day Hale were both born in 1855; and Lydia Field Emmet and Louise Cox were born in the 1860s. Solomon, *In the Company of Educated Women*; Joyce Antler, review of *In the Company of Educated Women*, *Signs* 12 (Winter 1987): 386–90; Gordon, *Gender and Higher Education in the Progressive Era*; Smith-Rosenberg, "New Woman as Androgyne," 245–96; Janet Wilson James, introduction to *Notable American Women, 1607–1950*, ed. Edward T. James, Janet Wilson James, and Paul S. Boyer (Cambridge: Harvard University Press, Belknap Press, 1971), xvii–l; and McDonagh, "Profiles of Achievement," 343–67.

18. On this generation—a generation of New Women who came of age in the teens—my findings are most consistent with those of Solomon and Smith-Rosenberg, who distinguish a "second" generation of New Women more interested in heterosocial worlds and experimentation. Birth decades for modernist women include Anne Goldthwaite in 1869; Blanche Lazzell, Jane Peterson, and Agnes Weinrich in the 1870s; Georgia O'Keeffe, Marguerite Zorach, and Katherine Dreier in the 1880s; and Theresa Bernstein in 1890.

19. On Lilian Westcott Hale, see Hale, *Life in the Studio*, and Hirshler, "Lilian Westcott Hale (1880–1963)."

20. Cott, *Grounding of Modern Feminism*, 36. On the New Woman, in general, see Smith-Rosenberg, "New Woman as Androgyne"; Cott, *Grounding of Modern Feminism*, 13–50; and Heller and Rudnick, *1915, the Cultural Moment*, 69–115.

21. Cott, *Grounding of Modern Feminism*, 37–38.

22. Ibid., 39.

23. As a general rule, Ashcan artists were born closer to 1870, while the early modernists were born around 1880. For example, George Luks was born in 1867, William Glackens in 1870, John Sloan in 1871, and Everett Shinn in 1873; Marsden Hartley was born in 1877, Abraham Walkowitz in 1879, Arthur Dove in 1880, and Max Weber in 1881. Both groups had a central figure and spokesperson born in the 1860s—Robert Henri (1865) for the Ashcan school and Alfred Stieglitz (1864) for the modernists.

24. Helen Appleton Read quoted in Homer, *Robert Henri and His Circle*, 159. On Henri as teacher and leader, see Homer, *Robert Henri and His Circle*, 158–62; Zurier, Snyder, and Mecklenburg, *Metropolitan Lives*, 26–27; and Haskell, *American Century*, 64–65, 94.

25. The quotes above are from Haskell, *American Century*, 64–65. Henri taught first at the Pennsylvania Academy of the Fine Arts, then at the New York School of Art (where

he began to outshine the school's founder, Chase himself, in popularity), and then started his own Henri School of Art in January 1909.

26. Henri made this statement about his methods in 1910. His comment and Stuart Davis's recollections are quoted in Homer, *Henri and His Circle*, 162.

27. Henri, "Progress in Our National Art," 387–401.

28. Todd, *"New Woman" Revised*, 18–19.

29. Doezema, *George Bellows and Urban America*, 1–2; Homer, *Henri and His Circle*, 157; and Baigell, *Concise History of American Painting and Sculpture*, 209. "The Eight" included Robert Henri, William Glackens, George Luks, John Sloan, Everett Shinn, impressionist Ernest Lawson, postimpressionist Maurice Prendergast, and symbolist Arthur B. Davies. Obviously, not all of these men were working in realist modes, but they did share an anti-academic stance. Several exhibitions had led up to the 1908 exhibition, including one in New York in 1902 and another two years later at the National Arts Club. Generally, however, Ashcan artists had tried to exhibit their work within the framework of the National Academy.

30. On the Armory Show, see Brown, *Story of the Armory Show*, and Davidson, *Early American Modernist Painting*, 164–68. Two exhibitions after the Armory Show were also particularly important for American modernists in the teens. They included the 1916 Forum Exhibition of Modern American Painting, with only seventeen artists, and the 1917 Society of Independent Artists exhibition, which was even larger than the Armory Show.

31. Haskell, *American Century*, 94. On Stieglitz's role in introducing modernism, see Homer, *Alfred Stieglitz*, 37–78, and Davidson, *American Modernist Painting*, 13–22.

32. Brown, *Story of the Armory Show*, 152.

33. Edward Abrahams, "Alfred Stieglitz's Faith and Vision," in Heller and Rudnick, *1915, the Cultural Moment*, 190.

34. Charles Caffin, *American Masters of Painting* (1902) and *The Story of American Painting* (1907). Both quoted in Dijkstra, *O'Keeffe and the Eros of Place*, 32, 35.

35. Homer, *Alfred Stieglitz*, 77.

36. For the use of "vulgar" to describe modernity, see Corn, *Great American Thing*, 24.

37. Artist Marsden Hartley, quoted in Francis Naumann, "New York Dada: Style with a Smile," in Naumann and Venn, *Making Mischief*, 11. My discussion of dadaism draws from this book and from Francis Naumann, *New York Dada*, and Corn, *Great American Thing*, 43–89.

38. On women and dada, see Amelia Jones, "Eros, That's Life, Or the Baroness' Penis," in Naumann and Venn, *Making Mischief*, 238–47, and Corn, *Great American Thing*, 57–60, 66, 75–76.

39. See Corn, *Great American Thing*, for a persuasive and thorough account of these struggles.

40. Anne Goldthwaite, "Memoirs," as reprinted in Breeskin, *Anne Goldthwaite*, 25.

41. On Zorach's meeting with Stein, see Tarbell, *Marguerite Zorach*, 15. Anne Goldthwaite tells a marvelous story of going to tea with Gertrude Stein with her friend Frances Thomason. Stein and Thomason made Goldthwaite climb up on a long table and walk the length of the room examining the pictures. Goldthwaite, who had no idea what to make of these

paintings at the time, was saved from embarrassing herself by the arrival of tea. Anne Goldthwaite "Memoirs," in Breeskin, *Anne Goldthwaite,* 24. Information on Anne Goldthwaite can be found in Heller and Heller, *North American Women Artists,* 214–15; *Notable American Women,* 61–62; Artists no longer connected with Downtown Gallery, reel ND1: #418–42, and Stock Books, reel ND50: #28–42, Downtown Gallery Papers, Archives of American Art, Smithsonian Institution, Washington, D.C. (hereafter cited as Downtown Gallery Records); Breeskin, *Anne Goldthwaite;* "Anne Goldthwaite as a Portrait Painter," *International Studio* (May 1916), Vertical File, National Museum of American Art, Washington, D.C.; and *Anne Goldthwaite: Memorial Exhibition.*

42. On Zorach's studies in Paris, see Tarbell, *Marguerite Zorach,* 15–16. Biographical information on Marguerite Zorach is drawn from the Zorach Family Papers, Archives of American Art, Smithsonian Institution, Washington, D.C. (hereafter cited as Zorach Papers/AAA); William Zorach Papers, Manuscripts Division, Library of Congress, Washington, D.C. (hereafter cited as Zorach Papers/LC); Dahlov Ipcar, interview with author, July 28, 1998 [tape in author's possession] (Ipcar is Zorach's daughter); Arnold Potter, interview with author, July 27, 1998 [tape in author's possession] (Potter is a friend of Zorach's); Dahlov Ipcar interview, November 13, 1979, Archives of American Art Oral History Program, Smithsonian Institution, Washington, D.C.; Stock Books, reel ND50: #675–86, Downtown Gallery Records; *Marguerite Zorach: Cubism and Beyond;* Hoffman, *William and Marguerite Zorach, the Cubist Years;* Tarbell, *William and Marguerite Zorach;* Tarbell, *Marguerite Zorach;* Rubinstein, *American Women Artists,* 172–76; and Waller, *Women Artists in the Modern Era,* 315–20.

43. *Colour, Rhythm and Dance,* 9. On Fergusson, see Cliffe, *Scottish Colourists,* 22, and *Colour, Rhythm, and Dance.*

44. "William Zorach, A Retrospective Exhibition of Sculpture," 1950, reel ND43: #238, Downtown Records.

45. William Zorach to Maguerite Zorach, Paris, April 27, 1911, box 1, folder 2, Zorach Papers/LC.

46. Marguerite Zorach to William Zorach, Arles, 1911, box 1, folder 2, Zorach Papers/LC.

47. Diaries, January 6, 1913, reel 2990: #946, Blanche Lazzell Papers, Archives of American Art, Smithsonian Institution, Washington, D.C.

48. Anne Goldthwaite, "Memoirs," in Breekskin, *Anne Goldthwaite,* 25. Goldthwaite also observed that some places were still just for men. There was "a tacit agreement" that the American women would give the American men one place where they were not observed.

49. Tarbell, *William and Marguerite Zorach,* 14.

50. Nathanson, "Anne Estelle Rice," 5.

51. On the turn-of-the-century New York avant-garde, see Stansell, *American Moderns.*

52. Rubinstein, *American Women Artists,* 165–68. The description of Edith Glackens playing the "Frog Game" is from Glackens, *William Glackens and the Ashcan Group,* 57.

53. Wood, *I Shock Myself,* 18–25.

54. Crunden, *American Salons,* 387. On Luhan and her salon, see ibid., 383–408; Watson,

Strange Bedfellows, 136–38; and Lois Rudnick, *Mabel Dodge Luhan*, 71–84. Luhan married several times, each time changing her name. In the teens she would have been Mabel Dodge. For simplicity and clarity, I use the name of her last husband and her name at her death—Luhan.

55. Watson, *Strange Bedfellows*, 136.

56. Ibid., 178–79, and Rudnick, *Mabel Dodge Luhan*, 66–71, 86–88.

57. *Provincetown Advocate*, July 3, 1915, in Noun, "Agnes Weinrich," 11.

58. Blanche Lazzell to sister Besse, July 4, 1915, as quoted in "Blanche Lazzell: A Modernist Rediscovered," pamphlet for exhibition at Archives of American Art, New York Regional Center, June 25–September 20, 1991.

59. Robert K. Sarlos, "Jig Cook and Susan Glaspell: Rule Makers and Rule Breakers," in Heller and Rudwick, *1915, the Cultural Moment*, 250.

60. Watson, *Strange Bedfellows*, 259. On Zorach in Provincetown, see *Marguerite Zorach: Cubism and Beyond*, 45. For the Zorach involvement in *Others*, see Watson, *Strange Bedfellows*, 298–303, 383 n. 74. Zorach also made a pen-and-ink portrait of Kreymborg. For Walter Arensberg's role as patron of the avant-garde and *saloniére*, I have relied here on Watson, *Strange Bedfellows*, 260–64, 276–79; Crunden, *American Salons*, 409–43; and Davidson, *Early American Modernist Painting*, 74–120. For Zorach's portrait of Marianne Moore, see Tarbell, *Marguerite Zorach*, 53. Zorach's daughter, Dahlov Ipcar, describes Zorach's friendship with Isabel Lachaise in her interview for the Archives of American Art Oral History Program, November 13, 1979. On the Stettheimers, see Watson, *Strange Bedfellows*, 252–60; Bloemink, *Life and Art of Florine Stettheimer*; and Sussman and Bloemink, *Florine Stettheimer*. On Zorach at the Stettheimers, see Haskell, *American Century*, 137. Zorach's picture in the dollhouse and a 1940s portrait of Florine Stettheimer are reproduced in Bloemink, *Life and Art of Florine Stettheimer*, 70, 224.

61. On Polly's and the Liberal Club, see Watson, *Strange Bedfellows*, 144–45, 395. On the Greenwich Village balls, see ibid., 228–31. Watson quotes Dell on 229.

62. Hoffman, *William and Marguerite Zorach, the Cubist Years*, 19. Theresa Bernstein describes Marguerite Zorach as a friend in *Theresa Bernstein: Expressions of Cape Ann and New York*.

63. On O'Keeffe's reading of *Fidelity*, see Eisler, *O'Keeffe and Stieglitz*, 243.

64. Bernstein, *Journal*, 45.

65. Pollitzer served as leader of the National Woman's Party from 1945 to 1949. For Pollitzer's biography, see introduction and afterward in Giboire, *Lovingly Georgia*.

66. From "Commissioner Dell Feted by Woman's Party," *Equal Rights* 13 (March 6, 1926): 26, as quoted in Lynes, "Georgia O'Keeffe and Feminism," 442. Lynes has found O'Keeffe listed as a founding member of the National Woman's Party, 448 n. 26.

67. Brown, *Story of the Armory Show*, 152.

68. Bernstein, *Journal*, 9.

69. Marguerite Zorach to William Zorach, [August 31, 1912], folder 9, box 1, Zorach Papers/LC.

70. Marguerite Zorach to William Zorach, [July 15], 1912, folder 7, box 1, Zorach Papers/LC.

71. In the Armory Show women accounted for 16 percent of the exhibitors—50 of 307 exhibitors listed in the catalogue raisonné in Brown, *Story of the Armory Show*, 241–327. This is marginally less than the 17 percent at the "conservative" National Academy of Design in 1900 (see appendix, table 1). At the Forum, Zorach as lone woman made up 5.8 percent. On O'Keeffe at the Museum of Modern Art, see McCarthy, *Women's Culture*, 208. The first retrospective the museum granted to a woman was also to O'Keeffe—in 1946. For a similar story of diminishing opportunities for English women, see Tickner, "Masculinity and Modernism," 65–67.

72. Marling and Harrison, *Seven American Women*, 11; Homer, *Robert Henri and His Circle*, 152–56; Homer, *Alfred Stieglitz*, 84.

73. On Dreier, see Herbert et al., *Société Anonyme and the Dreier Bequest*; Bohan, *Société Anonyme's Brooklyn Exhibitions*, 1–25.

74. On the Society of Independent Artists, see Marlor, *Society of Independent Artists*; Altshuler, *Avant-Garde Exhibition*, 77; Brown, *American Painting from the Armory Show to the Depression*, 66–67; and Watson, *Strange Bedfellows*, 280–81, 312–20.

75. These figures have been calculated by comparing Marlor, *Society of Independent Artists*, with Wolf, *New York Society of Women Artists, 1925*. Seventeen of twenty-four future members exhibited in the 1917 show.

76. Marlor, *Salons of America*, 15.

77. Ibid., 21. Marlor breaks down each of the seventeen exhibitions (two were held in some years) by total number of artists, number of women, and number of men.

78. McCarthy, *Women's Culture*, 188–96. McCarthy notes little concerted effort by Dreier to promote women artists. This echoes earlier female patrons whose primary commitment was to their collection. See also Bohan, *Société Anonyme's Brooklyn Exhibitions*, and Herbert et al., *Société Anonyme and the Dreier Bequest*.

79. For lists of directors, officers, and exhibition committees, see Marlor, *Salons of America*, 17–19, and Marlor, *Society of Independent Artists*, 56–60.

80. Theresa Bernstein, interview with author, June 22, 1999.

81. Marguerite Zorach to Jessica Dismorr, April 6, 1922, reel 4958: #71–79, Zorach Papers/AAA. The only other female director in 1922 was Gertrude Whitney, and it seems likely, based on Zorach's remarks, that she was not there.

82. Mary Lynn Kotz, "Georgia O'Keeffe at 90," *Art News* 76 (December 1977): 45, as quoted in Lynes, *O'Keeffe, Stieglitz, and the Critics*, 323 n. 31. The O'Keeffe interview is quoted in Mitchell, "Sexist Art Criticism," 686.

83. Zilczer, "'World's New Art Center,'" 2–7; Zilczer, *"Noble Buyer,"* 31–32; and Haskell, *American Century*, 107. The Daniel Gallery had forty shows between 1913 and 1918. Zilczer, "'World's New Art Center,'" 4. Harriet Bryant opened the Carroll Galleries, Robert Coady the Washington Square Gallery, and Stephane Bourgeois the Bourgeois Gallery in 1914. Other important new galleries included the Modern Gallery, which opened in 1915. Among the older firms adding modern works to their roster were Knoedler and Company, the Berlin Photographic Company, and Montross Gallery. The number of modern

art exhibitions in New York has been calculated by Judith Zilczer and cited by Watson, *Strange Bedfellows*, 376 n. 3.

84. "Annual Exhibition of American Painters and Sculptors," Bourgeois Galleries, New York, March 26–April 14, 1923, reel 4858: #580–87, Bourgeois Galleries Exhibition Catalogs, 1919–25, Archives of American Art, Smithsonian Institution, Washington, D.C.

85. Breeskin, *Anne Goldthwaite*, 132.; "Exhibition of Embroidered Tapestries by Marguerite Zorach," Montross Galleries, New York, February 5–17, 1923, reel 4859: #769–70, Montross Gallery Exhibition Catalogs, 1908–23, Archives of American Art, Smithsonian Institution, Washington, D.C.

86. Anne Estelle Rice to O. Raymond Drey, February 9, 1915, as quoted in Nathanson, "Anne Estelle Rice," 7.

87. On the GRD Studio, see Noun, "Agnes Weinrich," 14.

88. On the Studio Club, see McCarthy, *Women's Culture*, 232–36. The women represented by the Downtown Gallery come from a list of artists represented from about 1931. The women included Marguerite Zorach, Dorothy Varian, Julia Kelly, Isabella Howland, and Anne Goldthwaite. Reel ND43: #278, Downtown Gallery Records. For the number of women exhibited, see Tepfer, "Edith Gregor Halpert and the Downtown Gallery Downtown," 110, 277–85.

89. This is a subject that needs much more substantial research. These galleries included Sunwise Turn (1915–25, a gallery and bookshop where batik art was first exhibited), Touchstone Gallery, and Mildred Cowles Gallery. See Noun, "Agnes Weinrich," 13, and Hazel Clark, "The Textile Art of Marguerite Zorach," *Woman's Art Journal* 16 (Spring/Summer 1995): 19.

90. Edith Halpert, "Talk at Detroit Institute of Art," September 18, 1963, as quoted in McCarthy, *Women's Culture*, 198.

91. See clippings in Scrapbooks, reel 4866: #378–407, Bernstein Papers; Talbott and Sydney, *Philadelphia Ten*. On the MacDowell Club, see reel 4859: #503–30, MacDowell Club Exhibition Catalogs, 1911–19, Archives of American Art, Smithsonian Institution, Washington, D.C. These cover the season beginning February 1918 and ending May 1919. Not every month is accounted for in the catalogs, and there may have been other shows that I have not identified.

92. "New York Women Artists Open Their Annual," 16.

93. Anne Goldthwaite, "Memoirs," in Breeskin, *Anne Goldthwaite*, 28–30.

94. Wolf, *Society of Women Artists*, n.p. Information on the New York Society of Women Artists is drawn from this catalog.

95. Bernstein, *Journal*, 56.

96. Goldthwaite quoted in Wolf, *Society of Women Artists*, n.p.; and Beaux quoted in Tappert, "Choices," 431.

97. This discussion of Zorach's career is drawn from the sources in note 42.

98. Clark, "Textile Art of Marguerite Zorach," 23.

99. Slusser, "Modernistic Pictures Done in Wool," 30. For other examples of Zorach's

efforts to promote her work as art, see Mannes, "Embroideries of Marguerite Zorach," 29–33; "'Tapestry Paintings' Shown By Mrs. Zorach," 14; and "Tapestries of Marguerite Zorach," 3–7.

100. Zorach, "Embroidery as Art," 51.

101. Dahlov Ipcar interview, November 13, 1979, and Tarbell, *Marguerite Zorach*, 50.

102. Other images from this period have similar cubist experimentation. See, notably, *Prohibition*, 1920; *Madelin Iselin*, 1922 (both reproduced in *Marguerite Zorach: Cubism and Beyond*); and *Night Breeze*, 1925 (reproduced in "Figurative Exhibit," Owings-Dewey Fine Art, Santa Fe, New Mexico, March 9–31, 1990). On the Zorachs and cubism, see Hoffman, *William and Marguerite Zorach: The Cubist Years.*

103. Other women married to modernist artists experienced the same difficulties. Theresa Bernstein was always better at promoting her husband William Meyerowitz's career than her own. Adelaide Lawson Gaylor, an active modernist painter of landscapes and figures, had her reputation overshadowed by her husband, Wood Gaylor. On Lawson, see Wolf, *Society of Women Artists*, n.p. See also Marter, "Three Women Artists Married to Early Modernists," 88–95.

104. W. H. de B. Nelson, "Theresa F. Bernstein," *International Studio* (February 1919), as quoted in *Theresa Bernstein (1890–): A Seventy Year Retrospective*, 8.

105. "Theresa Bernstein: A Realist in the Old Sense of the Word," *New York Herald*, November 2, 1919, sec. 3, p. 5, reel 4866: #378, Bernstein Papers. I am indebted to Joan Whalen for the complete citation for this unidentified clipping from the Bernstein scrapbooks (*Theresa Bernstein (1890–): A Seventy Year Retrospective*, 14 n.8).

106. W. H. de B. Nelson had been on the six-member Forum Committee that organized the Forum Exhibition at the Anderson Galleries in 1916. Zilczer, "'World's New Art Center,'" 3. Frederick James Gregg was a critic for the *New York Sun* and had served on the organizing committee of the Armory Show in 1913. He was responsible for publicity and defended the exhibition in reviews and public debates. Altshuler, *Avant-Garde Exhibition*, 60–77, and Loughery, "*New York Sun* and Modern Art in America," 78–79.

107. On psychology and the sex-based nature of the self, see Satter, *Each Mind a Kingdom*, 223–25; John D'Emilio and Estelle Freedman, *Intimate Matters: A History of Sexuality in America* (New York: Harper and Row, 1988), 225–26; Smith-Rosenberg, "New Woman as Androgyne," 289; and Jeffrey Weeks, *Sex, Politics and Society: The Regulation of Sexuality Since 1800* (New York: Longman, 1981), 145–52. For some contemporary sources, see Floyd Dell, "Speaking of Psycho-Analysis," *Vanity Fair* 5 (December 1915): 53; Max Eastman, "Exploring the Soul and Healing the Body," *Everybody's Magazine* 32 (June 1916): 741–50; and Max Eastman, "Mr.—Er—Er—Oh! What's His Name?: Ever Say That?," *Everybody's Magazine* 33 (July 1915): 95–103.

108. Wood, *I Shock Myself*, 24–25.

109. Although I do not follow her interpretation of this work entirely, see Corn, *Great American Thing*, 66.

110. Stansell, *American Moderns*, 307.

111. For the collected criticism and commentary on O'Keeffe, see Lynes, *O'Keeffe, Stieglitz,*

and the Critics. My interpretation of O'Keeffe is indebted to ibid.; Lynes, "Georgia O'Keeffe and Feminism; Corn, *Great American Thing*, 238–91; Wagner, *Three Artists (Three Women);* and Dijkstra, *O'Keeffe and the Eros of Place.* All of these explore O'Keeffe's standing as a female artist, although not from the perspective of her place among a generation of women artists.

112. "Georgia O'Keeffe—C. Duncan—Rene Lafferty," *Camera Work* 48 (October 1916): 12–13. Reprinted in Lynes, *O'Keeffe, Stieglitz, and the Critics,* 166–67.

113. Henri, "Progress in Our National Art," 387.

114. I borrow the idea of trophy from Corn, *Great American Thing,* 240.

115. Alfred Stieglitz, "Woman in Art" (1919), in Norman, *Alfred Stieglitz,* 137–38.

116. On O'Keeffe's style, see Chave, "O'Keeffe and the Masculine Gaze," 120; on controlling her image see, Peters, *Becoming O'Keeffe,* 44; Lynes, *O'Keeffe, Stieglitz, and the Critics,* 2.

117. Paul Rosenfeld, "American Painting," *Dial* 71 (December 1921), as excerpted in Lynes, *O'Keeffe, Stieglitz, and the Critics,* 171–72. The Marsden Hartley essay was "Some Women Artists in Modern Painting," in his *Adventures in the Arts: Informal Chapters on Painters, Vaudeville, and Poets* (New York: Boni and Liveright, 1921; reprint, New York: Hacker Art Books, 1972), 116–19. It is excerpted in Lynes, *O'Keeffe, Stieglitz and the Critics,* 170–71. Also see Chave, "O'Keeffe and the Masculine Gaze," and Mitchell, "Sexist Art Criticism." Oscar Bluemner is quoted in Chave, "O'Keeffe and the Masculine Gaze," 123.

118. Elsie Driggs (1898–1992). For a short biography see the Web site for the Whitney Museum of American Art's American Century exhibition, <*http://whitney.ArtMuseum.net/ tac_helpframe.html*>; and Rubinstein, *American Women Artists,* 185–86.

119. Lynes, *O'Keeffe, Stieglitz, and the Critics,* and Lynes, "O'Keeffe and Feminism." For differing interpretations of the shift in O'Keeffe's image, see Eisler, *O'Keeffe and Stieglitz,* 282; and Cowart, Hamilton, and Greenough, *Georgia O'Keeffe,* 169. Eisler argues that O'Keeffe's image was one of "innocent, all-American girl" and that it was fashioned by Stieglitz for her; Cowart, Hamilton, and Greenough agree with Lynes that O'Keeffe created her new image but claim that it was one of intuition and subjectivity.

120. Georgia O'Keeffe to Anita Pollitzer, October 11, 1915, and October 20[?], 1915, in Cowart, Hamilton, and Greenough, *Georgia O'Keeffe,* 144–46. I retain O'Keeffe's original punctuation throughout. See generally the letters to Pollitzer from 1915 to 1917, ibid., 141–61. See also the excerpted statement in her unpaginated autobiography (opposite plates 12 and 13): "I decided I was a very stupid fool not to at least paint as I wanted to and say what I wanted to when I painted." O'Keeffe, *Georgia O'Keeffe.*

121. Georgia O'Keeffe to Anita Pollitzer, January 4, 1916, in Cowart, Hamilton, and Greenough, *Georgia O'Keeffe,* 147–48.

122. Georgia O'Keeffe to Mitchell Kennerly, Fall 1922, in ibid., 170–71.

123. Georgia O'Keeffe to Sherwood Anderson, February 11, 1924, in ibid., 175–76. On O'Keeffe's ambition to be objective and the changed criticism, see also Lynes, "Georgia O'Keeffe and Feminism," 444–45.

124. Francis O'Brien, "Americans We Like: Georgia O'Keeffe," *Nation* 125 (October 12, 1927): 362, as quoted in Lynes, *O'Keeffe, Stieglitz, and the Critics,* 269–72.

125. O'Keeffe, *Georgia O'Keeffe*, n.p. In the O'Keeffe catalogue raisonné, this pastel has been retitled "Alligator Pear" and dated 1923. Lynes, *Georgia O'Keeffe*, 1:224 (cat. no. 414).

126. Gladys Oaks, "Radical Writer and Woman Artist Clash on Propaganda and Its Uses," *[New York] World*, March 16, 1930, Women's Section, pp. 1, 3, as quoted in Lynes, "Georgia O'Keeffe and Feminism," 442.

127. Helen Appleton Read, "The Feminine View-Point in Contemporary Art," *Vogue* 71 (June 15, 1928): 76–77, 96. Reprinted in Lynes, *O'Keeffe, Stieglitz, and the Critics*, 291–93.

128. Read, "Women's Art Not Necessarily Feminine," as quoted in Wolf, *Society of Women Artists*, n.p. For a similar comment, see Elisabeth L. Cary, "Women Painters in Two Exhibits, a Question Ages Old: Socrates Introduces New Work Placed on View Here by Two Women's Groups," *New York Times*, April 15, 1928. Clipping in Theresa Bernstein Vertical File, National Museum of American Art, Smithsonian Institution, Washington, D.C. Cary writes that any question about the presumed femininity or masculinity of an artist's work is "futile and uninteresting, since in any exhibition worthy of comment it is the individualities that count, and individualities differ as much in the one sex as in the other."

129. Rosenberg, *Beyond Separate Spheres*, 114–46.

130. Tarbell, *William and Marguerite Zorach*, 18.

EPILOGUE

1. Leibold, "Photographic High Jinks at the Pennsylvania Academy of the Fine Arts," 3–7.

2. Ware, *Still Missing*, 160–67.

3. Gibson, *Abstract Expressionism*, and Leja, *Reframing Abstract Expressionism*, 253–68.

4. Quoted in Eleanor Munro, *Originals: American Women Artists* (New York: Simon and Schuster, 1979), 119, as reprinted in Robert Hobbs, *Modern Masters*, 100. On Krasner's deliberate unwillingness to fix her artistic approach, see Hobbs, *Lee Krasner*, 104–5; Wagner, *Three Artists (Three Women)*; and Wagner, "Lee Krasner as L. K.," 42–56.

BIBLIOGRAPHY

MANUSCRIPT COLLECTIONS

Boston, Massachusetts
School of The Museum of Fine Arts
 Museum School Records

New York, New York
National Association of Women Artists, New York
 National Association of Women Artists Archives

Northampton, Massachusetts
Sophia Smith Collection, Smith College
 Bush-Brown Family Papers
 Hale Family Papers

Washington, D.C.
Archives of American Art, Smithsonian Institution
 Art Students League Records
 Babcock Galleries Exhibition Catalogs
 Elizabeth Gardner Bouguereau Papers
 Bourgeois Galleries Exhibition Catalogs
 Brummer Gallery Exhibition Catalogs
 Catherine Lorillard Wolfe Art Club Records
 Gabrielle de Veaux Clements Papers
 Daniel Gallery Exhibition Catalogs
 Thomas Wilmer Dewing and Dewing Family Papers
 Doll and Richards Records
 Downtown Gallery Papers
 Frank and Elizabeth Boott Duveneck Papers
 Frank Duveneck Papers
 Emmet Family Papers
 Richard Watson and Helena de Kay Gilder Papers

Grand Central Art Galleries Records
Eliza Haldeman Correspondence
Hale Family Papers
Laura Coombs Hills Papers
Charles M. Kurtz Papers
Ladies' Art Association Records
Rose Lamb Papers
Blanche Lazzell Papers
Macbeth Gallery Records
Macdowell Club Exhibition Catalogs
William Meyerowitz and Theresa F. Bernstein Papers
Milch Gallery Records
Montross Gallery Exhibition Catalogs
Newman Galleries Photographs and Printed Material
New York Etching Club Records
Marie Danforth Page Papers
Pen and Brush Club Records
Pennsylvania Academy of the Fine Arts Records
People's Art Guild Records
Jane Peterson Papers
Philadelphia Society of Etchers Records
Plastic Club Records
Julius Rauzin Papers
Margaret Redmond Papers
Mary Fanton Roberts Papers
Sartain Family Papers
Edwin C. Shaw Papers — Correspondence with Maria Oakey Dewing
Smith Family Papers — Mary Smith
Alice Barber Stephens Papers
Vose Galleries of Boston Records
Zorach Family Papers
Library of Congress, Manuscript Division
William Zorach Papers

PRIMARY SOURCES

Allen, Grant. "Woman's Intuition." *Forum* 9 (May 1890): 333–40.
"American Painters." *Appleton's Journal*, n.s., 6 (January 1879): 85–87.
"Art and Artists in New York." Pts. 2–9. *Independent* 33 (March–May 1881).
"Art and Art-Life in New York." *Lippincott's Magazine* 29 (June 1882): 597–605.
"Art as a Steady Diet." *Scribner's Monthly* 17 (January 1879): 438–39.

"Art in America." *American Architect and Building News* 64 (June 3, 1899): 77–78.

"Art-Rivalry with Europe." *Critic* 10 (May 21, 1881): 138.

"The Art Season." *Scribner's Monthly* 20 (June 1880): 312–16.

"Art-Work for Women." *Art-Journal* 34 (March 1, 1872; April 1, 1872; May 1, 1872): 65–66, 102–3, 129–31.

Aylward, Emily Meredith. "The American Girls' Art Club in Paris." *Scribner's Magazine* 16 (November 1894): 598–605.

Barnes, Earl. "The Feminizing of Culture." *Atlantic Monthly* 109 (June 1912): 770–76.

Beaux, Cecilia. *Background with Figures.* New York: Houghton Mifflin, 1930.

———. "Professional Art Schools." *Art and Progress* 7 (November 1915): 3–8.

———. "What Should the College A.B. Course Offer to the Future Artist?" *American Magazine of Art* 7 (October 1916): 479–84.

———. "Why the Girl Art Student Fails." *Harper's Bazaar* 47 (May 1913): 221, 249.

Belloc, Marie Adelaide. "Lady Artists in Paris." *Murray's Magazine* 8 (September 1890): 371–84.

Benjamin, S. G. W. "American Art since the Centennial." *New Princeton Review,* n.s., 4 (July 1887): 14–30.

———. *Art in America: A Critical and Historical Sketch.* 1880. Reprint. New York: Garland Publishing, 1976.

———. "Present Tendencies of American Art." *Harper's New Monthly Magazine* 58 (March 1879): 481–96.

Bernstein Meyerowitz, Theresa. *The Journal.* New York: Cornwall Books, 1991.

Bishop, William H. "Young Artists' Life in New York." *Scribner's Monthly* 19 (January 1880): 355–68.

Boston Art Students Association. *The Art Student in Paris.* Boston, 1887.

Brownell, William C. "The Art Schools of New York." *Scribner's Monthly* 16 (October 1878): 761–81.

———. "The Art Schools of Philadelphia." *Scribner's Monthly* 18 (September 1879): 737–50.

———. "Recent Work of Elihu Vedder." *Scribner's Magazine* 17 (February 1895): 156–64.

———. "The Younger Painters of America.—First Paper." *Scribner's Monthly* 20 (May 1880): 1–15.

———. "The Younger Painters of America.—Second Paper." *Scribner's Monthly* 20 (July 1880): 321–35.

———. "The Younger Painters of America.—III." *Scribner's Monthly* 22 (July 1881): 321–34.

Butler, George. "Portrait Art, by a Portrait Painter." *Scribner's Magazine* 27 (January 1900): 125–28.

Caffin, Charles. "Some American Portrait Painters." *Critic* 44 (January 1904): 31–48.

Carter, Susan N. "Women in the Field of Art Work." *North American Review* 155 (September 1892): 381–84.

Champney, Elizabeth W. "Woman in Art." *Quarterly Illustrator* 2 (April–June 1894): 111–24.

Chase, William Merritt. "Women's Chances as Bread-Winners: Women in Art: From an Artist's View." *Ladies Home Journal* 8 (December 1891): 37.

"Commerce in Art." *New York Times*, February 26, 1882, 6.

Conger-Kaneko, Josephine. "The 'Effeminization' of the United States: The Dominant Influence of Women in Education, in Culture, in Social Life, and How It Has Affected American Character." *World's Work* 12 (May 1906): 7521–24.

Cook, Clarence T. "Art in America in 1883." *Princeton Review* 59 (May 1883): 311–20.

———. "Some Present Aspects of Art in America." *Chautauquan* 23 (August 1896): 593–602.

Cox, Louise. "Louise Cox at the Art Students League: A Memoir." *Archives of American Art Journal* 27 (1987): 12–20.

———. "Should Woman Artists Marry." *Limner* 1 (May 1895): 6–7.

Craik, Dinah. *A Woman's Thoughts about Women.* New York: John Bradburn, 1866.

"Culture under Fire." *Nation* 91 (September 22, 1910): 258–59.

Cummings, Thomas S. *Historic Annals of the National Academy of Design.* 1865. Reprint. New York: Kennedy Galleries and DaCapo Press, 1968.

D. S. M. "Women Artists." *Living Age* 220 (March 18, 1899): 730–32.

Day, Lewis F. "Artist and Artisan." *Magazine of Art* 9 (May 1886): 294–95.

———. "The Profession of Art." *Magazine of Art* 9 (January 1886): 122–23.

de Forest, Katharine. "Art Student Life in Paris." *Harper's Bazaar* 33 (July 1900): 628–32.

"Do You Strive to Capture the Symbols of Your Reactions? If Not You Are Quite Old Fashioned." *New York Evening Sun*, February 13, 1917, 10.

Durand, J. "The American School of Art." *New Princeton Review*, n.s., 6 (September 1888): 236–47.

E. S. "The Society of American Artists — The Modern Tendency." *Nation* 30 (April 1, 1880): 258.

Eaton, Walter Prichard. "Lydia Field Emmet — A Sincere Painter." *Delineator* 77 (February 1911): 89, 149.

Ellet, Elizabeth. *Women Artists in All Ages and Countries.* New York: Harper and Brothers, 1859.

"Emily Sartain, Artist." *Woman's Progress* 2 (October 1893): 1–8.

Ford, Sheridan. *Art: A Commodity.* 2d ed. New York: Rogers & Sherwood, 1888.

"Greatness in Art." *Scribner's Monthly* 16 (August 1878): 586–87.

Greene, Alice. "The Girl Student in Paris." *Magazine of Art* 6 (1883): 286–87.

Greta. "Boston Correspondence." *Art Amateur* 2 (February 1880): 48–49.

———. "Boston Correspondence." *Art Amateur* 2 (May 1880): 118–20.

Harwood, W. S. "The Art Schools of America." *Cosmopolitan* 18 (November 1894): 27–34.

Henri, Robert. "Progress in Our National Art Must Spring from the Development of Individuality of Ideas and Freedom of Expression: A Suggestion for a New Art School." *Craftsman* 15 (January 1909): 387–401.

Hoeber, Arthur. "Famous American Women Painters." *Mentor* 2 (March 16, 1914): 1–11.

Holland, Clive. "Lady Art Students' Life in Paris." *International Studio* 12 (January 1904): 225–33.

———. "Student Life in the Quartier Latin, Paris." *International Studio* 18 (November 1902): 33–40.

Hooper, Lucy W. "Art Schools of Paris." *Cosmopolitan* 14 (November 1892): 59–62.

Humphreys, Mary Gay. "Women Bachelors in New York." *Scribner's Magazine* 20 (November 1896): 626–36.

Ingersoll, Robert G. "Art and Morality." *North American Review* 146 (March 1888): 318–26.

J. R. T. "Means of Fostering American Art." *Lippincott's Magazine* 30 (August 1882): 208–11.

———. "On the Popular Appreciation of Art." *Lippincott's Magazine* 28 (October 1881): 418–20.

King, Pauline. "American Miniature Painting." *Century Magazine* 60 (October 1900): 820–30.

Kobbe, Gustav. "American Art Coming into Its Own." *Forum* 27 (May 1899): 297–302.

Koehler, Sylvester Rosa. *The United States Art Directory and Year-Book.* 1882. Reprint. New York: Garland Publishing, 1976.

Laffan, W. McKay, and Edward Strahan. "The Tile Club Afloat." *Scribner's Monthly* 21 (March 1880): 641–71.

Larned, Walter Cranston. "Millet and Recent Criticism." *Scribner's Magazine* 8 (September 1890): 390–92.

Lathrop, George Parsons. "The Progress of Art in New York." *Harper's New Monthly Magazine* 86 (April 1893): 740–52.

Laurvik, J. Nilsen. "The Annual Exhibition of the Pennsylvania Academy of the Fine Arts." *International Studio* 34 (March 1908): xxxi–xxxvi.

Leonard, John William, ed. *Woman's Who's Who of America, 1914–1915.* 1914. Reprint. Detroit: Gale Research Co., 1976.

Levy, Florence N. *American Art Annual.* Vol. 1. New York: Macmillan, 1899.

Linson, Corwin K. "With the Paris Art Student." *Frank Leslie's Popular Monthly* 34 (September 1892): 289–302.

Low, Will H., and Kenyon Cox. "The Nude in Art." *Scribner's Magazine* 12 (December 1892): 741–49.

McCabe, Lida Rose. "Some Painters Who Happen to Be Women." *Art World* 3 (March 1918): 488–93.

Mannes, Marya. "The Embroideries of Marguerite Zorach." *International Studio* 95 (March 1930): 29–33.

Mechlin, Leila. "Laura Coombs Hills." *American Magazine of Art* (September 1916): 458–61.

Merritt, Anna Lea. "A Letter to Artists: Especially Women Artists." *Lippincott's Monthly Magazine* 65 (1900): 463–69.

———. *Love Locked Out: The Memoirs of Anna Lea Merritt with a Checklist of Her Works.* Edited by Galina Gorokhoff. Boston: Museum of Fine Arts, 1982.

Merwin, Henry Childs. "On Being Civilized Too Much." *Atlantic Monthly* 79 (June 1897): 836–46.

Millet, F. D. "Mr. Hunt's Teaching." *Atlantic Monthly* 46 (August 1880): 189–92.

———. "What Are Americans Doing in Art?" *Century Magazine* 43 (November 1891): 46–49.

"Miss Emily Sartain." *Beecher's Illustrated Magazine* 4 (July 1871): 287–92.

Montgomery, Walter, ed. *American Art and American Art Collections.* 2 vols. Boston: E. W. Walker, 1889.

"Morals in Art and Literature. [Editor's Table]." *Appleton's Journal,* n.s., 3 (November 1877): 473–74.

Natt, Phebe D. "Paris Art Schools." *Lippincott's Magazine* 27 (March 1881): 269–76.

"A New Departure in American Art." *Harper's New Monthly Magazine* 56 (April 1878): 764–68.

"New York Women Artists Open Their Annual." *Art Digest,* January 1, 1936, 16.

Nieriker, May Alcott. *Studying Art Abroad and How to Do It Cheaply.* Boston: Roberts Brothers, 1879.

Nobili, M. Riccardo. "The Académie Julian." *Cosmopolitan* 8 (April 1890): 746–52.

Oakey, Maria R. "William Morris Hunt." *Harper's New Monthly Magazine* 61 (July 1880): 161–66.

O'Keeffe, Georgia. *Georgia O'Keeffe.* New York: Viking Press, 1976.

"Painting as a Profession for Women." *Godey's Lady's Book* (July 1871): 87.

Palgrave, F. T. "Women and the Fine Arts." *Macmillan's Magazine* 12 (May, October 1865): 118–27, 209–21.

Partridge, William Ordway. "Manhood in Art." *New England Magazine,* n.s., 9 (November 1893): 281–88.

Peirce, H. Winthrop. *The History of the School of the Museum of Fine Arts, Boston, 1877–1927.* Boston: T. O. Metcalf Co., 1930.

Pène du Bois, Guy. "The Essentially Feminine Art of Lydia F. Emmet." *Arts and Decoration* 2 (October 1912): 1–4.

Pennell, Elizabeth Robins. "Art and Women." *Nation* 106 (June 1, 1918): 663–64.

Peterson, Alice Fessenden. "The American Art Student in Paris." *New England Magazine,* n.s., 2 (August 1890): 669–76.

"Pettiness in Art." *Scribner's Monthly* 20 (May 1880): 146.

"The Picture of Commerce." *Harper's Weekly* 33 (May 18, 1889): 403.

"The Pictures at Goupil's." *Independent* 33 (February 10, 1881, and February 17, 1881): 9, 9.

"The Progress of Painting in America." *North American Review* 124 (May 1877): 451–64.

Randall, E. A. "The Artistic Impulse in Man and Woman." *Arena* 24 (October 1900): 415–20.

Read, Helen Appleton, "Women's Art Not Necessarily Feminine. New Group Demonstrates." *Brooklyn Eagle,* April 26, 1926.

"The Rewards of Painters." *New York Times,* October 1, 1882, 8.

Roberts, Mary Fanton [Giles Edgerton, pseud.]. "Is There a Sex Distinction in Art?:

The Attitude of the Critic toward Women's Exhibits." *Craftsman* 14 (June 1908): 239–50.

———. "The Quality of Woman's Art Achievement." *Craftsman* 15 (December 1908): 292–98.

Rowland, Geraldine. "The Study of Art in Paris." *Harper's Bazaar* 36 (September 1902): 756–61.

Saint-Gaudens, Homer. "Cecilia Beaux." *Critic* 47 (July 1905): 38–39.

———. "Modern American Miniature Painters." *Critic* 47 (December 1905): 517–29.

Scott, Leader. "Women at Work: Their Functions in Art." *Magazine of Art* 7 (1884): 98–99.

Seawell, Molly Elliott. "On the Absence of the Creative Faculty in Women." *Critic* 19 (November 29, 1891): 292–94.

Sheldon, George W. *American Painters, Enlarged Edition.* 1881. Reprint. New York: Benjamin Blom, 1972.

Shinn, Earl. "A Philadelphia Art School." *Art Amateur* 10 (January 1884): 32–34.

Slusser, Jean Paul. "Modernistic Pictures Done in Wool: A Note on the Quaint Embroideries of the Zorachs." *Arts and Decoration* 18 (January 1923): 30.

"Some Lady Artists of New York." *Art Amateur* 3 (July 1880): 27–29.

Somerville, E. O. "An 'Atelier Des Dames.'" *Magazine of Art* 9 (February 1886): 152–57.

Sparrow, Walter Shaw, ed. *Women Painters of the World.* 1905. Reprint. New York: Hacker Art Books, 1976.

Stillman, William James. "The Revival of Art." *Atlantic Monthly* 70 (August 1892): 248–61.

Sutherland, J. "An Art Student's Year in Paris." *Art Amateur* 32 (January–March 1895): 52, 86, 108.

Swift, Samuel. "Revolutionary Figures in American Art." *Harper's Weekly Magazine* 51 (April 13, 1907): 534–36.

"T." "The Disciples of William Morris Hunt." *Art Amateur* 13 (July 1885): 41.

"The Tapestries of Marguerite Zorach." *Design* 38 (June 1936): 3–7.

"'Tapestry Paintings' Shown by Mrs. Zorach." *Art Digest,* November 1, 1935, 14.

Two Brothers. "Art and the Woman." *Macmillan's Magazine* 83 (November 1900): 29–34.

"Two Views of Marie Bashkirtseff." *Century Magazine* 40 (May 1890): 28–32.

Van Brunt, Henry. "The Columbian Exposition and American Civilization." *Atlantic Monthly* 71 (May 1893): 577–88.

Van Dyke, John C. "Suggestiveness in Art." *New Englander and Yale Review* 50 (January 1889): 29–42.

Van Rensselaer, Mariana Griswold. "The Philadelphia Exhibition." Pts. 1, 2. *American Architect and Building News* 8 (December 11, 1880, and December 25, 1880): 279–81, 303–4.

———. "Some Aspects of Contemporary Art." *Lippincott's Magazine* 22 (December 1878): 706–18.

Walton, William. "Cecilia Beaux." *Scribner's Magazine* 22 (October 1897): 477–85.

Ward, Lester F. "Genius and Woman's Intuition." *Forum* 9 (June 1890): 401–8.

Warner, Charles Dudley. "Editor's Drawer." *Harper's Magazine* 80 (May 1890): 972–73.

Waters, Clara Erskine Clement. *Women in the Fine Arts from the Seventh Century B.C. to the Twentieth Century A.D.* 1904. Reprint. New York: Hacker Art Books, 1974.

Weir, John F. "American Art: Its Progress and Prospects." *Princeton Review* 54 (May 1878): 815–29.

Wheeler, Candace. "Art Education for Women." *Outlook* 55 (January 2, 1897): 81–87.

White, Frank Linstow. "Younger American Women in Art." *Frank Leslie's Popular Monthly* 36 (November 1893): 538–44.

Whiteing, Richard. "The American Student at the Beaux-Arts." *Century Magazine* 23 (December 1881): 259–72.

"Woman at the Easel." *Woman's Journal* (November 25, 1871): 370.

"Woman's Position in Art." *Crayon* 8 (February 1861): 25–28.

"Women Art Students' Clubs." *Scribner's Magazine* 22 (July 1897): 127–29.

"Women of Leisure." *Century Magazine* 60 (August 1900): 632–33.

Wood, Beatrice. *I Shock Myself: The Autobiography of Beatrice Wood.* San Francisco: Chronicle Books, 1988.

Wright, Margaret Bertha. "Art Student Life in Paris." *Art Amateur* 3 (September 1880): 70–71.

———. "An Atelier Des Dames." *Lippincott's Magazine* 22 (July 1878): 21–29.

———. "Copyists at the Louvre." *Art Amateur* 2 (May 1880): 116–17.

Zorach, Marguerite. "Embroidery as Art." *Art in America* 44 (Fall 1956): 51.

SECONDARY SOURCES

Adelman, Seymour. *Susan Macdowell Eakins, 1851–1938.* Philadelphia: Pennsylvania Academy of the Fine Arts, 1973.

Adler, Kathleen, and Tamar Garb. *Berthe Morisot.* Ithaca, N.Y.: Cornell University Press, 1987.

The Advent of Modernism: Post-Impressionism and North American Art, 1900–1918. With essays by Peter Morrin, Judith Zilczer, and William C. Agee. Atlanta: High Museum of Art, 1986.

Altshuler, Bruce. *The Avant-Garde Exhibition: New Art in the Twentieth Century.* New York: Henry N. Abrams, 1994.

American Paintings at the High Museum of Art. With essays by Judy L. Larson, Donelson Hoopes, and Phyllis Peet. New York: Hudson Hills Press, 1994.

American Paradise: The World of the Hudson River School. With an introduction by John K. Howat. New York: Metropolitan Museum of Art, 1987.

The American Renaissance, 1876–1917. Brooklyn, N.Y.: Brooklyn Museum, 1979.

Anne Goldthwaite: Memorial Exhibition. New York: M. Knoedler and Co., 1944.

Anscombe, Isabelle. *A Woman's Touch: Women in Design from 1860 to the Present Day.* New York: Penguin Books, 1985.

Antler, Joyce. "The Educated Woman and Professionalization: The Struggle for a New

Feminine Identity, 1890–1920." Ph.D. diss., State University of New York at Stony Brook, 1977.

Aronson, Julie. "Bessie Potter Vonnoh (1872–1955) and Small Bronze Sculpture in America." Ph.D. diss., University of Delaware, 1995.

Baigell, Matthew. *A Concise History of American Painting and Sculpture.* New York: Harper and Row, 1984.

Bailey, Elizabeth Graham. "The Cecilia Beaux Papers." *Archives of American Art Journal* 13 (1973): 14–19.

Barker, Deborah Ellen. "Painting Women: The Woman Artist in Nineteenth Century American Fiction." Ph.D. diss., Princeton University, 1991.

Battersby, Christine. *Gender and Genius: Towards a Feminist Aesthetics.* Bloomington: Indiana University Press, 1989.

Bederman, Gail. *Manliness and Civilization: A Cultural History of Gender and Race in the United States, 1880–1917.* Chicago: University of Chicago Press, 1995.

Bender, Thomas. *New York Intellect: A History of Intellectual Life in New York City, from 1750 to the Beginnings of Our Own Time.* Baltimore: Johns Hopkins University Press, 1987.

Benjamin, Walter. "The Work of Art in the Age of Mechanical Reproduction." In *Illuminations,* edited by Hannah Arendt, 217–51. New York: Schocken Books, 1969.

Berman, Avis. *Rebels on Eighth Street: Juliana Force and the Whitney Museum of American Art.* New York: Macmillan, 1990.

Bermingham, Peter. *American Art in the Barbizon Mood.* Washington, D.C.: Smithsonian Institution Press for the National Collection of Fine Arts, 1975.

Bienenstock, Jennifer A. "The Formation and Early Years of the Society of American Artists, 1877–1884." Ph.D. diss., City University of New York, 1983.

Blair, Karen J. *The Clubwoman as Feminist: True Womanhood Redefined, 1868–1914.* New York: Holmes and Meier, 1980.

———. *The Torchbearers: Women and Their Amateur Arts Associations in America, 1890–1930.* Bloomington: Indiana University Press, 1994.

Blanchard, Mary W. "Boundaries and the Victorian Body: Aesthetic Fashion in Gilded Age America." *American Historical Review* 100 (February 1995): 21–50.

———. "Oscar Wilde's America: The Aesthetic Movement and the Hidden Life of the Gilded Age, 1876–1893." Ph.D. diss., Rutgers, The State University of New Jersey, 1994.

———. *Oscar Wilde's America: Counterculture in the Gilded Age.* New Haven: Yale University Press, 1998.

Blaugrund, Annette. *The Tenth Street Studio Building: Artist-Entrepreneurs from the Hudson River School to the American Impressionists.* Southampton, N.Y.: Parrish Art Museum, 1997.

Bledstein, Burton J. *The Culture of Professionalism: The Middle Class and the Development of Higher Education in America.* New York: W. W. Norton, 1976.

Bloemink, Barbara J. *The Life and Art of Florine Stettheimer.* New Haven: Yale University Press, 1995.

Blumin, Stuart M. *The Emergence of the Middle Class: Social Experience in the American City, 1760–1900.* New York: Cambridge University Press, 1989.

Bogart, Michele. "Artistic Ideals and Commercial Practices: The Problem of Status for American Illustrators." *Prospects* 15 (1990): 225–81.

———. *Artists, Advertising, and the Borders of Art.* Chicago: University of Chicago Press, 1995.

Bohan, Ruth L. *The Société Anonyme's Brooklyn Exhibitions: Katherine Dreier and Modernism in America.* Ann Arbor, Mich.: UMI Research Press, 1982.

Boime, Albert. *The Academy and French Painting in the Nineteenth Century.* London: Phaidon, 1971.

———. *The Magisterial Gaze: Manifest Destiny and American Landscape Painting, c. 1830–1865.* Washington, D.C.: Smithsonian Institution Press, 1991.

Bolger, Doreen. *American Pastels in the Metropolitan Museum of Art.* New York: Metropolitan Museum of Art, 1989.

Boris, Eileen. *Art and Labor: Ruskin, Morris, and the Craftsman Ideal in America.* Philadelphia: Temple University Press, 1986.

Bradbury, Malcolm, and James McFarlane, eds. *Modernism, 1890–1930.* New York: Penguin Books, 1976.

Breeskin, Adelyn Dohme. *Anne Goldthwaite: A Catalogue Raisonné of the Graphic Work.* Montgomery, Ala.: Montgomery Museum of the Fine Arts, 1982.

Broun, Elizabeth. *Albert Pinkham Ryder.* Washington, D.C.: Smithsonian Institution Press, 1989.

Brown, Ann Barton. *Alice Barber Stephens: A Pioneer Woman Illustrator.* Chadds Ford, Pa.: Brandywine River Museum, 1984.

Brown, Milton. *American Painting from the Armory Show to the Depression.* Princeton: Princeton University Press, 1955.

———. *The Story of the Armory Show.* 2d ed. New York: Abbeville Press, 1988.

Brumberg, Joan Jacobs, and Nancy Tomes. "Women in the Professions: A Research Agenda for American Historians." *Reviews in American History* 10 (June 1982): 275–96.

Bryant, Keith L., Jr. *William Merritt Chase: A Genteel Bohemian.* Columbia: University of Missouri Press, 1991.

Burke, Doreen Bolger. *In Pursuit of Beauty: Americans and the Aesthetic Movement.* New York: Metropolitan Museum of Art and Rizzoli, 1986.

———. *J. Alden Weir: An American Impressionist.* New York: Cornwall Books, 1983.

Burke, Mary Alice Heekin. *Elizabeth Nourse, 1859–1938: A Salon Career.* Washington, D.C.: Smithsonian Institution Press, 1983.

Burnham, Patricia M. "Theresa Bernstein." *Woman's Art Journal* 9 (Fall 1988/Winter 1989): 22–27.

Burns, Sarah. "The 'Earnest, Untiring Worker' and the Magician of the Brush: Gender Politics in the Criticism of Cecilia Beaux and John Singer Sargent." *Oxford Art Journal* 15 (1992): 36–53.

————. *Inventing the Modern Artist: Art and Culture in Gilded Age America.* New Haven: Yale University Press, 1996.

————. "Old Maverick to Old Master: Whistler in the Public Eye in Turn-of-the-Century America." *American Art Journal* 22 (1990): 28–49.

————. *Pastoral Inventions: Rural Life in Nineteenth-Century American Art and Culture.* Philadelphia: Temple University Press, 1989.

Carnes, Mark, and Clyde Griffen, eds. *Meanings for Manhood: Constructions of Masculinity in Victorian America.* Chicago: University of Chicago Press, 1990.

Carr, Carolyn Kinder, and Sally Webster. "Mary Cassatt and Mary Fairchild MacMonnies: The Search for Their 1893 Murals." *American Art* 8 (Winter 1994): 52–69.

Chadbourne, Janice H., Karl Gabosh, and Charles O. Vogel, eds. *The Boston Art Club: Exhibition Record, 1873–1909.* Madison, Conn.: Sound View Press, 1991.

Chadwick, Whitney. *Women, Art, and Society.* London: Thames and Hudson, 1990.

Chauncey, George. *Gay New York: Gender, Urban Culture, and the Making of the Gay Male World, 1890–1940.* New York: Basic Books, 1994.

Chave, Anna C. "O'Keeffe and the Masculine Gaze." *Art in America* 78 (January 1990): 115–24, 177–79.

Cherry, Deborah. *Painting Women: Victorian Women Artists.* New York: Routledge, 1993.

Chesterton, Laura Prieto. "A Cultural History of Professional Women Artists in the United States, 1830–1930." Ph.D. diss., Brown University, 1998.

Chiarmonte, Paula. *Women Artists in the United States: A Selective Bibliography and Resource Guide to the Fine and Decorative Arts, 1750–1986.* Boston: G. K. Hall, 1990.

Cikovsky, Nicolai, Jr. "William Merritt Chase's Tenth Street Studio." *Archives of American Art Journal* 16 (1976): 2–14.

Clark, Eliot. *History of the National Academy of Design, 1825–1953.* New York: Columbia University Press, 1954.

Cliffe, Roger. *Scottish Colourists: Cadell, Fergusson, Hunter, Peploe.* London: John Murray, 1989.

Collin, Richard H. "Public Collections and Private Collectors." Review essay. *American Quarterly* 46 (September 1994): 448–61.

Colour, Rhythm, and Dance: Paintings and Drawings by J. D. Fergusson and His Circle in Paris. Edinburgh: John Swan and Sons, 1985.

Constable, William George. *Art Collecting in the United States of America: An Outline of a History.* New York: Nelson, 1964.

Cook, Blanche Wiesen. "Female Support Networks and Political Activism: Lillian Wald, Crystal Eastman, Emma Goldman." *Chrysalis* 3 (1977): 43–61.

Cooper, Helen A. *Winslow Homer Watercolors.* New Haven: Yale University Press, 1986, for the National Gallery of Art, Washington, D.C.

Corn, Wanda. "Apostles of the New American Art: Waldo Frank and Paul Rosenfeld." *Arts Magazine* 54 (February 1980): 159–63.

————. *The Color of Mood: American Tonalism, 1880–1910.* San Francisco: M. H. de Young Memorial Museum, 1972.

————. *The Great American Thing: Modern Art and National Identity.* Berkeley: University of California Press, 1999.

————, ed. *Cultural Leadership in America: Art Matronage and Patronage.* Boston: Isabella Stewart Gardner Museum, 1997.

Cott, Nancy F. *The Grounding of Modern Feminism.* New Haven: Yale University Press, 1987.

Cowart, Jack, Juan Hamilton, and Sarah Greenough. *Georgia O'Keeffe: Art and Letters.* Washington, D.C.: National Gallery of Art, 1987.

Crane, Diana. *The Transformation of the Avant-Garde: The New York Art World, 1940–1985.* Chicago: University of Chicago Press, 1987.

Crunden, Robert M. *American Salons: Encounters with European Modernism, 1885–1917.* New York: Oxford University Press, 1993.

Danly, Susan. *Facing the Past: Nineteenth-Century Portraits from the Collection of the Pennsylvania Academy of the Fine Arts.* New York and Philadelphia: American Federation of Arts and the Pennsylvania Academy of the Fine Arts, 1992.

Davidson, Abraham A. *Early American Modernist Painting, 1910–1935.* New York: Harper and Row, 1981.

Davies, Margery W. *Woman's Place Is at the Typewriter: Office Work and Office Workers, 1870–1930.* Philadelphia: Temple University Press, 1982.

Dawley, Alan. *Struggles for Justice: Social Responsibility and the Liberal State.* Cambridge: Harvard University Press, Belknap Press, 1991.

Dijkstra, Bram. *Georgia O'Keeffe and the Eros of Place.* Princeton: Princeton University Press, 1998.

Di Maggio, Paul. "Cultural Entrepreneurship in Nineteenth-Century Boston: The Creation of an Organizational Base for High Culture in America." Pts. 1, 2. *Media, Culture, and Society* 4 (1982): 33–50, 303–22.

Docherty, Linda Jones. "A Search for Identity: American Art Criticism and the Concept of the 'Native School,' 1876–1893." Ph.D. diss., University of North Carolina at Chapel Hill, 1985.

Doezema, Marianne. *George Bellows and Urban America.* New Haven: Yale University Press, 1992.

Douglas, Ann. *Terrible Honesty: Mongrel Manhattan in the 1920s.* New York: Farrar, Straus, and Giroux, 1995.

Drachman, Virginia. *Women Lawyers and the Origins of Professional Identity in America: The Letters of the Equity Club, 1877 to 1890.* Ann Arbor: University of Michigan Press, 1993.

Duncan, Carol. *The Aesthetics of Power: Essays in Critical Art History.* New York: Cambridge University Press, 1993.

Dwyer, Britta C. *Anna Klumpke: A Turn-of-the-Century Painter and Her World.* Boston: Northeastern University Press, 1999.

————. "Nineteenth-Century Regional Women Artists: The Pittsburgh School of Design for Women, 1865–1904." Ph.D. diss., University of Pittsburgh, 1989.

Echoes of New York: The Paintings of Theresa Bernstein. New York: Museum of the City of New York, November 20, 1990–March 31, 1991.

Efland, Arthur D. "Art and Education for Women in Nineteenth Century Boston."
 Studies in Art Education 26 (1985): 133–40.

———. *A History of Art Education: Intellectual and Social Currents in Teaching the Visual Arts.*
 New York: Teachers College Press, 1990.

Eisler, Benita. *O'Keeffe and Stieglitz: An American Romance.* New York: Doubleday, 1991.

Eldredge, Charles C. *Georgia O'Keeffe American and Modern.* New Haven: Yale University
 Press, 1993.

Elizabeth Boott Duveneck: Her Life and Times. Santa Clara, Calif.: Triton Museum of Art,
 January 28–April 1, 1979.

Ellen Day Hale, 1855–1940. New York: Richard York Gallery, 1981.

Epstein, Cynthia Fuchs. *Women in Law.* 2d ed. Chicago: University of Illinois Press, 1993.

Fairbrother, Trevor J., Theodore E. Stebbins Jr., William L. Vance, and Erica E.
 Hirshler. *The Bostonians: Painters of An Elegant Age, 1870–1930.* Boston: Museum of Fine
 Arts, 1986.

Falk, Peter Hastings, ed. *The Annual Exhibition Record of the Pennsylvania Academy of the Fine
 Arts, 1876–1913.* Vol. 2. Madison, Conn.: Sound View Press, 1989.

Faxon, Alicia. "Painter and Patron: Collaboration of Mary Cassatt and Louisine
 Havemeyer." *Woman's Art Journal* 3 (Fall 1982/Winter 1983): 15–20.

Fehrer, Catherine. *The Julian Academy: Paris, 1868–1939.* New York: Shepherd Gallery, 1989.

———. "New Light on the Académie Julian and Its Founder (Rodolphe Julian)."
 Gazette des beaux-arts 126 (May–June 1984): 207–16.

———. "Women at the Académie Julian in Paris." *Burlington Magazine* 136 (November
 1994): 752–57.

Felski, Rita. *The Gender of Modernity.* Cambridge: Harvard University Press, 1995.

Fidell-Beaufort, Madeleine. "Elizabeth Jane Gardner Bouguereau: A Parisian Artist
 from New Hampshire." *Archives of American Art Journal* 24 (1984): 2–9.

Fidell-Beaufort, Madeleine, and Jeanne K. Welcher. "Some Views of Art Buying in New
 York in the 1870s and 1880s." *Oxford Art Journal* 5 (1982): 48–55.

Fink, Lois Marie. *American Art at the Nineteenth-Century Paris Salons.* New York: Cambridge
 University Press for the National Museum of American Art, Smithsonian
 Institution, Washington, D.C., 1990.

———. "French Art in the United States, 1850–1870: Three Dealers and Collectors."
 Gazette des beaux-arts 92 (September 1978): 87–100.

Fink, Lois Marie, and Joshua Taylor. *Academy: The Academic Tradition in American Art.*
 Washington, D.C.: Smithsonian Institution Press, 1975.

Foster, Kathleen. "Makers of the American Watercolor Movement: 1860–1890." Ph.D.
 diss., Yale University, 1982.

Foster, Kathleen, and Cheryl Leibold. *Writing about Eakins: The Manuscripts in Charles Bregler's
 Thomas Eakins Collection.* Philadelphia: University of Pennsylvania Press, 1990.

Francis, Marilyn G. "Mary Nimmo Moran: Painter-Etcher." *Woman's Art Journal* 4 (Fall
 1983/Winter 1984): 14–19.

Freedman, Estelle. "Separatism as Strategy: Female Institution Building and American Feminism, 1870–1930." *Feminist Studies* 5 (Fall 1979): 512–29.

Frelinghuysen, Alice Cooney. *Splendid Legacy: The Havemeyer Collection.* New York: Metropolitan Museum of Art, 1993.

Gallati, Barbara Dayer. *William Merritt Chase.* New York: Henry N. Abrams, in association with the National Museum of American Art, 1995.

Garb, Tamar. "'L'Art Feminin': The Formation of A Critical Category in Late Nineteenth-Century France." *Art History* 12 (March 1989): 39–65.

———. "The Forbidden Gaze." *Art Journal* 79 (May 1991): 146–51, 186.

———. "Revising the Revisionists: The Formation of the Union des Femmes Peintres et Sculpteurs." *Art Journal* 48 (Spring 1989): 63–70.

———. *Sisters of the Brush: Women's Artistic Culture in Late Nineteenth-Century Paris.* New Haven: Yale University Press, 1994.

Garfinkle, Charlene G. "Lucia Fairchild Fuller's 'Lost' Woman's Building Mural." *American Art* 7 (Winter 1993): 2–7.

Garrison, Dee. *Apostles of Culture: The Public Librarian and American Society, 1876–1920.* New York: Free Press, 1979.

George de Forest Brush, 1855–1941: Master of the American Renaissance. New York: Berry-Hill Galleries, 1988.

Gerdts, William H. *American Impressionism.* New York: Abbeville Press, 1984.

———. *The White Marmorean Flock.* Poughkeepsie, N.Y.: Vassar College Art Museum, 1972.

Giboire, Clive, ed. *Lovingly Georgia: The Complete Correspondence of Georgia O'Keeffe and Anita Pollitzer.* New York: Simon and Schuster, 1990.

Gibson, Ann. *Abstract Expressionism: Other Politics.* New Haven: Yale University Press, 1997.

Gilbert, Sandra M., and Susan Gubar. *No Man's Land: The Place of the Woman Writer in the Twentieth Century.* Vol. 1: *The War of the Words.* New Haven: Yale University Press, 1988.

Glackens, Ira. *William Glackens and the Ashcan Group.* New York: Grosset and Dunlap, 1957.

Glazer, Penina Migdal, and Miriam Slater. *Unequal Colleagues: The Entrance of Women into the Professions, 1890–1940.* New Brunswick, N.J.: Rutgers University Press, 1987.

Goggin, Jacqueline. "Challenging Sexual Discrimination in the Historical Profession: Women Historians and the American Historical Association, 1890–1940." *American Historical Review* 97 (June 1992): 769–802.

Goodman, Helen. "Emily Sartain: Her Career." *Arts Magazine* 61 (May 1987): 61–65.

———. "The Plastic Club." *Arts Magazine* 59 (March 1985): 100–103.

Goodrich, Lloyd. *Thomas Eakins.* 2 vols. Cambridge: Harvard University Press for the National Gallery of Art, 1982.

Gordon, Lynn D. *Gender and Higher Education in the Progressive Era.* New Haven: Yale University Press, 1990.

Graham, Julie. "American Women Artists' Groups: 1867–1930." *Woman's Art Journal* 1 (Spring/Summer 1980): 7–12.

Green, Marcia Hyland. "Women Art Students in America: An Historical Study of

Academic Art Instruction during the Nineteenth Century." Ph.D. diss., American
University, 1990.

Green, Nicholas. "Circuits of Production, Circuits of Consumption: The Case of
Mid-Nineteenth-Century French Art Dealing." *Art Journal* 48 (Spring 1989): 29–34.

———. "Dealing in Temperaments: Economic Transformation of the Artistic Field in
France during the Second Half of the Nineteenth Century." *Art History* 10 (March
1987): 59–78.

Greer, Germaine. *The Obstacle Race: The Fortunes of Women Painters and Their Work.* New York:
Farrar, Straus, and Giroux, 1979.

Groseclose, Barbara S. "Painting, Politics, and George Caleb Bingham." *American Art
Journal* 10 (November 1978): 4–19.

Haber, Samuel. *The Quest for Authority and Honor in the American Professions, 1750–1900.*
Chicago: University of Chicago Press, 1991.

Hale, Nancy. *The Life in the Studio.* Boston: Little, Brown and Co., 1957.

Harris, Neil. *The Artist in American Society: The Formative Years, 1790–1860.* 1966. Reprint.
Chicago: University of Chicago Press, Phoenix Books, 1982.

———. *Cultural Excursions: Marketing Appetites and Cultural Tastes in Modern America.* Chicago:
University of Chicago Press, 1990.

———. "The Gilded Age Reconsidered Once Again." *Archives of American Art Journal* 23
(1983): 8–18.

———. "The Gilded Age Revisited: Boston and the Museum Movement." *American
Quarterly* 14 (Winter 1962): 545–66.

Haskell, Barbara. *The American Century: Art and Culture, 1900–1950.* New York: Whitney
Museum of Art, 1999.

Haskell, Thomas L., ed. *The Authority of Experts: Studies in History and Theory.* Bloomington:
Indiana University Press, 1984.

Helen M. Turner, N.A. (1858–1958): A Retrospective Exhibition. Cragsmoor, N.Y.: Cragsmoor
Free Library, 1983.

Heller, Adele, and Lois Rudnick, eds. *1915, the Cultural Moment: The New Politics, the New
Woman, the New Psychology, the New Art, and the New Theater in America.* New Brunswick,
N.J.: Rutgers University Press, 1991.

Heller, Jules, and Nancy G. Heller, eds. *North American Women Artists of the Twentieth Century:
A Biographical Dictionary.* New York: Garland, 1995.

Herbert, Robert L., Eleanor S. Apter, Elise K. Kenney, Ruth L. Bohan, and Rosalyn
Deutsche, eds. *The Société Anonyme and the Dreier Bequest at Yale University: A Catalogue
Raisonné.* New Haven: Yale University Press, 1984.

Higham, John. "The Reorientation of American Culture in the 1890s." In *Writing
American History: Essays on Modern Scholarship,* 73–102. Bloomington: Indiana University
Press, 1970.

Higonnet, Anne. *Berthe Morisot.* New York: Harper and Row, 1990.

Hirshler, Erica Eve. *Dennis Miller Bunker: American Impressionist.* Boston: Museum of Fine
Arts, 1994.

————. "Lilian Westcott Hale (1880–1963): A Woman Painter of the Boston School." Ph.D. diss., Boston University, 1992.

Hobbs, Robert. *Lee Krasner*. New York: Independent Curators International, in association with Harry N. Abrams, 1999.

————. *Modern Masters: Lee Krasner*. New York: Abbeville Press, 1993.

Hoffman, Marilyn Friedman. *William and Marguerite Zorach, the Cubist Years: 1915–1918*. Manchester, N.H.: Currier Gallery of Art, 1987.

Hoganson, Kristin L. *Fighting for American Manhood: How Gender Politics Provoked the Spanish-American and Philippine-American Wars*. New Haven: Yale University Press, 1998.

Homer, William Innes. *Alfred Stieglitz and the American Avant-Garde*. Boston: New York Graphic Society, 1977.

————. *Robert Henri and His Circle*. Ithaca, N.Y.: Cornell University Press, 1969.

Hoppin, Martha J. *The Emmets: A Family of Women Painters*. Pittsfield, Mass.: Berkshire Museum, 1982.

————. "Women Artists in Boston, 1870–1900: The Pupils of William Morris Hunt." *American Art Journal* 13 (Winter 1981): 17–46.

Hughes, Robert. *American Visions: The Epic History of Art in America*. New York: Alfred A. Knopf, 1997.

Husch, Gail E. "George Caleb Bingham's 'The County Election': A Whig Tribute to the Will of the People." *American Art Journal* 19 (1987): 4–22.

Hutton, John. "Picking Fruit: Mary Cassatt's *Modern Woman* and the Woman's Building of 1893." *Feminist Studies* 20 (Summer 1994): 318–48.

Huyssen, Andreas. "Mass Culture as Woman: Modernism's Other." In *After the Great Divide: Modernism, Mass Culture, Postmodernism*, 44–62. Bloomington: Indiana University Press, 1986.

In This Academy: The Pennsylvania Academy of the Fine Arts, 1805–1976. Philadelphia: Pennsylvania Academy of the Fine Arts, 1976.

Jacobs, Michael. *The Good and Simple Life: Artist Colonies in Europe and America*. London: Phaidon, 1985.

Jensen, Robert. *Marketing Modernism in Fin-de-Siècle Europe*. Princeton: Princeton University Press, 1994.

John La Farge. New York: Abbeville Press, 1987.

Johns, Elizabeth. *American Genre Painting: The Politics of Everyday Life*. New Haven: Yale University Press, 1991.

Joseph, J. Jonathan. *Jane Peterson: An American Artist*. Boston: Privately printed, 1981.

Kaplan, Amy. "Black and Blue on San Juan Hill." In *Cultures of United States Imperialism*, edited by Amy Kaplan and Donald E. Pease, 219–36. Durham, N.C.: Duke University Press, 1993.

Kasson, John. *Amusing the Million: Coney Island at the Turn of the Century*. New York: Hill and Wang, 1978.

Kimmel, Michael. *Manhood in America: A Cultural History*. New York: Free Press, 1996.

Kinnard, Cynthia D. "Mariana Griswold Van Rensselaer (1851–1934): America's First

Professional Woman Art Critic." In *Women as Interpreters of the Visual Arts, 1820–1979,* edited by Claire Richter Sherman and Adele M. Holcomb, 181–205. Westport, Conn.: Greenwood Press, 1981.

Kramer, Hilton. "Daniel Gallery Days: Recalling a Legendary Art Dealer and His World." *Art and Antiques* 16 (February 1994): 84–85.

Kryder, Lee Anne Giannone. "Self-Assertion and Social Commitment: The Significance of Work to the Progressive Era's New Woman." *Journal of American Culture* 6 (Summer 1983): 25–30.

Kunzel, Regina G. *Fallen Women, Problem Girls: Unmarried Mothers and the Professionalization of Social Work, 1890–1945.* New Haven: Yale University Press, 1993.

Landgren, Marchal E. *Years of Art: The Story of the Art Students League of New York.* New York: Robert M. McBride and Co., 1940.

Leader, Bernice Kramer. "Antifeminism in the Paintings of the Boston School." *Arts Magazine* 56 (January 1982): 112–19.

Lears, T. J. Jackson. *No Place of Grace: Antimodernism and the Transformation of American Culture, 1880–1920.* New York: Pantheon Books, 1981.

Leibold, Cheryl. "Photographic High Jinks at the Pennsylvania Academy of the Fine Arts." *Nineteenth Century* 12 (1993): 3–7.

Leja, Michael. *Reframing Abstract Expressionism: Subjectivity and Painting in the 1940s.* New Haven: Yale University Press, 1993.

Levine, Lawrence W. *Highbrow/Lowbrow: The Emergence of Cultural Hierarchy in America.* Cambridge: Harvard University Press, 1988.

Likos, Patt. "The Ladies of The Red Rose." *Feminist Art Journal* 5 (Fall 1976): 11–15.

Lilla Cabot Perry: A Retrospective Exhibition. New York: Hirschl and Adler Galleries, 1969.

Loughery, John. "Charles Caffin and Willard Huntington Wright, Advocates of Modern Art." *Arts Magazine* 59 (January 1985): 103–9.

———. "The *New York Sun* and Modern Art in America: Charles Fitzgerald, Frederick James Gregg, James Gibbons Huneker, Henry McBride." *Arts Magazine* 59 (December 1984): 77–82.

Lynes, Barbara Buhler. "Georgia O'Keeffe and Feminism: A Problem of Position." In *The Expanding Discourse: Feminism and Art History,* edited by Norma Broude and Mary D. Garrard, 436–49. New York: IconEditions, 1992.

———. *Georgia O'Keeffe: Catalogue Raisonné.* 2 vols. New Haven: Yale University Press, 1999.

———. *O'Keeffe, Stieglitz, and the Critics, 1916–1929.* Ann Arbor, Mich.: UMI Research Press, 1989.

McCarthy, Kathleen D. *Women's Culture: American Philanthropy and Art, 1830–1930.* Chicago: University of Chicago Press, 1991.

McCausland, Elizabeth. "The Daniel Gallery and Modern American Art." *Magazine of Art* 44 (November 1951): 280–85.

McClinton, Katharine M. *The Chromolithographs of Louis Prang.* New York: Crown Publishers, 1973.

McDonagh, Eileen L. "Profiles of Achievement: Women's Entry into the Professions, the Arts, and Social Reform." *Sociological Inquiry* 53 (Fall 1983): 343–67.

Marguerite Zorach: Cubism and Beyond. New York: Kraushaar Galleries, 1991.

Marling, Karal Ann, and Helen A. Harrison. *Seven American Women: The Depression Decade.* New York: Vassar College Art Gallery, 1976.

Marlor, Clark S. *The Salons of America, 1922–1936.* Madison, Conn.: Sound View Press, 1991.

———. *The Society of Independent Artists: The Exhibition Record, 1917–1944.* Park Ridge, N.J.: Noyes Press, 1984.

Marter, Joan M. "Three Women Artists Married to Early Modernists: Sonia Delaunay-Terk, Sophie Taüber-Arp, and Marguerite Thompson Zorach." *Arts Magazine* 54 (September 1979): 88–95.

Martin, Jennifer. "Portraits of Flowers: The Out-of-Door Still-Life Paintings of Maria Oakey Dewing." *American Art Review* 4 (December 1977): 48–57, 114–18.

———. "The Rediscovery of Maria Oakey Dewing." *Feminist Art Journal* 5 (Summer 1976): 24–27.

Martindale, Meredith. *Lilla Cabot Perry: An American Impressionist.* Washington, D.C.: National Museum of Women in the Arts, 1990.

Mary Cassatt: Modern Woman. Organized by Judith A. Barter. Chicago: Art Institute of Chicago in association with Harry N. Abrams, 1998.

Marzio, Peter C. *The Democratic Art: Pictures for a Nineteenth-Century America.* Boston: David R. Godine in association with the Amon Carter Museum of Western Art, Fort Worth, Tex., 1979.

Mathews, Nancy Mowll. *Cassatt and Her Circle: Selected Letters.* New York: Abbeville Press, 1984.

Melosh, Barbara. *"The Physician's Hand": Work Culture and Conflict in American Nursing.* Philadelphia: Temple University Press, 1982.

Miller, Angela. *The Empire of the Eye: Landscape Representation and American Cultural Politics, 1825–1875.* Ithaca, N.Y.: Cornell University Press, 1993.

Miller, David C., ed. *American Iconology: New Approaches to Nineteenth-Century Art and Literature.* New Haven: Yale University Press, 1993.

Miller, Lillian B. *Patrons and Patriotism: The Encouragement of the Fine Arts in the United States, 1790–1860.* Chicago: University of Chicago Press, 1966.

Milroy, Elizabeth. *Painters of a New Century: The Eight and American Art.* Milwaukee, Wis.: Milwaukee Art Museum, 1991.

Mitchell, Marilyn. "Sexist Art Criticism: Georgia O'Keeffe—A Case Study." *Signs* 3 (1978): 681–87.

Moldow, Gloria. *Women Doctors in Gilded-Age Washington: Race, Gender, and Professionalization.* Chicago: University of Illinois Press, 1987.

Morantz-Sanchez, Regina. *Conduct Unbecoming a Woman: Medicine on Trial in Turn-of-the-Century New York.* New York: Oxford University Press, 1999.

———. "Entering Male Professional Terrain: Dr. Mary Dixon Jones and the

Emergence of Gynecological Surgery in the Nineteenth-Century United States."
Gender and History 7 (August 1995): 201–21.

———. "The Gendering of Empathic Expertise: How Women Physicians Became
More Empathic than Men." In *The Empathic Practitioner: Empathy, Gender, and Medicine,*
edited by Ellen Singer More and Maureen A. Milligan, 39–58. New Brunswick, N.J.:
Rutgers University Press, 1994.

———. *Sympathy and Science: Women Physicians in American Medicine.* New York: Oxford
University Press, 1985.

Morgan, H. Wayne. *Keepers of Culture: The Art-Thought of Kenyon Cox, Royal Cortissoz, and
Frank Mather Jewett, Jr..* Kent, Ohio: Kent State University Press, 1989.

———. *New Muses: Art in American Culture, 1865–1920.* Norman: University of Oklahoma
Press, 1978.

———, ed. *An American Art Student in Paris: The Letters of Kenyon Cox, 1877–1882.* Kent,
Ohio: Kent State University Press, 1986.

Mott, Frank Luther. *A History of American Magazines.* Vols. 3, 4. Cambridge: Harvard
University Press, Belknap Press, 1957.

Muncy, Robyn. *Creating a Female Dominion in American Reform, 1890–1935.* New York:
Oxford University Press, 1991.

Nathanson, Carole. "Anne Estelle Rice: Theodore Dreiser's 'Ellen Adams Wrynn.' "
Woman's Art Journal 13 (Fall 1992/Winter 1993): 3–11.

Naumann, Francis. *New York Dada, 1915–23.* New York: Henry N. Abrams, 1994.

Naumann, Francis, and Beth Venn. *Making Mischief: Dada Invades New York.* New York:
Whitney Museum of American Art, 1996.

Nemerov, Alexander. *Frederic Remington and Turn-of-the-Century America.* New Haven: Yale
University Press, 1995.

1913 Armory Show: Fiftieth Anniversary Exhibition. Utica, N.Y.: Organized by Munson-
Williams-Proctor Institute; sponsored by the Henry Street Settlement,
1963.

Nochlin, Linda. *Women, Art, and Power and Other Essays.* New York: Harper and Row, 1988.

Norman, Dorothy. *Alfred Stieglitz: An American Seer.* New York: Random House, 1973.

Noun, Louise R. "Agnes Weinrich." *Woman's Art Journal* 16 (Fall 1995/Winter 1996): 10–15.

Novak, Barbara. *American Painting of the Nineteenth Century: Realism, Idealism, and the American
Experience.* 2d ed. New York: Harper and Row, 1979.

———. *Nature and Culture: American Landscape and Painting, 1825–1875.* New York: Oxford
University Press, 1980.

Oaklander, Christine I. "Clara Davidge's Madison Art Gallery: Sowing the Seed for the
Armory Show." *Archives of American Art Journal* 36 (1996): 20–37.

Ogren, Kathy. *The Jazz Revolution: Twenties America and the Meaning of Jazz.* New York: Oxford
University Press, 1989.

Oleson, Alexandra, and John Voss, eds. *The Organization of Knowledge in Modern America,
1860–1920.* Baltimore: Johns Hopkins University Press, 1979.

One Hundred Years: A Centennial Celebration of the National Association of Women Artists. With

essay by Ronald G. Pisano. Roslyn Harbor, N.Y.: Nassau County Museum of Fine Art, 1988.

Onorato, Ronald. "The Context of the Pennsylvania Academy: Thomas Eakins' Assistantship to Christian Schussele." *Arts Magazine* 53 (May 1979): 121–29.

———. "The Pennsylvania Academy of the Fine Arts and the Development of an Academic Curriculum in the Nineteenth Century." Ph.D. diss., Brown University, 1977.

Orr, Clarissa Campbell, ed. *Women in the Victorian Art World.* New York: Manchester University Press, distributed by St. Martin's Press, 1995.

Paine, Judith. "The Women's Pavilion of 1876." *Feminist Art Journal* 4 (Winter 1975/76): 5–12.

"A Painter's Family Album." *Victoria* (November 1990): 117–21.

The Paintings and Etchings of William Meyerowitz and Theresa Bernstein. Gloucester, Mass.: Cape Ann Historical Association, 1986.

Parker, Rozsika, and Griselda Pollock. *Old Mistresses: Women, Art, and Ideology.* New York: Pantheon Books, 1981.

Peet, Phyllis. *American Women of the Etching Revival.* Atlanta: High Museum of Art, 1988.

———. "The Emergence of American Women Printmakers in the Late Nineteenth Century." Ph.D. diss., University of California at Los Angeles, 1987.

Peiss, Kathy. *Cheap Amusements: Working Women and Leisure in Turn-of-the-Century New York.* Philadelphia: Temple University Press, 1986.

The Pennsylvania Academy and Its Women, 1850–1920. Philadelphia: Pennsylvania Academy of the Fine Arts, 1974.

Perry, Gill. *Women Artists and the Parisian Avant-Garde: Modernism and "Feminine" Art, 1900 to the Late 1920s.* New York: Manchester University Press, distributed by St. Martin's Press, 1995.

Peters, Sarah Whitaker. *O'Keeffe: The Early Years.* New York: Abbeville Press, 1991.

Petteys, Chris. *Dictionary of Women Artists: An International Dictionary of Women Artists Born before 1900.* Boston: G. K. Hall, 1985.

Philip Leslie Hale, A.N.A.. Boston: Vose Galleries of Boston, 1988.

Phillips, David. "Art for Industry's Sake: Halftone Technology, Mass Photography, and the Social Transformation of American Print Culture, 1880–1920." Ph.D. diss., Yale University, 1996.

Pilgrim, Dianne H. "The Revival of Pastels in Nineteenth-Century America: The Society of Painters in Pastel." *American Art Journal* 10 (November 1978): 43–62.

Pisano, Ronald G. *Henry and Edith Mitchill Prellwitz and the Peconic Art Gallery.* Stony Brook, N.Y.: Art Museum, Museums at Stony Brook, 1995.

———. *The Students of William Merritt Chase.* Huntington, N.Y.: Heckscher Museum, 1973.

Plagens, Peter. "The Critics: Hartmann, Huneker, DeCasseres." *Art in America* 61 (July/August 1973): 67–71.

Pollitzer, Anita. *A Woman on Paper: Georgia O'Keeffe.* New York: Touchstone, 1988.

Pollock, Griselda. *Mary Cassatt: Painter of Modern Women.* London: Thames and Hudson, 1998.

—. *Vision and Difference: Femininity, Feminism, and Histories of Art.* New York: Routledge, 1988.

Poovey, Mary. *Uneven Developments: The Ideological Work of Gender in Mid-Victorian England.* Chicago: University of Chicago Press, 1988.

Preato, Robert R. *The Genius of the Fair Muse: Painting and Sculpture: Celebrating Women Artists, 1875 to 1945.* New York: Grand Central Art Galleries, 1987.

Pyne, Kathleen. *Art and the Higher Life: Painting and Evolutionary Thought in Late Nineteenth-Century America.* Austin: University of Texas Press, 1996.

The Quest for Unity: American Art between World's Fairs, 1876–1893. Detroit: Detroit Institute of Arts, 1983.

Quick, Michael. *American Expatriate Painters of the Late Nineteenth Century.* Dayton, Ohio: Dayton Art Institute, 1976.

Radway, Janice A. *A Feeling for Books: The Book-of-the-Month Club, Literary Taste, and Middlebrow Desire.* Chapel Hill: University of North Carolina Press, 1997.

—. "On the Gender of the Middlebrow Consumer and the Threat of the Culturally Fraudulent Female." *South Atlantic Quarterly* 93 (Fall 1994): 871–93.

Radycki, J. Diane. "The Life of Lady Art Students: Changing Art Education at the Turn of the Century." *Art Journal* 42 (Spring 1982): 9–13.

Rewald, John. *The History of Impressionism.* 4th rev. ed. New York: Museum of Modern Art, 1973.

Reynolds, Gary A. *Irving R. Wiles.* New York: National Academy of Design, 1988.

Robertson, Bruce. *Reckoning with Winslow Homer: His Late Paintings and Their Influence.* Cleveland: Cleveland Museum of Art, 1990.

Rodgers, Theodore Robert. "Alfred Stieglitz, Duncan Phillips, and the $6,000 Marin." *Oxford Art Journal* 15 (1992): 54–66.

Rosenberg, Rosalind. *Beyond Separate Spheres: Intellectual Roots of Modern Feminism.* New Haven: Yale University Press, 1982.

Rosenzweig, Roy. *Eight Hours for What We Will: Workers and Leisure in an Industrial City, 1870–1930.* New York: Cambridge University Press, 1983.

Rossiter, Margaret W. *Women Scientists in America: Struggles and Strategies to 1940.* Baltimore: Johns Hopkins University Press, 1982.

Rotundo, E. Anthony. *American Manhood: Transformations in Masculinity from the Revolution to the Modern Era.* New York: Basic Books, 1993.

Rubin, Joan Shelley. *The Making of Middlebrow Culture.* Chapel Hill: University of North Carolina Press, 1992.

Rubinstein, Charlotte Streifer. *American Women Artists: From Early Indian Times to the Present.* Boston: G. K. Hall, 1982.

—. *American Women Sculptors: A History of Women Working in Three Dimensions.* Boston: G. K. Hall, 1990.

Rudnick, Lois Palken. *Mabel Dodge Luhan: New Woman, New Worlds.* Albuquerque: University of New Mexico Press, 1984.

Russett, Cynthia Eagle. *Sexual Science: The Victorian Construction of Womanhood.* Cambridge: Harvard University Press, 1989.

Saarinen, Aline B. *The Proud Possessors: The Lives, Times, and Tastes of Some Adventurous American Art Collectors.* New York: Random House, 1958.

Sandweiss, Martha A., ed. *Photography in Nineteenth-Century America.* New York: Harry N. Abrams, for the Amon Carter Museum, Fort Worth, Tex., 1991.

Satter, Beryl. *Each Mind a Kingdom: American Women, Sexual Purity, and the New Thought Movement, 1875–1920.* Berkeley: University of California Press, 1999.

Schapiro, Meyer. "The Introduction of Modern Art in America: The Armory Show." In *Modern Art, Nineteenth and Twentieth Centuries,* 135–178. New York: George Braziller, 1978.

Schneider, Rona. "The American Etching Revival: Its French Sources and Early Years." *American Art Journal* 14 (Autumn 1982): 40–65.

Scott, Anne Firor. *Natural Allies: Women's Associations in American History.* Urbana: University of Illinois Press, 1992.

Scott, Joan Wallach. *Gender and the Politics of History.* New York: Columbia University Press, 1988.

Sheehan, Roberta A. "Boston Museum School, a Centennial History: 1876–1976." Ph.D. diss., Boston College, 1983.

Simon, Robin. *The Portrait in Britain and America.* Boston: G. K. Hall, 1987.

Simoni, John P. "Art Critics and Criticism in Nineteenth-Century America." Ph.D. diss., Ohio State University, 1952.

Singal, Daniel Joseph. "Towards a Definition of American Modernism." *American Quarterly* 39 (Spring 1987): 7–26.

Skalet, Linda Henefield. "The Market for American Painting in New York, 1870–1915." Ph.D. diss., Johns Hopkins University, 1980.

Sklar, Kathryn Kish. "Hull House in the 1890s: A Community of Women Reformers." *Signs* 10 (1985): 658–77.

Sklar, Robert. *Movie-Made America: A Cultural History of American Movies.* Rev. ed. New York: Vintage Books, 1994.

Smart, Mary. "Sunshine and Shade: Mary Fairchild MacMonnies Low." *Woman's Art Journal* 4 (Fall 1983/Winter 1984): 20–25.

Smith-Rosenberg, Carroll. "The New Woman as Androgyne: Social Disorder and Gender Crisis, 1870–1936." In *Disorderly Conduct: Visions of Gender in Victorian America,* 245–96. New York: Oxford University Press, 1985.

Solomon, Barbara Miller. *In the Company of Educated Women: A History of Women and Higher Education in America.* New Haven: Yale University Press, 1985.

Stankiewicz, Mary Ann. "'The Eye Is a Nobler Organ': Ruskin and American Art Education." *Journal of Aesthetic Education* 18 (Summer 1984): 51–64.

Stansell, Christine. *American Moderns: Bohemian New York and the Creation of a New Century.* New York: Metropolitan Books, 2000.

Stein, Roger B. *John Ruskin and Aesthetic Thought in America, 1840–1900.* Cambridge: Harvard University Press, 1967.

Stott, Annette. "Floral Femininity: A Pictorial Definition." *American Art* 6 (Spring 1992): 61–77.

Susman, Warren. *Culture as History: The Transformation of American Society in the Twentieth Century.* New York: Pantheon Books, 1984.

Sussman, Elizabeth, and Barbara J. Bloemink. *Florine Stettheimer: Manhattan Fantastica.* New York: Whitney Museum of American Art, 1995.

Talbott, Page, and Patricia Tanis Sydney. *The Philadelphia Ten: A Women's Artist Group, 1917–1945.* Philadelphia: Galleries at Moore and American Art Review Press, 1998.

Tappert, Tara L. "Choices—The Life and Career of Cecilia Beaux: A Professional Biography." Ph.D. diss., George Washington University, 1990.

Tarbell, Roberta K. *Marguerite Zorach: The Early Years, 1908–1920.* Washington, D.C.: Smithsonian Institution Press for the National Collection of Fine Arts, 1973.

———. *William and Marguerite Zorach: The Maine Years.* Rockland, Maine: William A. Farnsworth Library and Art Museum, 1979.

Taylor, Joshua C. *The Fine Arts in America.* Chicago: University of Chicago Press, 1979.

Ten American Painters. New York: Spanierman Gallery, 1990.

Tepfer, Diane. "Edith Gregor Halpert and the Downtown Gallery Downtown, 1926–1940: A Study in American Art Patronage." Ph.D. diss., University of Michigan, 1989.

Theresa Bernstein. Stamford, Conn.: Smith-Girard, 1985.

Theresa Bernstein: Expressions of Cape Ann and New York, 1914–1972: A Centennial Exhibition. Stamford, Conn.: Stamford Museum and Nature Center and Smith-Girard, 1989.

Theresa Bernstein (1890–): A Seventy Year Retrospective. New York: Joan Whalen Fine Art, 1998.

Tickner, Lisa. "Men's Work?: Masculinity and Modernism." In *Visual Culture: Images and Interpretations,* edited by Norman Bryson, Michael Ann Holly, and Keith Moxey, 42–82. Hanover, N.H.: University Press of New England for Wesleyan University Press, 1994.

Todd, Ellen Wiley. *The "New Woman" Revised: Painting and Gender Politics on Fourteenth Street.* Berkeley: University of California Press, 1993.

Tomsich, John. *A Genteel Endeavor.* Stanford: Stanford University Press, 1971.

Trachtenberg, Alan. *The Incorporation of America: Culture and Society in the Gilded Age.* New York: Hill and Wang, 1982.

Troyen, Carol. *The Boston Tradition: American Paintings from the Museum of Fine Arts, Boston.* New York: American Federation of Arts, 1980.

Truettner, William H. *The West as America: Reinterpreting Images of the Frontier.* Washington, D.C.: Smithsonian Institution Press, 1991.

———. "William T. Evans, Collector of American Paintings." *American Art Journal* 3 (Fall 1971): 50–79.

Tufts, Eleanor. *American Women Artists, 1870–1930.* Washington, D.C.: National Museum of Women in the Arts, 1987.

Turner, Elizabeth Hutton. *Georgia O'Keeffe: The Poetry of Things.* Washington, D.C.: Phillips Collection, 1999.

Underwood, Sandra Lee. *Charles H. Caffin: A Voice for Modernism, 1897–1918.* Ann Arbor, Mich.: UMI Research Press, 1983.

Van Hook, Bailey. "Decorative Images of American Women: The Aristocratic Aesthetic of the Late Nineteenth Century." *Smithsonian Studies in American Art* 4 (Winter 1990): 45–69.

Wagner, Anne Middleton. "Lee Krasner as L. K." *Representations* 25 (Winter 1989): 42–56.

———. *Three Artists (Three Women): Modernism and the Art of Hesse, Krasner, and O'Keeffe.* Berkeley: University of California Press, 1996.

Waller, Susan. *Women Artists in the Modern Era: A Documentary History.* Metuchen, N.J.: Scarecrow Press, 1991.

Walls, Nina de Angeli. "Art and Industry in Philadelphia: Origins of the Philadelphia School of Design for Women, 1848 to 1876." *Pennsylvania Magazine of History and Biography* 117 (July 1993): 176–99.

———. "Art, Industry, and Women's Education: The Philadelphia School of Design for Women, 1848–1932." Ph.D. diss., University of Delaware, 1995.

———. "Educating Women for Art and Commerce: The Philadelphia School of Design, 1848–1932." *History of Education Quarterly* 34 (Fall 1994): 329–55.

Walsh, Mary Roth, *"Doctors Wanted: No Women Need Apply": Sexual Barriers in the Medical Profession, 1835–1975.* New Haven: Yale University Press, 1977.

Ware, Susan. *Still Missing: Amelia Earhart and the Search for Modern Feminism.* New York: W. W. Norton, 1993.

Watson, Steven. *Strange Bedfellows: The First American Avant-Garde.* New York: Abbeville Press, 1991.

Weaver, Jane Calhoun, ed. *Sadakichi Hartmann: Critical Modernist, Collected Art Writings.* Berkeley: University of California Press, 1991.

Weimann, Jeanne Madeline. *The Fair Women.* Chicago: Academy Chicago, 1981.

Wein, Jo Ann. "The Parisian Training of American Women Artists." *Woman's Art Journal* 2 (Spring/Summer 1981): 41–44.

Weinberg, H. Barbara. "Late-Nineteenth-Century American Painting: Cosmopolitan Concerns and Critical Controversies." *Archives of American Art Journal* 23 (1983): 19–26.

———. *The Lure of Paris: Nineteenth-Century American Painters and Their French Teachers.* New York: Abbeville Press, 1991.

———. "Thomas B. Clarke: Foremost Patron of American Art from 1872 to 1899." *American Art Journal* 8 (May 1976): 52–83.

Weinberg, H. Barbara, Doreen Bolger, and David Park Curry. *American Impressionism and*

Realism: The Painting of Modern Life, 1885–1915. New York: Metropolitan Museum of Art, 1994.

Weisberg, Gabriel P., and Jane R. Becker. *Overcoming All Obstacles: The Women of the Académie Julian*. New York: Dahesh Museum and Rutgers University Press, 1999.

Weiss, Jo Ann W. "Clarence Cook: His Critical Writings." Ph.D. diss., Johns Hopkins University, 1976.

Wexler, Victor G. "Creating a Market in American Art: The Contribution of the Macbeth Gallery." *Journal of American Studies* 25 (1991): 245–55.

White, Harrison, and Cynthia White. *Canvases and Careers: Institutional Change in the French Painting World*. New York: Wiley, 1965.

Wiebe, Robert H. *The Search for Order, 1877–1920*. New York: Hill and Wang, 1967.

Williams, Raymond. *Culture and Society: 1780–1950*. New York: Columbia University Press, 1958.

———. *The Politics of Modernism: Against the New Conformists*. New York: Verso, 1989.

Wilson, Richard Guy, Dianne H. Pilgrim, and Richard N. Murray. *The American Renaissance, 1876–1917*. Brooklyn, N.Y.: Brooklyn Museum, 1979.

Withers, Josephine. "Artistic Women and Women Artists." *Art Journal* 35 (Summer 1976): 330–36.

Wolf, Amy J. *New York Society of Women Artists, 1925*. New York: ACA Galleries, March 1–28, 1987.

Wolf, Bryan. "All the World's a Code: Art and Ideology in Nineteenth-Century American Painting." *Art Journal* 44 (Winter 1984): 328–37.

Wolff, Janet. *The Social Production of Art*. New York: New York University Press, 1993.

———. "Texts and Institutions: Problems of Feminist Criticism." In *Feminine Sentences: Essays on Women and Culture*, 103–19. Berkeley: University of California Press, 1990.

Wolff, Janet, and John Seed, eds. *The Culture of Capital: Art, Power, and the Nineteenth-Century Middle Class*. Manchester, England: Manchester University Press, 1988.

Wright, Helena E. *With Pen and Graver: Women Graphic Artists before 1900*. Washington, D.C.: Smithsonian Institution, 1995.

Wright, Lesley Carol. "Men Making Meaning in Nineteenth-Century American Genre Painting, 1860–1900." Ph.D. diss., Stanford University, 1993.

Young, Dorothy Weir. *The Life and Letters of J. Alden Weir*. New Haven: Yale University Press, 1960.

Yount, Sylvia. "'Give the People What They Want': The American Aesthetic Movement, Art Worlds, and Consumer Culture, 1876–1890." Ph.D. diss., University of Pennsylvania, 1995.

Zagarri, Rosemarie. "Morals, Manners, and the Republican Mother." *American Quarterly* 44 (June 1992): 192–215.

Zakian, Michael. *Agnes Pelton: Poet of Nature*. Palm Springs, Calif.: Palm Springs Desert Museum, 1995.

Zalesch, Saul E. "What the Four Million Bought: Cheap Oil Paintings of the 1880s." *American Quarterly* 48 (March 1996): 77–109.

Zilczer, Judith. *"The Noble Buyer": John Quinn Patron of the Avant Garde.* Washington, D.C.: Smithsonian Institution Press, 1978.

———. " 'The World's New Art Center': Modern Art Exhibitions in New York City, 1913–1918." *Archives of American Art Journal* 14 (1974): 2–7.

Zurier, Rebecca, Robert W. Snyder, and Virginia M. Mecklenburg. *Metropolitan Lives: The Ashcan Artists and Their New York.* Washington, D.C.: National Museum of American Art in association with W. W. Norton, 1995.

INDEX

Pages numbers in italics refer to illustrations.

Brooklyn Art Association, 75

Brown, Helen, 188

Brownell, William C., 15, 134, 136, 138, 140, 141, 150, 214 (n. 4)

Brush, George de Forest, 58, 85

Bryant, Harriet, 258 (n. 83)

Bryn Mawr School (Baltimore, Md.), 92

Bunker, Dennis Miller, 231 (n. 14)

Burne-Jones, Edward, 146

Bush-Brown, Margaret Lesley, 55, 66, 89, 93, 95–96, 96

Caffin, Charles, 143, 148, 171, 248 (n. 40)

Camera Work, 171, 176, 193, 248 (n. 40)

Carles, Arthur, 183

Carmencita (Sargent), 151, *152*

Carnegie, Mrs. Andrew, 70

Carnegie International Exhibition, 71, 72

Carolus Academy (Paris), 45, 49

Carolus Duran, Emile-Auguste, 44, 45

Carroll Galleries (New York), 184, 258 (n. 83)

Cary, Elisabeth L., 262 (n. 128)

Cassatt, Mary: at Pennsylvania Academy, 1; finances trip abroad, 41, 42–43; as student in Paris, 44, 45, 174; Salon painting by, 51; E. Sartain's friendship with, 55–56, 228 (n. 59); domestic scenes by, 59; L. Havemeyer's friendship with, 70, 228 (n. 59), 232 (n. 19); patronage for, 70, 232 (n. 19); and gallery-dealer system, 109; exhibits with Woman's Art Club, 119–20; and Woman's Building, 124, 126, 127; criticisms of, 126, 140; as expatriate painter, 236 (n. 75); and portraiture, 236 (n. 77); birth date of, 243 (n. 56); birth cohorts of, 254 (n. 17)

Catherine Lorillard Wolfe Art Club, 185, 244 (n. 63)

Catt, Carrie Chapman, 179

Centennial Exhibition, 2–3, 4, 72, 78, 118

Century Club, 69

Century Magazine, 2, 103, 159, 248 (n. 40)

Cercles, 39

Cézanne, Paul, 171, 173, 197

Chaplin, Charles, 45

Chapman, J. G., 219 (n. 25)

Charles Daniel Gallery (New York), 108, 177, 184, 187, 191, 258 (n. 83)

Chase, William Merritt: teaching career and students of, 58, 89, 218 (n. 17), 255 (n. 25); in Art Students League, 61; portraiture by, 85; L. Emmet as teacher under, 88; Beaux's view of, 89–90; on Dewing, 95; painting of studio by, 100–103, *101*; on success of women artists, 144; as defender of artists' masculinity, 148; art critics' views of, 152, 154, 246 (n. 15); compared with R. Henri, 170

Cherry, Deborah, 232

Chesterton, Laura Prieto, 223 (n. 69)

Chicago Art Institute, 214 (n. 2), 218 (n. 17)

Chopin, Kate, 248–49 (n. 45)

Chromolithographs, 103

Church, Frederic, 19

Church, Frederick S. 70

Church and Castle, Mont St. Michel (Clements), *91*

Church decorations, 66, 92

Clarke, Thomas, 109

Class. *See* Middle class; Working class

Clements, Gabrielle: training of, 45; in Paris, 45, 55; exhibition record of, 65–66; etchings by, 77, 84, 89, *91*, 92, 238 (n. 96); as E. D. Hale's life companion, 88, 89, 92–93; church decorations by, 92; homes of, 92, 94; as teacher, 92; studio of, 95

Coady, Robert, 258 (n. 83)

Coffin, William, 149

Cole, Thomas, 19

Collectors of art. *See* Art collectors

Constancy (Boyce), 178

Cook, Clarence, 77, 133, 143, 248 (n. 40)

Coolidge, Mary Hill, 70

Copley Society, 231 (n. 15)

Corcoran Gallery, 72

Corner of My Studio (Chase), 100–103, *101*

Cortissoz, Royal, 95

Cott, Nancy, 169

Cottier and Company, 79

Courtois, Gustave, 226–27 (n. 41)

Couture, Thomas, 44, 58, 224 (n. 9)

Cowart, Jack, 261 (n. 119)

Cox, Kenyon, 31, 58, 60, 61, 116, 225 (n. 17)

Cox, Louise King, 12, *13*, 26, 60, 80–82, *81*, 120, 163, 243 (n. 56), 254 (n. 17)

Craik, Dinah, 18

Creativity, 8–9, 167, 192, 194, 199. *See also* Genius in art; Self-expression/individualism

Critic, 140, 147

Critics. *See* Art criticism

Crooks, Mildred, 185

Cubism, 167, 186, 187

"Cultural housekeeping," 4, 18

Culture: and Victorian ideals of womanhood, 6–7, 17–18, 78, 126, 219 (n. 25); and middle class, 6–7, 134–35, 245 (n. 11); high, 6–9, 105, 134–35; mass, 7, 8, 9–10, 103–4, 205; and individual self-realization, 8–9, 106, 111–15, 149, 155–56, 205, 216 (n. 25); art criticism and, 132; as refinement, 134; effeminization of, 147–49, 171; and modernism, 166–68, 204; middlebrow, 168; and racial hierarchies, 215 (n. 16)

Curtis, Alice, 72

Dadaism, 167–68, 172, 182, 192, 253 (n. 16)

Daniel, Charles, 184

Daniel Gallery (New York), 108, 177, 184, 187, 191, 258 (n. 83)

Davies, Arthur B., 107, 108, 109, 114, 255 (n. 29)

Davies, Margery W., 214–15 (n. 75)

Davis, Stuart, 170

Dealers. *See* Gallery-dealer system

Decorative arts, 65, 66, 74, 77–82, 84, 118, 141, 145, 210

Degas, Edgar, 232 (n. 19)

Dell, Floyd, 177

Demuth, Charles, 176, 177, 178

Design schools, 3, 4, 18–19, 32, 88, 117, 240 (n. 11), 243 (n. 58)

Dewing, Maria Oakey, 68, 80, 94, 95, 158, 230 (n. 11), 235 (n. 58)

Dewing, Thomas, 94, 95, 248 (n. 40)

Dick, Gladys Roosevelt, 185

Dismorr, Jessica, 175, 183

Doctors. *See* Medicine

Dodge, Mabel. *See* Luhan, Mabel Dodge

Doll and Richards Gallery (Boston), 108–9, 110, 115

Dougherty, Paul, 111

Dove, Arthur, 254 (n. 23)

Downtown Gallery (New York), 108, 184, 185, 189, 259 (n. 88)

Dreier, Katherine, 182, 186, 254 (n. 18), 258 (n. 78)

Dress and costuming. *See* Aesthetic dress

Driggs, Elsie, 261 (n. 118)

Duchamp, Marcel, 172, 175, 177, 182, 192

Durand, Asher B., 218 (n. 17)

Durand-Ruel Galleries (New York), 109

Duveneck, Elizabeth Boott, 54, 58, 59, 136–37, 140–41, 228 (n. 67), 236 (n. 75)

Duveneck, Frank, 58, 59

Dwyer, Britta, 233 (n. 27)

Eakins, Susan Macdowell, 29–31, *30*, *33*, 94–95

Eakins, Thomas, 23, 30–31, 50, 85, 94, 137, 222 (n. 63)

Eastman, Max, 176

Eaton, Wyatt, 140

Eclectics, 185

Ecole de la Grande Chaumiere, 173

Ecole des Beaux-Arts, 45, 49, 58–59, 221 (n. 49)

Eddy, Arthur Jerome, 184

Effeminization of culture, 147–49, 171

"The Eight," 106, 107, 171, 255 (n. 29)

Eisler, Benita, 261 (n. 119)

Elder sisters, 55

Ellet, Elizabeth, 236 (n. 77), 242 (n. 46)

Emmet, Lydia Field: as student in Paris, 45, 49, 52–54, 57, 225 (n. 16); photographs of, 53, 80; exhibition record of, 71–72; and aesthetic dress, 80, 80; decorating commissions for, 82; portraiture by, 84, 86, 87–88, 236 (n. 75); earnings of, 84, 86, 88, 238 (n. 90); prices for artwork by, 84, 86, 236 (n. 75); as teacher, 88, 238 (n. 90); and gallery-dealer system, 109, 110–11; and Woman's Building, 124; Péne du Bois's criticism of, 154; murals by, 244 (n. 69); birth cohorts of, 254 (n. 17)

Emmet, Rosina. See Sherwood, Rosina Emmet

Employment of women, 82, 94, 160

Essential femininity, 5, 115–16, 130–32, 151, 154, 165, 191–200, 204–5. See also Femininity/feminization

Este, Florence, 55, 57

Etching, 65, 66, 68, 74, 76, 77, 84, 89–92, 90, 91, 210, 238 (n. 96)

Evans, William T., 70, 231 (n. 18)

Exhibitions: in Salon de Paris, 50–52, 63; by art associations, 65, 67, 76, 117, 118–19, 203; by women artists, 65–66, 67, 71–74, 75, 77, 84, 111, 180–89, 191, 203, 207–9, 233 (n. 27); sales figures from, 67; jury process for, 68–69, 105, 107, 231 (n. 13); at gentlemen's clubs, 69–70; by women's clubs, 70–71, 185–86; of pastels, 76; of etchings, 77; of portraiture, 85; in early twentieth century, 106; in galleries,

106–13, 115–16; one-man or one-woman shows, 108, 109, 110, 115–16, 184, 189, 191; by women's art associations, 117, 118–19, 121, 122, 186; in Woman's Building, 123–28; in Fine Arts Palace, 127; separate exhibitions of women's artwork, 127–28, 161; and Armory Show, 163, 167, 171, 175, 176, 180, 182, 184, 258 (n. 71), 260 (n. 106); of modern art, 163, 167, 171, 175, 176, 180–89, 191, 255 (nn. 29, 30), 258 (n. 71); hanging committees for, 231 (n. 13)

Faculty of art schools. See Art schools

Fates and Annunciation (Cox), 83

Fauves, 173, 175, 180, 187, 188

Felski, Rita, 216 (n. 23)

Femininity/feminization: and "cultural housekeeping," 4, 18; and "social housekeeping," 4, 18, 214 (n. 8); and modernism, 5, 8–9, 167–68, 191–200, 204–5, 216 (n. 23); and amateurism, 5, 27, 33, 67, 222 (n. 57); and watercolor, 5, 65, 74; and portraiture, 5, 84, 236 (n. 77); essential, 5, 115–16, 130–32, 151, 154, 165, 191–200, 204–5; and Victorian ideals, 6–7, 17–18, 78, 94, 126, 219 (n. 25); and consumption, 7, 8; and mass culture, 9–10, 104, 168, 205; as antithesis of professionalism, 14; and female art students, 35; and women's abilities in "lesser" media, 65, 74–83, 97, 103, 104, 145, 203; and aesthetic movement, 78; and art criticism, 115–16, 130–32, 143–49, 203–4; and rhetoric of "feminine art," 128, 157–62, 197–200; biological basis for, 145–47, 203–4; and effeminization of culture, 147–49, 171; and sexuality, 167, 192–93, 199; O'Keeffe's and Read's views on, 197–200; and illustrators, 240 (n. 11)

Feminism, 165, 166, 169, 177, 178–79, 187, 199, 204

The Greensboro Women's Fund
of the University of North Carolina Press
was established in 2000 to support the publication of
books by and about women.
Its founding contributors are
Linda Arnold Carlisle, Sally Schindel Cone,
Anne Faircloth, Bonnie McElveen Hunter,
Linda Bullard Jennings,
Janice J. Kerley (in honor of Margaret Supplee Smith),
Nancy Rouzer May, & Betty Hughes Nichols.

The generosity of contributors to this
fund has helped support the following books:

Captain Ahab Had a Wife:
New England Women and the Whalefishery, 1720-1870
LISA NORLING

Painting Professionals:
Women Artists and the Development of
Modern American Art, 1870-1930
KIRSTEN SWINTH

GENDER & AMERICAN CULTURE

Painting Professionals: Women Artists and the Development of Modern American Art, 1870–1930, by Kirsten Swinth (2001)

Remaking Respectability: African American Women in Interwar Detroit, by Victoria W. Wolcott (2001)

Ida B. Wells-Barnett and American Reform, 1880–1930, by Patricia A. Schechter (2001)

Taking Haiti: Military Occupation and the Culture of U.S. Imperialism, 1915–1940, by Mary A. Renda (2001)

Before Jim Crow: The Politics of Race in Postemancipation Virginia, by Jane Dailey (2000)

Captain Ahab Had a Wife: New England Women and the Whalefishery, 1720–1870, by Lisa Norling (2000)

Civilizing Capitalism: The National Consumers' League, Women's Activism, and Labor Standards in the New Deal Era, by Landon R. Y. Storrs (2000)

Rank Ladies: Gender and Cultural Hierarchy in American Vaudeville, by M. Alison Kibler (1999)

Strangers and Pilgrims: Female Preaching in America, 1740–1845, by Catherine A. Brekus (1998)

Sex and Citizenship in Antebellum America, by Nancy Isenberg (1998)

Yours in Sisterhood: Ms. Magazine and the Promise of Popular Feminism, by Amy Erdman Farrell (1998)

We Mean to Be Counted: White Women and Politics in Antebellum Virginia, by Elizabeth R. Varon (1998)

Women Against the Good War: Conscientious Objection and Gender on the American Home Front, 1941–1947, by Rachel Waltner Goossen (1997)

Toward an Intellectual History of Women: Essays by Linda K. Kerber (1997)

Gender and Jim Crow: Women and the Politics of White Supremacy in North Carolina, 1896–1920, by Glenda Elizabeth Gilmore (1996)

Delinquent Daughters: Protecting and Policing Adolescent Female Sexuality in the United States, 1885–1920, by Mary E. Odem (1995)

U.S. History as Women's History: New Feminist Essays, edited by Linda K. Kerber, Alice Kessler-Harris, and Kathryn Kish Sklar (1995)

Common Sense and a Little Fire: Women and Working-Class Politics in the United States, 1900–1965, by Annelise Orleck (1995)

How Am I to Be Heard?: Letters of Lillian Smith, edited by Margaret Rose Gladney (1993)

Entitled to Power: Farm Women and Technology, 1913–1963, by Katherine Jellison (1993)

Revising Life: Sylvia Plath's Ariel Poems, by Susan R. Van Dyne (1993)

Made From This Earth: American Women and Nature, by Vera Norwood (1993)

Unruly Women: The Politics of Social and Sexual Control in the Old South, by Victoria E. Bynum (1992)

The Work of Self-Representation: Lyric Poetry in Colonial New England, by Ivy Schweitzer (1991)

Labor and Desire: Women's Revolutionary Fiction in Depression America, by Paula Rabinowitz (1991)

Community of Suffering and Struggle: Women, Men, and the Labor Movement in Minneapolis, 1915–1945, by Elizabeth Faue (1991)

All That Hollywood Allows: Re-reading Gender in 1950s Melodrama, by Jackie Byars (1991)

Doing Literary Business: American Women Writers in the Nineteenth Century, by Susan Coultrap-McQuin (1990)

Ladies, Women, and Wenches: Choice and Constraint in Antebellum Charleston and Boston, by Jane H. Pease and William H. Pease (1990)

The Secret Eye: The Journal of Ella Gertrude Clanton Thomas, 1848–1889, edited by Virginia Ingraham Burr, with an introduction by Nell Irvin Painter (1990)

Second Stories: The Politics of Language, Form, and Gender in Early American Fictions, by Cynthia S. Jordan (1989)

Within the Plantation Household: Black and White Women of the Old South, by Elizabeth Fox-Genovese (1988)

The Limits of Sisterhood: The Beecher Sisters on Women's Rights and Woman's Sphere, by Jeanne Boydston, Mary Kelley, and Anne Margolis (1988)

DATE DUE